The Canada Pavilion at the Venice Biennale

Edited by Réjean Legault

National Gallery of Canada, Ottawa
5 Continents Editions, Milan

Contents

Forewords

This is the first publication dedicated to the Canada Pavilion in the Giardini della Biennale di Venezia in the building's sixty-year history. James Wilson Morrice, Geneviève Cadieux, Alex Colville, Edward Poitras, Rebecca Belmore, Rodney Graham, Shary Boyle, and Isuma are just a few of the visionary artists who have exhibited their work at the International Art Exhibition in Venice, raising awareness of our country's talent and creativity on the world stage.

More than just a venue for Canadian artists, the Canada Pavilion is also a distinct architectural landmark with a captivating history of its own. This book tells that story, unweaving the complex narratives that have shaped its genesis and life over the last six decades.

The National Gallery of Canada is proud to have played a defining role in this remarkable journey. When former National Gallery Director Harry O. McCurry travelled to Venice to install the first exhibition of Canadian painting in the Italian Pavilion in 1952, the prestige of the Biennale and the need to establish a more permanent presence for Canada was clear to him. Three years later, the Gallery commissioned Enrico Peressutti of the prominent Italian firm Studio BBPR to design a building for this purpose.

We extend our sincere thanks to the Canada Council for the Arts, the Canadian Embassy in Rome, the Royal Architectural Institute of Canada, and Global Affairs Canada for their longtime support, as well as the pavilion's vast network of donors, stakeholders, and endowment families for their generosity and goodwill. Special recognition is also due to the artists and architects who have represented Canada at both the visual arts and architecture biennales, and to all of the curators who have supported their projects over the years.

In 2017–18 the Gallery undertook a historic restoration of the Canada Pavilion. Reesa Greenberg, Distinguished Patron and Director of the National Gallery of Canada Foundation, generously funded this major project, which marked a remarkable partnership between Canada and Italy built on a continuing friendship of more than sixty years. We extend our warm thanks to Paolo Baratta, President of La Biennale di Venezia, as well as his team for their exceptional cooperation throughout the restoration, including the revitalization of the surrounding landscape designed by Cornelia Hahn Oberlander and Bryce Gauthier of Enns Gauthier Landscape Architects. We are also deeply indebted to the architect Alberico Barbiano di Belgiojoso, heir to BBPR, and to Emanuela Carpani, Director of architectural heritage for the Venice region, and her team, who were tremendously dedicated to the project from the outset.

Thanks are also due to my predecessor, Marc Mayer, for supporting Canadian artists in Venice, and to Karen Colby-Stothart, former Chief Executive Officer of the National Gallery of Canada Foundation, for her leadership in developing a new, sustainable financial model to fund the Canadian representation in Venice, and for her skilled oversight of the Canada Pavilion restoration project.

Today, the fully restored Canada Pavilion retains its distinct character—earnest and undeniably sophisticated—and provides a renewed platform upon which a new generation of artists can make their mark. It is our hope that this publication will inspire many to discover and appreciate this magnificent cultural landmark—a unique and beloved pavilion in one of the world's most inspiring centres for the celebration of international art.

Sasha Suda, PhD
Director and Chief Executive Officer, National Gallery of Canada

The buildings and green space that constitute the Giardini della Biennale di Venezia offer not only a history of architecture, but also a history of politics. The twenty-six national pavilions standing on the grounds reflect the geography of the world, which has been changing since the beginning of the last century. Their siting, size, and style reveal much about Western political history. Nestled between the British and German pavilions on the so-called "hill of three powers," the Canada Pavilion is definitely one of the most unusual because it completely refuses any sort of pompous idea of self-representation of the state, of the nation.

Designed in the mid-1950s by a group of very important Italian architects—the Milan collective BBPR—the Canada Pavilion is friendly, subdued, and very elegant, and reflects qualities that have come to be associated with Canadians. Its construction grew out of the new relationship forged between Canada and Italy after the Second World War and reminds us of the great contribution of the Canadian army to the liberation of Italy and the humanitarian aid Canada gave to the civilian population after the end of hostilities. So there is a historical and ethical significance to the pavilion that goes far beyond present relations.

Like the Biennale itself, which has evolved from a biennial art exhibition to a showcase for architecture in the former "off" year, as well as a host for cinema, dance, theatre, and music festivals, the national pavilions in the Giardini have had to adapt to changing demands. While some were radically altered or even replaced, it is now quite difficult to imagine the destruction of a pavilion. We have come to see the architecture of the Giardini as an "open air museum" within the "living" space of the Biennale. Although we do not wish to present the national pavilions as monuments, they are charged with memories. Therefore, the restoration of a pavilion must be considered a major event, demonstrating the extent of its value to its owner. And since the very existence of each of the pavilions reflects the history of the relationship between these countries, the conservation of the original buildings is of great significance. Just as the Biennale is a place of exchange, of dialogue, of research in the arts, so too is it a place for discussion about architectural conservation. These factors were very much at work throughout the Canada Pavilion restoration, during which we benefited from an extraordinary collaboration with the National Gallery of Canada as well as the Soprintendenza Archeologia, Belle Arti e Paesaggio per il Comune di Venezia e Laguna.

The restoration project also offered an opportunity to rethink the areas adjacent to the pavilion and contribute to their improvement. As with all of the national pavilions in the Giardini, the surrounding grounds do not belong to the pavilion; rather they are a public space under the care of the Biennale authorities. At the Biennale Office we thought, "why don't we add our initiative to that of the Canadians?" We decided to rejuvenate the hill extending from the Korean and Japanese pavilions all the way down behind the German, Canadian, British, and French pavilions by means of a connecting path. This created more accessible green space for visitors. The addition of a platform behind the Canada Pavilion for installations and public events also opened up views onto the Laguna. These terraces are now a wonderful part of the Giardini. The fact that this project coincided with the 150th anniversary of Canada made it all the more meaningful to all the parties involved, reminding us that the pavilion is linked to our history in a special way. The restored and renewed Canada Pavilion is a compelling contribution to the living space of the Giardini della Biennale.

Paolo Baratta
President, La Biennale di Venezia

I joined the Soprintendenza di Venezia in March 2015. One of the first major projects I had to deal with was the National Gallery of Canada's proposal to restore and enlarge the country's pavilion in the Giardini della Biennale. I immediately realized that an extraordinary opportunity to broaden my professional horizons had come my way quite by chance. Canada was about to commemorate a significant milestone in its history—the 150th anniversary of the Canadian Confederation—and the restoration of the pavilion in Venice was perhaps the most notable of the various events staged on foreign soil.

It has been an honour for me both personally and professionally to work with organizations such as the National Gallery of Canada and La Biennale di Venezia on a project that lasted more than three years and was always conducted in a straightforward, constructive manner. I remember well all the meetings we had, whether at the offices of the Soprintendenza in the Palazzo Ducale or at the headquarters of the Biennale in Ca' Giustinian, as well as our gatherings with experts in the Comitati Tecnico-Scientifici del Ministero dei Beni e delle Attività Culturali e del Turismo. I recall the fascinating discussions that compelled us to test the principles governing the conservation of cultural heritage, particularly as they apply to the specific fields of modern architecture and historic gardens. We had to consider the restoration and reuse of the building, the rearrangement of the immediate surroundings and their incorporation within the new overall layout of the gardens, landscaped with an eye to the future, all the while balancing permanence and transience, distinctiveness and shared rules, in the interests of a coordinated management of the entire complex. These were the main themes of the discussions, which never failed to stimulate and live up to the highest scientific and professional standards. It is no accident that the site was frequently visited by groups of students, from undergraduate to doctoral levels, and this is another reason to thank the National Gallery of Canada. The restoration of an architectural project is always an opportunity to study, carry out research, and deepen our knowledge of the building and our understanding of the original design concepts.

A project of this kind inevitably prompts discussions that will generate a shared sensibility on the diverse meanings of the building and its surroundings. No longer considered a mere "container," infinitely adaptable to the installation requirements of artists, the pavilion has now been re-established as an extraordinary cultural experiment in its own right, and part of the anthology of twentieth-century architecture represented in the Giardini.

This book draws together multiple strands: the historical background to the construction of the Canada Pavilion; the involvement of Studio BBPR in Milan; the development of the design concept; the National Gallery's motivations and aspirations as the building's original patron; the six decades of exhibitions held in the pavilion before its recent restoration; and its future prospects and cultural potential within the most beautiful setting for international creative diplomacy in the world.

The younger generations of Canadian artists and architects must be proud of what their country's government achieved in the immediate post-war years and of the imagination displayed in the following decades in promoting the creativity of so many of their predecessors. Together, we have done our best to preserve for them this jewel of modern architecture so that it will long continue to inspire artists and be a place of cultural exchange.

I am personally grateful to everyone who has worked on this project. I thank them all from the bottom of my heart. A special thank you to Francesco Trovo, Anna Chiarelli, and Chiara Ferro of the Soprintendenza; to Karen Colby-Stothart and Marc Mayer of the National Gallery of Canada; to Andrea Del Mercato, Cristiano Frizzele, and Manuela Lucà-Dazio of the Biennale; Alberico Barbiano di Belgiojoso of Studio Belgiojoso; Cornelia Hahn Oberlander; Bryce Gauthier of Enns Gauthier Landscape Architects; and Troels Bruun of M+B Studio.

Emanuela Carpani
Director, Soprintendenza Archeologia, Belle Arti e Paesaggio
per il Comune di Venezia e Laguna

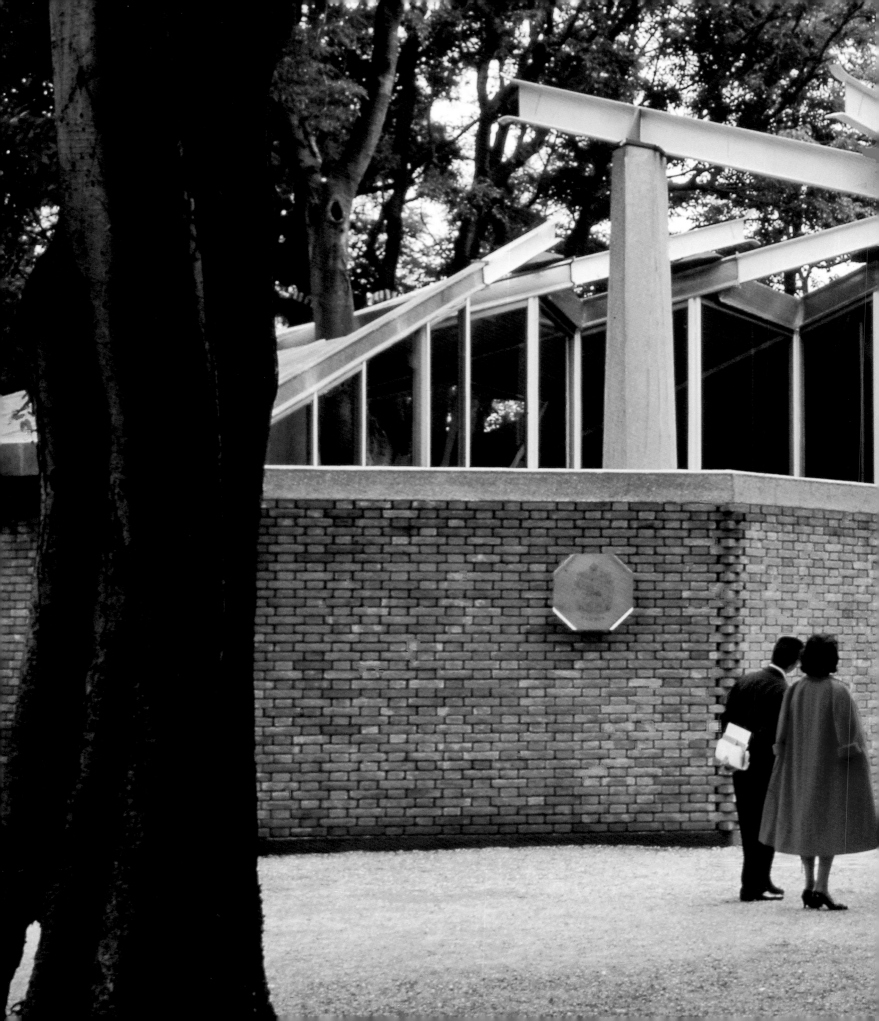

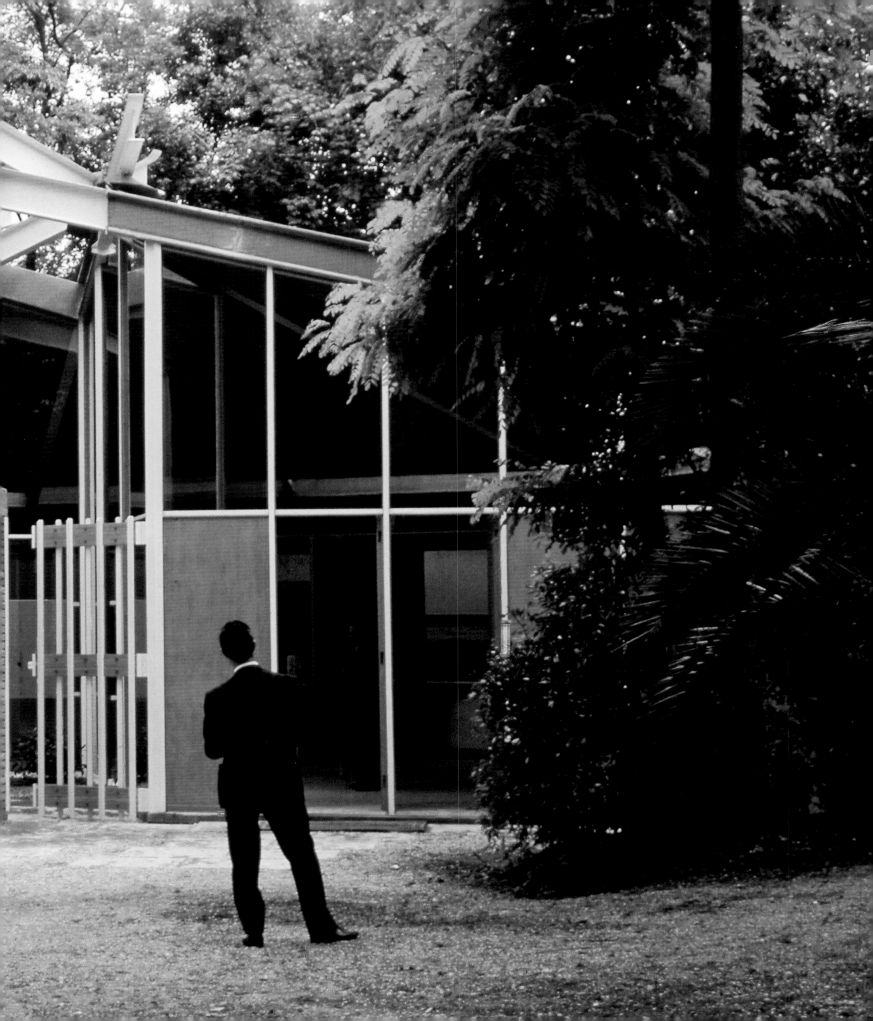

Introduction

This long-overdue book traces the history, architectural relevance, artistic life, and recent restoration of the Canada Pavilion in Venice—a masterpiece of modern architecture commissioned by the National Gallery of Canada in late 1955 and designed by architect Enrico Peressutti of the famed Studio BBPR in Milan. While the genesis of the book was the 2017–18 restoration of the pavilion, the research, reminiscences, and work undertaken should be understood within the broader context of the past decade, during which every aspect of Canada's participation in the International Art Exhibition at the Biennale di Venezia has been reinvented.

Opened in 1958, the Canada Pavilion has offered a permanent, dedicated exhibition space to those artists, curators, and architects chosen to represent the country. The Venice Biennale, held in the summer every two years since 1895, and in later decades extended into the spring and autumn, has offered a global survey of the best of contemporary art throughout the twentieth and twenty-first centuries. The Biennale has become a place where art, ideas, museums, markets, and international diplomacy intersect. It arguably remains the most important recurring contemporary art exhibition and critical showcase to this day. Architecture exhibitions were added in the off-year at the Canada Pavilion beginning in 1991.[1]

After the establishment of Canadian visual arts representation at the Biennale in the 1950s, organizational and financial responsibility for the Canadian program remained with the National Gallery for over thirty years. In 1988 this shifted to the Department of Foreign Affairs and International Trade, which partnered with the Canada Council for the Arts. The latter provided oversight of the artist-commissioner selection process, opening the door to participation by other Canadian art museums. The National Gallery continued to maintain the Canada Pavilion, which it owned, for the next two decades, offering occasional expert support to commissioners. While the new process was originally welcomed, the lack of administrative continuity, fragmented program authority, and chronic underfunding became new challenges. Shifting priorities at Global Affairs Canada saw the eventual cancellation of support for the Venice Biennale in 2008, and the Gallery cut its maintenance budget for the Canada Pavilion the same year. Although Canada Council financial support remained available, artistic project needs vastly exceeded available funds. Artists and curators were shouldering staggering personal fundraising obligations without organizational support in an aging and neglected pavilion. The program was in crisis. The architecture program faced similar challenges.[2]

And so, in 2010, with no source of stable funding to assure the production of visual-arts projects, and costly and urgent reconstruction on the horizon, the National Gallery, under the enlightened leadership of Director and Chief Executive Officer Marc Mayer, embarked on a ten-year mission to research, consult, and, if possible, rebuild Canada's commitment to national representation at the Biennale. To achieve this, the support of Canada's private arts philanthropy community was required on an unprecedented scale.

Indeed, the Canada Pavilion, as a physical artefact representing so much to so many, became the nucleus around which a passionate network of public and private champions of Canadian art and architecture coalesced. As research progressed and knowledge deepened, so did the circle of champions.

A new program-management model for the visual arts took shape under the leadership of the National Gallery as commissioner, in which in-house technical, fundraising, management, and occasionally, curatorial personnel are provided on a pro-bono basis. Expertise from across the country is, importantly, integrated through the biannual curatorial selection jury, the invitation of guest curators, and institutional partnerships undertaken in consultation with the selected artist(s).

In 2013 the National Gallery of Canada Foundation and its Board of Directors made the Venice Biennale a national priority and embarked on a major new fundraising strategy that would concurrently finance the restoration of the Canada Pavilion, fund the visual-arts exhibition project in the pavilion every two years, and work toward a self-sustaining financial model and revenue stream for the future.[3]

Over the next five years, a truly pan-Canadian network of visual-arts support coalesced, including corporate sponsors, the Canada Council, and private philanthropists. RBC Wealth Management and the RBC Foundation led the way with ambitious recurring commitments as presenting sponsor for the next decade. The Canada Council, under the visionary leadership of Director and Chief Executive Officer Simon Brault, formally rejoined the Gallery as a Biennale organizing partner in 2016, dramatically augmenting that agency's biannual financial support for both art and architecture and offering staunch public advocacy for Canada's participation in this international theatre.

Private philanthropists also responded on an exceptional scale. Canadians owe a debt of special gratitude to art historian and philanthropist Reesa Greenberg of Ottawa, whose specialized interests in contemporary art, architecture, and exhibition spaces led her to privately finance all research and construction costs for the restoration of the Canada Pavilion, and to support the publication of this book. Most important to the program's long-term sustainability, a national Canadian Artists in Venice Endowment was launched by the National Gallery of Canada Foundation. From this endowment, biannual yield is now dedicated to funding the Canadian visual-arts representation in perpetuity.[4] We are deeply indebted to the Donald R. Sobey Family, the Michael and Sonja Koerner Family, and the Jack Weinbaum Family Foundation, who have contributed generously to the Canadian Artists in Venice Endowment, pushing it well past the half-way mark of its capital goal at the time of this writing. Over fifty families, private foundations, and smaller government agencies from across Canada have also donated to the Foundation's biannual Venice exhibition campaigns, which will continue on an increasingly modest basis until the endowment goal has been reached. Since 2017 Global Affairs Canada has also resumed occasional and important funding. We have benefited from the unwavering support of Foundation Chair Thomas d'Aquino and Directors of the Board Michelle Koerner and Reesa Greenberg for their committed advocacy throughout. Special acknowledgement is due to biannual campaign cabinet members James Fleck, Michelle Koerner, Jay Smith, and Susan Kidd, who have shared their networks; as well as to hosts Jim and Susan Esker, Jane Irwin and Ross Hill, Michael and Renae Tims, Jay Smith and Laura Rapp, and Jeff Stober, all of whom have generously hosted multiple campaign events over the years. This enlightened and unconventional public/private partnership has saved the Canada Pavilion and Canada's national representation at the Venice Biennale. Our appreciation to all of these partners is profound.

The other extraordinary alliance that has emerged from this initiative is the dedicated bilateral Canadian/Italian network of architectural, professional, and diplomatic circles. Once again, it was the Canada Pavilion itself that served as the nucleus around which in-depth research, scholarship, diplomacy, and professional cooperation revolved. An understanding of our poignant shared history at the end of the Second World War was rekindled, alongside a spirit of working together on a modestly scaled but complex and architecturally significant project. While Canada owns the physical structure of its pavilion, it does not own the land on which it is built, and was compelled to respect strict heritage restrictions for both the building and landscape.[5] Re-envisioning the pavilion and landscape required close consultation and collaborative thinking with multiple local and national heritage and administrative authorities over many years.

The most prominent among the Italian authorities were La Biennale di Venezia (under the direction of President Paolo Baratta, actively supported by Director General Andrea Del Mercato and senior team members, including Manuela Lucà-Dazio and Cristiano Frizzele) and the Soprintendenza Archeologia, Belle Arti e Paesaggio per il Comune di Venezia e Laguna (under the direction of architect Renata Codello, succeeded by architect Emanuela Carpani, and actively supported by architect Anna Chiarelli, followed by architect Chiara Ferro). Superb and highly engaged teams of architects and other specialists from both agencies became familiar faces and friends on a bilateral committee that met regularly. Canadian ideas, proposals, and detailed plans were presented, debated, and negotiated over the period between 2014 and 2018.

What began as a proposed building expansion project to vastly enhance interior display space was not approved for various reasons, explained in the chapters that follow. Eventually, a major historic restoration project was agreed upon, including discreet, functional improvements to lighting, environmental, security, display, electrical, and technology systems. As museum professionals ourselves, we understood the technical risks and conservation issues associated with a building expansion within a delicate archaeological site, and came to both accept and agree with this course of action. By early 2016, the Canadian focus had shifted to working with heritage authorities to develop a scrupulous but modern restoration approach to a pavilion still in active use and, importantly, to reclaim and expand access to the exterior grounds and perimeter. Dense overgrowth, erosion, and recent temporary incursions, including a Biennale-operated food concession against the outer wall of the Canada Pavilion, became the next frontier for discussion.

In the Venetian context, landscape, trees, and indigenous plantings are precious and as rigorously regulated by heritage agencies as historic monuments. Property is also scarce, and the Biennale di Venezia manages all outdoor spaces closely, carefully considering visitor service needs in the densely attended Giardini, which can welcome as many as 600,000 people each year.

It was therefore an extraordinary gesture and unprecedented financial contribution on the part of the Biennale to invite cooperation with the Canadian team to prioritize the area around the Canada Pavilion for redevelopment. This was linked to active advocacy by the Canadian team around the approaching 2017 Canadian sesquicentennial and the opportunity for a symbolic and mutually beneficial Canadian/Italian joint initiative. The activity was folded within a Biennale-led renewal project already underway for the whole of the Giardini, begun in 2013. The stunning results of the jointly managed restoration and landscape renewal, all under the watchful eye of the heritage authorities, have made the Canada Pavilion one of the most beautiful sites in the Giardini.

Under my purview as Deputy Director, Exhibitions and Installations for the National Gallery, and subsequently as Chief Executive Officer of the National Gallery of Canada Foundation, I had the privilege of leading the Canadian team throughout the course of this project.

Among the first to join this team in 2013 was architect Alberico Barbiano di Belgiojoso of Studio Belgiojoso, Milan, who undertook early feasibility studies and expansion proposals in 2014 through 2015, and eventually directed the architectural restoration project from 2016 through 2018. As the son of Lodovico Barbiano di Belgiojoso (the second "B" in BBPR) and latter-day heir to Studio BBPR, his renown in Italy, his personal interest, and his deep knowledge of the pavilion's design were critical to the project's integrity.

Legendary Canadian landscape architect Cornelia Hahn Oberlander and her associate, Bryce Gauthier of Enns Gauthier Landscape Architects, joined the team in 2016, bringing exceptional experience and gravitas to the discussions of the architectural setting and landscape. An internationally recognized pioneer in her profession, Ms. Hahn Oberlander made an inspiring working trip to Venice at ninety-six years of age to meet with the bilateral working group and walk the site! Her influence and understated interventions in cooperation with Bryce Gauthier and our Italian partners—regrading around the pavilion, subtle enhancement of the front approach, the addition of an elegant rear platform and walkways extending through the trees and gardens—have recreated access and visibility, sun and shade, and transformed the site with nuanced understanding of the design sensibility of the period in which it was built.

Architect Troels Bruun from M+B Studio, Venice, and exhibition-design consultant Gordon Filewych of onebadant, Ottawa, both expertly oversaw all aspects of the project's technical execution from 2014 to 2018. Despite many unforeseen challenges, their competence and creativity brought a sophisticated project to realization. From 2014 through 2015 the Gallery also benefited importantly from the insights of the Royal Architectural Institute of Canada, notably those of Ian Chodikoff, Allan Teramura, and Barry Johns, as it learned about the pavilion, the site, and the perspective of Canada's architectural community.

The Canadian project owes a tremendous debt of gratitude to the Embassy of Canada in Rome and the Embassy of Italy in Ottawa for their constant and active engagement. The Canada Pavilion is, among other things, an artefact of the post-war diplomatic and political environment in which it was built, a subject expanded upon in this book. Both embassies were original participants in the story as early as 1952 and had valuable insight into its diplomatic and architectural significance. They were swift to support rebuilding an initiative that remains as relevant today as sixty years ago. We are deeply indebted to the Ambassador of Canada to Italy, Peter McGovern (2013–17) followed by Alexandra Bugailiskis, and the team at the embassy, notably Counsellor Louis Saint-Arnaud and Public Affairs Officer Enrica Abbate. We also acknowledge with appreciation the Ambassador of Italy to Canada, H.E. Gian Lorenzo Cornado (2013–16) followed by H.E. Claudio Taffuri, and Embassy colleagues for their constant advocacy and counsel. Recognizing the opportunity in our timing and working in close cooperation with these diplomatic partners, the Canada Pavilion restoration initiative became a prominent symbol through which Canada and Italy together marked Canada's 150th anniversary in 2017.

Numerous National Gallery staff members added knowledge and talent over many years, in particular Josée Drouin-Brisebois, Senior Curator of Contemporary Art; Anne Eschapasse, Deputy Director, Exhibitions and Outreach; Serge Belet and Clément Lormand, Senior Exhibitions Managers; Denis Gravel, Capital Project Officer; and Foundation team members Lisa Turcotte, Head, Patron Services and Events, and Tamara Andruszkiewicz, Pavilion Manager, Patron Services.

Special recognition is due to those artists and architects who graciously accommodated the requirements of the Canada Pavilion restoration schedule. In response to the need to close the pavilion to start work on the restoration, OPSYS reconceived their project for the 2016 Biennale

Architettura for the space in front of the pavilion. Geoffrey Farmer represented Canada at the Biennale Arte in 2017, conceiving and adapting his project for a half-dismantled building without a roof, and creating one of the most memorable artistic projects in Canada's Biennale history. Architect Douglas Cardinal and his colleagues represented Canada at the Biennale Architettura in 2018, and exceptionally occupied an alternate exhibition space in the Arsenale, allowing precious additional weeks of construction activity at the historic Canada Pavilion so that it could reopen on schedule in May 2018.

Around all of this intensive restoration activity, research was ongoing into every aspect with the intention of consolidating memory and knowledge around the original commission; legal and financial documentation; the Gallery's leadership in the realms of architecture and design in the 1950s; the original landscape design; the history of exhibitions; curators and artists presented; and more.

Architectural historian Réjean Legault of the Université du Québec à Montréal was brought on board to develop an exhibition on the pavilion for the 2018 Architecture Biennale and to put together this book; architectural historian Cammie McAtee was engaged to scour archives in Canada, Italy, and the United States to construct a meticulous chronology of the commission and the building's history; while Josée Drouin-Brisebois, assisted by Nicole Burisch, Assistant Curator of Contemporary Art at the National Gallery of Canada, turned to an in-depth study of the exhibition history. Serena Maffioletti, Director of the Archivio Progetti, Università Iuav di Venezia, provided a wealth of archival material on the pavilion and BBPR. A collaboration with the National Film Board of Canada under the leadership of Executive Director André Picard yielded rich archival footage from past collaborations with the Gallery in 1958–59 along with new interviews and footage during the restoration and reopening. Much of the project research described above and some National Film Board material were incorporated in the exhibition *Canada Builds/Rebuilds a Pavilion in Venice*, which launched the pavilion reopening in May 2018.

This book, under the direction of Réjean Legault, presents this remarkable history in a collection of superb essays and first-hand interviews with architect Alberico Belgiojoso and landscape architect Cornelia Hahn Oberlander, and provides an invaluable resource for future reference. Cammie McAtee breathes life into the fascinating political and cultural environment in which the National Gallery's commission took place. Serena Maffioletti positions the Canada Pavilion within the work of BBPR and its place within post-war Italian architectural culture. Réjean Legault continues the meticulous historical account, exploring the architectural context within which the design and construction of the pavilion took place, including its early critical reception in Canada and Italy. Josée Drouin-Brisebois looks back on six decades of exhibitions with observations on the evolution of the manner in which the building was used, the way it was perceived by artists, architects, and curators, and how it has served Canada in projecting artists to the world. Susanna Caccia Gherardini provides an important contribution on the conceptual intent and material constraints that informed the restoration project, while Franco Panzini describes the Canada Pavilion's place within the landscape history of the Giardini and the many challenges entailed by the renewal of the pavilion's surroundings. The essays are complemented by a selection of Andrea Pertoldeo's remarkable photographs documenting the restoration.

This volume is an exciting addition to our Canadian art history, featuring both Canadian and Italian experts in a fitting tribute to the completed restoration of a shared cultural and architectural icon.

Karen Colby-Stothart
Chief Executive Officer, National Gallery of Canada Foundation (2013–19)
and Deputy Director, Exhibitions and Outreach, National Gallery of Canada (2009–13)

Acknowledgements

The contributions of the following individuals were also instrumental in the success of the restoration of the Canada Pavilion and the many collateral activities that accompanied this work: Jean-François Bilodeau, Ann Bowman, Kathy Broom, Jean-Marc Cabalas, Stefan Canuel, Jazmín Cedeño, Maria Cook, Joseph D'Agostino, Carlo Dalla Vedova, Trevor Dupuis, Mark Fell, Michel Gaboury, Katerine Giguère, Sylvie Gilbert, Julie Huguet, Mylène Kahalé, Margherita Lancellotti, Kelly Langgard, Josée-Britanie Mallet, Denis McCready, Beatriz Mendes, Marie-Claude Mongeon, Alexia Naidoo, Julie Peckham, Marina Peressutti, Antonia Reiner, Ed Richard, Christine Sadler, Micol Saleri, Inderbir Singh Riar, Robert Sirman, Alexis Sornin, Michael Testa, Marco Tosato, Anne Trépanier, Lorenzo Truant, the late Luca Ugolini, Christiane Vaillancourt, Camille Verville, Lisa Walli, and Roberto Zancan.

Portfolio 1958　　　　　　　　　**Studio Giacomelli**

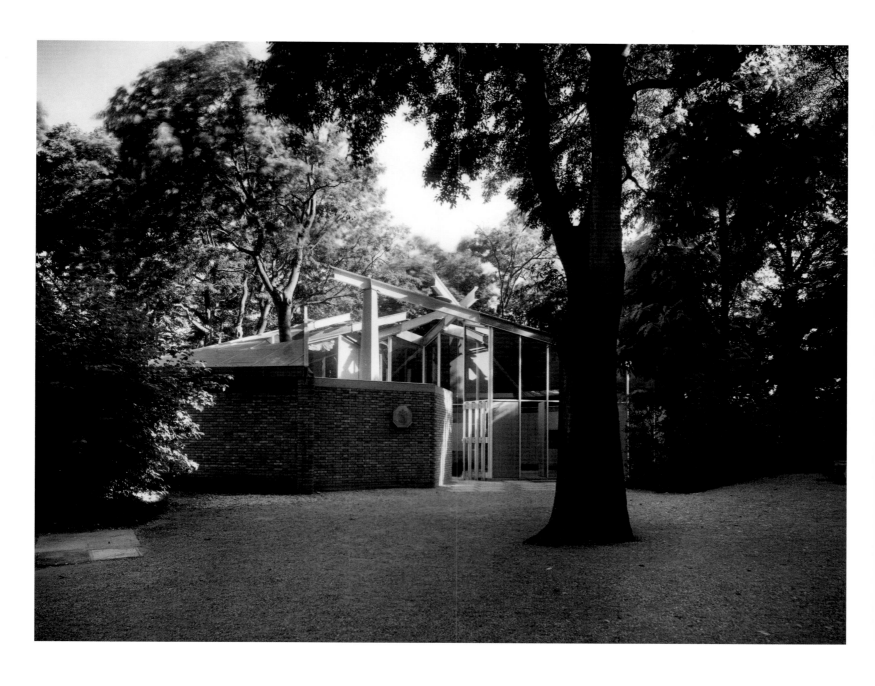

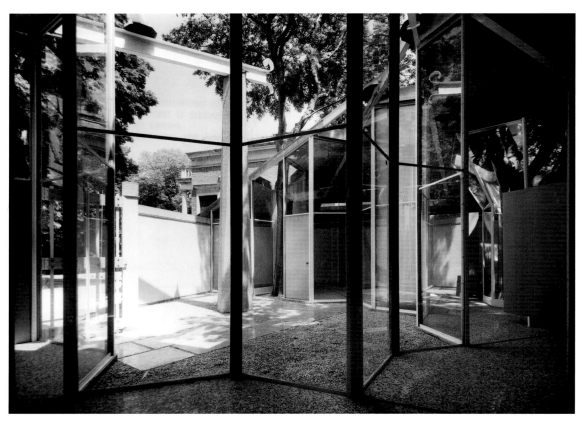

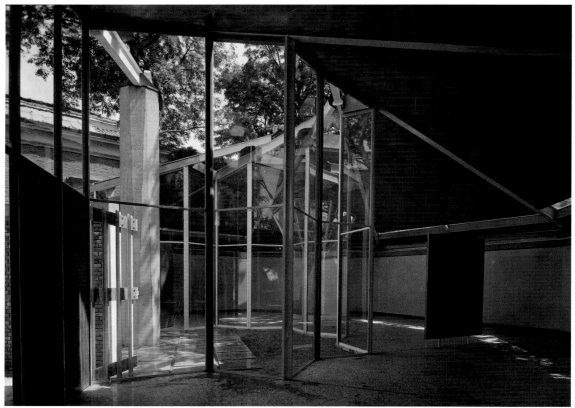

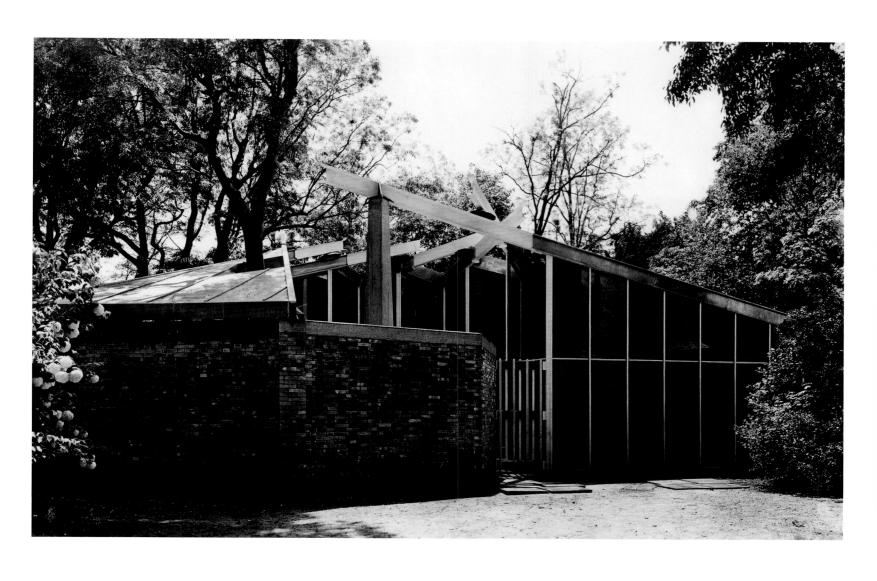

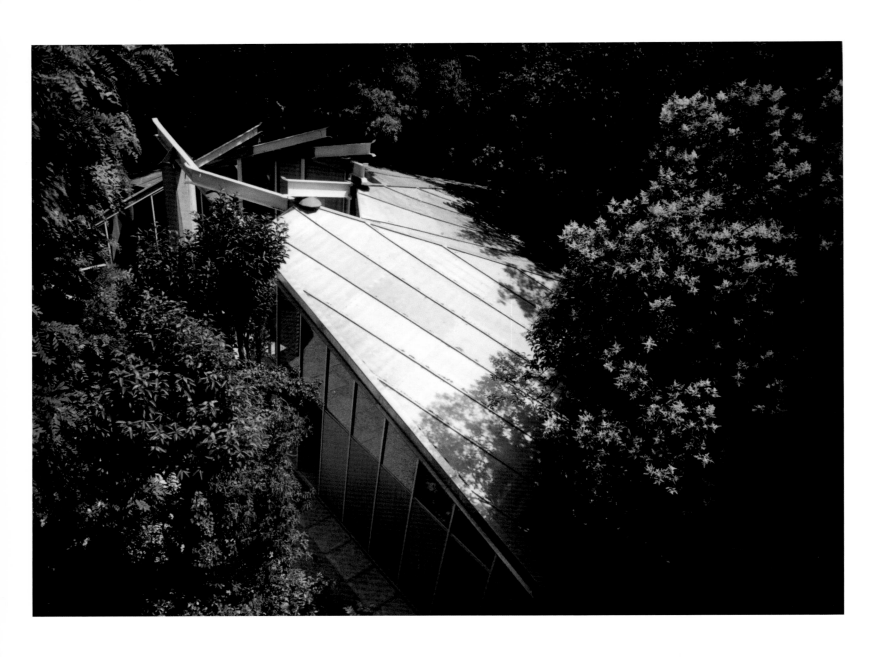

20

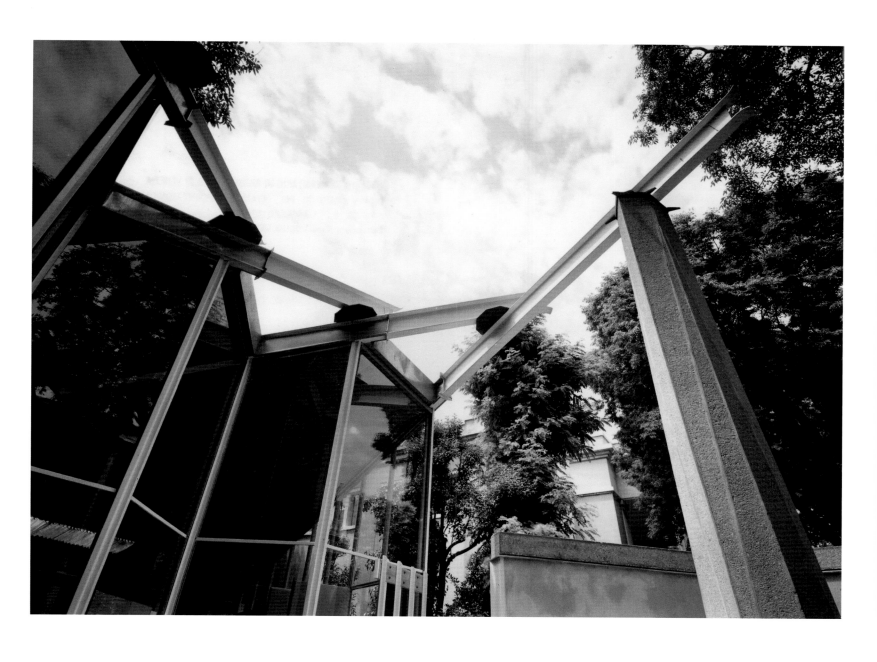

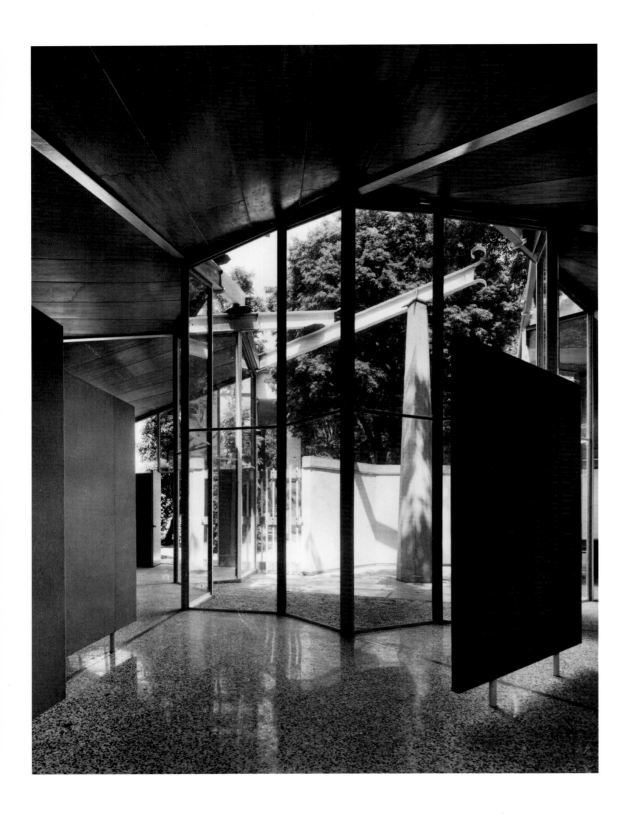

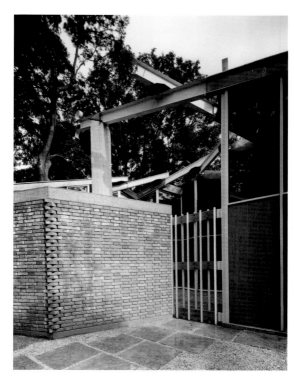
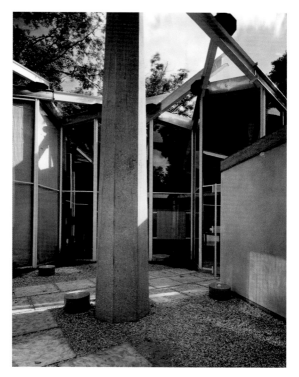

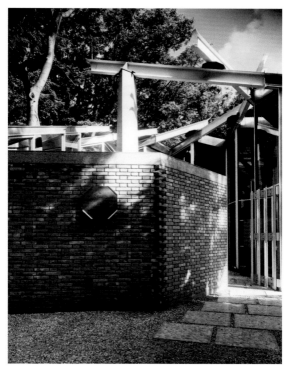

The National Gallery of Canada Commissions an Exhibition Pavilion

Cammie McAtee

At 11:30 a.m. on Wednesday, 11 June 1958, the Canada Pavilion officially opened at the XXIX Biennale Arte di Venezia. Despite a heavy downpour, some two hundred guests made their way through the grounds to see the newly completed pavilion and its first exhibition (fig. 1.1).[1] Although the Giardini was still dominated by buildings of varying classical lineage, several recent additions along the first alley demonstrated that the architectural as well as artistic character of the sixty-three-year-old art fair was changing. Taken together, they offered a concise visual summary of some of the major directions within post-war modernism. After entering the site through Carlo Scarpa's entrance kiosks (1952), visitors passed the long, almost blank, brick enclosure wall of the Swiss Pavilion by Bruno Giacometti (1952) and the high main volume of Scarpa's concrete Venezuela Pavilion (1953–56). A third new national pavilion—the Corbusian Japan Pavilion by Takamasa Yoshizaka (1956)—rose up next to the USSR Pavilion, then in a state of near ruin.

This introduction, however, did little to prepare visitors for the newest pavilion. At the end of the avenue, tucked between the German and British Pavilions, the Canada Pavilion came into view. Whereas the other national pavilions, classical and modern alike, adhere to a strict rectilinearity, the Canada Pavilion resists such definition at every turn of its brick perimeter wall. The entrance, located off axis, draws visitors diagonally across the plaza created by its neighbours. Unlike the other buildings, which were imposed on the natural site, the pavilion's somewhat curvilinear shape encloses two mature trees within its volume and in turn is embraced by the wooded site. At the same time, it responds to the architectural world surrounding it. Viewed straight on, the pavilion's sloping roof of I-beams can be read as a series of broken pediments.

If the rain made walking difficult that morning, it had little effect on the buoyant mood of the Canadian hosts and their guests, the grey light serving to heighten the strong lines and colours of the pavilion and the works of art on display inside. With the Chair of the National Gallery of Canada's Board of Trustees, Charles Percival Fell; the Gallery's Director, Alan Jarvis; Robert Hubbard and Kathleen Fenwick, respectively Chief Curator and Curator of Prints and Drawings; and the architect Enrico Peressutti of Studio BBPR looking on proudly, the Canadian ambassador to Italy officially opened the pavilion. Making his remarks in Italian, Pierre Dupuy thanked the Prefect of the Province, the Mayor of Venice, the Directors of the Fine Arts Department, and the Biennale for the opportunity the International Art Exhibition offered to Canadian artists, "who have no means of reaching you, but feel almost irresistibly stimulated and attracted in the distance by this consecration taking

place, as it merits, in the glory of your magnificent city, in the floating dream of Venice."[2] Speaking on behalf of the National Gallery, Fell drew attention to the pavilion's significance as the "first of Canada's buildings" specifically constructed for the exhibition of Canadian art.[3] After a lively inauguration that included such art-world luminaries as Peggy Guggenheim, the celebration continued in a luncheon at the Royal Danieli Hotel organized to thank the Venetians (figs. 1.2–1.3).

As Dupuy and Fell both underlined, it was by many measures a remarkable achievement. Only six years after the country had presented its debut exhibition at the Biennale in the Italian Pavilion, the construction of its own pavilion had secured Canada a permanent place at the most prestigious art show in the world. In his official report, the ambassador effusively praised the initiative, stating that the pavilion had brought Canada to "the international level in the field of art."[4] Dupuy also recounted the positive response the international art community expressed for the architectural design, which succeeded in reflecting the "Biennale's ambition, which is to show the most advanced aspects of creative art."

Designed for the exhibition of painting, sculpture, and works on paper, the Canada Pavilion was the first purpose-built art gallery realized by and for the National Gallery of Canada. As other scholars have explored, the project was closely tied to institutional and by extension national ambitions to promote a modern image of Canadian art abroad. The object of critical attention since the mid-1960s, the "modest" building, as it has been consistently qualified since the project's inception, has more recently been the subject of historical examination, its architecture interpreted through the lens of national identity.[5] Significant lacunae in the pavilion's biography remain, however, among them the circumstances through which an Italian architect received the commission, and the contributions of other actors working on behalf of the institutional client.[6] Contemporary architecture and modern design were central issues at the Gallery during these

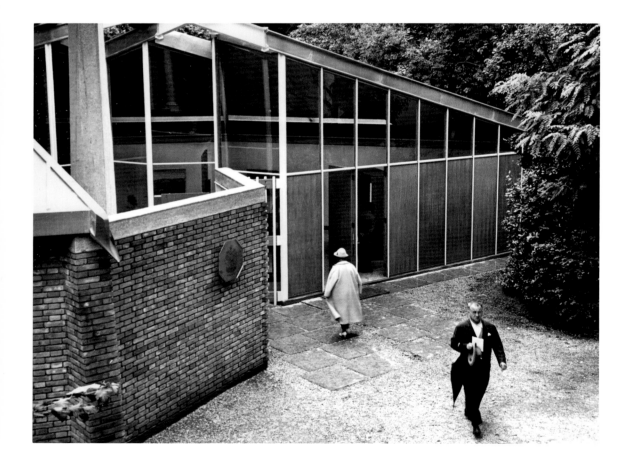

Fig. 1.1
Inauguration of the Canada Pavilion at the XXIX Biennale Arte di Venezia, 11 June 1958.
NGC Library and Archives, Ottawa.
Photo: Agenzia Fotografica Industriale

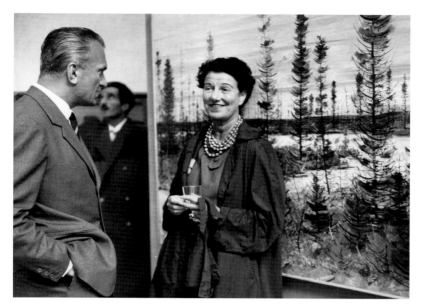

years, with the Board of Trustees, successive directors, and curators working toward realizing the dream of building a new gallery in the nation's capital. This essay will situate the commission and subsequent project for the Canada Pavilion within the activities of the Gallery's department of industrial design and architectural projects in the first half of the 1950s, an exciting period for the institution as it entered a major phase of expansion and professionalization.

Canada Goes to Venice

The ambition to construct a pavilion at the Biennale came soon after the first official exhibition of Canadian painting was presented in the Italian Pavilion in June 1952. While the hastily assembled show of twenty-two works by four artists received a mixed response from the critics, the international event left a strong impression on the Gallery's Director, Harry O. McCurry, who travelled to Venice to install the paintings.[7] What he was struck by, as Sandra Paikowsky astutely put it in her study of the 1952 exhibition, was "the prestigious new identity of the Biennale and its potential as a site for the promotion of official national cultures [that] was becoming of obvious interest to Canada and its own 'projection abroad.'"[8] The degree to which ambitions that went beyond the country's borders were being drawn into the Gallery's rhetoric is apparent in a short article about the Biennale in *Canadian Art*. Written by McCurry's protégé Donald W. Buchanan, the report announced that the country had taken "its place with most of the other nations of the free world in this assembly of the arts."[9] It also fell to Buchanan—fittingly, as this essay will show—to be the first to publicly express the hope that "some day Canada will have its own pavilion."[10]

At the March 1953 meeting of the Gallery's Board of Trustees, McCurry brought forward the idea that a "modest Canadian building" might be constructed in the Giardini.[11] At the next meeting he outlined the benefits of having a national pavilion and introduced a competitive element, pointing out that not only the "principle" European countries but also the United States and Argentina had pavilions that provided the artists of those countries with access to "an informed international public."[12] The government, McCurry argued, "should emulate the initiative of other nations [. . .] and build a suitable small pavilion to house Canadian art on a site to be donated by the authorities of the Biennale." His suggestion that "blocked lira available to the Canadian Government in Italy" might finance the project encouraged further investigation.[13]

Such a proposal would have been all but inconceivable just a few years earlier. Again, as Paikowsky identified, Canada's participation in the Venice Biennale owed much to the recommendations of the Royal Commission on National Development in the Arts, Letters and Sciences,

Figs. 1.2 and 1.3
Reception for the inaugural exhibition in the Canada Pavilion, XXIX Biennale Arte di Venezia, 11 June 1958. Alan Jarvis, commissioner; Donald W. Buchanan, assistant commissioner.
(top left): Enrico Peressutti and Peggy Guggenheim in front of Jacques de Tonnancour, *Black Spruce Country* (1957).
(top right): Betty Devlin Jarvis, Alan Jarvis, Pierre Dupuy, Charles Fell, and Enrico Peressutti (back turned) behind Anne Kahane, *Queue* (1954). NGC Library and Archives, Ottawa.
Photos: Agenzia Fotografica Industriale

the official report of which was presented to Prime Minister Louis St. Laurent in June 1951. The sections on the National Gallery in the Massey Report, as it came to be known in recognition of Vincent Massey's leadership as Commission Chair, all but wrote the script for the institution's future.[14] The Report pressed the government to increase both its moral and financial support, making recommendations that touched virtually every aspect of the institution's mandate and day-to-day operations. Given that Massey had been closely associated with the Gallery for some three decades—he joined the Board of Trustees in 1925 and became Chair in 1948, a position he held until his appointment as Governor General in 1952—it is not surprising that the Report urged for more support. But as much as it "opens the way to a new era," as Massey's friend and fellow trustee Lawren Harris appreciatively wrote, the Report also put the Gallery "on the spot [...] to make it an effective, dynamic, creative institution affecting every part of the country."[15] Expectations of what the institution could and should become were very high.

Moving quickly to implement the Report's recommendations, the Liberal Government made amendments to the National Gallery Act of 1913, the founding document that had incorporated the Gallery with a Board of Trustees, formalized its mandate to collect art, and gave it responsibility for "the promotion of the interests generally of art in Canada."[16] Finalized in December 1951, the revised act brought a wind of change through the cramped quarters of the east wing of the Victoria Memorial Building, where the Gallery had been located since 1910.[17] These changes are worth summarizing since they directly contributed to the optimistic climate in which the idea to build a pavilion in Venice would grow. Increased from five to nine trustees in April 1952, the board was given more autonomy to chart the institution's future, including the ability to directly enter into contracts in the "name of His Majesty or in the name of the Board."[18] Other doors opened when responsibility for the institution moved to the newly created Ministry of Citizenship and Immigration. Minister Walter E. Harris (1952–54) and his successor, John Whitney (Jack) Pickersgill (1954–57), would prove more sympathetic allies than their counterparts in Public Works had been. A direct line of communication with the minister brought closer ties to the Treasury Board. Growing interest in the Gallery within the halls of power helped secure more funds for acquisitions and new initiatives, and, over time, for additional staff members, who were recognized as scholars as well as civil servants.

Financing the Pavilion

Identifying funding for the Venetian project was McCurry's first order of business. Since the Gallery's annual budget was committed to operating expenses and acquisitions, a special appeal would have to be made to the government. Well aware that a project for an art pavilion in Italy might provoke a cry of "Liberal excess" from the official opposition, McCurry looked to a promising source of which many in the world of Canadian culture were aware. After the Second World War, the Canadian government had negotiated with several European countries for partial repayment for relief given to civilian populations by Canadian forces.[19] Known as "blocked funds," these monies were held in local currencies and had to be spent within their country of origin. The Massey Report advocated that they be used "to help finance cultural exchanges which could do much to enhance the reputation of Canada abroad and which would be of great value to Canadian citizens."[20] Administered by the Royal Society of Canada, blocked funds were used to support grants for students and professionals, including artists, to travel and work in France and the Netherlands.[21]

These funds were already aiding the Gallery. As early as 1950, McCurry had succeeded in tapping them for purchases in the Netherlands and France.[22] It was through this means that several major works, among them a pair of paintings by Vincent van Gogh (1886; acquired in 1950 and 1951), Lucas Cranach the Elder's *Venus* (c. 1518; acquired in 1953), *The Madonna of the Flowering Pea* (c. 1425; acquired in 1953), and *The Vollard Suite* of one hundred etchings by Pablo Picasso (1930–37; acquisition completed in 1957), entered the permanent collection.[23] By mid-1954, however, access to these funds for acquisitions came to an end.[24] Although External Affairs officials had seen the purchases as "a most desirable way" to use part of them, Europe's weak economic situation raised the question of whether such a practice was morally appropriate.[25]

McCurry, however, was undeterred in his efforts to leverage these funds. Italy offered different possibilities. In 1947 Canada had requested "nominal payment" from the Italian government for its part of the estimated $28.4 million cost shared with the United States and United Kingdom for relief given to the civilian population.[26] Though displeased by the additional burden this placed

on the country's economic reconstruction, after extensive negotiation, on 30 March 1950, the Italian government agreed to set aside $1,300,000 (CAN) in government 5% lire bonds. In 1953 the largest sum—$800,000—was allocated for the purchase and furnishing of an appropriate building in Rome for the Canadian chancery and ambassador's residence.[27] While rehousing the embassy removed a physical obstacle to diplomacy, the two governments explored ways to build an enduring peace. They turned to cultural exchange. In early 1954, $500,000 (CAN) was formally reserved for the creation of a Canadian Foundation in Rome under the terms of a signed "cultural agreement."[28] These cultural funds caught McCurry's attention for the Canada Pavilion project. Although their use would still require approval through a vote in the House of Commons, little serious opposition was anticipated in light of the fact that they were not taxpayer funds and would be used for the benefit of Canadian artists.

Modern Design and the National Gallery

In retrospect, the boldness with which McCurry and his colleagues Donald W. Buchanan, Kathleen Fenwick, and Robert H. Hubbard embarked upon an architectural project in Venice seems remarkable. This confidence came in part from recent initiatives that directly implicated the institution in contemporary design and architecture. The promotion of modern design officially became part of its mandate in 1947, when an industrial design section was established at the Gallery under the direction of Donald W. Buchanan (fig. 1.4), son of the newspaper magnate and Liberal Senator William Buchanan. Donald Buchanan's association with the Gallery began in 1934, when he received a Carnegie Corporation grant for an internship in museum administration.[29] His introduction to Canadian art inspired him to research and write the first biography of the Canadian modernist painter James Wilson Morrice, which was published in 1936. In 1941 Buchanan, who had amassed wide-ranging expertise in broadcasting, promotion, education, research, and publishing, joined the National Film Board. This work appealed to his nationalism. Ever "jealous of Canada's image abroad," as his long-time collaborator Robert Ayre put it, Buchanan saw the potential to raise Canada's international profile through the distribution of documentary photographs produced by the NFB Still Photography Division.[30]

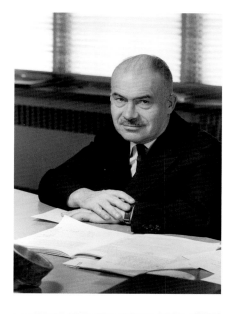

After the war, Buchanan was put in charge of the NFB's exhibition division, which created displays and exhibitions for various government departments.[31] He oversaw a wide variety of projects, directed the work of some forty designers, artists, and craftspeople, and collaborated with architects. The focus of his career decisively shifted in 1946, when C. D. Howe, Minister of Reconstruction, commissioned an exhibition on industrial design in Canada. Supported by three branches of government—the National Research Council and the National Gallery as well as the Department of Reconstruction and Supply—Buchanan's *Design in Industry* exhibition generated excitement among designers, retailers, and manufacturers as it travelled across the country.[32] Its success led to the formation of the National Industrial Design Committee (NIDC), an independent body of designers, architects, educators, manufacturers, and retailers dedicated to the improvement and promotion of industrial design in Canada, in June 1948.[33] As NIDC secretary, Buchanan gained an insider's view into contemporary design and architecture. His new responsibilities at the Gallery included establishing and maintaining information services and the Canadian Design Index of products of merit, and setting up an ambitious exhibition and publication program within a new design department (fig. 1.5).

the story behind the

design centre

encouraging better design in Canadian products

Until the creation of the NGC Industrial Design Division, Buchanan did not have an official role at the Gallery. Through the years, however, he had acted as its agent, regularly conducting business on the institution's behalf during personal trips. Significantly for the present study, it was Buchanan who met with Biennale authorities in 1950 to express the "desire of Canadian artists to be represented" in the exhibition.[34] This mission to disseminate Canadian cultural production also drove his editorial work for *Canadian Art* (1944–59), which would become an important vehicle for informing Canadians about industrial design and, in time, Canada's participation at and ambitions for the Venice Biennale.[35]

The Design Centre, as the public face of the Industrial Design Division came to be known, was founded and built on great ambitions.[36] In setting it up, Buchanan looked to the Walker Art Center's Everyday Art Gallery, the first dedicated design gallery in the US, and Chicago's Merchandise Mart, a commercial space for trade shows and exhibitions, including the Museum of Modern Art's annual "Good Design" shows. But while good will for the venture came from every direction, finding space

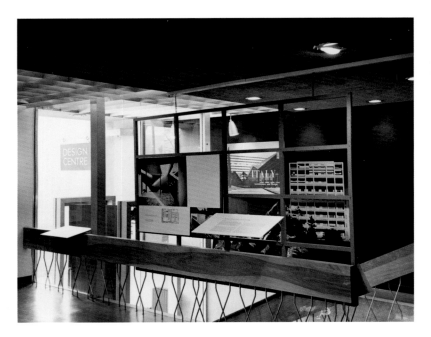

Fig. 1.6
The Modern Movement in Italy: Architecture and Design, Design Centre of the National Gallery of Canada, Ottawa, 6 November – 2 December 1953. Donald W. Buchanan, curator. National Film Board of Canada, Still Photography Division. Photos: Gar Lunney

for it proved challenging. Buchanan's proposal that a pavilion be constructed on either the roof or grounds of the Victoria Memorial building was undoubtedly inspired by the furnished house by Marcel Breuer recently constructed in the sculpture garden of the Museum of Modern Art.[37] The creative solution to the problem fell on deaf ears in Public Works; it was only through the intervention of Vincent Massey that an appropriate space was found. The Design Centre was promised the Royal Commission's office on the ground floor of the Laurentian Building on Elgin Street in downtown Ottawa after it completed its work, which Massey optimistically expected to happen in the fall of 1950.[38]

Sometime before October 1952, Buchanan entrusted the Centre's design to Watson Balharrie. The choice signalled that Buchanan was explicitly aligning the Design Centre with advanced ideas about modern architecture as well as design. Considered Ottawa's most progressive architect, Balharrie was also a founding member of the Affiliation of Canadian Industrial Designers (1946), the first such professional organization in the country, and had close ties to the NIDC, which counted among its members John Bland, Director of McGill University's School of Architecture, where Balharrie had been teaching since 1948.[39] His modernist credentials included membership in the Canadian branch of the Congrès Internationaux d'Architecture Moderne (CIAM) and he was a founding member of the Ottawa/Montreal-based Architectural Research Group (ARGO), a consortium of young architects committed to introducing European Modern Movement principles into Canadian architecture and urban planning.[40]

As Balharrie's firm had designed a trade-fair display for the NIDC in Toronto in 1950, Buchanan already had a good sense of his ideas about exhibition design.[41] In addition to a 2,000-square-foot gallery on a mezzanine level, the Design Centre also comprised a reading room and library, a small sales room, offices, workshop space, and storage.[42] Buchanan set the character of the reading room, furnishing it with a mix of chairs and tables selected from the NIDC's annual product-design competitions. Inaugurated by Minister Harris on 11 February 1953, the Design Centre occupied the Laurentian Building for three years.[43] The central location facing Confederation Square attracted civil servants and other office workers, who came during lunch hours to see exhibitions, and young homemakers, who stopped in to consult design files and the latest publications and products. Its exhibition program was geared toward raising public awareness of industrial design in Canada and encouraging "better design" through exhibitions about design in other countries, which were either borrowed or developed in-house.[44]

Buchanan was by no means the only person at the Gallery interested in modern design. Subscriptions to the British journal *The Architectural Review* and the California monthly *Arts and Architecture* kept the curator of Canadian art, Robert Hubbard, on top of current architecture and design, which he included in his art-history courses at Carleton College in the early 1950s (he added *Canadian Architect* when it began publication in 1955).[45] He ordered office furniture from the NIDC's Design Index and convinced government administrators to purchase him a portable Olivetti typewriter in 1955.

The Modern Movement in Italy Comes to Ottawa

In June 1953, Buchanan attended the third annual International Design Conference in Aspen, Colorado. Experts including the historian Nikolaus Pevsner; the educators Max Bill, György Kepes, and Xanti Schawinsky; the designers Leo Lionni and Charles Eames; the architect Enrico Peressutti; and the director of the first museum to establish a design department, René d'Harnoncourt of the Museum of Modern Art, came together to discuss "The Designer in Relation to Society."[46] Buchanan made the most of the opportunity, introducing the NIDC to colleagues in other countries. But by far the most important contact he made at the conference was with Peressutti. Although described in the conference material as coming from Milan, where he practised architecture with his partners Ernesto Rogers and Lodovico Belgiojoso, Peressutti had recently embarked upon a cross-Atlantic career. As the invitation to speak at Aspen attests, Peressutti was highly regarded by his American colleagues in both architecture and industrial design. After teaching for a term at the Massachusetts Institute of Technology in 1952, Peressutti had been offered (but declined) the directorship of the Institute of Design in Chicago, choosing instead a part-time position that would allow him to continue his architecture practice in Italy. In 1953, he began teaching fall semesters as a visiting professor at Princeton University.[47]

A polyvalent architect who designed furniture as well as buildings, Peressutti was sympathetic to the project to improve the quality of industrial design in Canada and offered to help Buchanan arrange a presentation at the upcoming Milan Triennale, the prestigious international design exhibition. Peressutti also told Buchanan about an exhibition on modern design and architecture in Italy organized by Ada Louise Huxtable for the Museum of Modern Art. Peressutti was then also designing an exhibition celebrating the hundred-year anniversary of the Viennese furniture maker Thonet that was scheduled to open at the New York museum in August (see fig. 2.6).[48]

Once back in Ottawa, Buchanan quickly made arrangements for *The Modern Movement in Italy: Architecture and Design* to be presented at the Design Centre.[49] To keep the exhibition within the NIDC's mandate, he added contemporary art, tableware, lamps, and chairs borrowed from private collections and luxury shops in Canada, the United States, and Italy to the large-scale photographic panels of recent buildings designed by Italian architects and engineers (fig. 1.6).[50] Corrado Baldoni, the Italian ambassador to Canada, presided over the inauguration on 6 November 1953. While the Italian government's interest in presenting the contributions of architecture and design to the "economic miracle" was understandable, the scheduling of the event was propitious in light of the negotiations about the terms of the "cultural agreement" that were underway between officials at the Department of External Affairs and their Italian counterparts. A photograph in the *Ottawa Citizen* of Buchanan touring the exhibition with Baldoni was the picture-perfect image of cultural exchange, and it undoubtedly made it into government files in two capitals.[51] At the end of the month, Peressutti came to speak at the Gallery.[52] During this, the architect's one and only trip to Ottawa, Peressutti stayed at the Chateau Laurier, and Buchanan gave a party for him in his Sandy Hill neighbourhood apartment.[53] Warm friendships grew out of this meeting; Buchanan and Hubbard both made a point of visiting Peressutti in Milan during European trips.

Canada Goes to Milan

With the Design Centre inaugurated and its lively travelling exhibition and lecture program launched, Buchanan turned his attention to international opportunities to showcase Canadian design. Peressutti was true to his word, and a letter of invitation from the Milan Triennale's executive committee was soon extended to Canada.[54] Although officials in the Canadian Government Exhibition Commission expressed doubts about the value of such "prestige" shows for boosting trade, the Trade and Commerce Department agreed to pay for, design, and install objects selected by Buchanan.[55] They did not, however, follow his recommendation to hire Peressutti to

oversee the project, a role the architect had played for the United States Information Agency at the 1951 Triennale.[56]

In a brief account of the 1954 Triennale in *Canadian Art*, Buchanan described how a "modest display" of furniture and appliances selected from the Canadian Design Index was arranged in a model living/dining room and kitchen (fig. 1.7).[57] A Canadian official reported the favourable response to both the high quality of Canadian design and manufacture—Jacques Guillon's nylon and birch chairs (1950) were especially well received—and the NIDC's interpretation of the exhibition's theme of affordable designs for small homes.[58]

Aside from the satisfaction that came from presenting Canadian industrial design to an international audience and seeing four Canadian designs awarded medals, Buchanan found the experience of attending the Triennale very stimulating. In a postcard to one of his colleagues, he related seeing "*formes utiles*," and lunching with Sol Steinberg, who was at work on mural drawings for BBPR's spiralling Children's Labyrinth (see figs. 2.10, 3.11).[59] The Canadian display went far, travelling from Milan to Paris, where it was shown at the Salon des Arts Ménagers in the gardens of the Petit Palais, and then on to the Ghent Museum of Decorative Arts, where it was presented as *Modern Canadees interieur*.[60]

A New National Gallery

While Buchanan was occupied with the NIDC and Design Centre, McCurry and the Gallery's trustees were taking steps toward realizing the institution's most cherished dream: the construction of a new gallery building. The Massey Report had all but demanded immediate action from the government to provide a suitable home for the nation's art collection. Massey himself had long been involved in these efforts: in the 1930s he had lobbied successive Prime Ministers R. B. Bennett and William Lyon Mackenzie King to commit to a building project.[61] It therefore came as a surprise to no one that the 1951 Report put the construction of modern facilities at the centre

Fig. 1.7
Furniture from the NIDC's Design Index presented at the X Milan Triennale, 1954. Donald W. Buchanan, curator.
Triennale Milano—Archivio Fotografico. Photo: Casali S.E.M.

of its recommendations. McCurry and the trustees clearly knew in advance that it would argue for a rapid resolution of the building problem, for in late 1950 they commissioned Eric Arthur, head of the University of Toronto's School of Architecture, to carry out a study of art galleries and cultural centres in the United States and to consult with the Gallery's curators on space needs. They were more than ready to move ahead in November 1951, when Prime Minister St. Laurent agreed that a national competition be held to select an architect.[62]

Announced in May 1952, the competition was initially overseen by Harry Southam as Board Chair, with the close collaboration of McCurry and Arthur, who was appointed professional advisor.[63] They were united in their desire that the new national gallery "should be a contemporary building with maximum flexibility."[64] In the conclusion of his historical preface to the competition brief, McCurry emphasized functionality and future expansion, before giving a clear directive: "the design of the building should be fundamentally simple, dignified, and unpretentious."[65] The trustees too had their say: Lawren Harris offered an especially perspicacious critique of ceiling heights and moveable screens and queried whether perfect functionality and beautiful form were both achievable.[66] Ever the bane of modern architecture, the function/form issue would return much later.

Comprising Alfred Barr, Eero Saarinen, and John Bland, the prestigious international jury convened by Arthur in Ottawa in mid-October further signalled that a truly modern image for the Gallery was the goal of the competition. Alfred Barr had worked with Edward Durell Stone and Philip Goodwin on the Museum of Modern Art's building, and in so doing had established the prototypical modern museum. Saarinen, one of the most dynamic young architects in the US, had significant expertise in designing national monuments. In 1939 his firm, Saarinen, Swanson, and Saarinen, had won the competition to design a new Smithsonian Gallery of Art on the National Mall in Washington DC (unrealized project). Arthur clearly had this competition in mind as a working model from the very start.[67] Bland, the only Canadian on the jury, was a deeply committed modernist who took Le Corbusier as his architectural hero. The three jurors were well aware of the cultural implications of the project. For his part, Saarinen proclaimed "the Canadian Massey Report [. . .] very good."[68]

The competition was unconventional insofar as it was not a building but a designer the jury sought.[69] Limited to members of the Royal Architectural Institute of Canada residing in the country, it was conceived as a two-stage process to discover an imaginative architect able to address the "problems of a great National Gallery" and who possessed a "sound understanding of material and construction."[70] While the competition would generate the character of the new building, it was fully expected that the design would be significantly modified in subsequent phases. Both Barr and Saarinen were extremely enthusiastic about this open approach.[71]

Delighted by the prestige the competition and its international jury brought to the Gallery, McCurry reported to Minister Harris that the Canadian architectural profession would be impressed by the "obvious desire to obtain the finest building and the most suitable architect," and that Arthur, Barr, Bland, and Saarinen all considered the competition to be "the most important held in North America during the last twenty-five years."[72] The jurors' remarks at every stage showed their agreement with the goals set out by McCurry and his staff. Any space overtly designed for effect or monumentality and any gesture that smacked of "stylistic formalism" was questioned. Everyone shared a concern that the purpose of the building—the exhibition of art—be immediately clear ("the visitor's interest should be aroused by a view, or an important work of art") and that traditional devices of monumentality be avoided.[73]

Just short of two years after the competition opened, on 23 February 1954, the jury selected Green, Blankstein, Russell and Associates, a Winnipeg firm, from three finalists shortlisted the previous March (fig. 1.8).[74] Its overall character reflected sensibilities recently imported from Chicago by Morley Blankstein and Isadore Coop, the first Canadians to study with Ludwig Mies van der Rohe at the Illinois Institute of Technology.[75] The jury described it as a "simple dignified and reposeful structure" that achieved "monumentality with modern means."[76] If more recent analyses of the project have questioned what was "Canadian" about the design, national identity in architecture was decidedly not an issue in 1954. The competition, Arthur concluded in his report to the Minister of Citizenship and Immigration, had "been successful in producing an outstanding architect, and that the first step has been taken in securing a truly notable home for the art treasures of the nation."[77] The Gallery's satisfaction with the outcome is summed up in Hubbard's characterization

of the project as "a handsome, contemporary design."[78] While the frank modern design received mostly negative press within Canada, there was significant appreciation of the project outside of the country. In March 1957, Harvard's Fogg Museum borrowed three drawings for an exhibition on contemporary museum architecture, and the Milan Triennale requested their loan for an exhibition later that year.[79]

However, despite the valiant efforts of everyone involved, the competition did not result in a purpose-built museum. Unable to make a decision about the site and with pressing security and conservation concerns for the collection in its present location, the government decided to temporarily house the Gallery in a new office building (later called the Lorne Building) planned for the site of the Laurentian Building on Elgin Street. The commission was given to the competition winners as compensation. In May 1959, Massey laid the cornerstone, and in January 1960, Prime Minister John Diefenbaker inaugurated the new National Gallery. If it was not a completely satisfactory end to a thirty-year project, the Gallery now had a modern home.

Venetian Dreams Meet Ottawa Realities

The Canada Pavilion commission must be understood in relation to the architectural history of the Gallery and its deep engagement with contemporary architecture and design during the process of conceiving its own purpose-built museum. Indeed, it was with a sense of cautious optimism that Buchanan could write in 1952 about the Venice project and the new building in the same breath: "It may be that some day Canada will have its own pavilion. But we can hardly look forward to possessing our own building in the gardens of this international festival of painting until we do an urgent job at home—that is to plan and to finish constructing permanent quarters for our own National Gallery in Ottawa."[80]

With the trustees' support for the Venice project secured in October 1953, a propaganda campaign quietly rolled out from the Victoria Memorial Building. A forceful argument would have to be made to convince the Minister of Citizenship and Immigration to take the project forward to the Prime Minister. From this point onward, it was very much a team effort, with virtually every member of the gallery staff working to disseminate the message that Canada must have its own pavilion. Participation in the next Biennale was critical. In early December 1953, McCurry wrote to Rodolfo Pallucchini, General Secretary of the Biennale Arte. He reported that Canadian authorities had been pleased with the results of the previous year's exhibition and, based on that success, he had recommended that Canada build a pavilion in the Giardini. The straightforward way the building project was raised may suggest that they had discussed the possibility in 1952. McCurry then enlisted Pallucchini's aid: "It would be helpful if Canada be invited to participate in the coming exhibition to about the same extent as in the previous year."[81] The strategy was clear: ensure a continued presence of Canadian art to generate an international profile for the country at the Biennale, and make sure that everyone would agree that the space available for the exhibition was inadequate.

McCurry also turned to his long-time ally, W. G. Constable, Curator of Paintings at the Museum of Fine Arts in Boston. A close friend of the Gallery since the early 1930s, Constable gave an unequivocal endorsement that drew a straight line between Canada's participation at the Biennale and the goals stated in the Massey Report: "To show there, is to vindicate the claims of a country's art to be seriously considered, and constitutes recognition of its importance internationally. Moreover, it is a challenge to the artists of that country to put their best foot forward and is a stimulus toward their absorbing new ideas; so preventing their art from becoming limited and parochial."[82] Acknowledging that maintenance as well as construction costs would be considerable, Constable nevertheless argued that the value would far outweigh the expense. In the intimate setting of a pavilion, "backgrounds and settings can be given character and individuality," and contemporary and earlier work could be shown together, which were "very important in the case of Canada, whose past achievements are too little known." McCurry must have been delighted by Constable's final point, which argued that culture played a significant role in the workings of international relations: "I have noticed how attention to these always increases an ambassador's prestige, and consequently that of his country."

In early January 1954, armed with plans for the upcoming Biennale, a positive report about Canada's showing at the previous one, Constable's letter, and the resolution about building a pavilion accepted by the Board of Trustees, McCurry approached Minister Harris, who in turn wrote

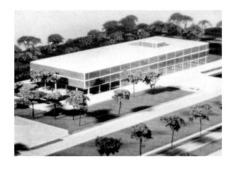

Fig. 1.8
Model of the winning entry in the competition for a new National Gallery of Canada (detail), 1954. Green, Blankstein, Russell and Associates, architects. John Bland Fonds, John Bland Canadian Architecture Collection, McGill University Library, Montreal

to the Treasury Board about the possibility of using blocked funds in Italy to build the pavilion. Evidently feeling optimistic, McCurry pushed ahead as he waited for the response. In late January, he took the step of writing to Enrico Peressutti to ask him for an estimate on the cost of building a "modest pavilion" of about sixty-by-forty-five feet.[83] Replying from Milan less than a week later, the architect explained how costs were estimated in Italy and suggested a pavilion of those dimensions with a height of twenty-four feet would cost approximately $46,664.[84] McCurry also kept the Minister informed about other developments, reporting that Israel had built a pavilion in 1952, the Dutch were currently rebuilding their national pavilion, and that plans for a Venezuela Pavilion were underway. He reminded Harris that Canada could "be the first member of the British Commonwealth to follow Great Britain into the arena" of international art.[85]

In mid-February, the much-anticipated letter came from the Treasury Board. Though noncommittal, the writer suggested that interest on the $500,000 set aside for the establishment of a cultural foundation might eventually be used, though this would have to be decided after the "cultural agreement" currently being drafted by the Treasury Board and External Affairs was accepted by both countries.[86] The Gallery, it was suggested, would have to be patient. Subsequent discussions with External Affairs were generally positive, but in mid-March 1954, Pierre Dupuy, who had been transferred from The Hague to Rome in 1952, expressed his opinion that the interest on the blocked funds in Italy should be reserved for fellowships. The ambassador went further, questioning whether the exportation of the "art production" of a country "still in the period of formation" was as important as the training of its historians, writers, artists, archaeologists, and musicians.[87] It was, of course, a thinly veiled criticism of Canadian art. Dupuy's unexpected hostility constituted a serious threat given that as the "cultural agreement" between Canada and Italy was initially framed, the Canadian ambassador would play a major role within the structure of the cultural centre.[88] McCurry and his staff quickly assumed battle positions. In a letter to the Information Division of External Affairs, McCurry again drew attention to the elite club Canada would be joining: "almost every important democratic nation in the world has constructed a special pavilion for exhibitions of the work of their artists in what has become over the last forty years the world's show window for art."[89] Although Peressutti had offered a lower figure, McCurry, who knew how quickly estimates could be surpassed and how deeply government budgets were often cut, then suggested that $75,000 would cover the costs for "a building which would meet Canada's needs adequately."

To back his claims about the project's importance for the country's cultural standing in the world, McCurry attached a *New York Times* article published just a day earlier. Written by the art critic Aline B. Saarinen (the new wife of Eero Saarinen), the article about the Museum of Modern Art's purchase of the US Pavilion took an extremely helpful tack.[90] Under the catchy title "Museum of Modern Art Taking Steps to Aid Our Cultural Prestige," Aline Saarinen discussed the Venice exhibition as *the* preeminent place of international cultural diplomacy. For too long the United States had "neglect[ed] [. . .] those fields of modern, creative performance which are respected abroad," a neglect that was "detrimental to our international friendships." It perfectly summarized the position McCurry and his colleagues were trying to foster. Nor did her reference to the museum as "our cultural ambassador" hurt perceptions of the Gallery's role in international politics. The article also amplified the competitive dimension: by building a new pavilion Canada could outdo the US, which was only refurbishing the "grimy and gloomy interior" of its neo-Georgian building. McCurry made sure the article was widely circulated; clippings of it appear in many government files, including those of External Affairs.[91]

The pressure was therefore on for the 1954 exhibition of Canadian art in the Italian Pavilion. Believing that Dupuy's opposition would be best countered by favourable reviews of the art on display and, with some luck, complaints about the limited space for its presentation, McCurry and Hubbard selected thirteen works by B. C. Binning, Paul-Émile Borduas, and Jean Paul Riopelle (fig. 1.9). Beyond the evident qualities of his painting, the choice of Riopelle was especially enlightened. Established in Paris since 1947, Riopelle was making waves on the international art scene, and any exhibition of his work was bound to draw critical attention.

The Gallery's propaganda machine again swung into action. In advance of the June opening, an anonymous report in *Canadian Art* complained that "as she possesses no pavilion of her own in Venice, Canada will again have to be housed in the large central space of the Biennale [. . .] the small space allotted to her allows only relatively few paintings to be shown."[92] Hubbard, who had been recently promoted from Curator of Canadian art to Chief Curator, travelled to Venice to install

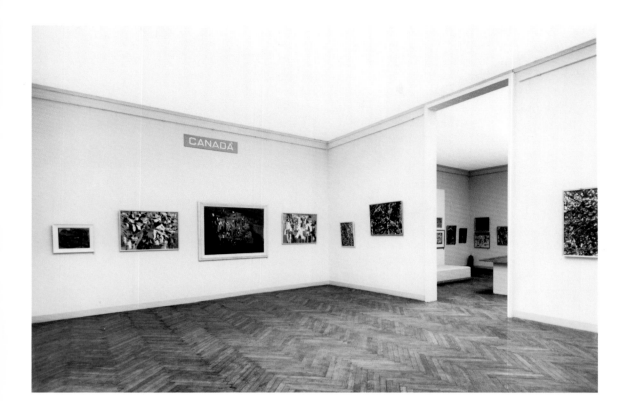

the show that would make or break the Gallery's bid to build a national pavilion. In a letter to McCurry, Hubbard described his impressions of the Canadian ambassador, who had attended the opening. Although Dupuy seemed conservative in taste, Hubbard reported that he had made "an effort to understand."[93] He also recounted how Constable, Lilian Somerville of the British Council, and Philip Hendy, Director of the National Gallery (UK), had "bombarded" the ambassador about the pavilion project to such an extent that he agreed to "write a favourable report." Hubbard also made a point of visiting Peressutti in Milan before returning to Ottawa.

Buchanan followed up in August when he was in Italy for the Milan Triennale. By this time Dupuy's feelings about the project had changed; he now assured Buchanan of his full support and offered his opinion that it would cost less than $50,000 to build a pavilion and no more than $1,000 per year to maintain it.[94] Dupuy's knowledge came from the experience of overseeing the construction and refitting of Canadian embassies in The Hague and Rome.[95] Although those projects were historical reconstructions, the ambassador had first-hand experience with modern architecture: in The Hague, he had lived in the Villa Groot Haesebroek (1928–31), designed by the Belgian architect Henry van de Velde.[96]

The campaign pressed on to build support within the art community. In the autumn, Hubbard published a substantial article on the Venice Biennale.[97] He colourfully recounted his experience installing the Canadian exhibition at the "show window for the art of the whole world"—a phrase that would be repeated over and over in correspondence about the pavilion—and the art presented at the Biennale as a whole. Moving to the architecture, Hubbard described some of the older buildings, his words emphasizing how outdated they had become—the "elderly British pavilion," "the low rambling French one," "the cold grey German one," the US's "miniature Jeffersonian temple," and the "melancholy and ruinous" state of the unused USSR Pavilion—before turning to several of the "contemporary style" national pavilions. Hubbard noted the "gleaming white" Austrian Pavilion designed by Josef Hoffmann (1934) and the "soft red brick" walls of the more recent Swiss Pavilion.[98] He reserved his highest praise for Gerrit Rietveld's rebuilt Dutch Pavilion

Fig. 1.9
Works by Paul-Émile Borduas and Jean Paul Riopelle in the Canada exhibition, Italian Pavilion, XXVII Biennale Arte di Venezia, 1954. Robert H. Hubbard, commissioner. Archivio Storico della Biennale di Venezia, ASAC. Photo: Agenzia Fotografica Industriale

inaugurated that year, extolling it as "one of the handsomest and most satisfying halls for the exhibition of pictures which I have yet seen."[99] Hubbard then arrived at the main issue:

> Even countries so young or small as Israel and Venezuela have built pavilions in the last year or so. Unfortunately the available land is almost gone, and the Biennale has called on CIAM, the international organization of architects, to advise on the best use of what remains. The moral is that countries intending to build pavilions should do so immediately. The land is provided free, the only expense to the exhibiting country being the cost of the building itself (about the equivalent of a modest house in Canada) and its outfitting every second year.[100]

After reporting the enthusiastic response of the international art community to the three Canadian painters, Hubbard closed with an argument that squarely brought the Massey Commission's recommendations and the country's geopolitical ambitions together:

> There are lessons to be learned from Venice. One is the tremendous importance attached by most other countries to the arts [. . .]. All sorts of inferences may be drawn from this, but I shall only mention one. That is the continuing need to present Canadian art abroad as well as we possibly can, something the National Gallery has insisted on for many years. But we must also make an impact by the quality of our work, by its contemporaneity and by the effectiveness of its presentation. At Venice, to be more specific, we ought to have a pavilion of our own. The cost would be a small investment with a high return. For it is here and in the other great show windows of the world that our national vigour will make itself felt, to the benefit of our prestige abroad and the stimulation of our creativeness at home.[101]

Although the project would face further obstacles on both sides of the Atlantic, by the end of 1954 McCurry, with the aid of his colleagues, had built a consensus with various government departments. It demonstrated once again that even if he was neither the visionary his predecessor Eric Brown had been, nor a *provocateur* like his successor, McCurry was a major institutional builder. It was his last contribution to the project. Seeing it through fell to Alan Jarvis, who took over as NGC Director on 1 May 1955. To free the new director from administrative duties that could take him away from the task of making the institution better known to Canadians, Buchanan was named Associate Director, a promotion that required him to relinquish his positions as Chief of Industrial Design and NIDC Secretary. Together, as Jack Pickersgill later reminisced, Jarvis and Buchanan "were responsible for a renaissance of the Gallery."[102]

Advocating for Modern Architecture and Design

Alan Jarvis's appointment as Director brought another articulate voice to the cause of modern architecture and design to the Gallery. If he is usually remembered for his support of modern art—Jarvis was a sculptor as well as a critic and curator—his most substantial practical experience was in the field of modern design, in which he had first become involved through wartime work for an aircraft manufacturer in Britain.[103] After the war, he joined the newly established Council of Industrial Design in the UK, the first governmental body ever created to promote design. (Canada's NIDC drew much from this slightly earlier design council.) As Director of the council's public relations, Jarvis set up design centres and education programs, and initiated a publication program. He also worked on the 1946 *Britain Can Make It* exhibition directed by his mentor, Sir Stafford Cripps, president of the Board of Trade.[104] Six years later, Jarvis organized a second "good design" exhibition: *For Bill and Betty*, a home furnishings show held at the Whitechapel Gallery in London as part of the 1952 Festival of Britain. Casting himself as the advisor to a newly married couple, Jarvis offered guidelines on how to avoid design mistakes. As Ness Wood has shown, with this project Jarvis moved from being a promoter of affordable design to a "tastemaker" who advocated that modern design and good taste were synonymous.[105]

Jarvis succeeded in stirring up passionate feelings about architecture and design as well as art almost immediately upon taking up the appointment as NGC Director.[106] Specifically chosen to bring a young face and dynamic vision to the institution, he pulled no punches in expressing his opinions. Statements such as "architecture is a primary symbol in any culture. What men build, it is even more important than what they paint or even as important as what they sing," thrilled architectural

audiences.[107] The comparative method that characterized his 1947 book *The Things We See* and the 1957 CBC television series of the same name hosted by Jarvis continued to structure his criticism. He effusively praised the work of modern architects and just as passionately decried poor architectural quality. If his comments on public buildings cost him precious political capital less than a year after his appointment, many within the architectural community saw him as an ally for progress.[108]

One of Jarvis's most pressing responsibilities was architectural in scope: planning the space in the Lorne Building—the new home of the NGC on Elgin Street. Translating the needs of a gallery into a government office building was a frustrating task that left little room for imagination. In 1957, however, an opportunity came for him to express his views on what a modern art gallery might look like. *Canadian Architect*, in collaboration with a manufacturer of porcelain enamel, sponsored a competition to design a "Community Art Gallery." In July 1957, Jarvis, along with the Toronto architects Peter Dickinson and Robert Fairfield, selected two projects.[109] Jarvis, who assumed the perspective of the user, claimed that he could "effectively" run the galleries described in the winning designs (fig. 1.10). Perhaps not surprisingly given that the main challenge of the competition was to present interesting ways to use a decorative material, the ideas about the exhibition space were fairly predictable, each a play between an enclosed gallery and an exterior sculpture court. Interestingly, the second-place project incorporated several trees inside the gallery's perimeter walls, an echo of the challenge Peressutti faced in Venice. It was designed by a group of Vancouver-based architects led by Geoffrey Massey, who had inquired about the commission for the Canada Pavilion in May 1956.[110]

Jarvis's appointment brought many changes to the Gallery. To fill Buchanan's place at the Design Centre and NIDC, Jarvis recommended his friend Norman Hay, a Canadian designer with

Fig. 1.10
(left to right): Peter Dickinson, Alan Jarvis, Robert Fairfield, and James Murray reviewing submissions to a competition for a "Community Art Gallery," July 1957. The Thomas Fisher Rare Book Library, University of Toronto. Photo: Arthur James / *Canadian Architect*

Fig. 1.11
Canada Pavilion, World's Fair, Brussels, 1958. Charles Greenberg, architect. Private collection. Photo: Norman Slater

38

whom Jarvis had become close in London.[111] And, in 1956, as part of his mandate to modernize the institution's look, Jarvis convinced the Canadian graphic designer Paul Arthur to move to Ottawa from Zurich, where he had been working for the influential design journal *Graphis*.[112] Son of the architect who had guided the gallery competition, the younger Arthur had strong views about modern architecture as well as design. The *RAIC Journal* (edited by his father) published his appraisal of the new Zurich Airport in February 1955 and his photographs of Le Corbusier's Chapel at Ronchamp in June 1957. But even if he was very much a modernist through his immersion in Swiss design, Arthur's early graphic work for the Gallery put his client's identity first. While the page layout of the long-awaited series of catalogues on the painting and sculpture collection was based on a modern system of quadrants, a sixteenth-century serif typeface was chosen to make the association with academic scholarship.[113] Responsible for the design of all of the Gallery's catalogues and reports between 1956 and 1967, Arthur added the art direction of *Canadian Art* to his growing list of prestigious publications in January 1958.[114] He may also have been behind the Gallery's short-lived plan to publish two architecture books by his father under their joint University of Toronto Press imprint.[115]

Canada's "Show Window" in Venice

The excitement that surrounded Jarvis's appointment and urgencies connected to the Gallery's building plans in Ottawa stalled progress on the Venice project. It was only in the autumn of 1955 that it was brought forward to the government's attention. The construction budget was now $25,000, a figure that perfectly aligned with the annual interest accruing on the blocked funds reserved for a cultural foundation in Rome.[116] The project took on speed in November. Jarvis contacted Pallucchini to reiterate the Gallery's desire to build and to ask for a site, and Minister Pickersgill submitted a formal request to the Treasury Board to approve the use of blocked funds to construct a pavilion.[117] On 8 December 1955, Buchanan, who had assumed leadership of the

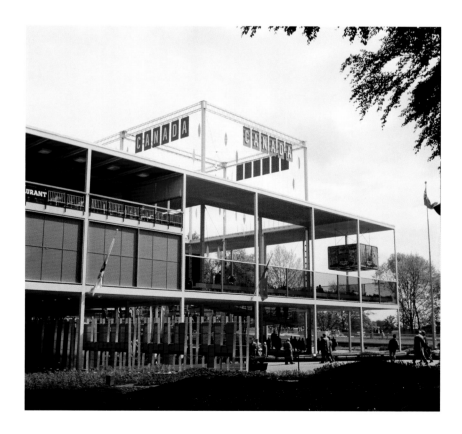

project, formally offered Peressutti the commission for the design and supervision of the construction of a small pavilion for the total cost of $25,000.[118] Although confirmation that land would be set aside for the pavilion in the Giardini had yet to be received, Buchanan informed the architect that construction was expected to start after the close of the 1956 Biennale. Accepting on behalf of his two partners, Peressutti offered to help "in connection with [the NGC's] approach with the authorities in Venice."[119] The only record of what his client requested is an undated brief of building requirements with a budget of $25,000, including the architects' fee. The list outlines dimensions for the gallery, an entrance hall, a storeroom, and an office. It also reflects close attention to the other pavilions, expressing a desire for as much height as possible and natural lighting through skylights, with reference made to the Dutch Pavilion so admired by Hubbard. Beyond these functional requirements, Peressutti was given carte blanche.[120]

Even if Peressutti was probably the only Italian architect known to the National Gallery, his star had considerably risen since his visit to Ottawa in 1953. He continued to teach each year at Princeton, and BBPR's Olivetti Showroom (1953–54) on Fifth Avenue in New York received much critical attention and appeared on the August 1954 cover of the influential magazine *Architectural Forum* (see fig. 2.8). If consulted, the two American jurors of the National Gallery competition, Barr and Saarinen, both of whom knew Peressutti personally, would certainly have expressed their approval.[121]

Funding for the project was released for the 1956–57 fiscal year, but bureaucratic complications delayed their use.[122] To avoid further problems, the Treasury Board suggested that the embassy in Rome act as paymaster and deposited the funds into their general account.[123] If the fact that funds could only be spent in Italy shielded the project from intense political scrutiny, in August 1956 a member of the official opposition, Wallace Bickford Nesbitt (Progressive Conservative, Oxford, Ontario), took a half-hearted swipe at it, lamenting in the House of Commons that $25,000 was given for the construction of a pavilion in Venice when nothing had been given to assist the

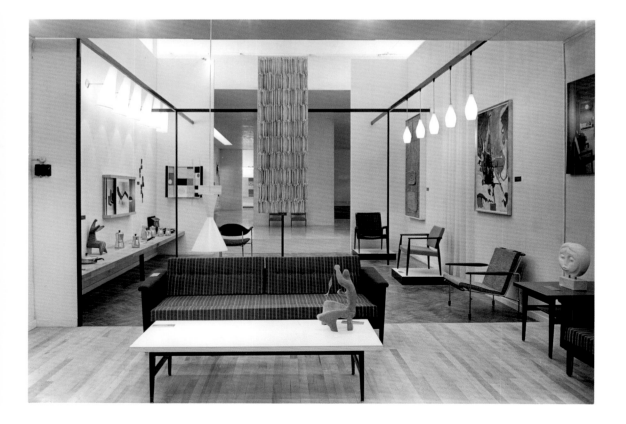

Fig. 1.12
Furniture by Robin Bush, Jan Kuypers, and Robert Kaiser and artworks by Harold Town and Louis Archambault in the Canadian display at the XI Milan Triennale, 1957. Norman Hay, curator. Triennale Milano—Archivio Fotografico. Photo: Camera Color

Fig. 1.13
Canada Pavilion, June 1958. Still from *City Out of Time*, National Film Board of Canada, 1959. Colin Low, director; Georges Dufaux, cinematographer

Stratford Festival's theatre.[124] However, its use for the exhibition of Canadian art took the air out of any serious criticism, and the budget item passed without further commentary.

How either Jarvis or Buchanan reacted to the proposals Peressutti submitted for the Canada Pavilion in 1956 is unrecorded.[125] Although Buchanan was in charge of the project, Jarvis also took an active role, during the 1956 Biennale visiting the two proposed sites with Peressutti's partner Lodovico Belgiojoso to confirm the selection of the one between the British and German Pavilions.[126] While the extensive correspondence about the site shows that everyone involved was aware of the constraints the small site placed upon the design, Jarvis and Buchanan also undoubtedly recognized the innovation of Peressutti's plan, which maximized the wall space without sacrificing a flow of inside-outside space. Jarvis may have seen the dynamism he found missing in much recent architecture alive in Peressutti's project. In an interview recorded a month before his 1956 trip to Venice, Jarvis deplored the "timidity business" that "drastically underestimates the Canadian people" and by extension its public architecture, and called for the creation of architecture "representative of an energetic, [. . .] courageous and high spirited people."[127] We can have no doubt of Buchanan's belief. Having made Canada's international image the ultimate curatorial project, he would never have supported a project in which he did not fully believe.

The relative silence about the project might partially be explained by its diminutive size in comparison to another project in which the Gallery was deeply involved. In June 1956, the Canadian government committed almost three million dollars for the country's participation at the 1958 World's Fair in Brussels.[128] Charged with organizing all the visual art exhibitions in the pavilion designed by the Ottawa-based architect Charles Greenberg, the Gallery's human resources were stretched to their limit. It is worth considering Buchanan's criticism of the "other" Canada Pavilion as a means of gauging his opinion of exhibition architecture. He memorably described the pavilion's formal image as "stand[ing] firmly overt in rectilinear righteousness enlivened by strong colours" (fig. 1.11).[129] If satisfied that its overall impression "befit a middle power," the large building

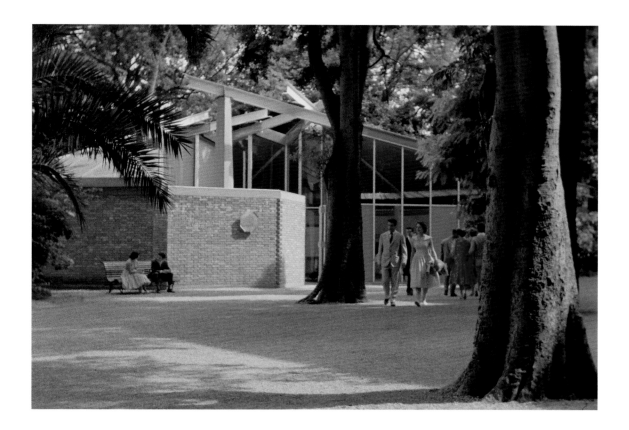

had proven challenging to curate. How he characterized the exposition's "smaller pavilions," which "tried to say less in less space, and [. . .] were thus more often able to achieve a happy unity of expression between displays and architecture," may tell us something of his goals for Venice. In September 1957, reporting on a visit to the construction site in the Giardini, Buchanan had confidently told the trustees that:

> . . . it is, architecturally, the most original and attractive pavilion in the Biennale grounds. While small, it is strategically sited between two of the main buildings, the British and German ones. The natural surroundings blend perfectly; for example, the gallery is built round two majestic trees that have been left to rise from the gallery floor through the roof.[130]

The Brussels show, which kept the curators on a rotating international schedule, left precious little time to worry about the Biennale. Jarvis and Buchanan began organizing the inaugural show in late 1957. The fact that the majority of the works were by James Wilson Morrice reflected Buchanan's interests and referenced Canada's earliest presence at the Biennale (Morrice had exhibited as an individual in the 1903 and 1905 exhibitions). The other half was devoted to paintings, prints, and sculptures by Jacques de Tonnancour, Jack Nichols, and Anne Kahane, who were chosen to represent the range of Canadian art in 1958. Works by the three contemporary artists appeared in both Brussels and Venice.

Always alert to opportunities to promote industrial design, Buchanan saw the pavilion as a "show window" for Canadian furniture as well as art. The 1957 Canadian display at the Milan Triennale primarily (but not exclusively) showcased furniture designed for Alcan's new mining town in British Columbia. Curated by Norman Hay, the exhibition presented NIDC award-winning designs in front of a dramatic panoramic view of Kitimat (fig. 1.12).[131] Before the exhibition closed, Buchanan notified Peressutti that it would not be necessary for any "Italian-made furniture" to be included in the pavilion and requested that a few pieces from the Triennale be put into storage.[132] A low white Formica table, a white metal armchair upholstered in orange plastic, and a walnut and white-steel frame desk designed by Robin Bush, and two chairs by Jan Kuypers for Imperial Furniture of Stratford, Ontario—a blue-green upholstered dining chair and one of Kuyper's iconic Nipigon chairs—were grouped together in the pavilion in a space Buchanan called the "information corner."[133]

The demands of the World's Fair and the administration of the Gallery made it impossible for both Jarvis and Buchanan to attend the opening. Travelling to Venice via Brussels in late May, Buchanan inspected the completed building and returned to Ottawa, leaving the installation of the inaugural exhibition to Hubbard, Fenwick, and Jarvis. Fenwick's diary documents an intense period of work and social engagements with members of the international art community. A shadow, however, fell over the celebrations. While Jarvis's provocative comments on a range of subjects had made him an easy target for Progressive Conservative politicians in the House of Commons, his recent mishandling of delicate negotiations for an acquisition of an Old Master painting angered the new majority government led by John Diefenbaker. His biographer has suggested that just as the Canadians began fêting their achievement in the Giardini, Jarvis was realizing that his future as director of the country's most prominent cultural institution was in peril.[134] The scandal ultimately led to the resignations of Jarvis and Charles Fell, Chair of the Board of Trustees, who had been a strong supporter of the Venetian initiative. The gift Jarvis's colleagues selected for his departure eloquently reflected the design projects they had pursued together: an Olivetti typewriter. Not long after, Buchanan also stepped down, but soon returned as a trustee, a position from which he watched over the Canada Pavilion until his untimely death in 1966.

While there was no doubt that the pavilion would receive international attention when the Biennale opened in June (some five hundred invitations were sent out), it was important that Canadians back home were aware of the achievement, which had been kept under rather close wraps. Well aware that the June inauguration would pit the small pavilion against its media rival in Brussels, Jarvis and Buchanan looked for ways to distinguish it. In April 1958, the trustees agreed to Jarvis's recommendation to support a NFB project to film the opening.[135] Directed by Colin Low and filmed by Georges Dufaux, *City Out of Time* (1959) was made for the "Canada Carries On / En avant Canada" series of short theatrical films, which were shown in movie theatres across the country. Something, however, seems to have gone wrong during the filming of the pavilion.[136] The focus on

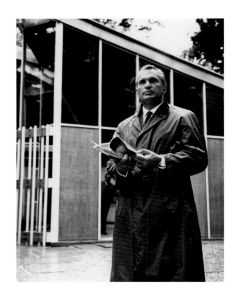

Fig. 1.14
Enrico Peressutti in front of the Canada Pavilion, 11 June 1958. NGC Library and Archives, Ottawa. Photo: Agenzia Fotografica Industriale

the historic city accompanied by a narrative voiced by William Shatner in English and Gilles Pelletier in French on the temporality of art was only briefly interrupted by footage of the Canada Pavilion. It was only halfway through the fifteen-minute film that audiences learned that the country had a pavilion at the Venice Biennale (fig. 1.13).[137]

In the end it was through *Canadian Art* that the news was diffused. In January 1958, Buchanan presented a summary of the arguments that had been assembled to convince the government to support the project, the constraints it faced, and the list of artists who would represent the country in 1958, and released the first images of the project (an early plan and elevation). A strategist par excellence, Buchanan laid out the many reasons why Canada had been so fortunate that "one of the most eminent and original of the younger Italian architects" had been "persuaded to take on the assignment."[138] A list of achievements and honours situated Peressutti at the forefront of contemporary architecture on both sides of the Atlantic. This was strengthened by Buchanan's addition of a citation by the distinguished American critic and historian Lewis Mumford, who had apparently identified Peressutti as one of the few architects who might succeed in striking a "desirable creative balance between the major but conflicting ideas of Le Corbusier and Frank Lloyd Wright."[139]

Canadian architects had to wait until after the close of the Biennale to receive official news of the project. If concerns that they would have been unhappy that the commission went to a foreign architect played a role in the Gallery's reluctance to publicize the project earlier, they were assuaged by a lavish photographic spread in *Canadian Architect* and the remark: "by way of someone's good sense, Enrico Peressutti was prevailed upon to design it."[140]

The Canada Pavilion was a far-seeing achievement. If Harry O. McCurry launched the project in 1953 with "modest" expectations, the Gallery Director, his successor, and staff understood that making a strong architectural statement in Venice was critical to the overall success of the enterprise. The many obstacles faced by the project were reframed as opportunities. The experience of the Design Centre and the competition for the new museum building in Ottawa gave McCurry, Buchanan, and Jarvis the confidence to put their trust in a respected Italian architect and in the language of modern architecture. The pavilion Peressutti designed for the Giardini succeeded in advancing Canada's post-war project to take its place on the international stage (fig. 1.14). Culture— design and architecture as well as art—was the most highly regarded *laissez-passer* for joining this elite club. For more than sixty years the subtle modernity of the National Gallery's Canada Pavilion has distinguished the country at Venice's "show window of art."

The Harmony of Human Proportions: BBPR's Architectural Dialogues

Serena Maffioletti

Situated in the universal space carved out by the Biennale in the ancient city of Venice, the Canada Pavilion brings together the cultures of its home and host countries in one of the most felicitous projects ever realized by Studio BBPR. The small building was inaugurated in 1958, the same year BBPR's Torre Velasca in Milan and Italian Pavilion at the Brussels World's Fair were completed, a time when the Milanese architecture collective was reaching the apex of its research into the roots of architecture within human history. Reflecting both culture and tradition, the towering skyscraper and the village-like pavilion encapsulated the entire trajectory of BBPR's ambitions for contemporary architecture, but in doing so, they provoked an international debate that overshadowed appreciation of the beauty and value of the pavilion in Venice. This essay traces the development of BBPR with a special focus on Enrico Peressutti, the partner responsible for the design of the project, ultimately revealing the Canada Pavilion as one of the most refined achievements of their journey.

Loftier Ambitions
Of the many choices that placed BBPR at the centre of Italian architectural debates and led them to become a point of reference on the international scene, the most crucial was their decision to work as a group. In 1932 Gian Luigi Banfi (1910–1945), Lodovico Barbiano di Belgiojoso (1909–2004), Enrico Peressutti (1908–1976), and Ernesto Nathan Rogers (1909–1969) gathered together under a name that was neither a motto nor a manifesto, but a simple, essential acronym: BBPR (fig. 2.1).

"We have loftier ambitions," the four members of BBPR wrote in a single voice. "We believe it is not enough for an architect to build; we also feel the need to speak, to express through the synthesis of our work not just the contingencies of life but the thought and character of the present era."[1] This statement, outlined in the introduction to their joint graduate thesis of 1932, represents BBPR's foundations, indicating that the group had set out to fulfill a specific cultural program: each of their reflections focused on concrete projects and on the practice of architecture, a profession that they carried out over many decades of collaboration, nourished by constant mutual consultation, and by their uniquely expansive and wide-ranging dialogue with the external world. They were tireless travellers and frequent conference participants; they wrote critiques that were widely disseminated; they taught in Italy and also abroad; they directed architectural magazines and curated exhibitions; and, over the course of the twentieth century in Italy, they succeeded in reinventing the figure of the designer, whom they saw as an intellectual engaged in the continuous reassessment of the theory and practice of architecture.

The four young men graduated together from the Scuola di Architettura of the Politecnico di Milano. They belonged to the generation that followed the early Italian Rationalists, sharing the same struggles and questions raised in the world of architecture by the Fascist regime. The profound redefinition of the architectural idiom, its technical innovation, and the breadth of the social objectives promoted by Rationalism all resonated with BBPR, though filtered through their critical reflection on praxis and its relationship with art, history, and philosophy. They identified with Edoardo Persico, Giuseppe Pagano, Giuseppe Terragni, Franco Albini, Ignazio Gardella, and the international masters, particularly Walter Gropius and Le Corbusier, finding their rightful place among them. Gropius showed them how to bring together theory, creation, and teaching; Le Corbusier instilled in them the union of beauty and function, the notion of the *maison de l'homme*, the synthesis of the arts, and the idea of constant, free reinvention. Starting in 1935, they became members of the Congrès Internationaux d'Architecture Moderne (CIAM) and the Maison des Artistes at the Château de la Sarraz, where they forged especially strong relationships with Alfred Roth and Max Bill. Rogers later explained: "Even during the dark years we always felt that our cultural objective was twofold: on the one hand we had to face the problems of our national culture; on the other hand we had to find nourishment from the best sources of foreign culture. Our goal was to be the intermediaries."[2]

Close in age and cultural background, but different in character and mindset, the partners formed a professional studio that functioned like a unit of space-time between balanced poles, where individuality was instrumental to achieving a deeper understanding of reality, and the sharing of ideas was key to arriving at the most suitable solution. Each architect contributed his distinctiveness, talent, and research to the collective: Rogers, a student of the philosopher Antonio Banfi, was a precocious art and architecture critic; Peressutti and Banfi were photographers; Rogers and Belgiojoso were writers. They were all committed on political, cultural, and civic levels, linked to the art world by long-standing friendships, and immersed in a dynamic system of international relations. "We had four different characters, almost opposite," remembered Belgiojoso, "but with great will

Fig. 2.1
Studio BBPR (left to right): Enrico Peressutti, Lodovico Belgiojoso, Ernesto Nathan Rogers, and Gian Luigi Banfi, 1930s. Julia and Gian Luigi Banfi Archives, Milan, on loan to Università Iuav di Venezia—Archivio Progetti

power we succeeded in imposing a discipline on ourselves, which over the years became increasingly second-nature, to realize the collective purpose of our projects, [. . .] convinced that the product of our collaboration would be better than an individual one, and renouncing the personal ambition of being the single author of a work."[3]

Public and private commissions and urban planning projects brought the opportunity to experiment with contemporary architectural languages, starting with works focused on the history of architecture and local traditions. As early as 1934, Edoardo Persico, one of the two editors of *Casabella*, reviewed the competition project for the Palazzo del Littorio in Rome by BBPR with Luigi Figini, Gino Pollini, and Arturo Danusso, perceiving in it "the universality of modern architecture."[4] Intended for the monumental new *strada* Mussolini cut through the remains of the Roman forum, the asymmetrical composition they proposed for the vast complex of the Fascist regime maintained a correlation with antiquity through proportions that harmonized with those of the ancient Basilica of Maxentius. BBPR's Colonia Elioterapica in Legnano, a sun-treatment institute for children completed in 1938, similarly tempered the typical Rationalist approach by scattering the buildings over the landscape and making unmistakable allusions to rural traditions (fig. 2.2). But the most convincing contribution to this search was the regional regulatory plan for the Valle d'Aosta (1936). A collaboration between BBPR, the industrialist Adriano Olivetti, Olivetti's publicist Renato Zveteremich, the engineer Italo Lauro, and the architects Piero Bottoni, Luigi Figini, and Gino Pollini, it was the first in-depth Italian survey of the architectural heritage, socio-economic conditions, and geographic factors of a single region. The Valle d'Aosta plan provided a starting point for other projects concerned with uniting urban planning and architecture, mindful of the interrelationship between contemporary buildings and their specific location—from the regional plan of an alpine landscape to the coexistence between antiquity and contemporaneity in an urban context. To convey both the cultural and landscape identity of the territory and the methodological foundations of the proposals, the collaborators prepared an exhibition and publication that experimented with the synergy of written, graphic, and photographic languages.

BBPR was determined to expand the role of architecture within the Rationalist perspective and to broaden that of the architect in the transformation of society and culture. Their inclusive program saw architecture as a living entity that must be nourished by many sources: history, stories, traditions, and their many mutating manifestations in the phenomenology of contemporary space-time. That BBPR was constantly reflecting on architecture as a colloquial and shared language is evident in their projects and built works; in their writings, particularly those by Rogers; and in their exhibition projects.

In the early years, exhibitions offered BBPR the opportunity to study the language of architecture in its relation to the visual arts—sculpture, painting, and the emerging arts of photography and graphic design—through collaborations with artists such as Lucio Fontana, Fausto Melotti, and Renato Guttuso.[5] Encouraged by the Triennale di Milano's commitment to exhibitions, BBPR's installations had a celebratory rather than a documentary purpose: quickly conceived and realized, the events, although of short duration, attracted large audiences. These projects provided the collective with a fertile ground to experiment with architecture's communicative capacity and to explore its illustrative, narrative, and educational potentialities.

Utilizing partitions articulated on geometrical structures like other contemporary Italian architects—Franco Albini's installations come to mind—BBPR animated their exhibition spaces with dynamic installations that encouraged dialogue with viewers to create an experience that would resonate with their sensibility and memory. Stately and humble objects, pictorial and sculptural works of art, engineered artefacts and commercial products, photographs, and text were brought together to create a series of "landscapes" marked by sudden transitions of scale, material, light, and colour. Stepping into the domain of the fine arts, BBPR sought to represent, through the multiplicity of images displayed, not the orderliness of an ideal world, but rather an open, inclusive, and pluralistic dialogue. In a review of the 1934 Esposizione dell'aeronautica italiana, Persico noted how their exhibitions, rich in allusions, atmospheres, and elements both harmonious and evocative, were installed in such a way as to let the viewer make his or her own interpretation.[6] Peressutti observed: "Step by step, the diverse aspects of the exhibition are assembled in front of our eyes, in time and space. [. . .] Curiosity urges us on, our imagination runs wild, and walls, photographs, objects on display take on a life of their own, they move, they grow to gigantic proportions, and little by little, if we listen hard enough we can almost hear the sound of their breath, their voice."[7]

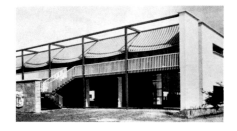

Fig. 2.2
Colonia Elioterapica, Legnano. BBPR, architects (1936–38). Reproduced in Alfred Roth, *La nouvelle architecture / The New Architecture / Die neue Architektur* (Paris: Les editions architecture, 1947), p. 136

The Transparency of Architecture

The productive dialogue between the arts that characterized BBPR's early years saw Peressutti explore the possibilities of photography as well as architecture.[8] His photographic debut took place at the 1933 Milan Triennale, and during the same period he published images that were a cross between Rationalism and classicism in the art and architecture journal *Quadrante*.[9] During the Second World War, his photography underwent a profound stylistic change—he captured the closed society and humiliation of the city of Milan as well as the Italian army's defeat in Russia—that was emblematic of the political and cultural experiences that eventually led the members of BBPR to fight against Fascism.[10] If those harrowing images concluded their pre-war research, it was Peressutti's interest in *architettura espositiva* that would launch BBPR's post-war explorations. Literally "exhibition architecture," this research was conceived with expository intentions, with works ranging from civic monuments to ephemeral exhibitions, small-scale architecture that suited Peressutti's creativity.[11] His contemporary and friend, the art critic Gillo Dorfles, remembered how "Aurel [Peressutti's nickname] excelled at drawing and design, and this included an innate talent for the physical realization of his ideas; [...] his extraordinary plastic and imaginative creativity always shone through. And I want to add that his warm affection always represented for me and all his friends the most genuine aspect of his nature."[12]

Returning to BBPR's studio in Via dei Chiostri in 1946, Peressutti realized the project that signalled the rebirth of Italian architecture: the Monument to the Victims of the German Concentration Camps in Milan's Cimitero Monumentale (fig. 2.3).[13] He dedicated the monument to Banfi, who had died in a camp at Mauthausen. The memorial has the primary shape of a cube formed by a series of steel rods arranged in crosses that contain the empty space. Based on the orderly elements of the golden section to represent the rationality of modern architecture, the volume encloses an urn containing earth from Mauthausen between its orthogonal lines and black-and-white marble surfaces. "People have spoken, and rightfully so," wrote Manfredo Tafuri, of the "monument as the 'commemoration of an ideal.' But this monument, this 'too rational' lattice confronting the immensity of the massacre, also constitutes a moment of reflection that gives meaning to the theme of 'continuity' later on explored by Rogers."[14]

Fig. 2.3
Monument to the Victims of the German Concentration Camps, Cimitero Monumentale, Milan. BBPR, architects (1946). Università Iuav di Venezia—Archivio Progetti, fondo Enrico Peressutti. Photo: Enrico Peressutti

The theme of the *casa dell'uomo* (house of man), which BBPR used as the fundamental concept in the rebirth of architecture, is here offered as a bare frame: but because of its transparency, the cube is penetrated by the landscape, which animates its cavity with a multiplicity of superimposed images. Nevertheless, that did not seem sufficient to fulfill the idea of the dialogue so crucial to BBPR: and so, to more effectively communicate the sombre message of the architecture, they inscribed excerpts from the Sermon on the Mount on some of the marble surfaces.

Exhibiting: The Dialogue Project

Marked by the war, deportation, and the loss of Banfi, the three surviving partners regrouped to take part in the reconstruction. Publishing took a crucial role at that juncture, strictly tied to their intention to renew the cultural and social terms of architecture. During his exile in Switzerland (1943–45)—a hub of international activity—Rogers had been intensely involved in publishing and teaching, pursuits that gave him the opportunity to face the question of reconstruction in its many aspects: cultural and ethical, technical and artistic, financial and pedagogical. Thanks to this experience, his anti-Fascist background, and the support of BBPR's international network, he was soon identified within Milanese Rationalist circles as the natural successor to Gio Ponti as the Editorial Director of the influential magazine *Domus*.[15] In January 1946, he added the subtitle *la casa dell'uomo* to the masthead, and gathered under it architects, urban planners, artists, and critics who, through their interdisciplinary dialogue, debated the values and forms of the reconstruction. The emblem of this concept of architecture was the "house," whose significance embraced the human environment in its entirety. "The point is to establish a taste, a technique, and a moral foundation as the terms of the same function. The point is to build a society," explained Rogers.[16]

If Rogers's tenure as Director came to an abrupt end in the autumn of 1947, when a political reshuffling brought Ponti back, the humanistic project underlying his version of the magazine found concrete form in the three exhibitions realized by BBPR at the IX Milan Triennale (1951). It was as though Rogers's ideals were being visualized in three-dimensions: a triptych of architecture as the "house of man." In the paper he gave at the Triennale conference "De Divina Proportione," he

Fig. 2.4
Architettura, misura dell'uomo, IX Milan Triennale, 1951. Ernesto Nathan Rogers with Vittorio Gregotti and Giotto Stoppino, curators and designers. Triennale Milano—Archivio Fotografico. Photo: Vincenzo Aragozzini

stressed the importance of architecture not within universal systems formed through history, but rather in the flux of the individual and collective relationship between humankind and space, in the constant reshaping of forms over time.[17] He explored this in an exhibition titled *Architettura, misura dell'uomo* (*Architecture, Measure of Man*). The installation was a kind of manifesto: a sequence of photographic images of vernacular (*spontanee*) and high (*d'autore*) architecture—disparate in terms of time and place—was suspended around the visitor, who became the centre of the space (fig. 2.4).[18] Rogers's words led visitors through the exhibition: "Mankind, architecture, mankind: therein lies the continuous cycle of the origins, of the means, and of the end. Walk freely through the room; what you see here reveals the topic: architecture, the measure of man. These documents acquire their full significance when you take your place among them with your feelings and thoughts, because here, too, you are protagonists of the architecture."[19]

Designed by Belgiojoso and Peressutti, the second exhibition in the BBPR triptych interpreted the Triennale's general theme: *La forma dell'utile* (The Form of the Useful). Guided by the ideal of the synthesis of form and function, of beauty and utility, the installation presented a selection of objects meant for designers, producers, and consumers. These were years in which Rogers's writings and the example of BBPR's own design objects encouraged the move away from the craft production of interior furnishings toward industrial design, embracing the relationship between artistic creation and industrial techniques within an integrated design for the human environment.

BBPR's third contribution, the United States Pavilion, was almost a synthesis of the two exhibitions mentioned above (fig. 2.5, see also fig. 3.7). In response to the commission from the Museum of Modern Art in New York, BBPR designed a low building subtly rising up from the natural landscape of the Parco Sempione. Its roof—an element that BBPR would never again design as a flat surface—had a wavy appearance, tilting up slightly toward the sky and creating a variety of ever-shifting views. The interior was criss-crossed by dynamic visual interactions that united the park, the exhibition space, and the inner garden in a multiplication of sensory perceptions enhanced by colour. The typology of the *casa a patio* was brought back, renewed in its materials and dimensions, and situated within the park's natural and historical context—between the fifteenth-century Castello Sforzesco, the nineteenth-century Neoclassical arch, and the steel structure of Gio Ponti's inter-war Torre Branca—all of which conspired to transform the pavilion into a contemporary domestic scene: the house of our time.

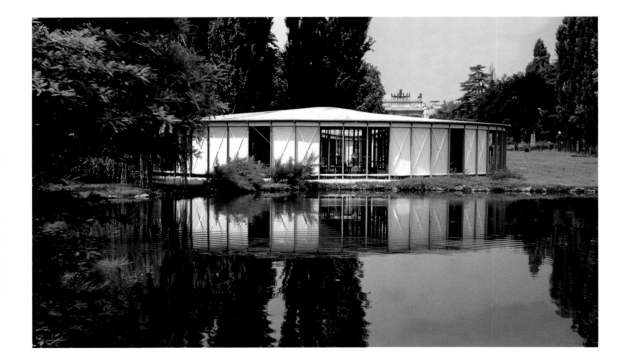

Fig. 2.5
United States Pavilion, IX Milan Triennale, 1951.
BBPR, architects. Università Iuav di Venezia—
Archivio Progetti, fondo Enrico Peressutti.
Photo: Enrico Peressutti

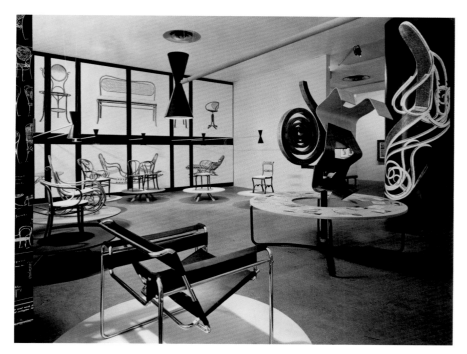

The success of the US Pavilion, the recognition of BBPR's contributions to industrial design and the art of exhibiting, and the collective's growing international reputation were sufficient credentials for the Museum of Modern Art to invite Peressutti to design the installation for the 1953 exhibition *Thonet Furniture, 1830–1953* (fig. 2.6).[20] His creative sensibilities resonated with the Viennese manufacturer's elegant designs, and its ability to mould wood and steel into art objects. For BBPR, Thonet constituted an "alternative" modern, which they looked at and helped disseminate, especially the work of Henry van de Velde and Adolf Loos. For his New York installation, Peressutti placed the furniture between two white walls punctuated by black geometries and animated by large-scale photographs. He then traced an ellipse, formed by twelve low and colourful circular surfaces, on which he placed chairs and a chaise longue. In the middle of the gallery, sculptural elements—an eight-metre "tree" bent into a spiral and a one-and-a-half-metre moulded piece of plywood—were lifted up, swaying "with an almost musical integration between the setting and the models," as Olga Gueft, editor of the influential New York magazine *Interiors*, vividly described.[21] Interweaving static and fluctuating geometries, structured and informal compositions, black geometries with polychromatic materials, the installation stands at the height of BBPR's exhibition trajectory begun in 1934. From this moment on, their public dialogue would always be rooted in the organic composition of materials, memories, and stories.

Memory and Invention

Soon after returning to Milan from New York in 1953, Peressutti travelled to the unspoiled region of Puglia in southern Italy. He was fascinated by the white geometries of its vernacular architecture—including the celebrated conical *trulli*—and observed the streets, houses, and courtyards in the ancient peasant towns animated by everyday activities. He photographed some of the same places featured in Giuseppe Pagano's exhibition *Architettura Rurale Italiana*, presented at the VI Triennale in 1936. But if Pagano, who was one of the Rationalist masters emulated by BBPR, had sought the typological and constructional roots of architecture, Peressutti now saw architecture as the stage of human activity and landscape as its reflection. In his photographs, architecture and nature are portrayed as equal elements of the same scene; Peressutti recognized the *casa dell'uomo* in the communion of the local population with its landscape; and he visually highlighted the forms of the

Fig. 2.6
Thonet Furniture, 1830–1953, Museum of Modern Art, New York, 11 August – 4 October 1953. Greta Daniel, curator; Enrico Peressutti, installation designer. Photographic Archive, The Museum of Modern Art Archives, New York. Photo: Alexandre Georges

Fig. 2.7
Trulli near Martina Franca, Puglia, c. 1953. Università Iuav di Venezia—Archivio Progetti, fondo Enrico Peressutti. Photo: Enrico Peressutti

rural world taking shape in the light and shadow of archaic harmonies (fig. 2.7). That these photographs had deep significance for Peressutti can be drawn from the fact that he sent a selection to Le Corbusier, who expressed his admiration for them.[22] Peressutti used the photographs as an instructional tool at the School of Architecture at Princeton, where he started teaching in 1953 and where he found a favourable context for a humanistic reflection on architecture.

The Olivetti Showroom on Fifth Avenue in New York, which Peressutti designed and realized in 1954, conveys the sense that he had found community in the United States. Costantino Nivola's plaster and sand bas-relief transformed the main wall into a narrative element that projected the colours of the sunny Mediterranean region, Venetian polychrome glass lamps by Venini were suspended from the blue ceiling, and the green floor rose up to offer the company's typewriters to passersby (fig. 2.8). Open to the busy avenue like a proscenium, the interior was presented as the landscape of a social project (the Olivetti factory) and of a myth (the Mediterranean). "The setting for a legend," the *Interiors* reviewer observed on this intersection of architecture, art, and industrial design.[23]

If the "mobility" of the surfaces in the New York showroom had put into question the delimitations of a room boxed in by walls, it was now the form of the envelope and the relationship between container/contained that questioned the relational and communicative device of architecture between form and function. It was once again the exhibition space that offered the field for experimentation. Formal experimentation was in no way new for BBPR: for the V Triennale (1933) they had designed the Casa del Sabato, a house for newlyweds, as a semi-cylinder wedged into a rectangular box; for the VII Triennale (1940) they designed the Padiglione delle Forme as interlocking spirals centred on a pair of human silhouettes; and their 1953 pavilion in Parco Stupinigi near Turin was imagined as a large tent, its frame covered with a loose purple fabric (fig. 2.9).

A year later at the X Triennale, they continued to focus on the spiral, seeing it as a metaphor for the continuous transformation of forms and the experience of architecture (fig. 2.10, see also fig. 3.11). First, carrying forward the concepts proposed in *Architettura, misura dell'uomo*, they deconstructed the volume, dissolving the boundaries between interior and exterior, and breaking down the surfaces with different materials and multiple angles.[24] To deepen the connection between architecture and the visual arts, they proposed to present works by artists as well as architects, including Fernand Léger, Le Corbusier, Henry Moore, Lucio Fontana, Marino Marini, Max Bill, and Isamu Noguchi. In the end, however, feeling that the exhibition had a pedagogical role best fulfilled by a more informal approach, they redesigned the pavilion into a space defined by six spirals gathered in pairs, a narrative intended to engage younger visitors in an educational dialogue carried out in the language of art. The spirals of the Labirinto dei ragazzi (Children's Labyrinth), as the pavilion was named, unfurled like sheets of paper, their curves unrolling to reveal Saul Steinberg's light, ironic drawings of architecture and the city, and then, flowing to the centre, coming to rest in a mobile by Alexander Calder, which swayed gently, its reflection multiplied in a small pool of water.[25]

During the 1950s, the synergy between Belgiojoso, Peressutti, and Rogers intensified, finding an outlet in new architecture and planning projects, teaching, and publishing, which placed them at the centre of the Italian architectural debate and consolidated their position on the international stage (fig. 2.11). Although Rogers had only directed *Domus* for two years, his efforts to maintain continuity with the work of the Rationalists had a profound influence on Italian architecture and led to his appointment in 1953 as Director of *Casabella*, a position he held until 1964.[26] Appending *continuità* to its name, Rogers expanded the magazine's dialectical approach, blending the Rationalist tenets of his predecessors, Persico and Pagano, with a concern for current social and cultural needs. Through the constant flux of a pluralistic interpretation of historical reality and the shaping and expression of a collective consciousness, Rogers, as he announced in the first issue of the renewed magazine, intended to create a shared tradition for architecture, understood as a "dynamic continuation, and not a passive reproduction: not manner; not dogma; a free, unbiased pursuit carried out with an assurance of method."[27]

As a dialectical project articulating a discourse that was both critical and propositional, *Casabella Continuità* was meant to build a *tendenza* (trend) by presenting multiple viewpoints and multidisciplinary approaches to architecture, with the goal of advancing the continuous revision of the aims and the cultural and productive processes of the architect, who faced the problems, themes, and dimensions of the contemporary world. "Tradition consists of two essential forces," explained Rogers, "one is vertical and represents the permanent rooting of phenomena in given places, the objective reason of which is consistency; the other is the circular, dynamic linking of

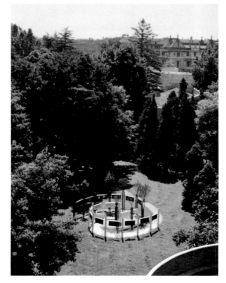

52

one phenomenon with another through a shifting intellectual exchange between men. All artists, or rather all works of art, are products of these two forces which collaborates with the processes of history and represents their true essence."[28] Attempting to reconnect architecture's disciplinary legacies with its spontaneous manifestations, Rogers highlighted the importance of history as tradition in the context of the contemporary project, valuing it as the collective repository of language, and as memory written in the physical geography of a place. *Casabella* was thus nourished by tradition, both Italian and international, renewing in the continuity of time and space the forms of a spoken language, a *lingua parlata*. Addressing *continuità*, Rogers invited a continuous renewal of the tradition of the Modern Movement in response to the changing cultural conditions of the human environment.

A pair of projects by BBPR completed in the late 1950s demonstrated the significance of interweaving traditional and contemporary architecture. Both were realized in the historic centre of Milan: the Castello Sforzesco museum (1954–56) and the Torre Velasca (1950–58). The museum was the culmination of twenty years of research devoted to the concept of the exhibition and its structure. The restoration of the five-hundred-year-old castle was integrated with the reinstallation of its collections, transforming the exhibition spaces into a symbol of civic identity (fig. 2.12).[29] The importance of a majestic building in the context of everyday city life, its location at the heart of the urban core, and its nineteenth-century "reinvention" as a civic symbol led BBPR to pursue a "museum style" in terms of its crucial educational function, all the while striving to maintain a more engaging and immediate level of communication with the viewer. The museum's disjointed and uneven spaces were given a continuous narrative by using visual sequences that connected all the parts, bringing coherence to the fortress and the artworks on display. The stately rooms were transformed by the objects, each displayed with the aid of appropriate materials and shapes, interacting harmoniously to piece together the fragments of the history of the city. "The artist is, in the end, the creator of the museum," wrote the architect Giuseppe Samonà in his review of the restored and reconceived castle.[30] "The real artist-architect has overcome the paradoxical ideas of a space separated from the works of art, instead opting for a sharper, more sensitive perception of its value in relation to the art."

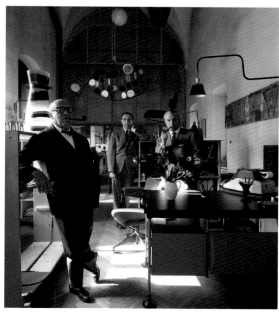

Fig. 2.8 (opposite page, top)
Olivetti Showroom on Fifth Avenue, New York, on the cover of *Architectural Forum* (August 1954). BBPR, architects (1954). Photo: Ezra Stoller

Fig. 2.9 (opposite page, bottom)
Padiglione delle Forme, VII Milan Triennale, 1940. BBPR, architects. Julia and Gian Luigi Banfi Archives, Milan, on loan to Università Iuav di Venezia—Archivio Progetti

Fig. 2.10 (far left)
Labirinto dei ragazzi, X Milan Triennale, 1954. BBPR, architects. Triennale Milano—Archivio Fotografico

Fig. 2.11 (left)
(left to right): Ernesto Nathan Rogers, Lodovico Belgiojoso, and Enrico Peressutti in the BBPR office, Via dei Chiostri, Milan, 1950s. Foto Archivio Belgiojoso

The projects for the Castello Sforzesco and the Torre Velasca were driven by the same objective: to reflect on the "Heart of the City," the focus of the 1951 CIAM congress. Rogers wrote:

> To conserve, to move, to re-establish, to enliven, or frankly to invent, the Heart! These are the different aspects of our work, which require that everyone—in different places and under differing circumstances—bring a particular approach to this subject, from the social, aesthetic, technical, and psychological points of view. It is clear that, in every case, our task is to give form to the dialectical synthesis of the complex culture in which we participate: to create artistic surroundings where the realities (and the problems) of today are expressed.[31]

This belief was at the core of the theoretical directions Rogers laid out in *Casabella Continuità*. As early as the second issue, he had claimed that contemporary architecture legitimately belonged to its time even when situated in historical settings, a position he argued in his defence of Frank Lloyd Wright's project for the Masieri Memorial (1952–55) on the Grand Canal in Venice.[32] It was a challenge BBPR was familiar with: in 1951 Peggy Guggenheim had asked them to design her house and art gallery in Venice. Their project proposed to link the ancient and the modern through a powerful yet sympathetic juxtaposition: a glass façade raised above the base of the unfinished Palazzo Venier dei Leoni that would allude to Gothic Venetian palazzos (fig. 2.13). This line of thinking about the presence of history in contemporary life would continue in their controversial project for the Torre Velasca.

Although built near the Duomo in the historic centre of Milan, the skyscraper, in its earliest versions, was made of glass with an exposed iron structure that juxtaposed its two functional components: a "shaft" containing offices and a "crown" of apartments (fig. 2.14). Through a process of research toward finding a meaningful and communicative form, BBPR brought the two parts together through the invention of a new figure where traditional building elements and materials were reimagined: in the tall concrete pillars, in the pink aggregate of the revetment, in the framed windows, and in the pitches of the roof. "To be modern means simply to feel contemporary history in the context of all history," explained Rogers in an editorial titled "Pre-existing environmental conditions and contemporary practical issues."[33]

BBPR justified (and defended) the choice of the high-rise as a building type of the contemporary city, and explained its shape as an organic expression of its function. More than any other Italian work of architecture of those years, Torre Velasca embodies the search for a synthesis of the phenomenology of our space-time, of the continuous "becoming" of the forms that history produces even in ancient places. "The tower," wrote Samonà, "tries to blend with its environment through the continuity of its materials; it endeavours to present its volume with the same solidity as the houses that make up most of the fabric of the city, whereby it truly appears to be an explosion of compact magma suddenly rising from one spot, spurting upwards in a concrete jet of the material of which

Fig. 2.12
Sala delle Colombine, Castello Sforzesco museum, Milan. BBPR, architects (1954–56). Università Iuav di Venezia—Archivio Progetti, fondo Enrico Peressutti. Photo: Enrico Peressutti

Fig. 2.13
Elevation for an art gallery addition to the Palazzo Venier dei Leoni, Venice. BBPR, architects (project: 1951). Università Iuav di Venezia—Archivio Progetti

it is made."[34] This tower-palimpsest, which quickly drew comparisons with Gio Ponti and Pier Luigi Nervi's polished Pirelli skyscraper (1956–61) in Milan's nascent business district, encapsulates all the elements of BBPR's research, echoing the city in the architecture, and the architecture in the city, both understood as a repository, a "museum" of our history.

Deeply Involved in Our Times

In addition to professional practice and publishing, BBPR's research was also grounded in another essential activity: teaching. In the aspiration to build an architectural pedagogy that responded to contemporary society, they carried out constructive debates within the dialectical crucible of CIAM. As a member of its council between 1947 and 1958, Rogers contributed—in dialogue with Gropius—to the reform of its didactic principles. Peressutti, who became an Italian delegate in 1947, was appointed by the executive committee as the representative in charge of organizing the 7th congress held in Bergamo in 1949.[35] Rogers presided over the committee dedicated to the "Reform of the teaching methods in Architecture and Urban Planning." Highlighting the divide between the school of architecture and society, art, and the profession, the committee proposed the compilation of the *Charte de l'enseignement de l'Architecture et de l'Urbanisme*.

In response to CIAM's call to expand beyond Europe, in 1948 Rogers had visited several South American universities as well as Chicago, Boston, and New York, where he established relationships later consolidated by Peressutti. The CIAM network played a crucial role in developing BBPR's international ties and prestige: Rogers and Peressutti became more and more occupied with conferences, exhibitions, and especially teaching abroad. In 1949 Rogers was invited to London to participate in the first CIAM Summer School, a manifestation of a new common and international teaching method. Having appreciated Rogers's contributions in London and driven by the same reformist spirit, Robert Furneaux Jordan invited him to teach at the Architectural Association School of Architecture in 1949, followed by Peressutti in 1951 and 1952.[36] This connection led to the presentation of the exhibition *Italian Contemporary Architecture* at the Royal Institute of British Architects in March 1952. Organized

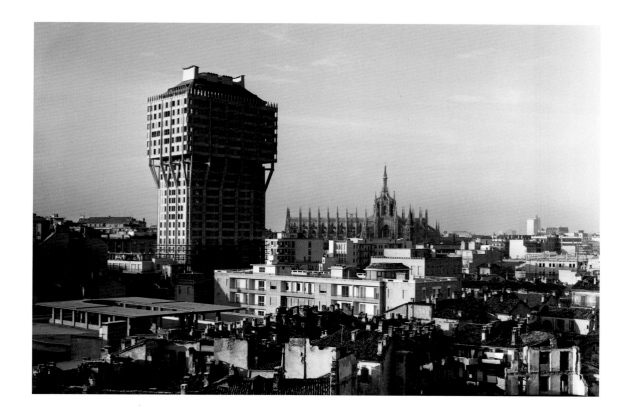

Fig. 2.14
Torre Velasca, Milan, c. 1958. BBPR, architects (1950–58). Università Iuav di Venezia—Archivio Progetti, fondo Giorgio Casali. Photo: Giorgio Casali

by the Italian branch of CIAM and curated by Franco Albini and Peressutti, the exhibition expressed, through the methodological continuity between the various scales of projects ranging from urban planning to industrial design, the main character of Italian architecture.

In the early 1950s, BBPR began to have an impact on architectural education by defining a new cultural project that combined professional training with intellectual commitment to architectural and urban transformations. While Belgiojoso and Rogers gravitated to the faculties of architecture in Milan and Venice, two poles of reflection on modernity, Peressutti taught for many years abroad as a visiting professor, choosing a freer and more direct form of instruction than the Italian academy offered at the time.[37] He was invited to teach for a term in 1952 at the Massachusetts Institute of Technology in Cambridge, and, starting in February 1953, he accepted a position as a visiting lecturer at Princeton University, where he led a semester-long studio in the School of Architecture each year until January 1960.[38]

At Princeton, enjoying the dialogue between American, Italian, and European cultures, Peressutti was able to combine his solid professional engagement with his novel approach to teaching, which grounded the studio project in a reflection on history as a dynamic factor in the life of forms. In this way, he furthered Jean Labatut's lessons to the students in a program that had resisted the turn toward modernism taken by most American architecture schools. At an important conference held at Princeton in December 1953, Peressutti delivered one of his most clearly formulated teaching statements, arguing that it was necessary to give students "a very great push [. . .] [to improve] their imagination and their sense of criticism. [. . .] For this I think that a kind of visual design is a very important development. Then it seems to me also that there is room for improving the sense of criticism, and in order to encourage stronger convictions, it would be good to give the students more opportunity for discussion."[39] Then, speaking from his own experience, he stated that it was indispensable for students to be in close contact with the reality of their time, especially through study travel:

> It would be very important for opening the eyes to history, human life, on why some forms—some architectural forms—are as they are. And then they should come back to the school and—I don't want to say, be a teacher—just give the other students their opinions, show them what they saw and what they learned from abroad. I think that this could be a valuable discussion among the students; it would produce the sense of growing, the sense of limits, or no limits, to life.[40]

Developing in synergy with the practice of architecture—especially the projects for the Castello Sforzesco and the Torre Velasca—and publishing through *Casabella*, Peressutti's tenure at Princeton deepened the connection between contemporary architecture and its environment, this time as he experimented with the different historical and cultural dimensions of North America. The relationship between past and present was fundamental; so much so that in December 1955, for a studio on museum projects, he took his graduate students—Charles Moore among them—to visit the Mayan ruins of Chichén Itzá and Uxmal (fig. 2.15). The first-hand experience of history and place was remembered by the students as being exceptional. Moore recalled:

> I remember Enrico saying about our doing this new building alongside the ruins, that it was like a young person meeting an old person on a train. It would be appalling if the young person weren't at least thoughtful, congenial, attentive to the older one. But it would be just as insulting to copy him, to ape his manners exactly.[41]

Fig. 2.15
Enrico Peressutti at the Mayan city of Uxmal, Yucatán, December 1955. Università Iuav di Venezia—Archivio Progetti, fondo Enrico Peressutti

For Peressutti, it represented a first step. In a letter to his friend Douglas Haskell, the editor of *Architectural Forum*, who had been on the jury for the students' projects, he wrote: "Although it can be improved very much from the point of view of a school's program, [it] still has a certain good direction in architectural education."[42]

In 1957 Peressutti led a studio on the revitalization of the city centre of Newport, Rhode Island. The idea was to redesign the city according to a "spiritual, social, economic relation between the historic and artistic surroundings and modern life; architectonic and functional relations between new buildings and the existing surroundings."[43] The students tackled the various scales of the project: while the structural analyses led to the pedestrianization of traffic areas, and the visual

studies to the understanding of the new urban skyline, the new forms were rooted in the "character" of the town. These themes echoed ones that Louis Kahn had studied in his plan for midtown Philadelphia (1953). Perhaps owing to this, but also to the affinity he felt for Kahn, whom he had likely met for the first time in late 1953, Peressutti invited him to be part of the studio's final jury.[44] He was probably the first member of BBPR to be in contact with Kahn, and possibly the first Italian architect to recognize the American architect's greatness.[45]

Peressutti's commitment to Princeton University further increased when the school announced plans to construct a new building for the School of Architecture. Returning to the BBPR motto "the utopia of reality," he focused his 1959 studio project on the development of the university campus as the centre of a metropolitan system, interpreted through its values and history. He later told an editor of the student newspaper: "I feel the duty to act and to produce—in the flow of history—works that can be representative of my age and worthy, for their being in keeping with the present if for nothing else, to stay characteristically beside those of the past."[46]

What Peressutti believed to be the emblematic values of the school, however, clashed with the university's determination not to commission a building that would contrast with Princeton's historic surroundings, fearing, he felt, "the most modern types of architectural expression."[47] Peressutti, who did not put forward his own candidacy for the project, was adamant that the new building should convey the cultural identity of the school, a synthesis of its tradition and its future, a symbol of "a modern way of living both on the spiritual and the physical level."[48] Early in the process, he proposed giving the project to "one of the most prominent, if not by the most important architect in the US," recommending Frank Lloyd Wright.[49]

The university, however, leaned toward what Peressutti termed "a conventional kind of planning and architecture."[50] What began as a debate inevitably turned into a serious public disagreement over ideology. In a November 1959 letter to the president that conveyed the disappointment of a faculty "deeply involved in our times," Peressutti announced:

> I feel that my fundamental conviction and principles, and as a consequence, the meaning of the responsibility I have as a teacher at this University, have been misshaped and completely reversed by the actual development on the Campus. [. . .] As you must understand, Mister President, it is my duty not only as an architect but mainly as a teacher to draw the logical and coherent conclusion from the above facts, and submit to you, with great regret, my official resignation as a professor of this University.[51]

The unwavering allegiance to his beliefs and the profound value he placed on architecture and its teaching testified to Peressutti's moral strength and consistency; these qualities were highlighted by *Casabella Continuità* when it conveyed the news of his resignation from Princeton to its readers.[52] In a letter to Rogers, Kahn expressed his admiration for Peressutti's "courage at Princeton," adding, "Only the living dead disagree with him."[53]

The Spiral of the Canada Pavilion

During these years, which were so central to BBPR's research, another work of synthesis came out of their office: the Canada Pavilion at the Venice Biennale. The commission came to BBPR through Peressutti's North American connections, and its design was undoubtedly informed by his overseas experiences.[54] Developed by Peressutti alone, its design was in line with Belgiojoso's characterization of his partner's process: "The defining feature of Peressutti, particularly during the latter part of his career, from 1950 onwards, was to create through images, with the immediacy of the intuition of form. His talent for creative synthesis was never the product of improvisation, but the expression of a long practice, of years of experience observing and corroborating the projects on which he worked."[55]

The project was also in continuity with BBPR's trajectory. The spiral that lay at the heart of many of their earlier exhibition pavilions also drove the one for Venice. The exhibition area of the Canada Pavilion, a spiral now composed of straight segments, unfolds as a continuous space delineated by a simple brick wall that appears to embrace a microcosm of art and nature. At its geometrical centre stands a single concrete pillar, a sculptural element that harmonizes with the mature trees on the site. The building's footprint is punctuated by two voids, two transparent vitrines: the smaller one encloses the trunk of a tree; the larger one outlines the small sculpture garden, which frames the second tree enclosed within the pavilion. Placed off-centre, the roof is supported by overlapping

steel beams, which create a multi-faceted surface. The individual beams that extend beyond the roof cover produce geometrical diaphragms below the tree canopy (fig. 2.16). Glazed insertions separate the roof from the perimeter wall, whose spiralling shape is interrupted to offer itself as an entrance façade: an opening that welcomes visitors, blending the interior exhibition space with the life of the Biennale. The pavilion encompasses all the elements that BBPR's research had focused on from the very beginning—the enveloping geometry, the contained measures, the transparency between art and nature, the understated dialogue with the visitor—which together reveal the harmony of human proportions.

Inserted between the British and German pavilions within an axial plan that was being modified by new buildings—those by Carlo Scarpa, Alvar Aalto, and Sverre Fehn among them—the Canada Pavilion, asserting its distance from the architectural tradition of the Biennale, spoke of BBPR's mature heterodoxy. Slightly hidden away on the threshold between the exhibition grounds and the lagoon, light and curvilinear as if to unite these two realms, it is almost monochromatic in appearance, tinged with the organic, warm tones of wood, brick, and terrazzo, which produce a harmonious combination with the colours of the trees and the warmth of the humbler Venetian buildings. Discreet, immediate, and informal, the pavilion is open and amenable to gathering together people, art, and nature.

Having travelled along a similar trajectory—albeit as a competitor to BBPR—in the study of the relationship between history and architecture, the critic Bruno Zevi saw in the pavilion, more than in any other work by the Milan collective, the organicism that he himself championed. He recognized its dynamism, describing it as "an open structure, a rotating cross-section arrested in an instant of its movement, [deploying] a non-generic freedom that draws its 'charge' from the destruction of the elementary and completeness of the interior space, representing it in a moment of its cinematic becoming."[56] Although Zevi recognized the diversity that BBPR brought to the "avenue of tombs" that preceded it, Peressutti remained, however, the most perceptive reader of the pavilion; his quick, impulsive photographs blend the many materials of the pavilion, revealing the emblematic value of a civil and everyday monumentality.[57]

Fig. 2.16
View through the courtyard of the Canada Pavilion, spring 1958. BBPR, architects (1955-58). Università Iuav di Venezia—Archivio Progetti, fondo Enrico Peressutti. Photo: Enrico Peressutti

The Canada Pavilion and the Torre Velasca were both completed in 1958, a time when the path taken by Italian architecture and *Casabella Continuità* came under attack, particularly in the French and the English press, culminating in Reyner Banham's incendiary April 1959 article "Neoliberty: The Italian Retreat from Modern Architecture."[58] The critique intensified at the CIAM conference in Otterlo the following September. It was with incredulity and sorrow that Rogers heard accusations that *Casabella* was promoting a stylistic and historicist regression of architecture, and that BBPR's work—particularly the Torre Velasca—was symbolic of the Italian retreat from modernity and betrayal of CIAM's principles. The acrimonious debate brought an end to the international dialogue that had involved BBPR, who had been so persevering and hopeful in the quest for renewal. At the same time, the younger generation of architects, whom Rogers had welcomed into the editorial direction of *Casabella*, broke with their predecessors, denouncing the work of the Rationalists as "an unresolved attempt to represent the contradictions of Italian society, turning them into positive values, with an abstract, optimistic confidence in the capabilities of design."[59]

The Canada Pavilion was caught in the midst of this architectural sea change, its legacy obscured as the international debate was renewed after the end of CIAM and as Italian architecture was being redefined by Vittorio Gregotti, Giancarlo De Carlo, and Aldo Rossi, all former students of Rogers and editors of *Casabella*. With the publication of Rossi's critique of modernism, *L'Architettura della città* in 1966, that page in the history of Italian architecture had definitively been turned.

Yet, fifteen years after the inauguration of the Canada Pavilion, it was with some regret that Paolo Portoghesi, a proponent of post-modernism, reassessed BBPR's ideal of *architettura ambientale* (environmental architecture):

> Certain examples, only apparently minor, such as the US Pavilion in the Parco [Sempione] in 1951, the Children's Labyrinth at the Triennale of 1954, and, above all, the beautiful Canada Pavilion at the Venice Biennale, woven around the trees of the park, hint at how much richer and more articulate the Italian contribution to the history of modern architecture could have been, if public commissions had made greater use of BBPR, removing them from the constraint—at once fascinating and limiting—that was their capacity of expressing the surviving values and the great aspirations of the most enlightened Milanese bourgeoisie.[60]

This, however, was also a reductive reading of the significance of BBPR's oeuvre, which the small pavilion reclaimed in its magnitude. In the secluded space of the Giardini, a place where each building expresses its own emblematic value, the Canada Pavilion remains the manifesto of an architectural utopia, the "substance of hoped-for things,"[61] aspiring to a universal tradition, placed at the crossroads between the "permanent rooting of phenomena in given places [and] the circular, dynamic linking of one phenomenon with another through a shifting intellectual exchange between men."[62] As Rogers wrote immediately after the war: "Life is made for us. [...] Down with the rhetoric of imperial piazzas, of Lictor towers, and if anyone wishes to talk to us, he should descend from his pedestal and mingle with us, so that we, too, may talk with him: one man to another."[63]

Designing the Canada Pavilion

Réjean Legault

"Early in June Canada opened her new pavilion at the XXIX Venice Biennale. The only new pavilion to be added this year to those of the twenty-two nations already installed there, it has excited much favourable comment for its grace and elegance, its happy relation to its site, its excellent use of limited space, its unpretentiousness, and its originality."[1] Published in the fall of 1958, this account of the Canada Pavilion's inauguration by Kathleen Fenwick, Curator of Prints and Drawings at the National Gallery of Canada, can be taken as the official reception of the building by the institution that commissioned it (fig. 3.1). Fenwick's account included a synthetic description of the pavilion:

> Externally, the pavilion with its steel supports, its terracotta-coloured brick, natural wood, and glass walls, appears of modest size as it emerges from the comfortable shelter of its trees. Inside it is surprisingly spacious, light, and airy, with its grey plaster and glass walls and its highly polished terrazzo floor, the latter a characteristically Venetian feature which aptly roots it into the Italian soil.[2]

The Gallery's positive reception of its new pavilion was echoed in other Canadian reviews. Praising it as the "only 'modern' building in the Giardini," John Steegman, Director of the Montreal Museum of Fine Arts, described the public's response: "On the opening day, everyone was drawn to see this new architectural experiment, so revolutionary among its sedate and more traditional neighbours."[3] At the time of its inauguration, the Canada Pavilion was celebrated as a truly innovative and truly modern building.[4]

The modernity of the pavilion was not the only aspect of its architecture underlined by reviewers. They also pointed to another facet: that of its Canadian character. As Fenwick stated: "Without any of the obvious superficialities generally supposed to be symbolic of national characteristics, the pavilion, built of wood, brick, glass, and steel, has an unobtrusive flavour of Canada."[5] Yet for Fenwick, this Canadian quality could also be perceived in the overall form of the building itself. After praising the skill of the architect and pointing out "his awareness of the Canadian atmosphere" through his knowledge of North America, she concluded: "The incorporation into the pavilion itself of two of the large trees on the site, their branches encased in glass below, and the roof and walls fanning out around them, heightens the Canadian flavour—for there is here a subtle suggestion of the tepee."[6]

This rather unexpected allusion to an emblem of North American Indigenous architecture had equally unexpected consequences for the critical reception of the pavilion. It was soon taken

up by critics eager to discern something Canadian in the pavilion's architecture, turning Fenwick's "subtle suggestion" into a straightforward one-to-one connection while shifting the positive reception into a negative association.[7] The question of the building's national identity has also dominated the historical interpretation of the pavilion.[8] Yet what are we to make of the duality—even tension—between the pavilion's modern character and its "Canadian flavour"? Through a close examination of the design process, this essay aims to uncover the many sources of the Canada Pavilion and in doing so to reassert the building's modernity.

The Protagonists

In her 1958 article, Fenwick gave credit to her colleague Donald W. Buchanan for his "enthusiasm, initiative, and perseverance" in seeing the project through, to the Canadian government for providing the "modest sum of twenty-five thousand dollars" for construction, and the "brilliant, young Italian architect" Enrico Peressutti for his design and oversight of every aspect of the pavilion's realization.[9] To begin this investigation, we must first turn to the two key actors in the project. Buchanan was the Gallery's Associate Director and the founder of the department most concerned with design and architecture culture: the Design Centre. Buchanan and Peressutti had met in June 1953 at the International Design Conference in Aspen, Colorado.[10] Five months later, Peressutti was invited to Ottawa to give a lecture on modern architecture and design in Italy.[11] He evidently impressed Gallery Director Harry O. McCurry for, in January 1954, he asked Peressutti to provide a construction estimate for a small art pavilion in Venice.

For nearly two years, the Gallery and government officials in Ottawa and Rome discussed building a Biennale pavilion. Approbation from the government to go ahead with the project finally came in December 1955. Commissioned by the Gallery's new Director, Alan Jarvis, the pavilion was financed with lira from blocked funds owed to Canada for wartime relief. As these funds could only be used in Italy, the project had to be given to an Italian architect.[12] Not surprisingly, they turned to one they knew and respected.[13] By that time, Peressutti had a foot in two of the most dynamic

Fig. 3.1 (above)
View of the Canada Pavilion. BBPR, architects (1955-58). Reproduced in *Canadian Art* (November 1958), p. 274

Fig. 3.2 (opposite page, top and middle)
Outline of possible pavilion footprint on sites "A" and "B," before 23 March 1956. Drawings: Studio BBPR. NGC Library and Archives, Ottawa

Fig. 3.3 (opposite page, bottom)
Detail of a plan of the Giardini showing a pavilion on site "A," before 26 January 1956. NGC Library and Archives, Ottawa

architectural cultures of the 1950s. In Italy, he was part of the circle that animated the post-war debate on the direction of modern architecture. In the United States, he was a sought-after visiting professor and a much-appreciated critical voice.[14] His teaching appointment at Princeton University—where he would spend four months a year—kept him close to the East Coast architecture scene. He was highly regarded by such leading figures as Philip Johnson, Eero Saarinen, and Louis Kahn.

Though the commission was given to Peressutti, the building was officially realized by Studio architetti BBPR, an architectural collective established by Gian Luigi Banfi, Lodovico Barbiano di Belgiojoso, Peressutti, and Ernesto Nathan Rogers in Milan in 1932. Before the Second World War, BBPR was associated with Italian Rationalism. However, after a hiatus in their practice during the traumatic war years, which saw the death of Banfi and the internment of Belgiojoso in German concentration camps, the escape of Rogers to Switzerland, and the service of Peressutti on the Russian front, BBPR went on to play a major role in the reassessment and renewal of modern architecture in post-war Italy. From modest but highly symbolic memorials such as the Monument to the Victims of the German Concentration Camps (1946), to large-scale urban interventions such as the famous Torre Velasca skyscraper (1950–58), both erected in Milan, BBPR's post-war work includes remarkable achievements that placed the collective at the forefront of European architectural culture. These works also revealed the three partners' efforts to develop a design language that delicately balanced cultural needs and modern technology.[15]

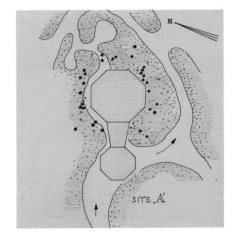

The Canada Pavilion was far from being the studio's first foray into the realm of exhibitions. BBPR had realized a few temporary structures, among them the United States Pavilion at the IX Milan Triennale (1951), the pavilion in the Parco di Stupinigi in Turin (1953), and the Labirinto dei ragazzi (Children's Labyrinth) at the X Milan Triennale (1954). They had also designed, either individually or collectively, many exhibition spaces and displays, including the Olivetti showroom in New York (1954) and the Castello Sforzesco museum in Milan (1954–56) (see figs. 2.8, 2.12). Consciously or not, the Gallery could not have made a better choice of architects. Reciprocally, the commission could not have offered BBPR a better opportunity to make a statement about their vision for a modern exhibition pavilion.

The Brief and the Site

Drafted by the Gallery, the brief submitted to Peressutti in February 1956 was extremely concise, consisting of a few entries on the desired features: dimensions for each room (gallery, entrance hall, storeroom, and office) for a total of 1,800 square feet (167 m²), modes of display, wall finishes, type of lighting, and flooring materials.[16] It also included a few prescriptions, such as that the gallery space should be "as high as possible" and the building entrance had to be "level with ground," the latter instruction a clear rejection of the pavilion on a podium model.[17] But aside from these notes, correspondence between the various protagonists is utterly silent about the intentions of either client or architect.[18] To better understand the genesis of the design solution, we must look elsewhere.

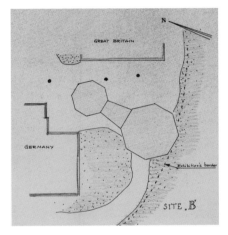

The second step in the process was the selection of the site. The first one offered to the Gallery—site "A"—was a small elevated and wooded area situated between the pavilions of the United States, Israel, and Czechoslovakia. While this area had been reserved for India, complications arose, and the project was not carried out. Rodolfo Pallucchini, General Secretary of the Biennale, advised Canada to profit from this opportunity since the Comune di Venezia had already authorized its use to build a pavilion.[19] Following a February 1956 meeting between Peressutti and Pallucchini, a second site—"B"—located between the German and British pavilions, was also proposed.[20] After visiting the Giardini, Peressutti argued in favour of site "B," reasoning that it provided a "wider area for construction," an "open space in front of the pavilion along the main public circulation," and a "wider horizon on the background of the pavilion looking toward the Laguna."[21] His letter was accompanied by three drawings: an annotated site plan of the Biennale gardens showing the two locations, and two plans depicting the general outline of a pavilion on each site (fig. 3.2, see also fig. 6.5). Drawn at the same scale, these two plans were intended to help the client visualize how a pavilion could be inserted into the densely planted sites. Their tripartite shape roughly reflected the spatial requirements laid out in the Gallery's brief. Given that Pallucchini had already sent a site plan with a possible outline for the pavilion (fig. 3.3)—an elongated rectangle with a short rectangular entrance hall—the tripartite shape can also be read as Peressutti's formal response to this sketchy proposal.[22]

Although Buchanan wrote positively to Pallucchini about site "B" in late March, it was only three months later, after Alan Jarvis's visit to Venice for the opening of the Biennale, that the choice was confirmed.[23] Known as the Montagnola di Sant'Antonio in memory of a fourteenth-century

church that had once stood there, the site presented major design challenges. Framed by the neo-Palladian British Pavilion and the neoclassical German Pavilion, it was defined by the axial symmetry and monumentality of its two neighbours. It was also home to a stand of mature trees. These constraints, architectural and natural, would play a determinant role in the pavilion's design.

The Preliminary Studies

Working from his Milan office, Peressutti made a series of studies before and after site "B" was officially chosen in June 1956.[24] The few drawings documenting this phase, none of which are dated, offer fascinating glimpses into the ideas and design process that guided the project's development.[25] One of them stands out, for it is the only drawing that shows Peressutti testing how a proposed scheme would fit into both "A" and "B" situations (fig. 3.4). The semicircular plan proposes a sequence of five triangular exhibition spaces, each extending into an alcove, which ends in a walled courtyard whose limits are as yet undefined.[26] Most notable is the structure of the scheme: a series of overlapping beams, with the last one resting on a central post. This structural idea would be maintained throughout the entire design process.

The most coherent group of drawings is a set of nine sketches for site "B." Each is a variation on a non-orthogonal configuration (fig. 3.5). While it is tempting to organize them into a developmental sequence that traces the progress of an idea, many of the sketches are just as likely to have been done at the same time, thus representing a series of design alternatives rather than a temporal sequence.[27]

What can we learn from these early conceptual sketches? They show that the architect worked in plan in an attempt to both fit the pavilion within the site and conceive a dynamic way to display artworks. They show the strong presence of a defining perimeter wall—whether angular or curvilinear—that contrasts with the light outlines of display panels. The plans share a constant interplay between inside and outside, the perimeter wall broken open to let the outside in. The sketches also record various strategies to integrate the site's mature trees. However, what may be most significant about them is that all the sketches are focused on a pentagonal outline with a second pentagon demarcating the centre.

Fig. 3.4 (above)
Early studies for the pavilion on sites "A" and "B," before 29 March 1956. Drawing: Enrico Peressutti. Archivio BBPR

Fig. 3.5 (opposite page)
Study sketches for site "B," 1956. Drawings: Enrico Peressutti. Archivio BBPR

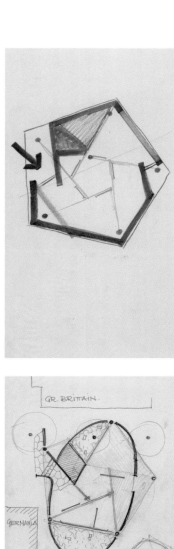
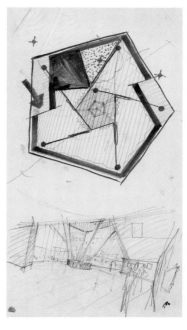
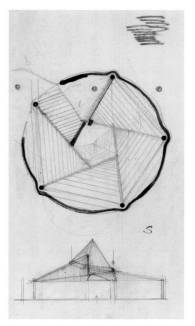
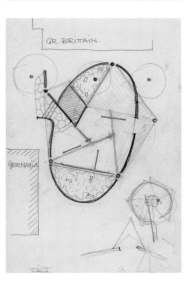

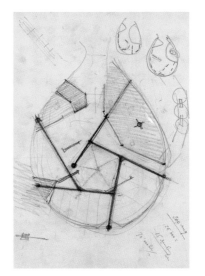

65

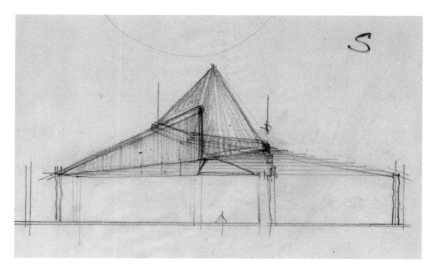

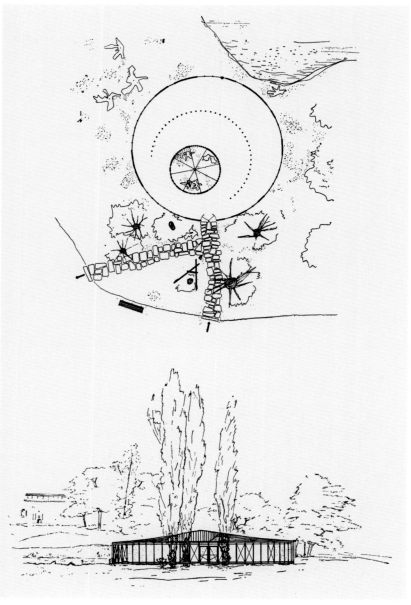

Fig. 3.6
Study for roof profile of the Canada Pavilion,
1956. Drawing: Enrico Peressutti. Archivio BBPR

Fig. 3.7
Site plan and elevation for the United States
Pavilion, IX Milan Triennale, 1951. BBPR,
architects. Reproduced in *Domus*, no. 260
(July–August 1951), p. 6

Suffice to say, pentagonal configurations are quite uncommon. However, the design mood of the time may offer some clues to explain this enigmatic starting point. Books such as the mathematician and poet Matila Ghyka's *The Geometry of Art and Life* (1946) and the architectural historian Rudolf Wittkower's study of harmonic proportion in Renaissance churches, *Architectural Principles in the Age of Humanism* (1949), fed a new fascination with geometry and proportions. This interest came to the fore at the conference "De Divina Proportione" held during the 1951 Milan Triennale, an event attended by many luminaries in the field including Rogers, Wittkower, Le Corbusier, and Ghyka, the last of whom gave a talk on pentagonal symmetries.[28] Peressutti, who was also in attendance, was sufficiently involved with these issues to participate in a second symposium on the theme that was held at the Museum of Modern Art in New York in March 1952.[29]

While Peressutti's precise source for the pentagon is unknown, details gathered from these sketches reveal one of its underlying purposes: the design of an unusual roof structure. The system is based on a rotating sequence of beams resting on posts, with a main vertical support located near the centre. The inner pentagon appears to be a roof opening. A section showing a faceted conical glass skylight emerging from a low-lying roof structure gives further clues about the architect's design intentions (fig. 3.6). Given the permanence of the pentagonal plan and the various configurations of the perimeter wall, it is as if the structure was conceived to support a twisting umbrella hovering above the exhibition space.

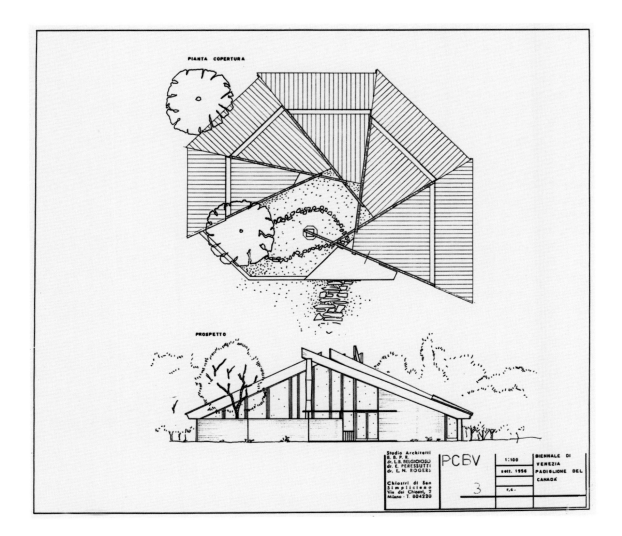

Fig. 3.8
Roof plan and elevation for the first proposal for the pavilion, September 1956. Drawing: Studio BBPR. Università Iuav di Venezia—Archivio Progetti

Read together, these sketches document Peressutti's struggle to define an appropriate form for the difficult site. They explore a variety of architectural themes: the suspended roof, the circular enclosure, the interior patio, the directional path. These themes point to another "contextual" source: precedents in BBPR's own projects. The most obvious one is the 1951 US Pavilion at the Milan Triennale (fig. 3.7, see also fig. 2.5). With its circular outline, central courtyard, radiating structure, and wavering roof form, this pavilion contains many features that reappear in the studies for the Canada Pavilion. The same is true of the 1953 Turin pavilion, which explores the spatial effects of a tent, and the 1954 Labirinto dei ragazzi, which exploits the potentials of a guided sequence. If the site was undoubtedly a key generative constraint at the heart of the Canadian project, BBPR's earlier realizations also consistently informed the design process.

The First Proposal: The Spiralling Octagon

Fully developed drawings for the first proposal were completed in Milan in September 1956. The elevation describes a conical pavilion whose main feature is a roof structure composed of overlapping wooden beams resting on a low perimeter wall (fig. 3.8). A central post supports the entire beam structure. Tall glass walls open up the volume to its surroundings.

Apart from the overlapping beam structure, this proposal is markedly different from the ideas explored in the study sketches. The pentagon structuring the earlier studies is gone, replaced by an eight-sided figure resembling a spiral. As the roof plan shows, the spiral-shaped pavilion was made of two distinct zones: an interior, subdivided in five sections along which the wall surfaces are deployed; and an exterior, conceived as an internal patio enclosing a tree. The roof is punctuated with glass slits to bring more light into the exhibition area. The only extant study drawing for this scheme shows how Peressutti, abandoning the pentagon, further pursued his geometrical explorations with a spiral-shaped plan roughly based on the involute of an octagon (fig. 3.9).[30] It also evokes forms from the natural world, bringing to mind Le Corbusier's well-known fascination with seashells.[31] Two perspectives relate to this spiral plan. The first, drawn at eye level, depicts an exhibition space sheltered by a radiating roof structure that hovers just above the perimeter wall. The second sheet, an extremely vivid perspective and bird's-eye view, describes a spiralling roof fanning out from a central mast (fig. 3.10).

Again, it was not the first time the figure of the spiral had appeared in the work of BBPR. At the 1940 Milan Triennale it took the guise of a double spiral in the modest Padiglione delle Forme (see fig. 2.9). Its second iteration was in the Labirinto (3.11, see also fig. 2.10). There, it was made up of six interlocking segments that created the maze. The design of this spiralling form showed great concern for the organic integration of the built work into the existing landscape.[32] Yet it was

Fig. 3.9 (above left)
Spiral-shaped plan for the pavilion based on the involute of an octagon, 1956. Drawing: Studio BBPR. Archivio BBPR

Fig. 3.10 (above right)
Perspective sketches for the first proposal for the pavilion, 1956. Drawing: Enrico Peressutti. Università Iuav di Venezia—Archivio Progetti

Fig. 3.11 (opposite page, left)
Aerial view of the Labirinto dei ragazzi, X Milan Triennale, 1954. BBPR, architects. Triennale Milano—Archivio Fotografico. Photo: Fotogramma

Fig. 3.12 (opposite page, right)
Model for the Canada Pavilion, 1956. Università Iuav di Venezia—Archivio Progetti

more than a formal device. As the art critic Gillo Dorfles astutely observed, the dynamic forces of its spirals generated a physical as well as visual experience of the pavilion and in doing so intensified the visitor's dialogue with art.[33]

The Second Proposal: From Wood to Steel

Although the first proposal was complete by mid-September 1956, the set of drawings was only sent to the Gallery from Princeton in late October with a model arriving from Milan a month later.[34] The model shows how much the radiating roof structure of deep wooden beams dominated the scheme (fig. 3.12). Although Jarvis and Buchanan had ample time to consider the proposal (the model stayed in Buchanan's office until 3 January), there is no written record of their response to this first project.[35] The only subject discussed in the correspondence was the problematic status of the site. Even more surprising was the fate of this proposal. If we are to trust the dates inscribed on a series of drawings held in the archive, a revised scheme had already been completed by October 1956.

The changes were subtle but significant: the deep wooden beams were exchanged for thinner steel I-beams, the tall glass walls rising above a low perimeter wall were replaced by lower glass panels and a higher perimeter wall (fig. 3.13). While the first proposal had given precedence to the timber roof structure, the revised project paid more attention to the composition of the façade and the articulation of the brick wall. It was this new profile that established the pavilion's formal character. Exactly what motivated these changes is unclear, but a closer analysis of the first proposal suggests that the pavilion's ceiling height and interior circulation would have been severely hampered by wooden beams eighty centimetres deep resting on a low perimeter wall. These limitations, however, fall short of explaining a revision shrouded in mystery that changed both the profile and materiality of the pavilion.

The Permission to Build

Despite an early agreement with the Biennale to proceed with site "B," obtaining permission to build on the wooded area near the lagoon was not a straightforward matter.[36] The submission of the first proposal in September 1956 triggered protracted negotiations with the Comune di Venezia. These exchanges, which started before the project was even sent to Ottawa, also drew in the Biennale's Director, who hadn't anticipated opposition from city authorities.[37] Forced to defend his project, Peressutti offered a rare but revealing description: "It seems to me that the shape of the new pavilion, roughly that of a cone, fits without disturbing the void between the two existing pavilions, and that it interprets quite well the configuration the Exhibition grounds take in that zone."[38] It also prompted him to advise his clients that "the Venetians are jealous of every tree."[39]

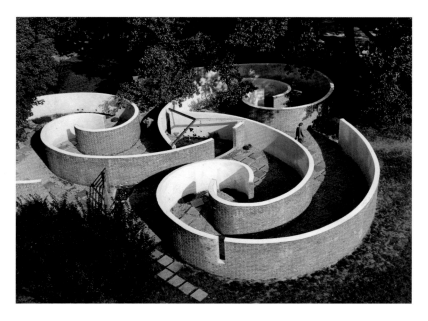
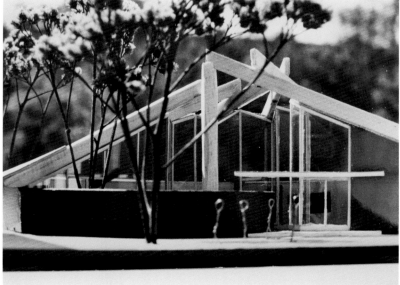

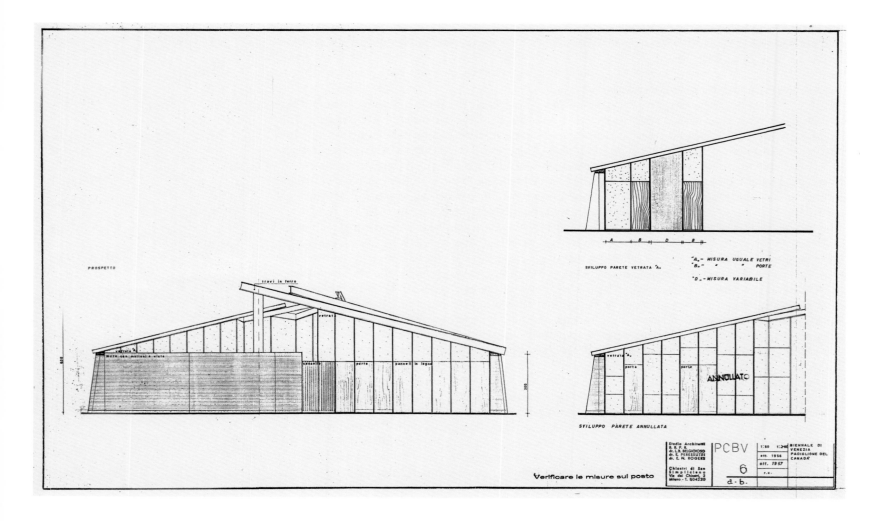

Fig. 3.13
Elevations for second proposal for the pavilion,
October 1956. Drawing: Studio BBPR. Università
Iuav di Venezia—Archivio Progetti

As this contretemps suggests, integration of the pavilion within the Giardini's historical landscape proved the most contentious issue. Municipal officials requested photomontages demonstrating how the building would relate to the site, specifically demanding a view from the entrance *piazzale* with the two flanking pavilions, and a view from the lagoon (see fig. 6.6).[40] Two sketches by Peressutti, based on the photomontages prepared by Belgiojoso in the Milan studio, show the care with which the pavilion was inserted into the site (fig. 3.14).[41] These constraints had a direct effect on the pavilion's status. After learning that the Venetian authorities opposed construction on the site, Peressutti tested the possibility of moving forward with what he termed a "temporary" construction.[42] Alvar Aalto's 1955 Finnish Pavilion had been approved this way.[43] This idea was to remain at the centre of the discussions about the project's future. In November, Biennale officials tried to convince the mayor, Roberto Tognazzi, that the pavilion, built primarily in wood (as it was described in the first proposal), could easily be moved to another part of the Giardini.[44] But another four months would pass before the project received the go-ahead, and this approval came only after Pierre Dupuy, the Canadian ambassador in Rome, intervened with a formal request to Tognazzi. The building permit was issued on 26 March 1957, on condition "that all the load-bearing structures be so constructed as to be easily demolished at a future date (should the pavilion be moved to a more suitable site...), and on condition that the trees are respected."[45] This proviso seems to have brought the matter to a close. There is no documentation to indicate that Comune officials reviewed the final project for a steel structure.

Another design price had been paid in exchange for this approval. In early February 1957, Peressutti had complied with an unexpected request from the city to reduce the building's surface.[46] His response was accompanied by a drawing showing both the original outline and the reduced version. The loss of space amounted to roughly twenty per cent of the original project, a final affront to a designer who had exerted heroic efforts to respect the site.[47]

Building the Pavilion

The Milanese building firm entrusted with the construction of the pavilion was Siccet-Arch. E. Monti-Cantieri Milanesi.[48] Formed in 1939 through the merger of the naval works Arch. E. Monti & Cantieri of Concorezzo and the construction firm Fratelli Feltrinelli, the company specialized in the interior finishing and furnishing of naval, hotel, banking, and industrial establishments.[49] By the mid-1950s, the firm was well known in modern architecture and design circles. Among other projects, they produced wooden furniture by Milanese designers presented at the 1954 Triennale.[50] Monti-Cantieri also became known through the commercialization of its Modernfold system, a retractable partition wall made famous by the architect Gio Ponti.

One clue as to why BBPR chose to work with the firm may reside in the roof's irregular geometric shapes, which had to be prefabricated and moved to the site for assembly.[51] The firm's substantial experience in shipbuilding and their industrial facilities outside of Milan made them a logical choice.[52] Moreover, the profile of the company's workforce—craftsmen who actively collaborated in the development of design solutions—accorded well with the approach favoured by BBPR.[53] The construction contract was prepared in December 1956, but site work was delayed until the building permit was issued at the end of March 1957. Relatively little is known about the building's construction.[54] In July 1957, Peressutti reported to Buchanan that the builder would shortly start "to assemble the roof over the perimeter walls which are nearly finished."[55] However, continual budgetary discussions slowed construction, which extended well into the following year. The Canada Pavilion was only completed shortly before the inauguration of the XXIX Biennale in June 1958.

The Fabric of the Pavilion

The new pavilion could not have been more different from its closest neighbours. The broken profile of its tilted structure—a radiating sequence of overlapping steel I-beams—especially stood out. This steel structure, which is exposed over the courtyard, supports a faceted roof sheltering the interior space. The criss-crossing beams generate the zigzag pattern of the glass curtain wall that floods the pavilion's interior with natural light. Inside, the interstitial space between the beams and the perimeter wall is glazed, reinforcing the overall impression of structural lightness.

The twelve-metre-long main beam that supports the entire structure rests on a mast-like reinforced concrete post. Its shape is a geometrical and constructional feat, as the post's octagonal base turns into a hexagon at the summit, echoing the shape of the Torre Velasca's concrete frame, construction of which was then also underway (see fig. 2.14). In the words of an especially astute observer, this post is nothing less than the building's "axis mundi."[56]

Contrasting with the industrial character brought by the steel structure, the perimeter wall was constructed with soft, orange-red "stock" bricks (*mattoni comuni scelti*) that are common to the environs of Venice.[57] Laid in simple Flemish bond, a pattern often adopted for garden structures, the bricks were bedded with a cement and lime mortar, and bonded with deeply raked joints.[58] Additional structural support at the corners comes from deep buttresses. While the bond pattern is similar to the one adopted for the Labirinto dei ragazzi, the tactility of the exposed bricks recalls that of Venetian garden walls. The perimeter wall is capped by a concrete band whose surface was bush hammered, which endowed the poured material with a lithic quality.

The pavilion's interior is equally the result of skilled craftsmanship. Workers from Monti-Cantieri carried out the prefabrication and on-site assembly of the roof's internal supports and ceiling made of Douglas fir. The fabrication of the ceiling, composed of interlocking wooden boards that had to adapt to the irregular geometry of the roof, was especially challenging. By contrast, the floor in *terrazzo alla veneziana* (or *seminato*) was made by local artisans. Known since ancient times, Venetian terrazzo is composed of marble chips, ground brick, and stone grit (*graniglia*) bound together with mortar. Once compacted and cured, the speckled surface is sanded to a high polish. The warm tones of the pavilion's terrazzo come from pinkish-red (*rosato rosso*) and blood-red (*al sanguigno*) marbles from Sant'Ambrogio near Verona, and inserts made of reddish marble (*magnabosco*) from Asiago.

GR. BR.

(fotomontaggio) (dalla montagnetta)

Germania GR. BR.

2° fotomontaggio (dal Canale)
(schizo)

Fig. 3.14
Perspective sketches for photomontages of
the Canada Pavilion viewed between the British
and German Pavilions and from the Laguna,
after 26 September 1956. Drawings: Enrico
Peressutti. Archivio BBPR

Mirroring the roof beams' alignment, these inserts also help create a visual subdivision of the pavilion's interior space. The floor is also punctuated by a series of brass rings that hold the legs of the movable display panels.[59]

The Canada Pavilion's Venetian identity is further substantiated by the pavement at the entrance and in the courtyard. The paving is composed of slabs of *Rosso Asiago Magnaboschi*, a variety of dark reddish limestone more commonly known as *Rosso di Verona*. While the pattern is in continuity with the one designed for the Milan labyrinth, its provenance—the Verona stone typical of Venice's urban spaces—asserts its rootedness in local building traditions.[60]

The pavilion also stands out through its precise detailing. Many of the construction details were drawn at full scale, attesting to the great attention the architects paid to the building's fabrication. But Peressutti and his colleague Belgiojoso also drew much from the interaction of architect and craftsmen, and some details were worked out directly on the building site.[61] Such is the case of the octagonal "caps" inserted between each of the junctions of the overlapping I-beams. Evidently intended to protect and conceal the bolted connections of the beams, these caps, fabricated by a tinsmith out of zinc sheets, also serve to express where the elements overlap. The same is true of the metal scuppers that terminate the lower end of the steel beams: they simultaneously provide water drainage for the zinc roof and create a visual counterpoint to the linearity of the perimeter wall (fig. 3.15). They offer proof, if it was needed, that the design process extended from the drafting board to the building site.

One last detail, the curved ends—or curls—of the structural steel beams, is more enigmatic. Conceived and fabricated as an add-on that had little functional justification, these curls appear as an "ornamental" end to the conventional steel beams.[62] Their unusual profiles reinforce the idea that, in the end, the character given to the Canada Pavilion by the architects was really that of a playful garden pavilion.

Designing an Architectural Manifesto

In their description of the completed pavilion, BBPR emphasized the geometrical foundation of the design:

> The project is based on the principle of the Archimedean spiral generated from the octagon, which is expressed, in plan, in the pillar of reinforced concrete that supports the sequence of beams of the roof.[63]

The octagon was indeed at the heart of the project, being the source of the spiralling plan as well as the base theme for details throughout the building. This formal description, however, gave nothing away about the many hurdles that impacted its genesis. Nor did it say anything about the project's continuity with BBPR's long-term research into dynamic exhibition spaces. In short, this statement merely provided the formal cues to read a pavilion whose unusual form was no meek response to a site fraught with natural and architectural constraints.

The design process that gave birth to the pavilion was not unlike that of either the small Labirinto or the imposing Torre Velasca, where the search for an appropriate architectural language would take the designers into uncharted territory. Likewise, the resulting object—the Canada Pavilion—was nothing if not demanding for the visitor, for its formal expression and its spatial configuration were unlike anything that had been proposed thus far for the Giardini (fig. 3.16).

The Italian response to the pavilion was limited but very positive. The influential architecture critic Bruno Zevi, who was the European champion of Frank Lloyd Wright and organic architecture, recognized it as a work of great quality. While critical of the site selected for the pavilion, which he felt would destroy a strategic perspective within the Giardini, Zevi hailed the way BBPR negotiated the sightlines all the while respecting the mature trees. The pavilion was nothing less than "a masterfully recumbent form, sculpted with the most polished and intelligent knife in the Giardini."[64] Zevi's critique made it clear that BBPR's primary challenge had been to conceive a pavilion for the Biennale and for the Giardini. That is, to create a pavilion with deep roots in its Venetian context.

This returns us to the question of the pavilion's national identity, or, what is Canadian about the Canada Pavilion? Peressutti appears to have been the first to raise this issue. In a rare letter describing the project to his client in which he discusses the difficulty posed by the building's

Fig. 3.15
View of brick wall of the pavilion with detail of zinc scupper, 1958. Università Iuav di Venezia—Archivio Progetti, fondo fotografico. Photo: Studio Giacomelli

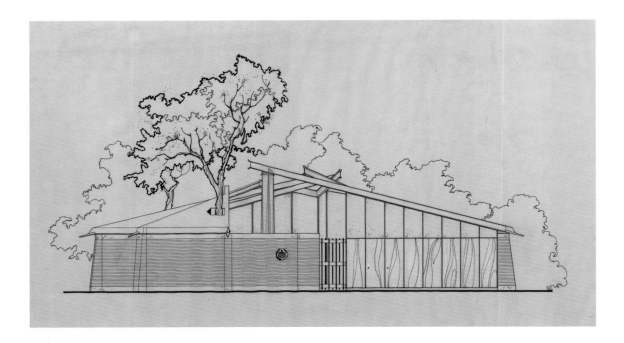

integration with the site, Peressutti wrote: "For my part, it seems to me that the pavilion is really fit to be in that place, and moreover it has a certain Canadian flavour although it is very modern. (No revivals!)"[65] While he said nothing more about it, Peressutti's candid suggestion evidently fell on receptive ears. By the time of the inauguration, the idea had taken on a life of its own, the pavilion's siting beneath the trees interpreted as a metaphor for the country's close association with nature. As Kathleen Fenwick eloquently described: "As it stands amid the trees on its wooded site it gives the impression, which in the eyes of the world is closely associated with this country, of a modern civilization emerging from vast regions of virgin land and forest."[66]

Italian critics also seized on this image. In his 1959 review of BBPR's work, the philosopher Enzo Paci suggested that an "allusive atmosphere" emanated from the pavilion, an allusion to the "world" of Canada, where the constraints of the exhibition space were merged with a sense of open space, of the life of nature.[67] For Paci, the pavilion's formal expression stemmed from a synthesis of technique, artistry, and culture. Its "allusive atmosphere," therefore, derived from its embrace of the site, not from any preconceived architectural image.

This question of image brings the discussion back to the subtle reference to the tepee first raised by Fenwick. John Steegman, who most likely met the architect at the pavilion's inauguration, went much further. According to him, "Peressutti was fascinated by the structural design of the Indian tepee. He freely adapted this form and translated it into terms of steel girders, glass, and wood."[68] Given that the tepee's conical armature is made up of a series of standing poles lashed together at their point of crossing, it may very well have provided inspiration for the pavilion's beam structure. Such an allusion in the 1950s should not come as a surprise. Like many architects of the day, Frank Lloyd Wright and Le Corbusier chief among them, and historians like Sibyl Moholy-Nagy, Peressutti was fascinated by vernacular architecture.[69] This passion was conveyed in the photographic documentation of the *trulli* of Italy's Puglia region, which Peressutti undertook in the early 1950s, and in the subjects he set for his students at Princeton.[70] In December 1955, he took them to the Yucatán Peninsula for a design studio on the Mayan sites of Chichén Itzá and Uxmal (see fig. 2.15).[71] Peressutti regularly lectured on "spontaneous architecture," as Italian architects and critics often called vernacular architecture. His 1953 talk at the National Gallery on modern architecture in Italy even included a discussion of the *trulli*.[72] But as intense as Peressutti's fascination was for "spontaneous architecture," or for a specific building type like the North American tepee, it cannot fully account for the pavilion's final design.

Fig. 3.16
As-built elevation of the Canada Pavilion, July 1958. Drawing: Studio BBPR. Archivio BBPR

If the tepee remains a plausible reference, it was used first and foremost as an idea to draw from rather than as a form to imitate.[73] Structurally, the overlapping steel beams of the pavilion's sloping roof have little to do with the upright poles that define the Indigenous dwelling. The "idea" of the tepee was appropriated, transformed, and fused with other building types—the tent, the labyrinth, the garden pavilion—but also with the complex geometrical figures—the pentagon, the octagon, the spiral—that drove the design process. As such, the tepee may lurk in the pavilion's subconscious, but it falls short of fully explaining either the designer's intentions or the building's final form.

The design of the Canada Pavilion evolved during a period of intense reflection in Italy about the future of modern architecture. As the editor of the leading architecture journal *Casabella Continuità*, Peressutti's partner Ernesto Rogers was at the epicentre of these deliberations. His 1957 editorial on the "continuity or crisis" of the Modern Movement triggered a debate on the delicate question of the place of history and context in contemporary architecture.[74] Sparked by recent architecture in Turin that exhibited revivalist tendencies, the debate blew up into an international controversy when the outspoken British critic Reyner Banham accused Italian architects of retreating from modern architecture.[75] In his erudite response, Rogers reiterated the need to consider the pre-existing environmental conditions (*preesistenze ambientale*) in any new work, promoting a vision of modern architecture that sought to address the historical context, the physical situation, and the technical condition of each project.[76] Yet, while BBPR believed that it was possible to develop a modern architectural language in dialogue with history and tradition, the three partners adamantly rejected the imitation of past styles.[77] As Peressutti forcefully told his Canadian clients, "No revivals!"

But the pavilion was not only a response to *preesistenze ambientale*; it was also conceived through a dialogue with major protagonists of contemporary architecture. The spirit of Frank Lloyd Wright, whom Peressutti greatly admired, can be sensed in the pavilion's siting and "organic" form.[78] The presence of Ludwig Mies van der Rohe can be felt in the exposed steel I-beams of the structure.[79] The lessons of Pier Luigi Nervi can be read in the subtle geometry of the concrete column that rises in the courtyard. The sense of touch of Alvar Aalto can be perceived in the material fabric—the brick, the wood—of the pavilion. Last but not least, the poetics of Le Corbusier—nowhere more in evidence than in the Ronchamp Chapel completed in 1955—can be felt at once in the overall form and the idiosyncratic details of the pavilion.[80] The pavilion fully engaged the architecture of its time.

Designed at the height of BBPR's search for an alternative language for modern architecture, the Canada Pavilion is nothing less than a built manifesto. As an exhibition building, it was primarily conceived for the experience of viewing art, not for the representation of national identity. In this sense, it was designed to present, not to represent. Furthermore, its placement in the southern corner of the Giardini, under the trees of the Montagnola di Sant'Antonio, between the imposing British and German pavilions, had a major impact on its formal configuration. It both embraced and challenged its contextual conditions. The architect's privileging of abstraction over representation, open rather than closed form, materiality over figuration, and the dialogue between interior and exterior, endowed the pavilion with all the traits of a true modern work. With the restoration of the Canada Pavilion in May 2018, sixty years after its inauguration, it is possible to once again "see" and experience a genuine example of BBPR's modern architectural language and a unique contribution to the architectural landscape of the Giardini della Biennale.

The Life and Times
of the Canada Pavilion

Josée Drouin-Brisebois

In its relatively short history, the Canada Pavilion, the country's permanent home in the Giardini, which serves as an exhibition space during the illustrious Venice Biennale, has seen its share of successes, challenges, and transformations. When I first embarked on my research of Canada's exhibitions at the Biennale from 1958 to 2017, I had preconceived notions about the selection of artists and how each country has represented itself in what is the oldest and arguably most important international showcase of contemporary art in the world. After almost a decade of experience selecting artists and curating exhibitions in the Canada Pavilion, I had formed ideas about our nation's representation in Venice, and how cutting-edge the choice and display of certain artists has been. To me, the selection of some of these artists seemed countercurrent to the focuses and trends embraced by other nations. I soon realized that these concepts would be challenged, and I began to see just how intricate the landscape of the Venice Biennale is—how it has its own ebbs and flows and identity crises amid what has been at times vehement criticism and political strife. This new awareness has made my task of painting a portrait of the life of the Canada Pavilion—concentrating on how artists, curators, and architects have used the building over the last six decades—that much more complex.

Since the inauguration of the Canada Pavilion in 1958, artists, architects, and curators have engaged the building in myriad ways, some more successfully than others. Designed by Enrico Peressutti of the Milanese architectural firm Studio BBPR, the pavilion was conceived to display the "fine art" being produced in the mid- to late 1950s: easel paintings, works on paper, and small-scale sculptures. Its form responded to recent trends in architectural and exhibition design, especially in post-war Italy, that sought to create more dynamic experiences for viewers, to form a connection between the gallery and surrounding environment, and to bring in natural light. However, as artistic practices evolved, as the scale of works became more monumental, and as new tools and technologies appeared, the building remained unchanged. Developments in approaches to artmaking over the next four decades—photography, conceptual art, large-scale sculpture, installation art, video, and film, to name but a few—posed challenges to the pavilion's size, space, and lighting. By the mid-1970s, the modest pavilion with its unconventional geometry, glass walls through which natural light flows, and vibrant terrazzo floor was already proving to be a challenging space for many artists and curators.

This essay traces the life of the pavilion as curators, artists, and architects have engaged with its space in innovative ways or struggled with its architecture. It looks at the following exhibitions: James Wilson Morrice, Jacques de Tonnancour, Anne Kahane, and Jack Nichols (1958); Guido Molinari and Ulysse Comtois (1968); Michael Snow (1970); *Canada Video*: Colin Campbell, Pierre Falardeau/Julien Poulin, General Idea, Tom Sherman, Lisa Steele (1980); Geneviève Cadieux (1990);

Rodney Graham (1997); David Altmejd (2007); Steven Shearer (2011); and Geoffrey Farmer (2017).[1] We will also briefly consider how architects have used the pavilion from 1991 to 2018 within the Architecture Biennale.

There are many external factors that lie outside the scope of this essay but merit further study. One of these is the selection process of curators, artists, and, later, architects who have conceived exhibitions for the pavilion. This process has changed greatly from the early years when the National Gallery of Canada was the main organizer for the Art Biennale (1952–86), to the period when the Canada Council for the Arts ran a peer-reviewed competition (1988–2009), to recent years when exhibitions have again been overseen by the National Gallery (2011–).[2] For the Architecture Biennale, which was introduced into the national pavilions in 1991, the selection process has also grown over the years, and currently involves a competition run by the Canada Council for the Arts.

Although I became increasingly aware of the market's effect and influence even in the pavilion's infancy, an examination of the relationship between the Venice Biennale and the art market is also beyond this text. One of the Biennale's original aims was to export and create a new market for contemporary art, at first for Italian artists and later for international artists as well. Between 1942 and 1968 the Biennale had a sales office that enabled the purchase of works by artists represented in the various pavilions (the Biennale took a commission).[3]

Inaugural 1958 Group Exhibition

In the early years, exhibitions in the pavilion focused on a "national" component, and artists were chosen by the Gallery's curators and directors to showcase the diversity of artistic practices in Canada. This idea of diversity involved an emphasis on works in different media (primarily paintings but also small-scale sculptures, watercolours, and prints), and the inclusion of distinct generations of artists from various regions of Canada (although for many years mainly Toronto and Montreal). From 1958 to 1968, the exhibitions were all group shows, with the exception of 1962, when Jean Paul Riopelle was selected as the first solo artist to represent Canada at the Biennale. Group exhibitions afforded the opportunity to give a broader sense of artists working in the country at the time.[4]

The inaugural exhibition in 1958 set the stage: it comprised a retrospective of early twentieth-century paintings by James Wilson Morrice and a selection of recent works by Jacques de Tonnancour, Anne Kahane, and Jack Nichols (fig. 4.1, see also figs. 1.2, 1.3).[5] In the introduction to the catalogue, Alan Jarvis, then the Gallery's Director, spoke of curator Donald W. Buchanan's approach, which was to highlight the influence of the work of Morrice, who was credited with introducing modern art movements to Canada.[6] As Jarvis wrote: "Before him, we were an artistic backwater into which European movements arrived a quarter of a century late; after him, we began to swim in the full stream of Western art."[7] The aim was to clearly position Canadian artists as fully engaged participants in the widely acknowledged modern movement. They were identified by their approaches to making and associated with specific schools, regions, and even teachers in an attempt to write a history of new Canadian art that would be relevant not only to Canadians but also to international audiences.[8]

The inaugural exhibition is key to understanding how the building was conceived to display art being produced at the time. In consultation with Buchanan, who worked with Peressutti on the project, BBPR designed thin, floating partition walls on cylindrical metal posts set into brass holes in the terrazzo floor and installed wooden panels on the inside of the glass walls, layered with sheer curtains to diffuse the natural light. They also created wooden pedestals for Kahane's sculptures inside the pavilion and stone plinths in the courtyard outside. The free-standing partition walls could more than double the length of available hanging surface.[9] Reporting on the progress of the pavilion in September 1957, Buchanan stated: "It may not be desirable always to use all these screens at one time, so the number of paintings that can be hung should never exceed fifty."[10] This was generous considering the number of works possible for display in previous Canadian exhibitions in the international section of the Italian Pavilion (see fig. 1.9).[11] Having a dedicated, albeit small pavilion meant that the country's presence in the Venice Biennale would not only be guaranteed—it had been an invitational model until then—but also afforded the opportunity to better manage the representation of Canada's artists to tell the story of the nation's art.

During the pavilion's first decade, the exhibitions mirrored the development of an emerging Canadian art that was grappling with outside influences as well as different, if not oppositional, schools of thought, such as tensions between figuration and abstraction and between artists influenced by international modern movements versus those with more personal styles. In addition, the

Fig. 4.1
Inaugural exhibition of works by James Wilson Morrice, Jacques de Tonnancour, Anne Kahane, and Jack Nichols in the Canada Pavilion, XXIX Biennale Arte di Venezia, 1958. Alan Jarvis, commissioner; Donald W. Buchanan, assistant commissioner. NGC Library and Archives, Ottawa. Photo: Agenzia Fotografica Industriale

shows reflected the clash between the competing art scenes and schools in Canada specifically associated with French and English speaking regions, as well as notions about the importance of international recognition versus home-grown talent fuelled by individuality and the isolation afforded in this expansive country.

Although painting was foregrounded, these initial group shows often included other art forms, for instance the sculptures of Anne Kahane, Frances Loring, Elza Mayhew, Sorel Etrog, and Ulysse Comtois; and the prints of Jack Nichols, Albert Dumouchel, Harold Town, and Yves Gaucher.[12] Working in different regions of Canada, the artists often had nothing in common in terms of their practices. As the introductions to the Venice exhibition catalogues of the time reveal, their work was brought together to emphasize the importance of diversity in such a vast country, a condition that could be seen as being at the core of Canadian art.[13]

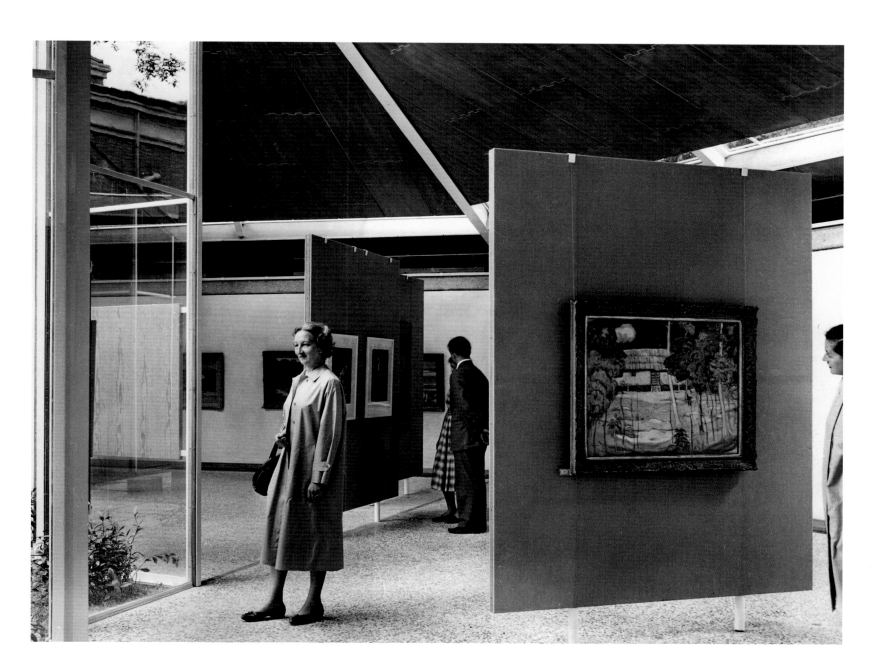

1960s

The idea of representing Canadian diversity and the narrative of Canadian art history in the Venice exhibitions continued until 1968, when Brydon Smith curated a show on the work of Ulysse Comtois and Guido Molinari.[14] In a break from previous exhibitions, Smith didn't isolate the works of each artist. Rather, he created a dialogue between them by focusing on the relationship between two distinct artistic practices stemming from Montreal. Although he "wanted to assemble an exhibition in which the two artists would keep their identities," Smith stated:

> The selection of Comtois' non-colouristic aluminum and phenolic laminate sculptures, and Molinari's recent paintings has emphasized a stylistic link between these Montreal artists. They compose their works by repeating simple geometric units. Molinari divides his canvases into a series of vertical stripes of equal widths; Comtois builds his columns by stacking one rectangular block or circular disk upon another around an axis. However, within these austere formal limits, both artists achieve a wide range of effects.[15]

Smith did not try to present an overview of Molinari and Comtois's production over the last decade but rather selected very recent works by each artist. In doing so, he focused on a specific moment in their practices. As for the display, a neutral carpet was installed to cover the terrazzo floor and white pedestals were used to support Comtois's sculptural columns, while the glass walls remained bare, allowing natural light to flood into the building. The important role of colour and light in this exhibition is evident in the vivid documentary photographs of the show (fig. 4.2). The paintings on the surrounding walls engulfed the visitor in a rich, albeit calculated, experience of colour, while the sculptures, situated close to the glass panels, engaged the natural light and the inner courtyard, which can be seen through the glazing. In this particular exhibition we can see how the pavilion's dynamic geometry created an immersive environment for visitors, while the transparency and natural light produced the illusion of a larger, airy space.

Fig. 4.2
Ulysse Comtois, Guido Molinari, Canada Pavilion, XXXIV Biennale Arte di Venezia, 1968. Brydon Smith, commissioner. NGC Library and Archives, Ottawa

Fig. 4.3
Jean Paul Riopelle standing in front of *Pavane* (1954); *Jean Paul Riopelle*, Canada Pavilion, XXXI Biennale Arte di Venezia, 1962. Charles Comfort, commissioner; J. Russell Harper, assistant commissioner. AAF—ArchivioArte Fondazione Cassa di Risparmio di Modena

Smith offered a wonderful anecdote about the effect of the exhibition in the catalogue. He wrote:

> After the final selection was made, Comtois, Molinari, and I were sitting in a restaurant in Montreal discussing The Rolling Stones' popular song, "She's a Rainbow," and the emphasis on colour in contemporary North American life. I felt a little uneasy, realizing that perhaps I had done Comtois a disservice by including only non-colouristic sculpture. Comtois may have sensed this, for he remarked that the aluminum surfaces of his sculptures reflect all the surrounding colour, and that at Venice they would interact with Molinari's colourful paintings. This unanticipated symbiotic relationship should turn the exhibition into a beautiful colour experience.[16]

What is evident is that the visitor's experience in the 1968 exhibition was paramount, whether through the perception of colours and visual effects created by vertical stripes of different hues or the tactile element of Comtois's sculptures, which could be physically altered by the visitor. The show also confirmed the spatial limits of the pavilion. As early as 1962 a tension could be felt between its modest size and large-scale works that were intended for more expansive institutional spaces and galleries. Several of Riopelle's paintings, among them the three-by-five-and-a-half-metre canvas *Pavane* (1954), seemed too large for the space (fig. 4.3).

1970s
The Biennale of 1970 is of particular interest as Toronto-based Michael Snow was the second artist, after Riopelle, to have a solo exhibition in the Canada Pavilion. In the introduction to the catalogue, curator Brydon Smith discussed the motives behind this choice:

> The decision to have one artist represent Canada at the XXXV Venice Biennial was based on the effective presentation of the relatively few works in the Canadian Pavilion in 1968 (ten sculptures by Ulysse Comtois and nine paintings by Guido Molinari). Fewer works than in previous years meant that the movable panels, which had fragmented the equiangular spiral sweep of the exhibition area, could be removed; this opened up the interior to more sunlight through the inner fenestrated walls around the small court, and to easier and more continuous movement of visitors through the space. The resulting unity between the art and the pavilion enhanced the exhibition to such a degree that the presence of one artist seemed to be the next logical phase. Also, devoting the whole exhibition to one man's art would give the artist an opportunity to realize concepts at the time of installation and would not limit the exhibition to things past.[17]

Here, we see the emergence of a more collaborative relationship between artist and curator. Until this moment, the curator had assumed almost full control; artists produced works and curators selected them, guided by various criteria and considerations. By focusing on recent and new work created specifically for the pavilion, Snow's exhibition offered the opportunity to showcase a distinct moment in the artist's career, to create a portrait of one of the country's most exciting and experimental artists working at the time, choreographed for an international audience.

In this examination of the ways curators and artists have worked together and used the Canada Pavilion, 1970 marks a turning point. In the exhibition catalogue, Smith discussed the synergic nature of the process, going so far as to characterize the selection of works as "theirs." This is in direct contrast to Smith's statement in the previous catalogue in which he mentioned that "in the selection of the works by Ulysse Comtois and Guido Molinari [. . .] two considerations dominated *my* choice."[18] In the Snow publication, Smith wrote: "During the past year and a half, Michael and I discussed the bases for the exhibition. Our selection comprises mainly constructions which include photographic prints. These are augmented by two constructions, which incorporate framing or optical devices to be looked *through* rather than *at*, and by three films."[19] Not only does this demonstrate that the selection was collaborative, but that there was also a conceptual dimension to the exhibition centred on challenging visitors' experiences of *looking* and engaging with art. In an article published in the *Globe and Mail* Smith described the selection of Snow's thirteen works as "a harmonious interaction between art and pavilion which unexpectedly reinforced and enhanced the reflective qualities in many of the works."[20]

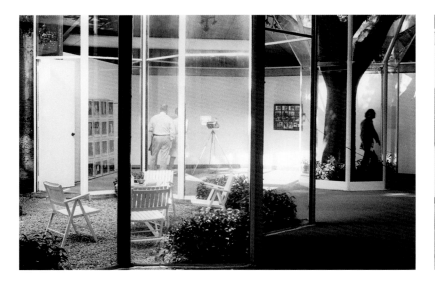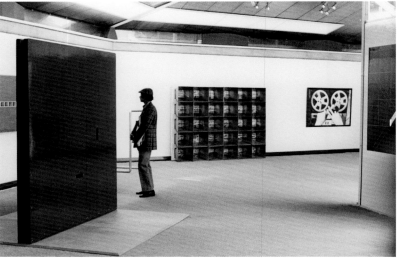

The exhibition presented works ranging from the *Walking Woman* painting series (1961–67), to conceptual photographs, sculptures, and mixed-media works such as *Authorization* (1969), *Sink 2/3* (1970), and *Tap* (1969), to three films: ←——→ (1968–69); *One Second in Montreal* (1969); and *Breakfast* (1970), the last of which was in production at the time of the catalogue's writing (fig. 4.4).[21] Some works had impressive exhibition records, while a handful of them had been shown only once in Toronto. The slide projection and photograph *Sink 2/3* and the sculpture *Shore* were premiered in the show. Recurring themes in the works include concepts gravitating around the framing device, the process of making artworks (and films), and (self) reflection (some works had reflective surfaces such as mirrors and aluminum). Many call into question our traditional experience of works of art by creating complex (and fractured) scenarios in which sound, images, the written word, and time are carefully orchestrated.

The year 1970 was also significant for the Biennale as a whole. On the heels of much unrest, criticism, and protest, it was searching for a new identity and relevance. The art prizes were abolished and the sales office was closed. These changes opened the door to showcase more experimental artists, such as Michael Snow. In his *Sunday Times* review, the art critic John Russell stated, "By the end of the 1960s the Biennale had been given up for dead a dozen times over; in 1968, when soldiers were on hand against a bad dream of wholesale sabotage, it was decried as archaic, superfluous, gerontocratic, dealer-ridden, and overdue for dissolution. So it should be said that the Biennale this year has made a real effort to move into the 1970s as an independent, re-adapted, and disprejudiced institution."[22] In his appreciation for this renewed Biennale, which included conceptual art, audio-visual art, earthwork art, televised art, and what he defined as "multidisciplinary art of every imaginable kind," Russell singled out Snow's *Sink 2/3* as an example of what he saw as the new image.[23]

In 1972, 1976, and 1978 (there was no Biennale in 1974) the selection of artists and exhibitions themselves focused on unconventional artistic practices and, in the cases of Greg Curnoe (1976) and Ron Martin and Henry Saxe (1978), a questioning about regionalism. The Gallery's curators Brydon Smith and Pierre Théberge concentrated on different types of encounters, from Smith's description of being deeply moved by the work of Gershon Iskowitz and Walter Redinger, whom he qualified as expressionists, to Théberge's surprising choice of artists working in the less-populated Ontario cities of London (Curnoe and Martin) and Tamworth (Saxe), who were emerging on the national scene.[24] These exhibitions seem somewhat anachronistic, especially when we consider the turn away from painting and sculpture in 1970 with Snow's conceptual approach and multidisciplinary use of film and photography. Over the course of the decade, the impulse of the curators was to look again to

Fig. 4.4
Michael Snow, Canada Pavilion, XXXV Biennale Arte di Venezia, 1970. Brydon Smith, commissioner. NGC Library and Archives, Ottawa Photos: Michael Snow

more traditional media. That being said, the choices of artists and their approaches to the pavilion are most intriguing. For example, in 1972 the large-scale paintings and sculptures of Iskowitz and Redinger completely filled the building, leaving relatively little space for visitors to experience the works, hinting once again at a struggle between contemporary art production and the building's modest size. Conversely, four years later the pavilion provided an airy atmosphere for Curnoe's eight paintings, the space echoing the views from as many windows in his London studio, effectively transporting his personal creative space to Venice. Also of note is the Martin and Saxe presentation, which was relatively spare in comparison with that of Iskowitz and Redinger.

Whereas the late 1950s and the 1960s were characterized by a search for and writing of a Canadian art-historical narrative through group exhibitions showcasing the diversity of artistic practices across the country, I would argue that in the 1970s the emphasis was on the voices of lesser-known artists paired together, who worked in isolation, were not concerned with international trends, and had strong political and philosophical viewpoints. The Biennale was perhaps seen as an opportunity to show the difference between Canadian artists and their American and European counterparts, particularly with Curnoe, who was known to be a committed anti-American activist.

1980s

In 1980, the decision to feature a group exhibition of artists working in video art was driven by the overall theme of the Biennale.[25] In the preface to the exhibition catalogue, Gallery Director Hsio-Yen Shih explained: "In keeping with the theme proposed for the 1980 Biennale of Venice—the so-called 'rebellion of the younger generation' since 1968—Canada has chosen to present an art form which was developed within the last decade and which has already demonstrated a considerable creative strength."[26] To my knowledge, this is the first time that the Biennale's theme was the driving force behind the selection of artists, or rather the choice of media. Although there had been themes since 1972, the concept of rebellion appears prominently in the press material and exhibition catalogue. Titled *Canada Video*, the exhibition and accompanying publication featured the work of eight innovative artists: Colin Campbell, Tom Sherman, Lisa Steele, the duo of Pierre Falardeau and Julien Poulin, and the artist collective General Idea (AA Bronson, Felix Partz, and Jorge Zontal). According to the curator Bruce Ferguson, the mandate of the 1980 Biennale was for all participating nations to focus on what had happened in their country in the last decade.[27] From that perspective, video art was a telling choice for Canada.

As made evident in Ferguson's catalogue essay, the acknowledgement of this relatively new form of expression went hand in hand with the recognition of the support structures for artists and independent producers in Canada. Notable in this regard was the Canada Council for the Arts, which not only adopted a policy of support for video production in the late 1960s, but also provided assistance to alternative artist-run spaces that were developing around the same time.[28] As such, the catalogue documents a significant moment in Canadian art and its early foray into video.[29] That being said, the installation itself left something to be desired, as two monitors, each encased in a grey monolith, were simply displayed facing each other across the pavilion, simultaneously playing a three-hour program that alternated on odd- and even-numbered days (fig. 4.5). They were complemented by a selection of documents and scripts presented on shelves, with a dozen folding chairs stationed in front of the two screens. In his essay, Ferguson discussed at great length the different artistic approaches to the medium and audiences; unfortunately, this was not reflected in the exhibition itself. Some of the works are described as requiring a more intimate one-on-one viewing experience (Lisa Steele), while others played with mass-media dissemination tropes (such as those by General Idea). By treating all of the videos in the same manner, the specificity of these encounters was all but lost. Interestingly, Ferguson was keenly aware of the difficulties in presenting video and considered the paradox at the core of the medium in his essay. In fact, some of the criticism of the 1980 exhibition centred on the viewers' experience and the unreasonable time demand on visitors in the context of a hectic Biennale.

Canada Video is intriguing as an example of a clear disconnect between the pavilion and the art being showcased. The pavilion was employed in the strictest sense of the term as a container. The act of showcasing video art seemed more important than the exhibition design and the interaction with viewers. It was also arguably the first time the art chosen to represent Canada on the international stage purposefully challenged (or rebelled against) what was deemed "accepted" as an art form within its own borders. The show may very well have influenced the strong association

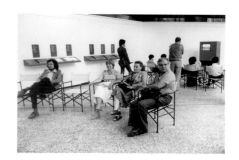

Fig. 4.5
Canada Video: Colin Campbell, Pierre Falardeau/ Julien Poulin, General Idea, Tom Sherman, Lisa Steele, Canada Pavilion, XXXIX Biennale Arte di Venezia, 1980. Bruce Ferguson, commissioner. NGC Library and Archives, Ottawa

between Canada and video art for an international audience. In later years, from 1997 onward, video would recur regularly (at times as a relatively new form of expression for the artists) in exhibitions by Rodney Graham (1997), Janet Cardiff and George Bures Miller (2001), Jana Sterbak (2003), Rebecca Belmore (2005), and Mark Lewis (2009).

The challenge of displaying contemporary art in the Canada Pavilion continued to be felt throughout the 1980s in the exhibitions of Paterson Ewen (1982), Ian Carr-Harris and Liz Magor (1984), Melvin Charney and Krzysztof Wodiczko (1986), and Roland Brener and Michel Goulet (1988). Notably, the pairs of artists that were chosen to represent Canada speak more to concepts articulated in their work than to the individualism or diversity of voices apparent in earlier exhibitions. The above-mentioned shows focused on key developments in Canadian art, including the emergence of installation art in the Magor and Carr-Harris exhibition—both artists were concerned with the making of meaning and the viewer's role in this process—the debate around public art and questioning of monuments with Charney and Wodiczko, and the use of found and manufactured objects in the sculptures of Brener and Goulet.[30] The year 1988 also marked the first Canadian participation at the Biennale since 1952 not administered and financed by the National Gallery (with the help of the Department of External Affairs), opening up the curatorial role to different institutions. The competition model for the Canadian participation at the Venice Biennale would stay in place until 2011 when the Gallery resumed its role as the main organizer.

1990s

In 1990 Geneviève Cadieux, the first woman artist to be given a solo exhibition in the Canada Pavilion, worked closely with curator Chantal Pontbriand, Director of the magazine *Parachute*, in association with the Montreal Museum of Fine Arts. The artist made a bold decision to keep the pavilion's doors closed and to use the glass façade in the courtyard as the support structure for her signature large-scale colour photographs of body close-ups (fig. 4.6).[31] Cadieux's work melds photography, sculpture, and architecture to create unusual if not uncomfortable encounters for viewers. Her Venice exhibition was no exception. In this instance she presented a single work, *La fêlure, au choeur des corps*, a site-specific photographic installation made up of colour photographs mounted on Masonite with an overall dimension of six by thirteen metres, which was designed to look like a skin stretched over the interior of the building's glass panels. In her catalogue essay, Pontbriand described the glass façade of the Canada Pavilion as a vitrine that provides "a window on nature as, in the opposite case, a window on art."[32] She offered insight into how the decision to use the courtyard came about, and the success of the piece's desired impact on the visitor:

> Simply as a pavilion in a public garden, the building is a historic artifact representing a certain conception of architecture and a dated interpretation of the relationship between nature and culture. As an exhibition space, it is commonly viewed as a problem, weighted with cultural baggage and physically inhospitable for many types of art. This troublesome site, then, led Geneviève Cadieux to devise a work for the windows of the interior court of the pavilion, which in this instance is considered to be a showcase. The work, to be viewed exclusively from the outside, invites the viewer to enter the courtyard. There, mounted on the gigantic windows, two colour photographs show a monumental image of a kiss incorporated into an image of a scar. The scale of the enlargements coupled with the proximity of the viewer, who is constrained by the size of the courtyard to stay close to the piece, initially blurs the definition of the images and produces a disconcerting topological impression. The viewer quite tangibly senses the texture of the skin enveloping him on all sides. [...] The viewer is encompassed in this sea of skin, as if swallowed by the beast of love. His image is reflected in the windows, participating in an endless play of reflections imparted by the spiral form of the architecture, where the scar and the lips echo each other as exponents of violence wreaked upon the body.[33]

The success of Cadieux's exhibition stemmed in large part from the artist's innovative approach to the building and intervention within its existing structure. She did not struggle with the pavilion; she utilized it to her advantage.

Nevertheless, the reviews written at the end of the 1980s and early 1990s reflect a growing discontent with the pavilion as a space for showing the best of Canadian art and a desire to have a more appropriate space at such an important international art event. Sarah Milroy, writing for *Canadian*

Fig. 4.6 (opposite page and above) *Geneviève Cadieux: La fêlure, au chœur des corps,* Canada Pavilion, XLIV Biennale Arte di Venezia, 1990. Chantal Pontbriand, commissioner. Photos: Geneviève Cadieux

Art, spoke of "the dreaded teepee, bane of many a curator's best-laid plans."[34] John Bentley Mays, the influential art critic for the *Globe and Mail*, went even further:

> Canada's ugly art pavilion ripe for the wrecker's ball [. . .] is ugly to behold, and, say curators and artists who've tried, a nightmare to work in. The interior area curves broadly, something like a croissant, around a glassed-walled atrium which admits floods of Venetian light. Now such a design might be delightful in a garden folly or a pool-side summer kitchen, but it spells nothing but trouble for any curator or artist who must use it. Adding to the exhibition problems is the message sent by the architecture of this heap of glass, steel beams and brick—a message which isn't *art* at all, but something like *wildlife area orientation centre* or *public washroom in the park*.[35]

And yet, Mays described Cadieux's exhibition as a triumph:

> Though it's been won, not by using, but by abandoning the one space in Venice permanently dedicated to exhibiting Canadian art. [. . .] Certainly no painter I can think of could have overcome the pavilion's limitations in the handy way she did. Nor, for that matter, could most sculptors have done so, though sculpture and installation art are surely the only forms which work with any effectiveness in the space.[36]

While Mays's disparaging comments may have been telling of his lack of appreciation of modern architecture, they were also revealing of another common misconception: that the artist and curator had to fight the architecture of the pavilion, rather than interpret and engage with it.

In the following years, sculpture would feature prominently in the exhibitions of Robin Collyer (1993), Edward Poitras (1995)—the first Indigenous artist to represent Canada at the Biennale—and Tom Dean (1999). As invited curators took on the task of organizing the exhibitions between 1988 and 2009, the approaches were often more experimental and, at times, tentative. These commissions provided curators the opportunity to organize a show abroad and to develop international networks. They also proved challenging for many curators and artists, who faced time and money constraints and were often unaware of the intricacies of organizing an exhibition in Venice and the potential pitfalls of the Biennale. Each new curator also had to figure out how Canada participates in Venice. Throughout the 1990s, organizers often struggled with the building, which was also starting to show its age. Many exhibitions were conceived to present an artist's production without addressing the architecture itself or how the production could be integrated with the building. Some curators went as far as to blame the pavilion for the international critics' lack of interest in Canadian artists.

Of all the exhibitions in the Canada Pavilion in the 1990s, *Rodney Graham: Island Thought* (1997), curated by Loretta Yarlow, Director/Curator of the Art Gallery of York University, is notable for its approach to the building (fig. 4.7). According to Yarlow, Graham's presentation of the film *Vexation Island* was designed to interact with the pavilion's "idiosyncratic architecture."[37] In the catalogue, she described how, on an exploratory visit to Venice to see the empty building and determine how to best turn it into a theatre for his film, Graham noticed that most of the pavilions were boarded up for the winter. The curator mentions how "these boards converted the Canadian pavilion into a 'rustic hut.' Graham quickly recognized this look as a perfect context for his film, while the boards covering the glassed courtyard conveniently darkened the interior space. He decided to retain them for the duration of the Biennale."[38] In the catalogue, the artist explained his motive for keeping the pavilion boarded up:

> I intend to keep it this way since it renders the interior darker and therefore more amenable to a projection. And not incidentally, in this way, from a certain perspective it almost resembles the stockade in the 50s Walt Disney production of *Treasure Island*. In the 1950s, the original designers of the Canadian Pavilion, Ernesto Rogers and the BBPR Group, wanted it to look like a wig-wam. In fact, it resembles nothing so much as an architectural manifesto—a rustic hut-type, complete with tree and of a distinctly European, specifically Laugerian, inspiration. In its placement—in relation to the open space defined by the French, British, and German pavilions—it suggests an example of the humblest forms of rural architecture: the out building. As a repository for tools or animals (gardening shack, chicken shed), it has a subordinate relation to the main house. This is a space in which I work comfortably.[39]

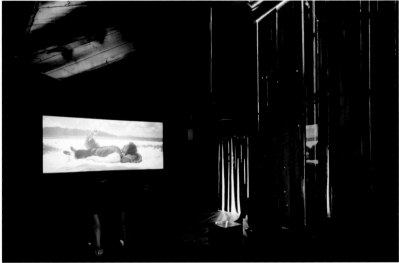

As in many of Graham's works, *Vexation Island* featured the artist in one of his guises, this time as a middle-class Englishman in uniform stranded on what appears to be a deserted island. The marooned Robinson Crusoe–inspired character experiences recurrent states of unconsciousness interspersed with temporary moments of wakefulness that continually repeat as the film loops with no apparent resolution or possible escape.

Graham's film and inspired approach to the exhibition responded not only to the geographic locale of Venice, itself made up of islands, but also to the Giardini as an "architectural" garden of pavilions—many of which were built in the 1950s—that speaks to a utopian vision of nations interestingly and ironically echoed in Walt Disney's eccentric imagination.[40] Taking this analogy one step further, one can interpret the Giardini as a form of theme park in which, as Graham suggests, the Canada Pavilion becomes the set for *Treasure Island*, the perfect context for a tale about the artist as castaway. Graham challenged the criticism of the pavilion as a shed, while at the same time encouraging this reading by keeping the winter hoarding to give the building a more ramshackle look and creating a scenario that valorized its small scale and peculiar qualities. This was also the first time a video was projected in the Canada Pavilion, and the difficulty of darkening the interior was resolved in a creative way.[41]

The Cadieux and Graham shows signalled a new direction to exhibiting in or working with the Canada Pavilion, where the building was integrated into the early conception of the project. In these instances, it was no longer an exhibition space in traditional terms. It was employed as an architectural/sculptural support in the case of Cadieux, and as a conceptual and narrative element for Graham. Herein lies the difference between the space being used to show works of art and the space as a work of art. In the following decade, artists and curators would continue to experiment with different ways of engaging with the architecture (or not), all the while aiming to spotlight the production of some of Canada's most innovative creators.

Canada at the Architecture Biennale, 1991 to 2016

Although the Venice Biennale had incorporated architecture as part of the Art Biennale since 1968, 1980 marked the first official international architecture exhibition.[42] Directed by Paolo Portoghesi, *La presenza del passato* (*The Presence of the Past*) coincided with the founding of an independent architecture department. The exhibition was held in the Corderie dell'Arsenale, Venice's massive former shipbuilding complex, which was opened to the public for the first time. It would take another decade for the architecture exhibition to become a true biennale, and it was only in 1991 that the

Fig. 4.7
Rodney Graham: Island Thought, Canada Pavilion, XLVII Biennale Arte di Venezia, 1997. Loretta Yarlow, commissioner. Photos: Attilio Maranzano

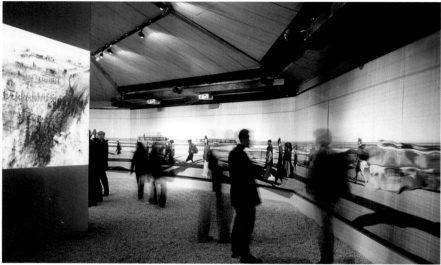

national pavilions were used for the Architecture as well as Art Biennales.[43] Canada has participated in twelve iterations of the Architecture Biennale. The Canada Pavilion hosted its first architecture exhibition with the project *CCA: Buildings and Gardens* (1991). The Venice presentation was a re-mounting of an exhibition curated by Larry Richards that was first presented at the Canadian Centre for Architecture in Montreal in 1989. If the focus on a private institution was an unusual choice, the chance to present the country's newly dedicated centre for the study of architecture to an international audience made it an appropriate one.

In general, each Architecture Biennale has focused on a specific question or exhibition theme, and participating national pavilions, with some notable exceptions, have tended to stick closely to this concept by offering their own responses, at times embracing or challenging it. In 2000, the Canada Council for the Arts began organizing the architecture exhibitions and eventually introduced a competition system to select projects. In a few instances, the selected architect and/or artist(s) utilized the pavilion to create site-specific installations in ways that resembled the Art Biennale commissions. These include *Melvin Charney: UN DICTIONNAIRE ...* (2000), which responded to the theme *Less Esthetics, More Ethics*. Melvin Charney, whose unique practice straddled the line between architecture and art, worked with Phyllis Lambert to present his monumental project of the same title.[44] Started in 1970, it featured his collection of press clippings depicting buildings and urban centres that had been damaged by natural disasters, war, and social conflicts. After adding a grey wash over photographs of these clippings, he then applied his own classification system. In an echo of his 1986 Art Biennale exhibition, Charney also "occupied" the plaza in front of the pavilion with a sequence of three agitprop-like constructions (fig. 4.8).

The 2002 Architecture Biennale featured the work of the visual artists Michael Awad and David Rokeby, and the accomplished musician Eve Egoyan. The Biennale's theme *Next*, which posed the question, "What will architecture be like in the future?," was integrated into the title of Canada's presentation: *Next Memory City—Toronto: Venice*. The exhibition included large-scale video projections by Rokeby and a large photographic mural by Awad covering the pavilion's walls (fig. 4.9). In 2006 the Vancouver-based architects Bill Pechet and Stephanie Robb, working with the curators Greg Bellerby and Chris Macdonald, presented *SweaterLodge*: a giant orange polar-fleece sweater made from recycled plastic bottles and bicycle-powered projectors showing Vancouver scenes. It addressed the theme *Cities, Architecture and Society*. In 2010, in response to the theme *People Meet Architecture*, Philip Beesley presented *Hylozoic Ground,* an immersive and responsive environment created from an intricate network of cut plastic meshwork fitted with proximity sensors that reacted to human presence.

Fig. 4.8
Melvin Charney: UN DICTIONNAIRE..., 7 Biennale Architettura di Venezia, 2000. Phyllis Lambert, commissioner. Canadian Centre for Architecture, Montreal. Photo: Michele Buda

Fig. 4.9
Next Memory City—Toronto: Venice—Michael Awad, Eve Egoyan, David Rokeby, Canada Pavilion, 8 Biennale Architettura di Venezia, 2002. Kathleen Pirrie Adams, commissioner; Michael Awad and John Knechtel, curators. Photo: Michael Awad

Many exhibitions saw the curators/architects using the platform of the Biennale to invite other, often younger, architects or teams from across Canada to contribute to the larger project, as in 1996, 2008, 2012, 2014, and 2016. In recent years, there seems to have been an explicit focus on political subjects that echo the concerns brought forward in the Biennale's overarching themes. For example, in 2014, the Toronto-based architectural practice Lateral Office directly addressed the theme *Absorbing Modernity: 1914–2014*. Building upon their sustained commitment to the Arctic since 2007, the firm's exhibition *Arctic Adaptations: Nunavut at 15* reflected on the "legacy of modernism in [Canada's North], its present realities, and envision[ed] a future architecture that is adaptive, responsive, and rooted in Nunavut's unique context."[45] Organized around five thematic axes—recreation, health, housing, education, and arts—this project, which garnered a Special Mention from the Architecture Biennale jury, was developed in collaboration with five Canadian architecture schools, four additional design firms, and more than two dozen Nunavut-based individual and institutional partners (fig. 4.10).

Another example is the 2016 Biennale *Reporting from the Front*, which focused on living conditions and "how architecture could propose solutions when considered as an instrument of self-government, of humanist civilization, and as a demonstration of the ability of humans to become masters of their own destiny."[46] The Canadian participation, titled *Extraction*, led by landscape architect Pierre Bélanger in association with a multidisciplinary team, including commissioner Catherine Crowston from the Art Gallery of Alberta, examined the effect of mining on the environment, especially as Canada is seen as the "global resource empire and largest extraction nation on the planet."[47] Citing contemporary art practices, Robert Smithson's *Asphalt Rundown* (1969) among them, Bélanger initially proposed to fill the Canada Pavilion with gold ore. However, as the building had to be closed for restoration, Bélanger decided instead to pile one hundred tons of raw gold ore in bags in front of the pavilion to form a wall (see fig. 5.8). Over the course of the exhibition five-hundred-gram samples of gold ore were distributed to visitors. The intervention also featured

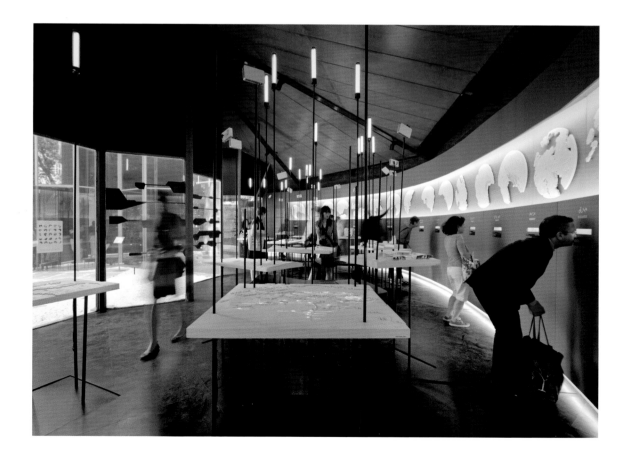

Fig. 4.10
Lateral Office: *Arctic Adaptations: Nunavut at 15*, Canada Pavilion, 14 Biennale Architettura di Venezia, 2014. Royal Architectural Institute of Canada, commissioner; Lola Sheppard, Matthew Spremuli and Mason White, curators. Photo: Andrew Latreille

a video visible only when visitors laid face down and peered through the eye of a gold survey stake with the markings UK, FR, CA, and 2017 embedded in the ground. The video comprised eight hundred images gathered from eight hundred contributors from eight hundred years of history presented in eight hundred seconds.

2000s

Over the course of the 2000s most of the Canadian Art Biennale exhibitions featured video and film: Janet Cardiff and George Bures Miller's *The Paradise Institute* (2001), which included a movie theatre in a sound-proofed wooden structure wedged into the pavilion; Jana Sterbak's *From Here to There* (2003), for which the artist configured her multi-channel video projection of a dog's journey in Venice and the Laurentians to echo the glassed courtyard's irregular shape; Rebecca Belmore's evocative *Fountain* (2005), in which a video of the artist's performance in the cold Pacific Ocean was projected on a wall of falling water; and Mark Lewis's *Cold Morning* (2009), which presented his films exploring modern urban life in the darkened interior of the pavilion.

As the focus of this essay concerns the different ways artists and curators have utilized the pavilion over the course of six decades, David Altmejd's 2007 exhibition is of particular significance as it signals a change in how the pavilion was considered (fig. 4.11). The curator, Louise Déry, Director of the Galerie de l'Université du Québec à Montréal, described Altmejd's inspired approach to the Canada Pavilion as influenced by the surrounding natural setting and its inhabitants, specifically the trees inside and outside of the building and the presence of so many birds in the garden. She wrote:

> From the outset, the artist interpreted the building as an aviary, imagining it as a shelter where birds could nest, feed, and reproduce. The work is composed of steel bridges and rods, shelves, display surfaces, and mirrored wooden cabinets. The structures are assembled and linked together, sometimes stacked, sometimes overlapping, to form a complex, skilfully articulated labyrinth that unfurls at and above floor level. [...] This immense arrangement is inhabited by a multitude of birds (taxidermy specimens and models cobbled together from bits and pieces), stuffed squirrels, werewolf bodies ensconced in mirrored crates and half-man, half-bird figures wearing black leather pants with a contemporary flair. The whole is decorated with artificial and sculpted tree sections, silicone objects, quartz crystals, and pyrite disposed here and there in prominent display cases, isolated in little nooks (the artist calls them hideouts) and in larger compartments that viewers can enter.[48]

Opposite the glass panels, mirrors were mounted on the interior walls to create the illusion of a much larger space as well as to confuse the boundaries between inside and outside. In a way, the pavilion with its geometric shape became a crystal. As mirrors were also integrated into Altmejd's monumental sculpture, on large surfaces and in small crystal-like forms, the reflections were multiplied to create kaleidoscope effects. The mirrored walls, which also brought more light into the space, unified the interior, creating relationships between the two works: *The Index* and the imposing sculpted figure *Giant 2*, which rested against the wall. With nooks and cavities carved into his body, the giant became a suitable habitat for the pavilion's taxidermied and imagined fauna.

The approach to the exhibition space was deliberate and, as Déry said in an interview, they sought to prove that they could work in a "specific way in this specific space. Instead of fighting against the architecture we needed an artist who could enjoy the situation. I wanted to make a break with the past, after ten years of showing video in the space. I wanted to raise sculptural issues and involve the transparency of the space."[49] Déry's statement announced a relatively new criterion to be taken into consideration in selecting artists to represent Canada: those chosen should not only be the best but should also take pleasure in and/or appreciate the pavilion's architectural space.

2010s

Since 2010, I have been part of the national selection committee for the Art Biennale, which is composed of curators and directors from across the country, and can attest that this criterion is an important discussion during the deliberations. The work of Steven Shearer (2011), Shary Boyle (2013), BGL (2015), and Geoffrey Farmer (2017), each of whom are known for their paintings, sculptures, and complex installations, was discussed, and special consideration was given

Fig. 4.11
David Altmejd: The Index, Canada Pavilion, LII Biennale Arte di Venezia, 2007. Louise Déry, commissioner. Photo: Ellen Page Wilson

to each artist's or collective's sensitivity to different, and at times unorthodox, if not challenging, exhibition spaces.

In the 2010s, the artists' approaches have varied greatly. In a similar vein to Altmejd, Shary Boyle and BGL created immersive exhibitions where the viewers' experience was paramount. Boyle sought to create an emotional journey through her imaginary realm populated by invented mythological characters, set in a darkened, cave-like space; BGL transformed the pavilion into laby-rinthine commercial and domestic spaces with a second-storey addition, conceived for a fictional shopkeeper with artistic aspirations.

The last exhibitions I will touch upon in more detail are *Steven Shearer: Exhume to Consume* and *Geoffrey Farmer: A way out of the mirror*, which represent two exceptional and completely different approaches to working with the pavilion. The first was a return to the building as an exhibition space for the display of a selection of medium-sized works; the second, a once-in-a-lifetime opportunity to dismantle and utilize the pavilion as its own monument and ruin before its restoration. I was closely involved in both projects, as curator of Shearer's exhibition and project director for Farmer's show, which was curated by Kitty Scott, then of the Art Gallery of Ontario.

After my initial visit to Venice with Shearer and discussions about the early exhibitions from 1958 to 1968, it became clear that the artist was interested in considering the original design. Indeed, he conceptualized an exhibition that would honour the building's architectural language, thereby acknowledging BBPR's vision.[50] Shearer was also struck by the situation of the Canada Pavilion and its surroundings, specifically the neighbouring German and British Pavilions, and wanted to somehow elevate Canada's small-scale pavilion to new heights. He proposed a temporary false front architecture/sculpture that incorporated both his *Poems* and the North-American tool shed, a recurring motif in his work.

Arguably, BBPR's concept for the pavilion was driven by a desire to create a modest seasonal structure that corresponded with their philosophies about bridging the modern with the vernacular. In so doing, it can be seen as a reaction to the monumental and imperialist impulses of architecture associated with Mussolini's Fascism and to the surrounding classical pavilions: British (1909), French (1912), and German (rebuilt under Hitler's orders in 1938). BBPR's political and social conscious-ness—an acute awareness of the viewer's experience, a high regard for history and tradition, an interest in popular architecture, and a desire to address the context of place—was at the core of what inspired Shearer and influenced his ideas. For the last few years, the artist had been thinking

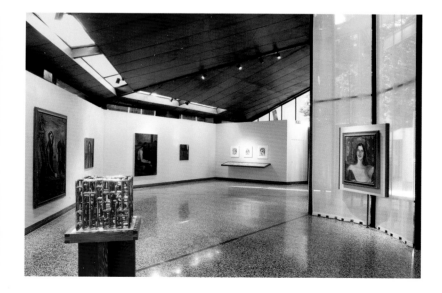

Fig. 4.12
Steven Shearer: Exhume to Consume, Canada Pavilion, LIV Biennale Arte di Venezia, 2011. Josée Drouin-Brisebois, commissioner. Photo: Sebastiano Pellion di Persano

about a show focused on his paintings, drawings, and small sculptures on a more intimate scale. The pavilion seemed perfect for just such a scenario.

As Shearer was unfamiliar with the pavilion's architectural history, his first response to the site was intuitive. The building appealed to him, perhaps because of his own interests in vernacular and modern architecture. What struck me from our first meeting in Venice was the attention to detail that was already affecting the artist's concept even though much of the interior was hidden from view (the space had been completely blacked out for Philip Beesley's exhibition). Once we studied archival images of the pavilion and its original interior, it became obvious that Shearer's impulse for the show was to bring the pavilion back to life, effectively using it in the way it was envisioned: to display small- to medium-scaled works in a dynamic space (fig. 4.12). This approach reflected the artist's long-standing practice of looking at things that have been forgotten and discarded because they have seemingly lost their value, and his desire to reinfuse these objects with meaning by changing their context.

In an interview, I asked Shearer about his impressions of the building and whether he knew of its description as a "garden shed."[51] He claimed he was unaware of this and said: "Next to the other pavilions, it looks like a Parks Board building." He added: "The reality is that many artists likely have an embarrassing relationship to the architecture of their country's pavilion, whether it is due to a small or overbearing scale or a Fascist aesthetic." Shearer continued to talk about his interest in the sculptural quality of painting and his belief that the pavilion "seems to bring out the physicality of such works."[52]

Shearer's idea was "to celebrate the original intentions and spirit of its design."[53] Much effort was thus made to recreate or emulate elements from the initial 1958 exhibition design. The wood mouldings at the base of the walls were restored, curtains were rehung in front of the glass walls, wooden panels mounted on the glass walls were rebuilt, and the brass holes embedded in the terrazzo floor were used for the anchoring of vitrines and a pedestal. There hadn't been any paintings on display in the pavilion since the Paterson Ewen exhibition in 1982. Together we selected new paintings, sculptures, and drawings, and older works borrowed from generous lenders. In the layout we paid special attention to how the works inhabited the space, to the relationship between the figures in the paintings and the visitor's experience, considering how the characters' gazes seemed to follow you as you walked through the pavilion. The artist was also fascinated with the ways in which the sculptural qualities and complex compositions of his paintings became more apparent through the multiple perspectives afforded by the pavilion's geometry. We retained the transparency of the glass panels, which were only slightly tinted to filter the natural light and protect the fragile works on paper. The interior walls were covered in textured plaster in the Venetian tradition.

In many ways, Shearer's exhibition was a return to the past, an appreciation of the pavilion's original design as a presentation space conceived to display a selection of smaller works, which provided multiple perspectives and natural light, and encouraged a dynamic relationship between the artworks and viewers. The show emphasized these qualities. An argument could also be made that although his production is contemporary, it retains modern sensibilities and as such was more in sync with the pavilion's modern architecture.

Finally, it would be impossible to overlook Geoffrey Farmer's ambitious multipart installation *A way out of the mirror* in the 2017 Art Biennale (fig. 4.13, see also 6.10). In our early conversations, the Vancouver-based artist asked if it might be possible to delay the completion of the pavilion's planned restoration in order to allow him to use the building as it was being disassembled. He was particularly interested in seeing and utilizing the space in a transitory moment and the freedom that it would afford his project. According to the exhibition's curator Kitty Scott: "Farmer's approach has been to subtly dismantle and subtract portions of it (the pavilion), with the aim of creating a much more open space that looks outward and upward instead of turning in on itself."[54] At the artist's request and with the permissions of Venice authorities, all the glass panels including the skylights and the structure around the tree were removed, a part of the roof and the front façade were also taken out, and a door was carved out of the brick wall to connect to a new exterior platform. With these significant interventions the Canada Pavilion became permeable, the boundaries between the pavilion and the surrounding garden erased.

For Farmer, the pavilion was an integral part of his artwork. In a written statement, he evoked how it stands as "a reminder of the process of destruction and renewal."[55] He continued:

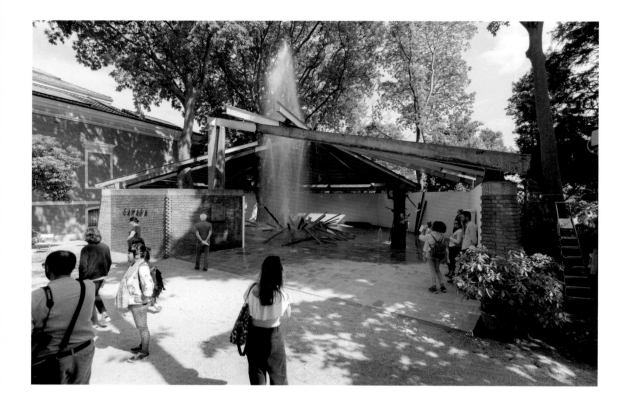

The pavilion was built using war reparation funds and is symbolic of the changing relations between Canada and Italy at that time.[56] During the year of its restoration, I would like visitors to the Canada Pavilion to experience the architectural form in a dimensional way, to be able to circumnavigate it, and understand its relationship to the Giardini. [. . .] By allowing visitors to experience the pavilion with the glass removed for restoration, and with a fountain in the interior courtyard, my hope is to create a moment (monument) of architectural reflection, of surprise, care, and renewal. The fountain is both inspired by its development and history within Italy, but as well, refers to the ecology of water and Venice's intimate relationship to its powers.[57]

Farmer's artistic practice embraces transformation, which manifests itself as continually altering projects that recognize their own instability and fragility of meaning. His works evoke a sense of poetic improvisation and theatricality in which viewers find themselves interpreting found objects, sounds, props, and text to create narratives that seem to play on the slippage between objective truths and perceptions of reality. The fluctuating state of the Canada Pavilion and its surrounding landscape provided another layer of uncertainty for the artist, as permissions for each proposed removal had to be obtained from the Venetian authorities. Structural reinforcements also had to be made to ensure that the roof was secure and the exposed surfaces protected. At the same time, the surrounding landscape was being redesigned by famed Canadian landscape architect Cornelia Hahn Oberlander, including the removal of bushes to be replaced by new plantings and the building of a walkway complete with a platform and seating.[58]

The sculptures *Praying Mantis*, *The Wounded Man*, *Duvet*, *Drinking Fountain*, and *Trough* were all functioning fountains produced for Farmer's exhibition. They were installed alongside other cast bronze works inside and outside of the deconstructed pavilion. Farmer discussed the overall Venice installation in relationship to his own development and maturation as an artist, including references to his early experiences studying at the San Francisco Art Institute, the importance of the

Fig. 4.13
Geoffrey Farmer: A way out of the mirror, Canada Pavilion, LVII Biennale Arte di Venezia, 2017. Kitty Scott, curator. Photo: Francesco Barasciutti

Washington Square Park Fountain, and literary sources such as Allen Ginsberg's poetry, which had a particular influence on him. The San Francisco Art Institute/Washington Square Park fountain, the centrepiece of the exhibition, alternated between being a contemplative source animated by subtle choreographed waterworks and a powerful geyser reaching thirteen metres high that intermittingly soaked the entire site over the course of the day. Following each eruption, the water would cascade back into the building through the skylights and openings in the roof and run along the *masegni* stone floor down into a hidden reservoir, effectively transforming the whole pavilion into a fountain.

Farmer's foundational experiences and connection to knowledge production were further referenced in the books that were part of some of the sculptures, including *Praying Mantis*, which Farmer described as a self-portrait as a young adult with long gangly limbs and a somewhat awkward sense of his own body. A monument to personal and collective trauma, the exhibition also acknowledged the loss of one of the founders of Studio BBPR, Gian Luigi Banfi, who died in the Mauthausen concentration camp during the Second World War. Farmer's exhibition represents a unique moment in the pavilion's life as it became subject to dismantlement and ruin before its renewal. The water can thus be interpreted as the element of this transition or the baptism of a new life.

Through the examination of nine case studies over the course of six decades, we can see how curators, artists, and architects have engaged in various ways with the architecture of the Canada Pavilion. Although the building was designed for the paintings and sculptures being produced in the late 1950s and 1960s, especially works that shared a modern sensibility, it has since been integrated into artistic, curatorial, and architectural projects in innovative ways. As contemporary art became more diverse, increasingly conceived and produced for large gallery spaces, a discontentment slowly set in during the 1970s and 1980s. In certain instances where the artist's production was better suited to a white-cube gallery environment, we notice a clear divide between content and context, as artists and curators struggled with or simply ignored the building. At other times, curators and artists were confronted by the uncontrolled flow of light, especially onerous for the showing of video and film, and by the building's modest scale. Certain artists, architects, and curators rose to the occasion, appreciating the challenge and adapting to the constraints of the pavilion, either by integrating the building or some of its elements into their project, using it as an exhibition space for the works in the spirit of Enrico Peressutti's intention, or transforming it to suit their needs, either by creating immersive installations or environments or even dismantling it. The life of the pavilion continues now that the building has been restored, with renewed functionality and upgraded amenities.[59] Speaking about the exceptional restoration project, Paolo Baratta, President of the Venice Biennale, went as far as to say that the building should now be considered the co-curator of each exhibition.[60] I would argue that, as made evident in these case studies, many users have already listened to, felt the influence of, and integrated the pavilion into their production and exhibition concepts. One can only imagine how artists, architects, and curators will continue to respond to the Canada Pavilion and its renewed landscape.

"A careful, museum-quality restoration": Rethinking and Rebuilding the Canada Pavilion

Susanna Caccia Gherardini

In 1983 a group of Spanish architects led by Ignasi de Solà-Morales Rubio carried out an architectural and historical survey of the German Pavilion designed by Ludwig Mies van der Rohe for the 1929 Universal Exposition in Barcelona and subsequently reconstructed it (fig. 5.1).[1] This marked the start of the recent history of an approach to restoration that would betray its complexity (and contradictions) in the semantic shifts that accompanied its development. Today the pavilion attracts visitors as one of the most successful expressions of Mies's poetics. But the reconstruction produced a radical shift in the meaning of the work. What visitors experience is not just temporary architecture that has been turned into something permanent,[2] but the representation of an identity (the *mise en scène* of German art in the late 1920s), a transition in the genealogy of the work of a modern master into an icon and its associated rhetoric.[3] The result exalts the author-work relationship, which, in the case of architecture, was a late-eighteenth-century phenomenon associated with Romanticism that in turn was closely linked to the construction of individual celebrity.[4]

These issues extend to the pavilion Canada built in the Giardini della Biennale in 1958 and decided to restore sixty years later. In the course of the original project, the pavilion was officially given the status of a temporary building insofar as it could be disassembled and moved to another site if necessary. Indeed, the Comune di Venezia only approved the project on condition "that all the load-bearing structures be so constructed as to be easily dismantled at a future date (should the pavilion be moved to a more suitable site, as the designers themselves have proposed)."[5] In the minds of the authorities involved, the pavilion's character was to be consonant with the tradition of transitory exhibition buildings as exemplified by the 1851 Crystal Palace in London, whose design was met with widespread acclaim.[6]

The restoration of a modern building such as the Canada Pavilion raises many questions. This essay explores a number of theoretical considerations related to the conservation of the modern: what are the power relations between clients, local and national authorities, and architects; what are the guiding principles of the project; what kind of documents should be privileged in defining an approach; and finally, what kind of modernity are we actually talking about? These questions are coupled with a closer examination of the project's development, from the preliminary extension proposals to the final restoration program, paying special attention to the interventions on the pavilion's material fabric. The goal of this essay is to shed light not only on the physical intervention but also on the thought-provoking process entailed by the conservation of the Canada Pavilion.

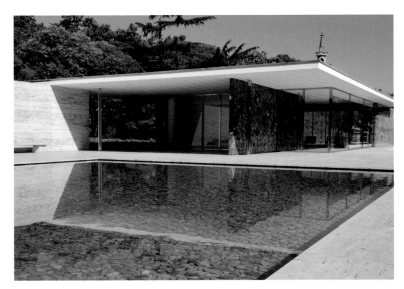

The Need for Theory

The travails of the pavilion's restoration reveal a series of complex issues. The first of these concerns is the need to safeguard a modernity that is not only fragile and precarious, but is divorced in terms of culture and construction from the contemporary world.[7] The second and perhaps even more relevant theme is the reversal of what constitutes a document.[8] A work's originality and/or origin, an association that has spawned a vast literature, is legitimized through the examination of its genesis. Drawings, sketches, and correspondence are the palimpsests of what has been called a possible *second degré* narrative.[9] In the final analysis, the work—not just the one to be restored, but also to be admired, the one that art literature associates with the author's workshop—seems almost secondary with respect to the genetic explanation sought in the quasi-naturalized documentary record.[10] It is philological rather than historical study that dictates choices that then affect actions that concern the materiality of the artefact. These actions are nothing short of translations of the power relationships created over time between the various actors—among them clients, architects, and authorities—taking part in this game of exchange.[11]

After decades in which historiographic interpretation based on the author and on the genesis of works dominated architectural studies, it is now through restoration that the problems of modern architecture in terms of its materiality and historicity are being readdressed.[12] This comes to the fore in the discussion of sources and their hierarchy. Absurd as it may seem, sometimes it is not the work itself—in this case the building—that is taken as the primary source. This place is instead ceded to the paper archives, which are created, like all archives, to pass down "a" memory, with a particular weight given to images.[13]

Authorship

The steel and brick Canada Pavilion was designed between 1956 and 1957 by Studio BBPR, whose founding partners included the father of Alberico Barbiano di Belgiojoso, the architect charged with the pavilion's recently completed restoration, and himself a member of the firm, which he joined a few years after obtaining his architecture degree at the Politecnico di Milano in 1963.[14] Restoring a work like the Canada Pavilion sixty years after it was built puts the focus back on critical issues such as originality and its various manifestations, and authorship, while paying less attention to temporality and the traces it has left on the building. In the process this project returns to a concern that has appeared many times in the history of architectural restoration: modernity as both a didactic and normative model. The start of this mutation can be dated to 1977, when Le Corbusier

Fig. 5.1
German Pavilion, Barcelona, 2019. Ludwig Mies van der Rohe, architect (1928–29; dismantled 1930; reconstructed 1983–86). Photo: Cyrille Simonnet

Fig. 5.2
Pavillon de l'Esprit Nouveau, Bologna, 2009. Le Corbusier and Pierre Jeanneret, architects (1924–25; demolished 1926; reconstructed 1977). Photo: Tim Benton

and Pierre Jeanneret's Pavillon de l'Esprit Nouveau, built for the 1925 Exposition des Arts Décoratifs in Paris, was reconstructed in what might be described as a kind of fit of nostalgia in Bologna (fig. 5.2).[15] A more recent example is the project to recreate Le Corbusier's Brussels World's Fair Philips Pavilion in Eindhoven, another case where a work designed and constructed to be ephemeral has acquired such an iconic status as to inspire a full-scale reconstruction.[16] It also extends to turning an unfinished project into a work whose authenticity is almost enigmatic, as in Saint-Pierre de Firminy-Vert, a church designed by Le Corbusier between 1960 and 1965, but completed long after his death by his assistant José Oubrerie in 2006.[17] Such enterprises open questions about the object itself and its status as a copy, a simulacrum, a philological reconstruction, a paradigm of a deliberately contextless modernity.[18]

However, while these remakes perhaps lie outside the strict definition of what constitutes a work of restoration, they do serve as reproductions with the didactic purpose of explaining one of the bases of modernity: the illustrative, quasi-pedagogical nature of the authorial model.[19] After all, the growing interest in modern architecture has had some curious spin-offs, including the phenomenon of architecture collecting. A celebrated (and controversial) example of this is the gallerist and design dealer Patrick Seguin's purchase of several buildings by Jean Prouvé, including his famous Maison Métropole (1949).[20] Transforming a work of architecture into art, collecting has had the effect of lending new value to what are essentially symbolic goods.[21] Collecting has also led to radicalizing a kind of hyper-philological restoration, forcing this practice to the threshold of what might be provocatively described as a possible philological snobbery.

Heritage as Social Product

The type of restoration encouraged by collecting has too often seen material authenticity sacrificed in favour of conservation, or, much more frequently, of the reconstruction of the work's presumed original appearance toward the goal of preserving its aesthetics. As the art sociologist Nathalie Heinich points out, patrimonial precaution and aesthetic precaution are not always easy to reconcile.[22] On the contrary, this tension throws into relief the extent to which the appropriation of space, even more so when it is *architecture d'auteur* (authorial architecture), generates conflict. It alters the very role of a criticism that turns away from critique to become instrumental in the shaping of the collection being assembled.

Rather than developing a conciliatory consensus around a work's presumed value, restoration brings to light the power relationships that over the years build up between the various actors who consider the feasibility and meaning of the intervention to be performed. In the specific case of the Canada Pavilion, this involved the National Gallery of Canada as client, a group of architects, and the various authorities in charge: the Biennale di Venezia; the Comune di Venezia; and two heritage bodies, the Soprintendenza Archeologia, Belle Arti e Paesaggio per il Comune di Venezia e Laguna, and the Ministero dei Beni e delle Attività Culturali e del Turismo in Rome.

What the study and understanding of power relationships can provide is an awareness of how heritage is essentially a "social product."[23] Indeed, the complex restoration operation of the Canada Pavilion is a rare example—one that demands to be examined—of the social processes that have altered and continue to alter not only the terms of the debate, but the very practice of restoring the modern artefact.

The first thing we must understand is that heritagization—especially the aesthetic preservation of architectural works that are meant to be representative of a cultural period, of an identity, of an author—has now replaced conservation. The restoration project has drawn the Canada Pavilion into a tug of war between material and immaterial heritage, an internal tension that has not been sufficiently explored within the field of conservation (fig. 5.3). Not simply an exhibition space delimited by its physical dimension, the building in the Giardini della Biennale also carries the themes of national identity within the broader collection of pavilions in a cultural event that every year sees different curators give new meaning to the spaces of the Biennale itself.[24] This opens a breach in another issue that has so far remained in the background.

"A building of great architectural interest"

The pavilion was officially commissioned by the National Gallery of Canada in December 1955. The timing of the project—the first decade after the Second World War—and the ties that grew between Canada and Italy during and after the conflict would loom large over discussions about the building's

restoration. The Canadian delegation pointed out "the particular cultural significance of the project as a Canadian-Italian post-war diplomatic initiative with strong associations to the memory of Canadian soldiers lost in the liberation of Italy from Fascism."[25] From this perspective, the choice of the original architects, Studio BBPR, who produced one of the most moving war memorials, the Monument to the Victims of the German Concentration Camps (1946) in Milan (see fig. 2.3), might be considered significant. In any case, it would be hard to find a better example of the concept of bearing witness, as the ancient Greeks understood it.

But this is not all. The pavilion does not exist in isolation; it acquires meaning when considered in relation to the overall system of Biennale pavilions and the gardens themselves, a fact that underlies the "declaration of outstanding importance" issued for purposes of protection. This issue was introduced into the equation in 2010 by government officials in charge of protecting Venice's architectural and landscape heritage. In a letter to the Director of the National Gallery, Renata Codello, Director of the Soprintendenza Archeologia, Belle Arti e Paesaggio per il Comune di Venezia e Laguna, stated that the pavilion is "a building of great architectural interest [...], as an integral part of what has now become an interesting museum of modern architecture within the Biennale's grounds, reflecting the architectural trends of the various nations present."[26] At the same time, exhibition buildings, even those designed with an eye to articulating the close relationship between the nation and its spatial representation, are essentially structures allowing flexible internal arrangements to accommodate different and changing installations. These buildings are perhaps the most intriguing elements within a larger history of curatorship still to be written. Focusing attention almost exclusively on the shell risks distorting the modern relationship between interior and exterior and forgetting

Fig. 5.3
Canada Pavilion, winter 1996. Archivio Storico della Biennale di Venezia, ASAC

Fig. 5.4
Alberico Belgiojoso inside the Canada Pavilion during restoration work, winter 2018. Photo: Andrea Pertoldeo

the lessons of Bruno Zevi's *Saper vedere l'architettura* (1948).[27] In the case of the Canada Pavilion, the building stands in an elevated location that recalls Le Corbusier's *quatre horizons*, and within a garden whose chronologically uneven landscape is turned into a series of discreet, autonomous interventions, each treated as an authorial work.[28]

Returning to the issue of the relationship between material and immaterial heritage, the role of philological reconstruction—the study of a subject through its historical record—must still be addressed. While the documents available for the restoration of the Canada Pavilion are substantial, it is hard to tell what took—and perhaps still takes—precedence among the various narratives (historical, biographical, those of the client and the architect), drawings, photographic images, and written documents. A question worth pondering is what Elisa Brilli calls "the rise of images and the eclipse of the literary."[29] Architectural restoration is often based on the use of images (especially photographs), rather than on the literary materials that accompany the initial design and its subsequent modifications. While the role played by images in the restoration of the Canada Pavilion is not as clear as it has been in other such projects, Le Corbusier's Villa Savoye perhaps chief among them, it is still necessary to address the problem of what has come to be known as "documentality": how records are constituted, and how to differentiate between archive and source, questions that have been debated above all in the United States and in Italy over the last ten years.[30] These are issues that restoration cannot ignore, not only for problems of legitimacy. But this privileging of the image is above all a truly interesting example of what the historian Pierre Nora termed a "second-degree history."[31]

Authority

The second process that concerns the pavilion's restoration is the extremely delicate matter of copyright and the consequent preservation of the memory, rather than the history, of an architectural work.[32] This may apply to the architect or firm engaged to perform the restoration, in this case Lodovico Barbiano di Belgiojoso's son, who is described in the project dossier as the heir and continuator of Studio BBPR (fig. 5.4).[33] Alberico Belgiojoso had previously led a number of significant restoration projects, among them the museum and exhibition spaces of the Palazzo Reale in Milan (1994–2007); the transformation of the Corenno palace and boathouses at Lago di Lecco (2001–07); and various spaces of the Brera monumental complex (2005–06) in Milan. While this experience established his credentials in the field of architectural conservation, officials in the Soprintendenza seemed to consider his connection to the original architects most important, expressing in an opinion on a proposal to extend the pavilion submitted for approval in March 2014 that the work should be undertaken by a party who is able to ensure continuity with the original building.[34] This position not only legitimizes the concept of copyright, a notion that remains abstract with respect to the process through which the project was originally commissioned and the various design phases, in which BBPR partner Enrico Peressutti had a primary role, but returns to a conception of architecture that Zevi had criticized as early as 1948.[35]

Written documents such as those that record the negotiations between the client, the restoration architect, and actors within the various heritage agencies bear witness to an operation whose origins and multiple aspects emerged in a recent study of the many restorations of the Villa Savoye (1928).[36] Does the architect—or presumed heir—have the right to redesign rather than preserve a listed building? We can credit Le Corbusier with introducing this issue into modern architecture. In 1963, after exploring every avenue to redesign the Villa Savoye, including rearranging its interior spaces, he theorized the possibility of restoring it to its original state, arguing that he had the right to do so based on the principle of authority, rather than on the basis of copyright. But how is one to recognize the principle of authority and how should it be exercised today? In an extremely well-argued essay, the historian and archivist Sébastien Dubois links authority to the forging of personal fame that authors, in his case writers, are able to achieve.[37] But literary works lead different kinds of lives than do architectural creations, which, although they can change, must respond to a specific use.

Rethinking the Canada Pavilion

In 2014, aided by the "authority" lent to the project by Alberico Belgiojoso, the National Gallery of Canada began to explore ways to adapt the Canada Pavilion to the demands of twenty-first-century art, notably installation art (fig. 5.5). The project was also motivated to respond to changing approaches in how exhibitions are set up and displayed and to give sufficient latitude for the authorial input of the curator. The first proposals focused on increasing exhibition space. They considered a number

of different possibilities, ranging from various below-ground-level extensions, to conceiving a space adjacent to the pavilion that could be shared with the Biennale itself, to adding a temporary structure. In the end, it was decided to opt for a conservative restoration project, or, to put it into the language of the documents, to make the pavilion *esattamente come l'originale* (exactly like the original).

Negotiations about the extension and then restoration of the Canada Pavilion lasted more than three years. They came to a close when the Soprintendenza approved the final version of the design in June 2017.[38] Three main proposals and their variants were put forward in February and March 2014 (figs. 5.6, 5.7). Solutions "A" and "B" were intended to have a minimal impact on the site and the existing building, proposing two variants for an underground extension at the rear of the building. Hidden from view from the main *strada*, the extension was to have windows on the Laguna. Reached by stairs and a small elevator, the two underground projects also proposed to include a terrace on the addition's roof. The third solution, "C," was the only one to propose a visible extension, which was carefully studied in relation to the position, distance, and architectural image of the existing pavilion. Its intention was to create a positive dialogue with the BBPR building. Each proposal included a limited restoration of the 1958 building, emphasizing that no architectural changes would be made to the structure; only the glass wall in the courtyard and the terrazzo floor would be replaced "with the same material and system of the present."[39]

Belgiojoso's three proposals immediately met opposition from officials at the Soprintendenza, who expressed concern about setting a dangerous *precedente*: "In any case it will be difficult that the use of an external space, either underground or above ground, will be allowed, because this has never been done with other pavilions, and an operation like this for Canada will be a 'precedent,' and will generate similar requests by other pavilions; and this would be a serious problem."[40] The heritage office then requested the support of an ad hoc committee set up in Rome to sort out the thorny problem posed by the Canada Pavilion.

While this kept the door open to the possibility of extending the pavilion, the Soprintendenza was adamant that even if the other parties (the Biennale and Comune di Venezia) accepted the project, it would have to respect another criterion: "The extension of the pavilion must be clearly recognizable from the existing original one by BBPR."[41] The work, the author, the true, the false, and the fake—these are all themes that once again emerge clearly from the records and the many discussions about the restoration of the Canada Pavilion.[42]

Fig. 5.5
Cover of the Canada Pavilion project dossier with sketch by Enrico Peressutti (1956), March 2014. Studio Belgiojoso

Originality

Meetings and negotiations about the future of the pavilion continued into the following year, when, "in accordance with the suggestions of the institutions," another extension proposal, once again with three variant schemes, was submitted to the Soprintendenza. It was presented in June 2015 along with a report on the state of the health of the trees on the site and a series of recommendations about the specific rebuilding work to be carried out on the original building.[43] What came out of these discussions was recognition of the unique nature of the Canada Pavilion, part of which is due to the specificity of its site as an ideal spot from which to admire the Laguna, the horizon thus becoming an added heritage feature.[44] In this way one of the most delicate problems enters the picture: the role played by originality in creating identity, a matter that has been central to the issue of the Canada Pavilion ever since it was designed in the mid 1950s.[45]

The reluctance of heritage officials to approve any extension project became clear during meetings held between January and June 2015 that were attended by representatives of the Venetian institutions involved, as well as by Belgiojoso, and a delegation from the National Gallery. As the prospect of building on the site became increasingly unlikely, officials at the Soprintendenza, in agreement with those at the Biennale, went so far as to suggest that Canada could solve its problem by leasing exhibition spaces within the Arsenale.

The National Gallery, however, was committed to the Canada Pavilion and began to move the discussion toward "a careful, museum-quality restoration of the original structure," all the while continuing to press for extra exhibition space.[46] In November 2015, the Soprintendenza passed the dossier to the Ministero dei Beni e delle Attività Culturali e del Turismo, which set up three joint committees: the Comitato tecnico-scientifico per le belle arti, Comitato tecnico-scientifico per il paesaggio, and the Comitato tecnico-scientifico per l'arte e l'architettura contemporanee. The positions of the parties remained unaltered, and the National Gallery decided in March 2016 to abandon the idea of enlarging the pavilion once and for all. From that point on, all the attention shifted to the sixty-year-old pavilion. A number of tests and studies were then performed to assess its state toward developing a "complete program for proper restoration."[47]

Fig. 5.6
Sketches outlining three solutions for the extension and notes on the restoration of the Canada Pavilion, 27 March 2014. Drawing: Alberico Belgiojoso. Studio Belgiojoso

Fig. 5.7
Cutaway drawing for extension of the Canada Pavilion, March 2014. Drawing: Alberico Belgiojoso. Studio Belgiojoso

The Restoration Program

To make way for diagnostic work, the pavilion was closed in 2016. The Canadian entry at that year's Biennale di Architettura was given the space in front of the pavilion for its presentation, part of which took the form of a blockade of sacks of gold ore with the shrouded pavilion as a backdrop (fig. 5.8). The following year's art exhibition took advantage of the in-between status of the pavilion. Benefitting from the restoration project, the artist Geoffrey Farmer inserted a series of sculptures in the open space created by dismantling the glass façade and partially dismantling the roof (see figs. 4.13, 6.10).

Once the analysis of the state of the pavilion had been completed in agreement with the Soprintendenza, the final version of the project was at last approved in December 2017.[48] The restoration program's schedule had already been laid out in the dossier that was issued in October 2016. It detailed the removal and replacement of current glazing systems with new safety glass with protective films; the repair and where necessary replacement of steel profiles; the replacement of the exterior roof membrane and refurbishment/replacement of all flashing and finish elements; the refinishing and repair of the exposed steel structure; the repair and polishing of the existing terrazzo floor and baseboards; the replacement of discoloured and delaminated plywood ceiling panels and restoration of other wooden elements; and the addition of an internal perimeter wall to provide secure hanging and hide new electrical wiring and outlets.[49] To conform with anti-seismic regulations, the structure had to be reinforced. To address the pavilion's equipment, plans were made to upgrade the mechanical, electrical, and security systems. Direct measures were also outlined to make the space more amenable to contemporary art forms. A new lighting system, an internal shading system for blacking out the windows, and a removable raised platform to protect the terrazzo were described in the documents.

A further examination of the technical and construction details as well as the building's structural components was performed prior to the start of the restoration work undertaken by Belgiojoso in collaboration with the Venice-based architect Troels Bruun of M+B Studio and in consultation with the Canadian designer Gordon Filewych, who represented the National Gallery. While Bruun brought

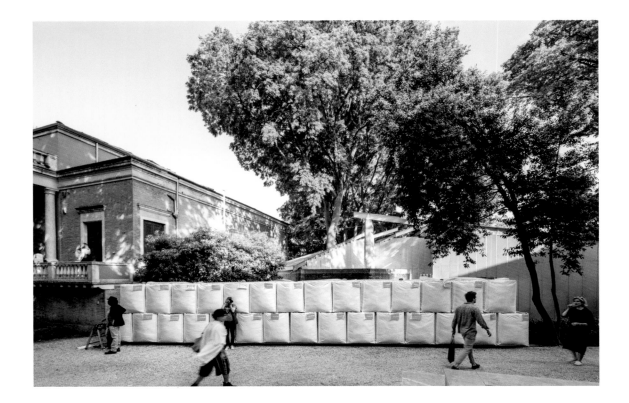

Fig. 5.8
OPSYS: Extraction, 15 Biennale Architettura di Venezia, 2016. Catherine Crowston, commissioner; Pierre Bélanger, curator. Photo: Laurian Ghinitoiu

in-depth knowledge and hands-on experience of the Biennale and its pavilions to the restoration, Filewych ensured that the project responded to the needs of the Gallery.[50] Particular care was taken in appraising the building fabric, such as the perimeter wall that was constructed, as the 1957 plans describe, of *mattoni comuni scelti (non spigolati) a faccia vista* (common fair-faced brick without hard edges) and *fughe in malta bastarda da 107* (joints of 107 cement mortar), and surmounted by a cast concrete beam *con superficie lavorata a punta* (with bush-hammered surfaces).[51] The goal of the restoration program was to preserve all these details, almost declaring the type of identity that was being materialized (fig. 5.9).

Rebuilding the Pavilion

The degree to which "museum-quality" standards were followed in the restoration work initiated in December 2017 is exemplified in the meticulous cleaning of the brick perimeter wall. The loose surface deposits on the bricks were removed using soft brushes and a vacuum cleaner, followed by mould treatment with an appropriate anti-fungal product selected after taking surface specimens and applied by brush or spray. The treatment was repeated until all accretions had been removed and residual solid particles were scraped off with a scalpel, followed by rinsing with de-ionized water. Once the cleaning operations had been completed, further work to reinforce zones where the surface had been worn down, flaked away, or cracked was undertaken using low-viscosity ethyl silicate or acrylic micro-emulsions tested on samples.[52] While this process effectively removed the patina of time—the temporality of the work—great care was taken to harmonize the hue of the bricks by a specialized painter who made touch-ups to broken edges.

However, the work did not stop with the building envelope; on the contrary, the careful and exhaustive structural survey that had been conducted led to a number of modifications, including the removal of the roof to add bracing beams and make structural reinforcements in response to anti-seismic regulations (see Pertoldeo portfolio).[53] The profile of the roof, covered with Zintek panels, has remained identical to the original, even though a double layer of lagging had to be introduced to provide proper insulation and weatherproofing.[54] To prevent condensation caused by the roof cladding, further insulation was pressure blown between the ceiling proper and a false ceiling made of wooden panels. The false ceiling itself was adapted to integrate electrical wiring, a system of tracks for lighting, and a mechanism for hanging works.[55]

While on the one hand the roof had to be replaced to consolidate the building structure and to meet current regulations, the designer was careful to conserve or replicate as much as possible the other features of the building. The steel frames supporting the glazed panels above the main entrance, in the inner courtyard, and around the interior tree were dismantled. The frames were then repaired, with damaged elements reproduced and replaced when necessary, and reinstalled with shatterproof glass panes without altering the original profiles.

As is well known, the original BBPR pavilion was, in a certain sense, built around the two trees present on the site.[56] The obligation to preserve the trees had major consequences for the building over time. The growth of the internal tree began to impact the glass casing specially designed to enclose it (see Studio Giacomelli portfolio). Alberico Belgiojoso painstakingly worked to find a solution that would maintain the vitrine's original profile while accommodating the tree's future growth. Likewise, the presence of the roots of these two trees began to put pressure on the original Venetian terrazzo floor inside the pavilion. While the entire floor was smoothed and polished, larger cracks that had appeared over the years were carefully repaired with marble chips and grouting.[57] The repaired areas were then touched up by a painter to harmonize the tones of the sixty-year-old floor. The system of brass cylinders inserted into the floor to anchor the supports of display panels was also preserved. To ensure the longevity of the terrazzo, a brick foundation was inserted along the periphery of the inner-courtyard wall. Finally, gaps between the red Verona paving stones outside the entrance and in the courtyard were filled in with approximately twenty "identical" pieces of marble.

The Words of Restoration

From the very beginning of this architectural restoration story, words about the building have played a central role in its definition. The first instance comes before the pavilion was even built. Almost at its inception it was labelled temporary and moveable. This definition has continued to characterize a building that in reality turned out to be much closer to a permanent architectural structure.

Fig. 5.9
Canada Pavilion under restoration, winter 2018.
Photos: Andrea Pertoldeo

Documents—those drawn from the historical record and those produced during the renewal project—enable us to draw together the various strands of the whole project, and they do it on many levels. Written documents produced for the restoration of the Canada Pavilion are riddled with expressions such as "identical," "exactly like the original," "rebuild according to the original design," and "build exactly like the existing ones." It is not difficult to think that the constant change in the relationship between word and thing is connected to strategies of appropriation of the pavilion and is a response to the conflict that evolved between the actors involved.[58] In reality, what appears to be a full-fledged micro-history brings to light another theme that lies at the heart of the current revisionism in the culture of restoring the modern: the constant rethinking of how one should relate to pre-existing things and the difficult relationship between a building's image and what working on site may bring up. And all of this must be engaged without succumbing to the temptation of trying for an eighteenth-century *retour à l'origine*.

In its vacillation between material and immaterial heritage, restoration engenders a form of knowledge that appears to be more than a little indebted to John Dewey, which has recently led to a profound change in the restoration of modern architecture (or at least modern works boasting authorial and iconic status).[59] It is precisely in the present civilization—in which images really "take position," as the art historian Georges Didi-Huberman has put it, and almost constitute a tyranny of values (social, not merely cultural)—that the "revisionism" of a restoration founded on material history comes into play.[60] The knowledge of twentieth-century building sites and building techniques—the *histoire matérielle du bâti* (material history of building)—has come to seem like an almost excessively didactic therapy against the relativism that pervades so many cultural circles in contemporary architecture.[61]

In conclusion, the choice and use of words in the correspondence and in the various project dossiers on the Canada Pavilion deserve to be considered on their own terms. This may help avoid a trivialization of the shifting semantics that occurred over the course of negotiations that led to the

106

restoration. The gradual shifts in language—from the use of the terms "extension/enlargement" and "rebuilding" in the first project dossiers, then to the preference for words such as "upgrading" and "restoration," ending with the almost matter-of-fact "museum-quality restoration"—constitute one of the most interesting and sensitive aspects of the entire affair. The key feature of this operation is the constant change in the language used to define a given action and the legitimization conferred by the individual words.[62] Understanding the complex play of words employed to explain the nature of the work carried out and their subtle change over time is crucial to distancing the object from social practices that exploit a word's immutable meaning to ensure an action's continuity and to maintain control. If one wants to understand not only the expressions associated with the project's transition from an enlargement to a restoration, but also the complexity of the roles and tables on which that game is played, tracking the way words are used and understanding how they come to acquire different meanings is an essential undertaking. In short, paying attention to language is something that now more than ever should be part of the many reflections on restoration.[63]

While the primary goal of the restoration of the Canada Pavilion was to provide a renewed exhibition space for Canadian artists and architects at the Biennale di Venezia, the unfolding of the project could not help but expose the many issues and contradictions that have shaped the field of architectural conservation of the modern. As we have seen, the story of the restoration was immersed in this subtle language game. But it proved to be a challenging and stimulating process, and the result, a newly rebuilt Canada Pavilion, is a compelling example of a restoration that simultaneously fulfills the desires of historic preservation and the needs of twenty-first-century cultural life.

"The Venetians are jealous of every tree":
The Canada Pavilion
and the Giardini della Biennale

Franco Panzini

The Canada Pavilion, like all other national pavilions at the Venice Biennale, is situated within a green area now known as the Giardini della Biennale: a historic park, whose origins date back to the first years of the nineteenth century. After almost sixty years of use, the Canada Pavilion, built between 1957 and 1958 for the National Gallery of Canada, was in need of a major renewal. In addition to restoring the pavilion's architecture and updating its equipment, the Gallery also recognized that the state of the green spaces surrounding the building needed to be assessed and a set of guidelines developed for their revitalization. The initiative was necessary for several reasons: the paving stones at the entrance of the building were in a state of disrepair; there were several depressions in the gravelled areas; and, above all, the surrounding vegetation—primarily spontaneous plants at the rear of the building—had grown out of control, encroaching on the walls of the pavilion and almost completely blocking access to the adjacent green spaces. Since it involved the area external to the pavilion, it was understood that the project would be developed in collaboration with the Servizi Tecnico-Logistici of the Biennale, in a joint team effort between Italy and Canada. In 2016 the commission was entrusted to one of the most influential North American landscape architects of the twentieth century, the Canadian Cornelia Hahn Oberlander, working in association with Bryce Gauthier of the Vancouver firm Enns Gauthier Landscape Architects. Oberlander has been collaborating with the National Gallery of Canada for more than thirty years. During this time, she has created a number of remarkable landscapes both inside and outside the Gallery's building in Ottawa that address the institution, its collections, and its site.

Biophilia
Since the 1970s, Cornelia Hahn Oberlander's work has focused on the conservation and revitalization of natural ecosystems, and on their beneficial effects on people. In fact, Oberlander has become an outspoken proponent of the theories expounded by Edward Osborne Wilson, the American biologist, naturalist, and theorist. Wilson argues that human evolution is deeply influenced by its relationship with other species and with the biotic world in general, and that the human brain is innately drawn to contact with nature to the degree that, in its absence, not only does it not thrive, but actually declines.[1] These principles, which have influenced many North American landscape architects, represent the philosophy behind the revitalization of the space adjacent to the Canada Pavilion. The Canadian

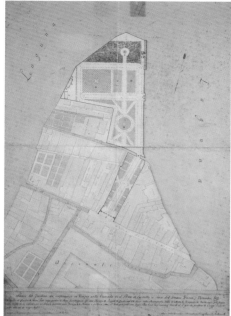

team's first report clearly states: "The Canada Pavilion will introduce the public to nature because, in the words of Wilson in his biophilia hypothesis, *the longing for nature is built into our genes.*"[2]

 The renewal of the open space, encompassing in a unitary landscape the pavilion, the existing tall trees, the shrubs, and the water of the Laguna—as well as the visitors—can be considered a biophilic project insofar as it aims to bridge the gap between the natural world and the built environment. Interestingly, this approach is not dissimilar to the sympathetic inclusion of the pre-existing tall trees of the area in the original project by the designer of the pavilion, the architect Enrico Peressutti of the Milan architectural collaborative Studio BBPR.

Napoleon's Giardini

Napoleon Bonaparte is not a popular figure with the citizens of Venice. In 1797 he decreed the end of the independence of the Republic of Venice and sanctioned the looting of thousands of works of art from the city, which were only partially returned in subsequent years—a fate shared with many other regions of Italy. But the brief period of French domination also benefited Italian cities insofar as it ushered in a fruitful era of new projects—often grandiose and later abandoned—of urban planning and public buildings. Napoleon visited Venice only once, during the last few weeks of 1807. On the celebration of the third anniversary of his imperial coronation on 2 December, he inaugurated the Strada Eugenia (now Via Garibaldi), a wide street in the Castello district built by filling in a canal. There, he announced an ambitious initiative to create a public promenade with walkways and gardens in the vicinity of the new street.

 The task was assigned to the renowned Venetian architect Giannantonio Selva, who, at the same time, was entrusted with the landscape planning project to transform the island of San Michele into a picturesque cemetery.[3] In May 1808 Selva's design for the public promenade was presented to the city's mayor. The site was obtained through the demolition of four religious complexes (fig. 6.1). Selva engineered a subdivision of two areas: a walkway and a public park (fig. 6.2). The rectangular walkway featured a central avenue flanked by holm oaks, with lateral service roads and symmetrical flowerbeds arranged on the two sides. The garden, accessible by a bridge situated at the end of the promenade, was also structured by the juxtaposition of two parts. The first featured a geometrical sequence of large formal flowerbeds; the second, situated at the south end of the garden and embraced by the lagoon, had a more naturalistic character. Built upon the remains of the demolished

Fig. 6.1
Bird's eye view of Venice showing the religious complexes on the future site of the Giardini della Biennale. Detail from Jacopo de' Barbari, *View of Venice*, 1500; woodcut printed by Anton Kolb, Venice, 132.7 × 277.5 cm (sheet). Minneapolis Institute of Art. The John R. Van Derlip Fund (2010.88)

Fig. 6.2
Plan for the public garden in the district of S. Pietro di Castello, Venice, 1807. Giannantonio Selva, architect. Pen, India ink, and watercolour on paper, 100.8 × 67.2 cm. Gabinetto dei Disegni e delle Stampe, Museo Correr, Venice (Cl. III n. 6332)

Fig. 6.3
Clarence Gagnon, *Public Gardens, Venice*, 1905–06. Etching on japan paper, 19.8 × 12.5 cm. National Gallery of Canada, Ottawa (200)

buildings and planted with evergreens, the southern end was conceived as a panoramic viewpoint. A small temple was intended to grace its top area. A little less than a century and a half later, this Romantic lookout among the tall trees would be chosen as the site for the Canada Pavilion. In the report accompanying his project, Selva explained his intentions:

> It would be a pleasant surprise to first enter by the narrow area of San Domenico [by which he meant the promenade], and, after crossing the bridge, to see the second, larger part, with a view to the west of the Laguna; and finally to find the third, [the] largest part, bordered by water, presenting from all sides picturesque views of the scattered islands, and of the green shore beyond the view of the most beautiful part of the city.[4]

The demolition work to clear the site and lay out the garden began in 1809. Pier Antonio Zorzi, a man of letters and an expert in agriculture, undertook the botanical planning. He chose both native species such as boxwood, plane, and linden trees, and exotic plants such as palm trees, magnolias, and Indian bean trees, novelties recently arrived in Europe from the southern United States. In 1812 the work that had essentially followed Selva's plans was complete, although with a slight modification: the temple that should have crowned the summit of the garden was not realized, replaced instead by a temporary pavilion. Despite these improvements, this green space, located in a peripheral zone of the city, was never very popular. Moreover, by the middle of the century the garden's formal design no longer reflected contemporary taste and its transformation began anew. In the 1880s the formal areas were replaced by a sequence of graceful flowerbeds of varying sizes, a change that reflected shifts in decorative taste in garden design that had been evolving in England and mainland Europe since the first half of the century. Of Selva's original plan only the rectilinear walkway and the panoramic outlook on the hill at the end of the gardens remained in place.

The modification of the park took place concurrently with an emerging phenomenon that would substantially alter the city: the beginning of middle-class tourism. Many elements contributed to its development: the railway built in 1861 that connected Venice to the mainland, the first pocket guidebooks, and the fervour of illustrious visitors to publish accounts of their travels.[5] John Ruskin, for instance, visited Venice eleven times between 1835 and 1888, capturing the decline of Venetian architecture in his drawings, watercolours, and daguerreotypes. On these graphic studies he based his three-volume treatise *The Stones of Venice* (1851–53), a work that, even as it highlighted the decay of a city in the midst of a deep crisis, paradoxically increased its allure as a destination for intellectuals and artists.[6] This, in turn, stimulated new initiatives aimed at that particular audience.

One example was the National Art Exhibition, which was inaugurated in May 1887 with great fanfare in the presence of the Italian royal family. The event took place in the southernmost area of the public gardens, along whose serpentine paths a few oddly shaped pavilions had been hastily erected. The event was deemed a success, and the prospect of attracting a stable influx of international cultural tourists encouraged the mayor, Riccardo Selvatico, to propose that an art exhibition be held in the Giardini on a regular basis. This idea took concrete form in 1895 with the first International Art Exhibition, which would henceforth take place every two years, deriving from its recurrence the name with which it became known the world over: the Venice Biennale.

The exhibition was conceived as a gathering of the best international contemporary art, presented not in a large, purpose-built structure like a museum, but rather in pavilions scattered around a public park. Such a unique setting is one of the exhibition's novel features, as well as one of the reasons for its success (fig. 6.3). Starting in 1907, a few countries were given the opportunity to build permanent pavilions on the grounds. The first group was erected before the First World War, with a second wave of construction following between the wars. The presence and location of the major international powers in the original Napoleonic gardens, now known as the Giardini della Biennale, stood as a kind of metaphor of the current geopolitical situation. New pavilions were built with increasing regularity after the Second World War, a period when Italy was eager to dispel its association with Fascism by displaying a new openness toward international culture.[7] Pavilions were constructed by nations that had acquired new importance in the global order; this included Canada. Over the course of the second half of the twentieth century several more structures were erected, and modifications were made to existing ones. Celebrated architects including Carlo Scarpa, Gerrit Rietveld, Alvar Aalto, Sverre Fehn, and James Stirling contributed to the creation of a unique indoor-outdoor environment: a *plein-air* museum of modern architecture set in a historic garden.[8]

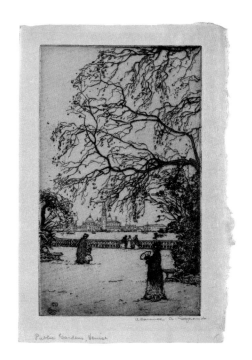

"On condition that the trees are respected"

Designed by Enrico Peressutti of BBPR, the Canada Pavilion is surrounded by the vegetation of the Giardini, and integrates into its interior footprint two large European hackberries (*Celtis australis*), a native Mediterranean species, which were part of the existing landscape. In its very configuration, therefore, the pavilion includes the *genius loci* of the site, expressed through the cohabitation of a historic garden and a building designed for the exhibition of works of art. It was the first of the Biennale pavilions to have adopted this strategy, which became necessary in view of both the shortage of land on which to build and the necessity to preserve the trees. Peressutti's approach subsequently became a point of reference for other projects for the Giardini, starting with the Nordic Pavilion designed by Sverre Fehn in 1958 and built a few years later. In this notable case, the exhibition area, a rectangular hall that makes no clear distinction between indoor and outdoor space, was intended to be in continuity with the pavilion's natural surroundings. The preserved trees that live within its enclosure grow upwards, crossing the structural frame of the roof unhindered.

Such care for the natural environment in relation to architecture was also a consistent feature in the creative approach of the four architects who came together to form Studio BBPR in 1932. One of their earliest projects was the implementation of the regulatory plans for Valle d'Aosta, promoted by the industrialist Adriano Olivetti in 1936. It was the first (albeit partial) landscape planning project in Italy that paid heed to regional morphology and to the enhancement of natural features with a view to attracting tourism. A concern for connecting architecture with site quickly became standard within the young firm's work. During the Second World War, *Domus* magazine organized an informal competition for architects, inviting them to design their ideal home without restrictions on place, dimensions, or cost. Submitting individual projects, all four BBPR partners succeeded in getting their projects published in the magazine in 1942.[9] The common element that united their designs was the immersion of the house within a natural environment. Lodovico Belgiojoso placed his building in an alpine setting surrounded by mountains; Ernesto Rogers's house was placed on hills covered in multicoloured vegetation; Gian Luigi Banfi created a mobile home tethered to trees. For his project, Peressutti chose a space with "the horizon, the sky, the sea, the earth, green space, some rocks."[10] He also incorporated nature into the house's interior by way of two cubes, one made of crystal, the other of aluminum. He described: "In the first I framed a rock from the landscape, a sculpted rock that had been turned into an architectural element, and from which I obtained the staircase and the fireplace" (fig. 6.4).[11] BBPR's focus on creating architecture in dialogue with the environment was galvanized by their collaboration with landscape architects: starting in 1952, Pietro Porcinai—the most celebrated Italian landscape architect of the twentieth century—was regularly involved in their projects.[12]

The sensitivity shown by BBPR toward the natural landscape was a significant asset for the Canada Pavilion project. Not long after the Canadian government had given permission to proceed and Peressutti had been formally offered the commission in December 1955, the project encountered serious obstacles.[13] At the end of January 1956, Rodolfo Pallucchini, a historian of Venetian Renaissance art, who was then the General Secretary of the Biennale, wrote to Alan Jarvis, the Gallery's polymath Director, to congratulate him on the decision to go ahead with the project. At the same time, however, Pallucchini expressed his concern about finding the right location for the pavilion within a treed park that was becoming overcrowded with buildings. "We are in great difficulty in finding spaces for new buildings," he wrote. "The only zone available for building [. . .] is a small wood on an elevated spot between the Czechoslovak, the United States and the Israel Pavilions."[14] Asked by his clients to verify the suitability of the site, Peressutti visited the gardens twice in the following months, the first time during a snowfall. "It was cold and snowing I think as in Canada," he wrote to Donald W. Buchanan, the Gallery's Associate Director, who was in charge of the project.[15] As well as the site initially suggested, the architect also considered a second one that he and Pallucchini had located between the pavilions of Great Britain and Germany, at the top of the Montagnola di Sant'Antonio, the hill created out of the rubble of buildings demolished to create the Napoleonic gardens. Peressutti thought this area to be the most suitable since it was connected to one of the main pathways of the park and offered a "wider horizon on the background of the pavilion looking toward the Laguna."[16] Along with his letter he enclosed a plan with the hypothetical pavilion positioned on the two different sites, both densely populated by trees (fig. 6.5). In the end, it was Jarvis who made the final decision during his visit to Venice for the opening of the Biennale on 14 June 1956. Following Peressutti's advice, he chose the second option, even though it appeared

Fig. 6.4
Perspective for *casa ideale* competition sponsored by *Domus*, 1942. Drawing: Enrico Peressutti. Reproduced in *Domus*, no. 176 (August 1942), p. 313

more problematic than the first in view of its dense vegetation. Peressutti and his team started working, but soon the project faced intense scrutiny by the public works department of the Comune di Venezia. In an October 1956 letter to Buchanan, Peressutti wrote: "They are jealous of every tree and afraid of how it will look from the Laguna" (fig. 6.6).[17]

 The problem Peressutti was confronting faced virtually every new project on the Biennale grounds. Although the gardens were managed by the Biennale administration, the land itself was owned by the city, and it was officials from the latter who were in charge of approving new projects. In the case of the Canada Pavilion, that responsibility was carried out with a certain degree of recalcitrance, with an eye to preserving the existing trees. Months went by without a decision being made. With the Canadian government's authorization to disburse funds for construction set to expire at the end of the tax year (31 March 1957), Pierre Dupuy, the Canadian ambassador to Italy, tried to speed up the project by writing directly to the mayor of Venice in early February.[18] Only at the last possible moment—on 26 March—did Mayor Roberto Tognazzi inform the ambassador that the committee had approved the project, but on two conditions: "that all the load-bearing structures be so constructed as to be easily dismantled at a future date [. . .], and on condition that the trees are respected."[19] Peressutti had no hesitation in fulfilling this last request. The pavilion incorporates two tall trees that shade the full-height windows of the inner courtyard with their foliage. These natural elements, together with the frank expression of the modern architectural materials, strongly contribute to the rustic vigour and archaic character that make the building unique. It is precisely the presence of the enclosed trees, together with the configuration of the building, that have encouraged the reading of the pavilion's form as an evocation of the traditional dwellings of Indigenous peoples of North America. This interpretation, which emerged soon after the building's inauguration, has been reiterated ever since.[20]

Renewing the Landscape: "A Canadian approach"

Over the sixty years that have passed since the pavilion was completed, the trees around the building have grown and there has been a remarkable overgrowth of the spontaneous vegetation along the slope that descends toward the lagoon.[21] To remedy the site's degradation, the Canadian team led by Cornelia Hahn Oberlander with Enns Gauthier Landscape Architects developed a strategy to draw out the special geographical position of the pavilion and visually reconnect the open space behind it with the vast views toward the Laguna. The goal was to return the hill to a state that evoked Selva's original concept: a panoramic viewpoint built on the ruins of the demolished monasteries. The project

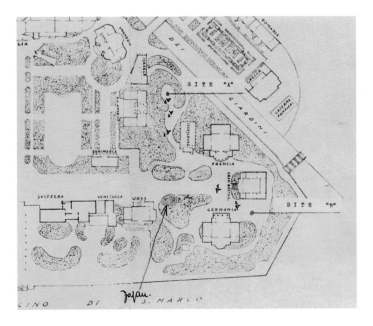

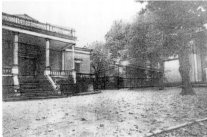

Fig. 6.5 (far left)
Annotated plan of the Giardini della Biennale showing building sites "A" and "B" for the Canada Pavilion, c. March 1956. Studio BBPR. NGC Library and Archives, Ottawa

Fig. 6.6 (left, top and bottom)
Photomontages showing the proposed Canada Pavilion in relation to the British and German Pavilions and from the Laguna, after 26 September 1956. Studio BBPR. Archive of the Embassy of Canada in Rome

was developed in two phases: in 2016 a concept plan for the entire area between the German and Canadian pavilions was produced (fig. 6.7); and in early 2018 design guidelines specifically detailing the plans for the green area surrounding the Canada Pavilion were introduced. The overall concept was expressed in these terms:

> While it is understood that the land around the Canadian Pavilion is managed by the Biennale authorities, our design suggests a Canadian approach could solve many of the issues that the grounds struggle with, namely an overgrown landscape that hinders views between the canal, the sea wall, and the adjacent biennale site. [. . .] The main design element will be a deck system raised above a planting of low growing grasses carefully selected to maintain a consistent form that needs to be mowed only once a year. The low height of the planting will allow unobstructed views through the [proposed] sculpture garden and to the canal and water beyond, creating the opportunity for a greater connection and dialogue between these spaces. We propose a simple landscape of grass meadows, berms, and stone, reminiscent of the vast open spaces of Canada—the untrodden wildness the Europeans first encountered when they came to our country.[22]

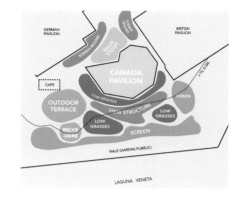

The proposal's underlying philosophy, therefore, emphasized the landscape aspect of the Canada Pavilion by eliminating the visual obstructions created by the wild vegetation to the view toward the water. This opening, the landscape team proposed, would offer visitors the chance to discover a vista that evoked, in its vastness, the character of the natural spaces of Canada.

The project also intended to imbue the more casual open spaces around the pavilion with a greater continuity and sense of identity. Oberlander proposed to create a sort of entry point toward the Canada Pavilion through the addition of a pair of symmetrical, man-made hummocks covered in low plantings. These elements were intended to act as a kind of doorway to the building and the plaza in front of it, an area that would also include two long benches. This open space would continue along the eastern side of the pavilion, join the external area of a café at the rear of the German Pavilion, and then slope down toward a small existing belvedere overlooking the canals. The open space behind the pavilion was to be encircled by a raised wooden deck—a panoramic viewpoint with seating—designed for the enjoyment of the vista (fig. 6.8). The connecting boardwalk was the object of considerable attention. Several schemes were considered before the team arrived

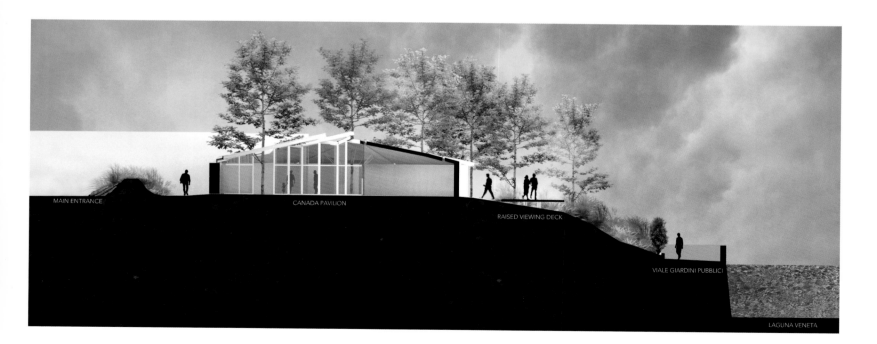

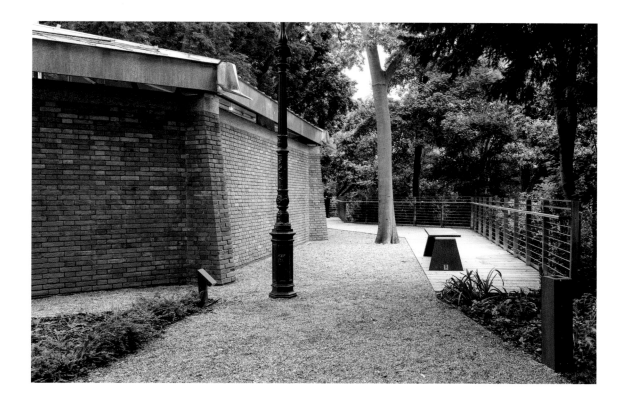

at a definitive solution consisting of a path adapted to the morphology of the terrain that respected the existing trees. For the hillside sloping down toward the lagoon, the Canadian team proposed that the main trees be preserved, but that the overgrown spontaneous vegetation be replaced with low-growing species, primarily grasses, to ensure an unobstructed view. The underlying principle of the whole reorganization of the open space around the pavilion was that it should be reconceived as an outside exhibition area. The trees on the slope would be equipped with hammocks to create a relaxation zone. It was not the first time the idea of extending the exhibition space at the rear of the pavilion had been raised. In August 1968, in preparation for the next Biennale, Canadian curators proposed to solve the problem of limited space by inserting a paved stone area behind the pavilion, which would be accessed through a new door in the outside wall.[23] The project went no further.

If the Canadian team's proposals for the entrance to the pavilion and the redefinition of the area behind it as a sculpture garden were not accepted by the Biennale authorities, their ideas for making the space more accessible to visitors were better received. In fact, Oberlander and Gauthier's plan for the area corresponded with a project the Biennale was working on at the time—the creation of a promenade behind the pavilions—and helped define the layout of what became the definitive scheme: a sequence of gravelled areas and raised wooden planks.[24] The construction of the elevated platform was particularly delicate. The work was done using only compressed-air excavators, which greatly reduces the possibility of damaging tree roots, and the metal frames supporting the wooden planks were installed with plates anchored to small posts rather than cement plinths. Completed in 2017, the panoramic boardwalk quickly became a favourite feature with visitors (fig. 6.9).

The overall intervention behind the pavilion preserved all of the existing trees, maintained the screen made up by the low vegetation—shrubs and grasses (most of which were replaced)—and inserted small posts to help stabilize the slope. Once the viewing platform was completed, new decorative plants (acanthus, vinca, pittosporum, viburnum, etc.) were planted. The purpose of this dense vegetation was to conceal an additional railing along the edge of the site, which was installed to improve security. The outcome of the initial stage of the upgrading operation is summarized in the introduction to Oberlander and Gauthier's 2018 design guidelines: "The first phase of our work

Fig. 6.7 (opposite page, top)
Diagrammatic plan for the proposed landscape rehabilitation, July 2016. Cornelia Hahn Oberlander with Enns Gauthier Landscape Architects

Fig. 6.8 (opposite page, bottom)
Section for the proposed landscape rehabilitation, July 2016. Cornelia Hahn Oberlander with Enns Gauthier Landscape Architects

Fig. 6.9 (above)
Raised deck behind the Canada Pavilion, May 2018. Photo: Andrea Pertoldeo

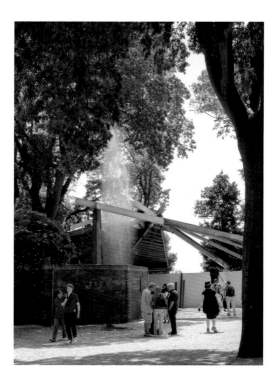

together saw the dramatic transformation of the overgrown area immediately surrounding the Canada, German, and British Pavilions, which achieved a beautified landscape, improved visitor access and circulation, [and opened] spectacular views; improved seating and circulations in and around the pavilions."[25]

The second set of plans finalized in early 2018 included details for the finishes of the board-walk and the restoration of the spaces surrounding the pavilion. After extensive consultation, the designers chose to restore the access area in front of the building to its original configuration: a chessboard arrangement of red Verona flagstones that mark the entrance. The only new element introduced to this area is a concrete block bench, which was placed to one side of the entrance; it also helps to divert the rainwater that, given the natural incline of the terrain, would otherwise pour toward the pavilion.

Roots

The topography of the Giardini della Biennale, as it appears today, has been shaped by the progressive erosion of the original garden layout caused by new constructions. It is also a symptom of the imbalance between the increasing pressure to erect new pavilions or to expand existing ones, and the limited space available. In response to the relentless reduction of space dedicated to green areas, a series of regulatory measures prohibiting any further building on the grounds of the Giardini was adopted in 1985.[26] Furthermore, in 1998 many of the pavilions deemed to be "historic" were placed under heritage protection, thus crystallizing the existing situation. To assuage the disappointment of countries that had applied for exhibition space, in more recent years areas outside of the Giardini have been offered, which has effectively broadened the scope of the Biennale throughout Venice.

However, even maintaining the existing state of affairs requires active management. This is complicated by the administrative structure peculiar to the Giardini, a location that embraces the ideal of an international territory of artistic expression that is by definition without borders, but where boundaries are delineated by the repercussions of the administrative situation on the ground. It is important to remember that the countries that own pavilions have only a temporary lease of the land

Fig. 6.10
Geoffrey Farmer: A way out of the mirror, Canada Pavilion, LVII Biennale Arte di Venezia, 2017. Kitty Scott, curator. Photo: Francesco Barasciutti

Fig. 6.11
Excavation in the courtyard of the Canada Pavilion, winter 2017. Photo: Enns Gauthier Landscape Architects

on which their buildings stand. Lease agreements do not extend to any of the surrounding areas. This rule has made it possible to add new buildings in the interstitial spaces between existing pavilions. This is precisely what happened in the case of the Canada Pavilion, which was inserted between the pre-existing and much larger British and German ones. However, as far as the surrounding areas are concerned, all maintenance work, including emergency interventions, is handled directly by the Venice Biennale, which also acts as an intermediary between the various national delegations. The Comune di Venezia, the owner of the Giardini, and the Soprintendenza Archeologia, Belle Arti e Paesaggio per il Comune di Venezia e Laguna, a national body responsible for historical and landscape heritage, have jurisdiction over any physical modifications to the green space and the buildings.[27] Any proposed alteration outside of the pavilions—whether temporary or long-term—is carefully assessed by special committees, whose task is to be mindful of preserving the peaceful status quo that upholds this ideal domain teeming with international protagonists and yet without clear national demarcations. Through its executive decisions, the Biennale must strike a delicate balance between the different requests of curators and those of the individual national pavilions in order to keep a homogeneous environment, and to preserve equal terms among all participants. Trees, of course, pay no heed to this intricate network of diplomacy; their branches and extensive root systems freely cross the spaces allocated to the various nations, offering their own example of a supra-national integration.

The 2017 edition of the Art Biennale was officially attended by 615,000 visitors. To this already astronomical number the guests present at the individual opening events, the technicians and workers that crowd the grounds during the preparatory phases of the event, and staff must be added. Each edition of the Art and Architecture Biennales attracts a larger audience. Growth has created new problems, such as the damaging pressure on the tree roots underneath the traffic areas and on the open green spaces, now trodden by the hundreds of thousands of visitors who flock to the exhibitions each year. Equally detrimental are the concentrated loads of machinery that transport artwork and materials, some of which can weigh over a ton. This situation places the vegetation in a state of permanent stress, particularly the oldest generation, whose environment has constantly deteriorated. On top of these factors, in recent decades art exhibitions everywhere have moved toward complex multimedia installations. This is, of course, true of the Biennale, where successful installations have modified either the use or the perception of pavilions, immersing visitors in sensory and emotionally charged experiences. Such installations, unfortunately, often interfere with the tree roots around the buildings, or even require excavation, a practice that is enormously detrimental to the root systems underneath and around the foundations of the pavilions. Paradoxically, the very success of the Biennale harms the unique setting to which it owes a great deal of its popularity. In response to these issues, the Biennale now takes an active role in the management of the green areas surrounding the pavilions, which are considered significant elements in their own right, through a sophisticated system of oversight that considers the health of the vegetation in the development of new projects.

An episode involving the Canadian presentation at the 2017 Art Biennale illustrates the potential areas of contention in the Giardini between the interests of art versus those of the trees. Geoffrey Farmer, the artist chosen to represent Canada, created an installation titled *A way out of the mirror* (fig. 6.10, see also fig. 4.13). The artist put to good use the setting of the pavilion, which had already been partly dismantled for its restoration, adding sculptural elements that represented personal traumas and national dysfunctions. The installation included a fountain that sent a jet of water spraying upwards, surprising visitors, and cooling the hot summer air; it was considered one of the best installations that year. Its realization, however, had unexpected and unfortunate consequences: the excavation work to inter the fountain and its large water tank exposed the roots of the large European hackberries growing within the pavilion and immediately outside of its brick precinct walls (fig. 6.11). Recognizing that continuing the work would further disturb the roots and even endanger the survival of the trees, the Biennale's technical department halted construction to assess the situation. Only after the implementation of safety measures to protect the roots and other appropriate changes to the project were made was work allowed to resume. The lesions on the roots were disinfected, the exposed roots were wrapped in a protective material that was kept at a constant state of humidity, and the fountain was redesigned and repositioned. This incident drew attention to the restrictions inherent in the site. It also impacted how the new below-ground climate-control system was installed during the pavilion's restoration.

Fig. 6.12
Cornelia Hahn Oberlander in the Taiga Garden of the National Gallery of Canada, Ottawa, 1987.
Photo: *Ottawa Citizen*

A Found Landscape

Although the Italian and Canadian teams initially disagreed over the selection of the plants that would cover the slope facing the lagoon following the area's refurbishment, the issue was eventually settled amicably. The most contentious question focused on whether to use plants already present in the garden, to return to historically documented specimens, or to introduce new species better suited to withstand future climatic changes. The Canadian team advocated the third option. The Italian approach to the restoration of historic gardens unhesitatingly leaned toward the internationally recognized Florence Charter, compiled in 1981 by a joint committee of representatives of the International Council on Monuments and Sites (ICOMOS) and the International Federation of Landscape Architects (IFLA). In its discussion of maintenance and conservation, the charter states that botanical species "must be selected with regard for established and recognised practice [. . .], and with the aim to determine the species initially grown and to preserve them."[28] Some North American specialists and landscape architects question the wisdom of this statement, deeming it outdated. Robert Melnick, an expert in the conservation of historic landscapes, summarized the new approach: "Does it matter more, in preservation terms, that a landscape retains the exact tree genus and species or that the spatial and visual consequences of those trees are maintained? Would it be better to plant replacement trees that are more resistant to warming, or to re-plant trees that will not survive their twenty-first-century environment?"[29] Oberlander agrees with this view, and has given a concrete example of its practice not only in the Canada Pavilion project, but also throughout her professional life—for instance, in the restoration of the garden she conceived for the Friedman Residence in Vancouver. The house, which was designed by the architect Frederic Lasserre and completed in 1953, is considered a leading example of the modern design principles that became fashionable in Vancouver in the early post-war period. "The garden was among the first Canadian projects of a landscape architect soon to become a leader in the profession," recalls Ron William in his monumental history of landscape architecture in Canada.[30] In 2011 the building underwent a careful and extensive renovation. While the structural refurbishment followed the original architectural design and progressed without problem, the revitalization of the garden posed the question as to whether it was best to replant the same species used in the 1950s. In the end, Oberlander decided that changes in Vancouver's climate in the intervening decades demanded the introduction of more adaptable species. As Susan Harrington wrote in an essay on this project:

> According to Oberlander, bloom times are earlier and overlapping in the twenty-first century, and the year when the restoration project was completed was the hottest summer in Vancouver since 1890. Many of the original plant varieties were no longer available at nurseries, and some of the original plants struggled to survive in the changing climate. [. . .] In an interview, she noted, "Now that we know that we are living in the age of the Anthropocene, we must structure our gardens to survive. No storms will kill my plants, no unexpected frost will kill my plants, and no drought will kill my plants."[31]

If the subject is still in its infancy and in need of further exploration, future debates about and theoretical approaches to landscape restoration will undoubtedly take climate change into consideration. The first taste of such a deliberation in Venice around the Canada Pavilion project of landscape renewal has confirmed the fact that the Biennale is a place for the pursuit of research.

A second lesson can also be taken from the project. A characteristic feature of many of Oberlander's projects is that they often highlight landscape features that are present in the site but hidden from view. Such was the case for the garden she designed for the entrance to the National Gallery of Canada in Ottawa (fig. 6.12). The Taiga Garden's large granite rocks and the vegetation that thrives among them often surprises visitors. An intriguing aspect of the project is that the rocks were not added to the landscape, but were part of the original terrain, covered by soil. Soon after the project's completion in 1988 Oberlander observed: "It was a found landscape. I discovered when digging for soil depth that the area was covered with flat rocks, so I exposed them and repositioned others—some weighing as much a ten tons—that had been excavated during the construction."[32]

The revitalization of the landscape for the Canada Pavilion works on a similar premise: it enhances the characteristics of the environment present in the site that over the years have been lost, buried by carelessness and weeds (fig. 6.13). These features were brought back to life by this intervention in the Giardini della Biennale, which is a lesson in the art of landscape architecture.

Fig. 6.13
Rear of the Canada Pavilion, May 2018.
Photo: Franco Panzini

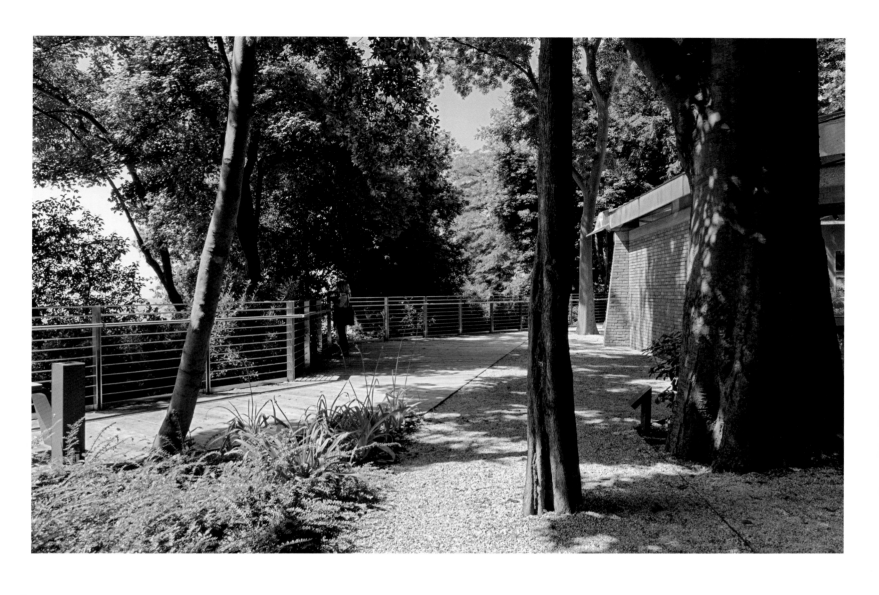

123

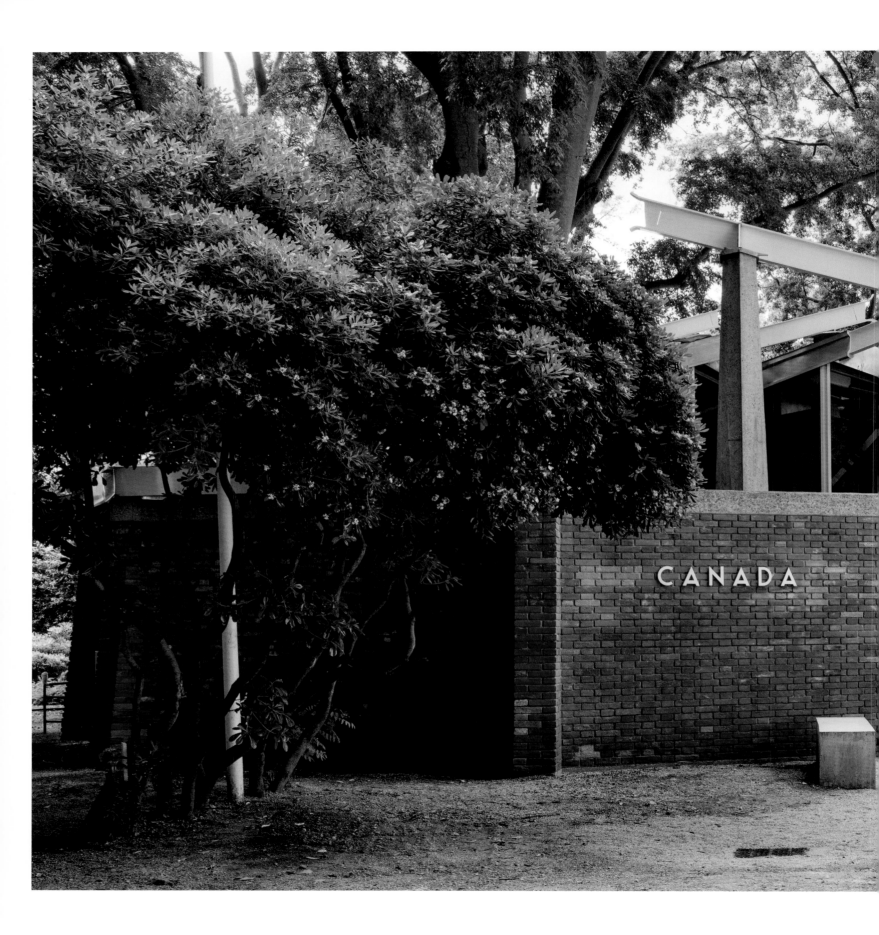

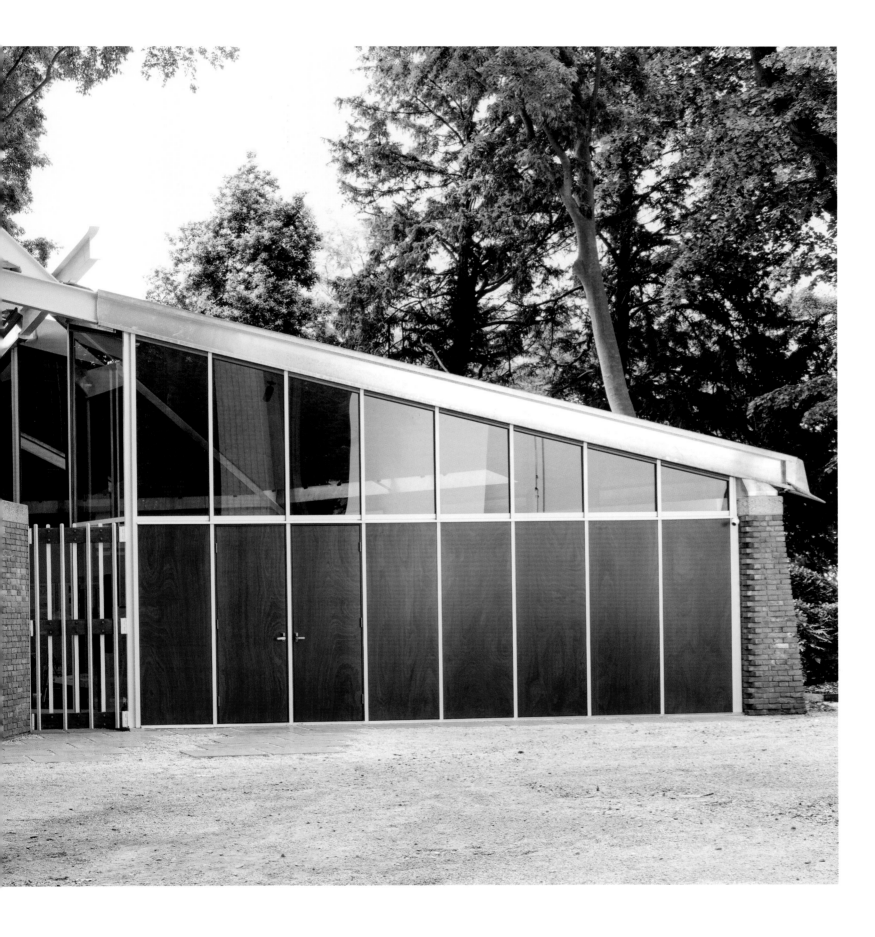

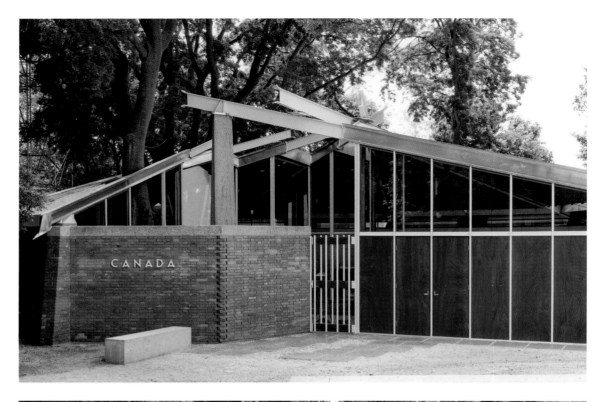

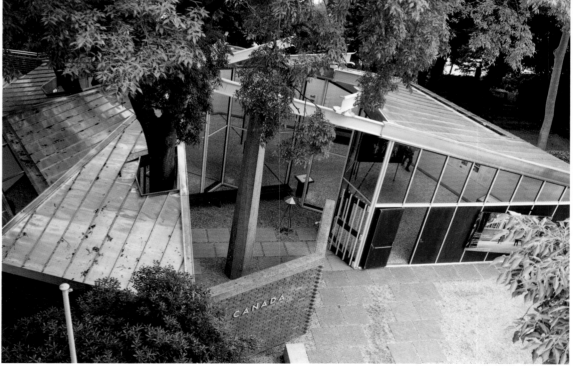

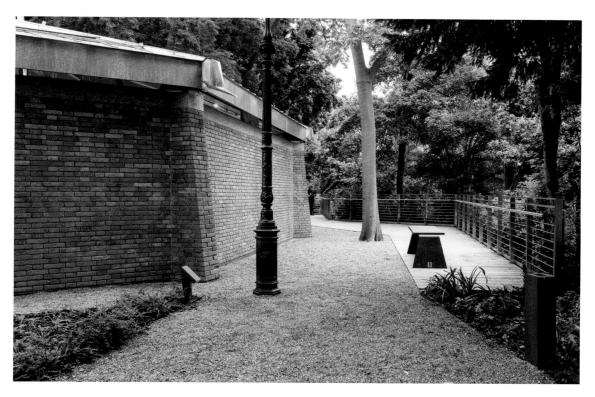

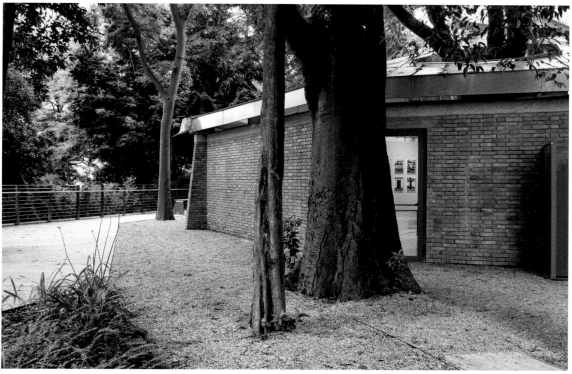

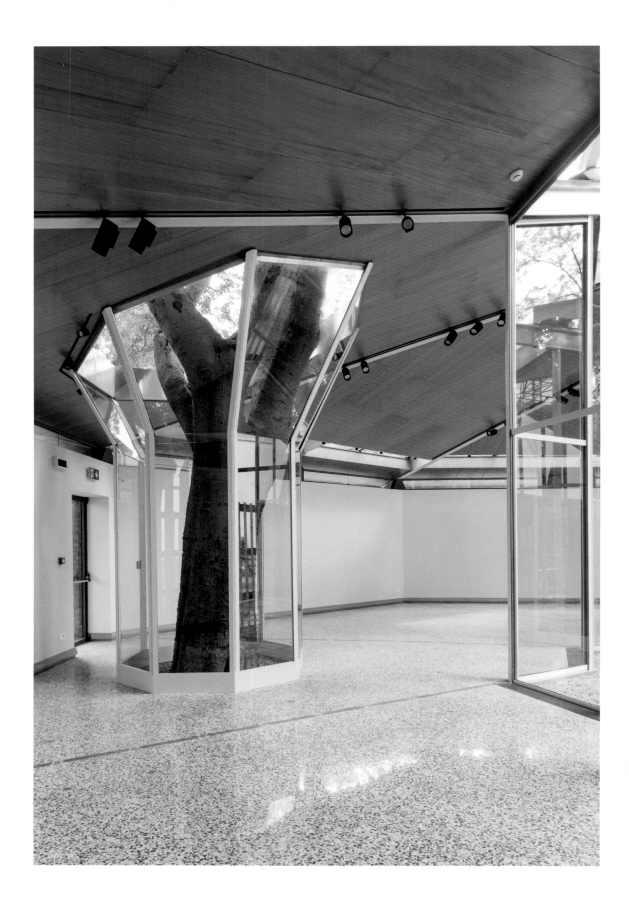

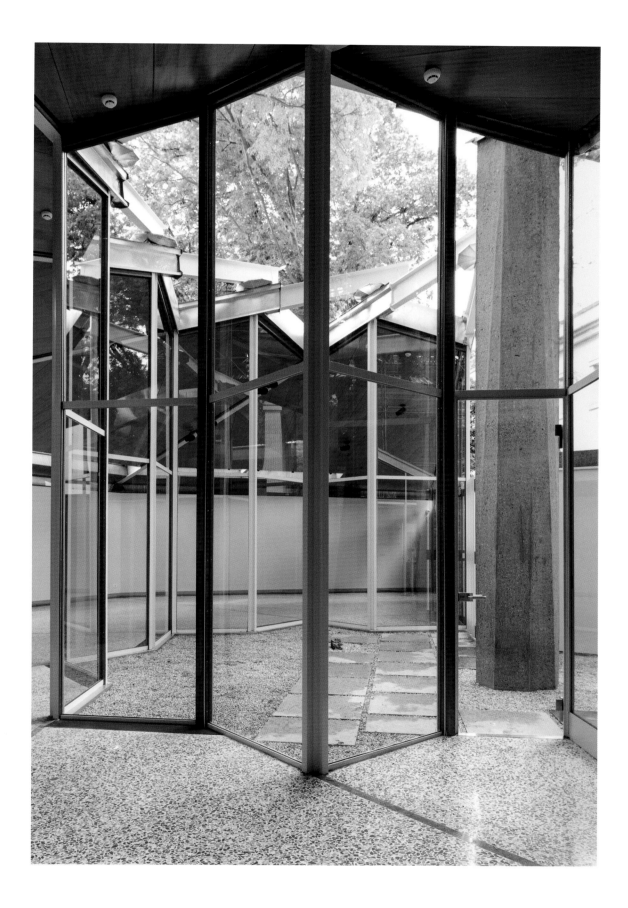

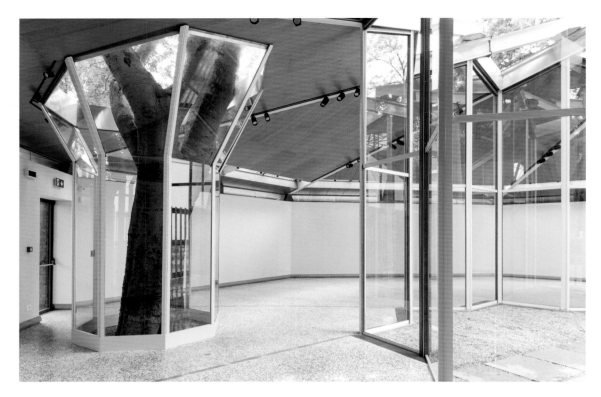

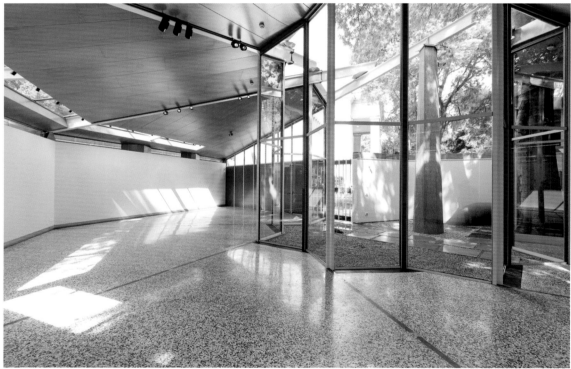

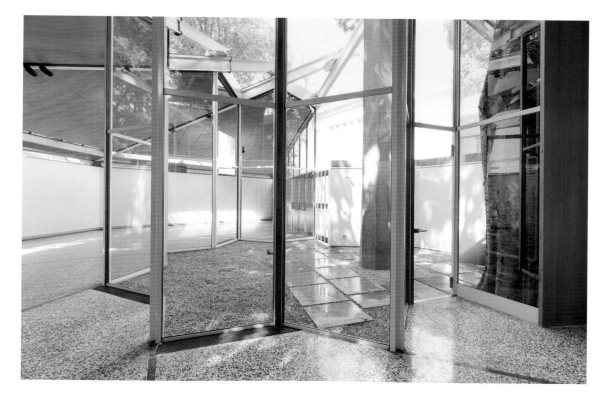

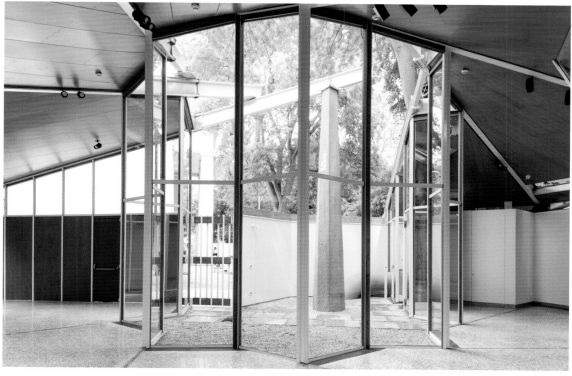

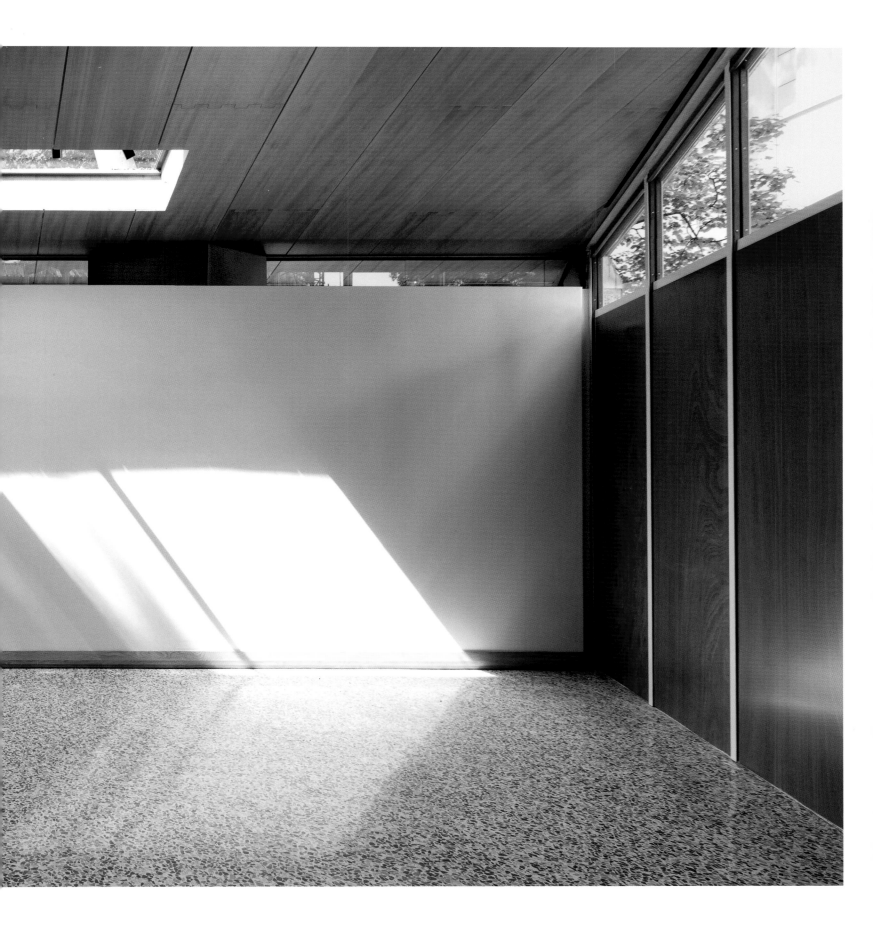

Interview with Alberico Belgiojoso

In 2013 the National Gallery of Canada appointed Alberico Barbiano di Belgiojoso of Studio Belgiojoso (Milan) as architect for the renewal of the Canada Pavilion at the Venice Biennale. Belgiojoso is the heir of Studio BBPR, the firm hired in December 1955 to lead the project for the design and construction of the Canada Pavilion.

The following text is an excerpt from an interview in Italian conducted by Réjean Legault, assisted by a team from the National Film Board of Canada in Belgiojoso's Milan studio on 27 February 2018.

Q

Were you familiar with the Canada Pavilion when the National Gallery approached you to work on its extension and then on its restoration?

A

I knew a lot about the Canada Pavilion, because I saw it develop during my childhood and because it has always been considered an important and singular work by Studio BBPR from Milan. I had also visited it several times, giving guided tours to friends and acquaintances. Therefore, I knew the issues surrounding the building very well.

What was your first impression of the architecture of the pavilion?

It is quite a special building because it takes into account different constraints and conditions. Firstly, being positioned between two super-monumental pavilions—the pavilions of Great Britain and Germany—its anti-monumentality is interesting. Apart from this physical closeness, this location was also symbolic, for it placed Canada between two enemies of the Second World War—a war in which Canada also fought. This rejection of monumentality was no doubt a deliberate choice, most likely sought by both the client and the architects. And Enrico Peressutti, the member of Studio BBPR who had analyzed the project in depth, had fully adopted this approach.

The building also seems to make reference to Indigenous dwellings of North America. One can sense it in the conical shape of the pavilion as well as the beams sticking out of the roof. But what is most interesting is how this original inspiration was formalized into the famous spiral of Archimedes, with a geometric shape that was studied with great rigour. What is interesting, therefore, is how the project, which maybe started from a nongeometric model, slowly became very geometrical.

Can you talk about the principles that guided the design of the pavilion?

For BBPR, constructive logic has always been very important. The origin of a project, its inspiration, can come from many sources, like Canada's position compared to the two other pavilions or the idea of designing this building with the spiral. But once this has been decided, then the constructional logic is always very strict. It is well known in the Modern Movement that form follows function. This is not always true, of course. But it is a principle that had great import in architectural theory, and in BBPR's work. This is because the Modern Movement needed to innovate the architectural language with respect to the traditions of the nineteenth century and of historicist styles. And one of the ways to innovate was to represent constructive logic as precisely as possible.

Then there was the question of the *preesistenze ambientale*, that is, the necessity to take into consideration the preexisting environmental conditions or context, which complexified everything. It is the same consideration that was applied to the project for the Torre Velasca (1950–58) in Milan, and to many other projects by BBPR.

We know that Enrico Peressutti was the main designer of the project. Did every project have to be examined and approved by the three BBPR partners?

Yes, indeed. This collaboration was always strongly nurtured. That is, nothing went forward before being approved by the partners. Some projects were taken care of by some people more than others, but the control was strict. They argued a lot in the sense that everyone had to truly accept the solutions before they were shared. And this improved the ideas. I personally witnessed this process. One thing that often happened was that sometimes, when they were quite close to the conclusion, the project was changed, driving the collaborators crazy. But because the improvement was, let's say, obvious, they would all understand and agree. A project by BBPR was always a collective project.

Building in Venice was—and still is—very challenging. Was it the first time BBPR was involved with a Venetian project?

Indeed, building in Venice is always an interesting challenge for an architect. And BBPR had once before been involved in Venice. Around 1951, they did some exploratory design work for the palazzo of the Peggy Guggenheim Collection on the Grand Canal. As you know, the building is an eighteenth-century palazzo that had only been built to the ground-floor level. So the project, led by Peressutti, was to create an additional floor for an exhibition space with a large transparent glass wall that overlooked the Grand Canal. Unfortunately, it was never realized. Aside from the Canada Pavilion, BBPR never did another project in Venice.

Could you explain
the structural logic
of the pavilion?

The structure of the pavilion is quite exceptional. It comes from this idea of the wooden poles that are lashed together and that emerge from the Indigenous tent. Now made of steel, the poles are turned into overlapping beams that crisscross over the courtyard to support the roof of the pavilion. The first beam, which holds the whole structure, leans above the entrance to reach a central concrete pillar in the courtyard. According to this structural logic, each beam rests on the next one. At the other end, the beams rest on the perimeter wall, which is separated from the roof by horizontal glass panes. The roof of the building is thus detached from the perimeter wall. This sequence of beams crisscrosses playfully over the courtyard. And the beams are terminated with a kind of ornamental curl that is very visible from the inside as well as from the outside over the roof.

Inside the pavilion, the beams play a major role, defining the triangular sections that set the character of the interior space. Moreover, as the beams rest one on top of the other, the ceiling must follow them, what we call warping, so it's not a flat surface but a rotating surface. It embellishes the interior—but it drove the carpenters crazy when they had to redo it! One of the consequences of this structural design is that the glass walls that open into the inner courtyard have a zigzag pattern since they follow the crisscrossing of the beams. So the result of this constructional—but also technical—logic is a very rich architectural design.

How do you see
the role of the trees
in this project?

The trees can certainly be considered the main "protagonists" of this architectural scene. This is especially true in the relation between the central pillar of reinforced concrete and the two natural trees, one inside and one outside. So there are three vertical elements: one free column in the courtyard, and two encased trees. In effect, the interior space has this beautiful glass funnel, with the tree in the middle of it. So all the exhibits are shown in the presence of the tree that animates the space.

Could you talk about the first phase of the project, which entailed extending the existing building?

The National Gallery first approached me to conceive a project to extend the pavilion. The building is quite small compared to the other pavilions around it, and its expansion seemed quite justified. But of course, given the limited space between the pavilions, the only way to expand was to go underground. This option was considered by the Soprintendenza Archeologia, Belle Arti e Paesaggio per il Comune di Venezia e Laguna and the Biennale. We did several studies to explore the various possibilities. And since we were dealing with four entities, that is, the National Gallery of Canada, the Biennale, the Soprintendenza, and the Comune di Venezia, we always presented more than one solution to have comments and feedback from all the institutions, toward the goal of finding the one solution that would satisfy everyone.

At the beginning, we considered the underground space toward the lagoon. We were on a hill—that is, a slightly elevated space—so all the problems that usually exist in making a basement in Venice, such as high water level, humidity, etc., were minor. So it appeared to be possible. We also studied the possibility of extending on the side toward the German Pavilion. We also thought that since the Biennale usually provides a small bar kiosk for visitors behind the pavilion, this extension could also be used by the Biennale for technical amenities like storage, water connections, electricity, etc. Another option we considered was to build an extension under the existing pavilion. These different options raised the question of the entrances. Given that the current interior above ground and the basement would have had to be connected, there had to be a staircase and also an elevator. And, of course, both would have sacrificed the floor and the existing interior space of the pavilion. Another interesting option we studied was to work with the levels so that the basement could have created a terrace between the pavilion and the lagoon on the backside. Naturally, it would have become more visible than if it had been completely underground. So, as you see, there were various propositions to make a fairly large space, much bigger than the current one. And all of them were beautiful and technically feasible solutions.

But then a change of leadership at the Soprintendenza created a new context. The new representative felt that the Ministero dei Beni e delle Attività Culturali e del Turismo had to be consulted before going forward with an extension. A large committee was put together to study the file. I explained the project and tried to convince the members of its appropriateness, but in the end the committee decided against the excavation for the basement. It suggested instead that Canada use the outside space on the side for temporary pavilions for the presentation of exhibitions. This proposition, which was clearer and very feasible, was consistent with the initial idea. However, this proposition was also rejected by some of the institutions involved. In the end, the only solution left to the National Gallery was to carry out a restoration of the existing building, with the option that, when necessary, it would be able to place part of its exhibitions on the outside of the pavilion.

Was this your first restoration of a BBPR building?

The issue of restoring BBPR's work was not new to me. When a building has reached the age of fifty years, it usually requires some kind of intervention. Moreover, buildings must change to accommodate new users and new needs. As everyone knows, architecture is made for a certain time, for a certain use. Which raises the issue of transformation or sometimes restoration.

I had worked on the restoration of other BBPR projects. A fairly important case is the Torre Velasca (1950–58, restored 2009–12) in Milan, which is obviously much bigger than the Canada Pavilion. For the pavilion, we were fortunate to be within the time frame of fifty years adopted by the ministry of cultural heritage, which gave the building a protected status. This happened just a year before changes in the legislation, which moved the prerequisite to seventy years. Because the protection of the pavilion was put in place shortly before this change, every intervention required the Soprintendenza's approval.

What was the physical state of the pavilion before the restoration work?

The state of the pavilion was not that bad, but there were some issues. The roof had a water leak and there was some swelling in the ceiling. There was some swelling in the floor as well, mainly because of the roots of the tree. Since nature usually wins over architecture, the tree roots were pushing up the terrazzo, creating a very visible crack.

Moreover, the metal structures of the window frames, which were partly made of steel and partly made of zinc, had begun to rust at certain points. This was especially evident in the lower parts of the window frames, where the insulation from the water was not complete. In spite of these problems, the building was still functional. But it was time to restore it.

What was the central idea guiding your restoration project?

The basic idea was always to preserve the original fabric of the building as much as possible, in the sense that, in a building of this type—small but extremely well conceived and constructed both in its structure and its materiality—every detail is fundamental. Our concern for the original building was shared by officials at the National Gallery, who wanted to stay as close to the original concept as possible. Then, of course, there was the problem of technical adaptation and upgrades. We tried to answer these new requirements—in constant dialogue with the officials at National Gallery—without changing the building.

One of the main restoration issues had to do with the repair of the glass window walls in the courtyard that were a bit rusted and cracked. We did all we could to keep the original elements. When it was not possible, we changed certain parts but kept the exact same shape, with invisible welding. Another demanding issue was the air conditioning. Venice has a very difficult climate; it is at times very humid and at times very cold, even in the seasons when there are exhibits. Cold and wet together, it's worse than in Milan! That is why air conditioning became mandatory, which required a lot of thinking and a lot of studies to accommodate it in the tight space of the pavilion.

Q	A

Did the state of the trees inside the building create any challenges to the restoration?

Regarding the trees, there is also a problem, of course, which is that of the wind. The "interior" tree has grown a lot; it is now about three times higher than the pavilion. Therefore, the movement of the wind has a certain effect, even on the inside of the pavilion. We talked about pruning it, but for now we avoided doing any cutting. And then we noticed that this tree is protected by other trees so that the movement of the wind is reduced as long as the other trees remain there. So these trees had a great effect on the project.

Indeed, the relationship between the architecture and the trees raised a very difficult and very interesting problem. It is an interesting problem because over time the tree on the inside and the one in the courtyard had grown. When you put nature and architecture together, the problem is that as nature grows, it moves. The architecture, however, stands still. So the interior tree had become too big for the glass that surrounds it.

We discussed how to solve this problem for months. At first we thought of replacing the tree with a smaller one, a young one that would grow over time. Then we realized that it was difficult to do this operation without demolishing the glass panes and ruining the terrazzo floor. Then we decided to enlarge the glass space enclosing the tree.

We also came to realize that by working only on a small detail—that is, on how the upper glass panes rest on the lower ones that lean inward, and by cutting one of these protrusions—the tree would be fine for another fifteen years. It will fall to our successors to find a new solution. We solved the problem of the second tree, the one in the courtyard, by moving a wall a small distance. But it was easier there. We moved one of the two glass walls that surrounded it by five centimetres.

Did you encounter any special challenges during the restoration?

An important aspect—perhaps the most difficult one—was to rebuild the glass walls that open up onto the courtyard. It was also complicated because after the National Gallery had seen what the pavilion looked like with the glass walls during the 2016 Geoffrey Farmer exhibition, they asked if it would be possible to remove them at will. This certainly could be done, but it required great care so that the exterior look would not be changed, while still leaving the possibility of disassembling the glass wall from inside.

Another major challenge had to do with the tree in the courtyard, or more specifically, with the roots of the tree that go beneath the pavilion. The roots had swollen a bit, generating a crack in the floor. Our first proposal was to restore the floor. But I know from experience that it is very difficult to restore a terrazzo floor well. When we did the restoration of the Palazzo Reale (1994–2007) in Milan, a project by BBPR, we had to restore some pieces of the terrazzo. Even if we had one of the best Italian companies to work on that floor, we could not get the restored parts to look the same as the original. So I insisted on not touching anything at this point, and to leave the crack as it was. But convincing the client to adopt this solution was not easy!

How was the collaboration with the authorities in charge of protecting the building?

I would say that one of the most interesting aspects of this project was collaborating with the different institutions we had to consult with. Needless to say, every institution had its own mission and its own rationale. Naturally, the Soprintendenza was primarily concerned with the preservation of the building, especially from the outside, because this institution has more power on the outside than on the inside. Yet, except for the pavilion's extension project, we were almost always in agreement. The same is true for the Biennale, which wanted to make sure that the Soprintendenza's recommendations were respected. As for the Comune di Venezia, we had some serious discussions, especially at the beginning at the project. But they were very positive because there was such a shared concern for the building's conservation.

Now that the restoration has been completed, how do you feel about the project?

I think the restoration was rather well executed, and that the pavilion has been well preserved, both in terms of the conservation of the original idea and the implementation of solutions necessary for the upgrading and renewal of the building's structure, fabric, and systems.

This project was demanding for everyone: for the many institutional stakeholders, for us as the restoration architects, and for our collaborators in Venice, like Troels Bruun and the contractors, who were fantastic. I think it is a very successful renewal project. It was very important to everyone—Canada, Italy, and the Biennale—that this building be restored with such care. And I hope that all the users, beginning with the National Gallery, who had to face so many constraints, are satisfied.

To conclude, what do you want future generations of architects to know about the pavilion?

Now that the Canada Pavilion, a project from the 1950s, has been preserved, we can be assured that it will have a much longer life. And from the feedback I have received from the people who have visited it, and to whom I have explained the restoration project, they seem to see it in very positive terms.

The anti-monumentality, rigorous geometry, and structural logic of the pavilion are very interesting. It is an example of how an architecture concept that is inventive and very respectful of technical means can result in a very rich form. This is a building that does not sacrifice the architectural idea but rather enriches it. This is especially important now when the creation of a pure image often prevails over the technical logic and the technological condition.

Interview with Cornelia Hahn Oberlander

In 2016, the National Gallery of Canada invited landscape architect Cornelia Hahn Oberlander from Vancouver, British Columbia, to renew the landscape of the Canada Pavilion at the Venice Biennale. A distinguished leader in her field of design, Oberlander was named Companion of the Order of Canada in 2017.

The following text is based on an interview conducted by Réjean Legault, assisted by a team from the National Film Board of Canada, in Oberlander's Vancouver residence and office on 6 and 7 February 2018.

Q

Can you share your first impressions of Venice and the Canada Pavilion in the Giardini della Biennale?

A

When I visited the city for the first time in 1978 I travelled with art historians Abraham Rogatnick from Vancouver and Giuseppe Mazzariol from Venice, who showed me the wonders of the city. I also met Pietro Porcinai, a very famous Italian landscape architect and professor, whom I knew from the International Federation of Landscape Architects. At that time I didn't know about the existence of the Canada Pavilion.

My second visit to Venice was in September 2016. The purpose of my trip was to study the site of the Canada Pavilion. What I saw was a "little house" that did not relate to the buildings that were near it, the British Pavilion and the German Pavilion. It was in dire need of a renovation and had no relationship to either the Giardini or the famed Laguna. And the vegetation was in a bad state: overgrown and in such quantities that it hindered the view to the water. You couldn't see anything except the trees! So, my first impression of both the pavilion and the site, I am sorry to say, was quite negative.

What was your vision for this exceptional commission?

From the outset, I must say that this project was developed in collaboration with Bryce Gauthier of Enns Gauthier Landscape Architects of Vancouver. Bryce and I had collaborated on many projects in the past and I knew he had both the temperament and the design sensibility for this project. We both agreed that not only the Canada Pavilion, but also the entire southern edge of the Giardini needed a new vision. Our objective was to reclaim the overgrown area around the pavilion and to replace it with a new landscape that visitors could enjoy.

Upon my first visit, I found that the pavilion did not respond to the site, and saw that the grades around the building made access very difficult. I also saw that it needed to have connecting paths between the British Pavilion and the German Pavilion, so that it was part of an exploration to go from one pavilion to the next.

Our careful study of the site informed our basic approach, which we outlined in the design proposal. The main goal was to pursue an accessible, sustainable, and beautiful design that made very minimal intrusions upon the site. The objective was to improve the aesthetic quality of the space, rehabilitate the heritage landscape around the pavilion, and enhance the overall user experience around the building. The landscape around the café located behind the pavilions and its relation with the Canada Pavilion were essential to the overall design intent. From the café a visitor had to be given the opportunity to take in the wonderful views of the Laguna, the historic belvedere, and the pavilion itself. We suggested a barrier-free access path, which would provide a better link to a very popular café, which visitors could enjoy on hot days. This path would also improve connections between the Canada, British, French, Korean, and German pavilions, and we worked closely with our colleagues at the Biennale to achieve this.

What were the main challenges of the project?

The greatest challenge was to link this little pavilion with the rest of the Biennale. I wanted to bring the landscape closer to people visiting the pavilion, and I wanted to improve the connection between buildings in such a way that the Canada Pavilion would become the centre of the pathway, but more importantly, the centre of the entire space—stealing the show from the larger pavilions! And at the centre of this walkway you come to a beautiful deck structure projecting out over the hill, with a magnificent view of the Laguna. And this deck structure, located right next to the Canada Pavilion, becomes its new backyard. It's beautiful. And this was another challenge: making the Canada Pavilion stand out from the crowd of bigger buildings. So the path, the café, the deck, and the pavilion all come together to create this wonderful space to sit, enjoy the breeze, the shade, and the view. It's perfect.

Another challenge was to make sure to have a proper entrance. The grades did not relate to the front entrance. And this is something we had to address. But we had to be careful. It was important to the Biennale that whatever we did was sensitive to the historic nature of the site. In 1958 BBPR installed a paving of Verona stone at the entrance and in the courtyard. We had the stones cleaned, the broken ones replaced, and it was all re-laid. We subtly changed the grade so the entrance is much improved. We also added a small concrete bench, which allowed us to reduce the slope. Now you don't just fall into the building. And it is a place for people to sit and talk. As for the spaces around the pavilion, the idea was that we would clear some of the overgrown vegetation to get a better view of the pavilion and the Laguna. And we managed to do that.

What kind of planting did you want for the site?

At first I felt that the planting around the pavilion was old-fashioned. For my part, I like modern grasses. But that didn't go over well with the custodians of the Giardini. There were restrictions about the use of grasses. The grasses that could have been used were all from San Remo, a coastal city in Liguria, which can be considered a local grass. In the first instance I thought it would make people happy because they are all city dwellers and would presumably like this planting.

It was at this time that we met Marco Tosato, a landscape architect with experience in the restoration of historic Italian gardens. He introduced us to these ancient, native plant species that had been grown in the area for years. They were natives that had been used as far back as the first century AD. They were not all to my taste, but they were hardy plants that could survive without irrigation. One must make compromises sometimes, and I am happy that these plants are at least authentic to the region.

What were the design criteria for the project?

The criteria, which were spelled out in the documents we prepared for the project, were accessibility, sustainability, and beauty. Accessibility means that people of all ages, all capacities, can use the path system that links the British Pavilion with the Canadian and the German pavilions. This entails a park with a path system that is universally accessible for everybody, and that would give a setting to the pavilion. In my vocabulary, sustainability means that we take care of the drainage, of the water that falls from the sky. We also must make sure to prevent erosion on slopes. That would be sustainability in its simplest forms. Unfortunately, in Venice, in spite of our hopes, we were not able to implement all of these principles.

Of course, when dealing with the Biennale, the City of Venice, the heritage office, local residents, and others, one must make compromises. Not every aspect of my vision was achieved, but on the whole we were successful. The Canada Pavilion is now a centre of energy for the entire Biennale. It invites social interaction and dialogue. It is a public space in the truest, most Canadian, sense.

When did a preoccupation with sustainability begin to emerge in your work?

It was in 1987 with the Brundtland Report commissioned by the United Nations. The report, titled *Our Common Future*, spelled out that we have to take care of the environment and pass it on to the next generation.[1] And the United Nations accepted that. Unfortunately, not many people have read it. And not many people practise it. But I only take jobs that address sustainability issues.

When you work on a landscape project in such a historic setting, how do you balance sustainability and the question of history, of memory?

Memory is for those who knew the Canada Pavilion in 1958 when it opened, and reality is what we have now with climate change and with hundreds of thousands of people from densely populated cities coming to the Giardini each year. And that's what they should consider.

Memory must be confronted with the reality of today. You have to be a realist to understand that our times are very different than when Napoleon came to Venice in 1807. There is a movement afoot to use only the shrubs of the Napoleonic era. But we managed to get around this. The plants should be simple to maintain in the climate of Venice, and they should be sturdy, grow well, and not become a jungle.

The landscape architect has to think very hard about how people will use the site in the twenty-first century, and how we can create platforms and walkways for better accessibility to the whole site.

Can you tell me more about your design principles?

As you know, I work from a concept to design, to develop and to implement, and the concept is based on the site, the soil, and the existing vegetation. I learned long ago that this is the best way to think about landscape. My design principles are very clear. First of all, building and site must achieve a fit. And that comes from proper grading. I learned that from the Vancouver architect Arthur Erickson in the 1970s. I noticed early on as a student at Harvard that the only way to get good landscapes done was to collaborate with architects. That collaboration process can be found in all my work.

Is there an architectural project that played an especially important role in your career?

Yes—the Museum of Anthropology in Vancouver (1971–76) by Arthur Erickson. I have been working on the museum since 1974. The mound you see there today is the same mound that I created at the time, except for the event platform that was built in 2011. The inlet from the sea is also something we planned in 1974. But we were only permitted to build it in 2011. The university is not so nervous anymore because I knew technically how to waterproof the site that would now be enhanced by the presence of a pond. As a landscape architect you can't just design; you must also know how to build. And I think I am one of the few landscape architects that can do that.

Grading is more important than what you plant. Because good grades allow you to walk through a landscape without any difficulty. I believe grading can enhance a site. Again, at the Museum of Anthropology, these mounds—or berms—allow you to discover one area after another. Berms enable the creation of surprise and discovery in a landscape. Grading is a science, a very precise science. When you worked with Arthur Erickson, as I did for thirty-five years, you made grading plans. Grading is more important than what you plant.

What triggered your interest in landscape architecture?

I wanted to be a landscape architect from my eleventh year on. And so when I came to America in 1939 I had to go to high school. And in high school I learned that Smith College in Northampton, Massachusetts, had a degree in landscape architecture and architecture. I applied and was accepted. And I enrolled in that program. And in 1943 I applied at Harvard to be admitted to the Graduate School of Design where Gropius at that time was already the head. And we were taught the Bauhaus way. And that is basic design, that you don't just scribble—here a tree, there a tree—that you have a concept and you work from that. My training was perfect. And it's perfect for today.

The American landscape architect Dan Kiley was an inspiration for you. Would you say that he was a precursor of ecological design?

I worked for Dan Kiley. That was in the summer of 1951. He was an exponent of modern landscape architecture and was working on different projects in collaboration with various architects. At the time, I also lived with the Kiley family [in Vermont], which was unforgettable. One day, Dan said to me: "Cornelia, tread lightly in the woods." And I said, "But Dan, I always wear sneakers!" He looked at me and said nothing. But it later dawned on me what he meant: look at the ecology and preserve the grounds. And that was a great lesson. So Dan Kiley was very influential. He did not use the word ecology. But in design terms we agreed on many of the simple solutions. And his designs are still outstanding today.

Could you talk about the landscape-design approach called "rewilding"?

The new approach to gardens with climate change and also economic restraint is called "rewilding," which means that you take the plant material from the ecology of the region in which you are working, and let it just develop by itself. Its working definition is: "Rewilding ensures that natural processes and wild species play a much more prominent role in land- and seascapes, meaning that after initial support, nature is allowed to take more care of itself. Rewilding helps landscapes become wilder, whilst also providing opportunities for modern society to reconnect with such wilder places for the benefit of all life."[2] Rewilding is when native plants colonize themselves. It deals with plants that are already there. If you want to have a garden, use only the ecology of your area, then the garden cannot be destroyed. It is a structured affair. Rewilding also deals with areas that could be useful for people. For instance, along a freeway there is often a ribbon of planting that could be left alone and people could use it. Rewilding is a new approach for the twenty-first century.

I would have liked to transpose this approach onto the Biennale site. But they are not there yet. Sweden is ready for it. The northern countries are, but not Venice. There was one person that understood it. His name is Troels Bruun, the local architect for the Canada Pavilion. He was smitten by it. He said he would like to use it all over the grounds of the Biennale. Needless to say, we would have loved to do it. But there are also the existing regulations and institutions, and there are different ideas about what landscape can do. However, I believe that in our time with climate change, rewilding is the only way to go.

What would be the advantage of rewilding for the site of the Canada Pavilion?

Rewilding has the advantage of being low maintenance. It's there by itself. You don't have to do anything. If you use the local ecology of a given site, you don't have all this maintenance gardening to do. You also don't get all these overgrown horticultural shrubs. I strongly believe that if we plant plants from our ecology and not from exotic places, these plants will withstand climate change, frost, water, thunderstorms, and even bigger storms. And if the garden has a structure, that is even better. Then it cannot be destroyed. And rewilding would be a very good spiritual experience for the people who come from densely urban areas.

The Venice pavilion was not your first project for the National Gallery of Canada. Can you talk about your other collaborations with the Gallery?

I have worked on many projects for the National Gallery of Canada. The first was the Taiga Garden (1988) (see fig. 6.12). This garden is a northern landscape, and I took the inspiration from the Group of Seven painter A. Y. Jackson's *Terre Sauvage* (1913). That was the first time that people learned about the Canadian northern landscape, when the Group of Seven went up north to make these pictures. And the most outstanding one is *Terre Sauvage*.

I also worked on the Gallery's other gardens. The idea was that the design of the landscape outside the building had to relate to the art inside. One is the minimalist garden, the courtyard with crabapple trees, which could be seen from the galleries devoted to minimalism. Another one is the goat path that ascends to Nepean Point at the back of the museum, which I call the Op Art path because it could be seen from the Op Art gallery.

Another project was for the installation of a sculpture by Roxy Paine from New York. Paine does trees in metal. The Gallery bought his sculpture *One Hundred Foot Line* (2010), and the question was where would they locate it. At first, they said that they would locate it in the Taiga Garden. But can you imagine hundreds of feet trampling through my Taiga Garden? It's too fragile a landscape. So I found a place outside, at the back of the museum, in a site that echoes the city of Ottawa on the one side and the Ottawa River on the other side. That is where we located Paine's sculpture.

Finally, I worked on the Garden Court project (2018).[3] It was strongly suggested that we try to echo the escarpment of the museum overlooking the Ottawa River, which is a pre-European settlement Canadian landscape. And so what you see there today is the escarpment with its Canadian Shield limestone rocks, which has been made accessible for people to see. With this project I think we have succeeded in making a contemplative space for the twenty-first century.

Could you tell me about the five *P*'s?

The first three *P*'s were given to me when I brought Judy, my oldest daughter, to Smith College. Thomas Mendenhall, then president of Smith, said to the incoming freshman class: you will succeed if you practise patience, persistence, and politeness. And so I kept those three *P*'s. After that, I added two more, which are professionalism and passion. And those are now the five *P*'s with which I practise my profession.

What is *Biophilia*?

Biophilia by Edward O. Wilson is one of the most important books written about man's relation to nature.[4] He argues that if you cut that relation, man will lose his aesthetic and cognitive senses. There's a longing for nature, says Wilson. It's built into our genes. And if we do not satisfy that, man will be not able to function properly. Now how do I know Wilson? I used to serve on the Harvard Graduate School of Design Council. He came to every meeting to talk about his work to us. That's how I got introduced to Wilson a long time ago.

Interestingly, my mother believed very strongly that we should all grow up amongst nature. And we had a beautiful garden in Berlin and we had a farm in New Hampshire. So I was always surrounded by nature and I had to work in the garden or at the farm. I learned farming early on in life. I know about raising vegetables and I taught that to my children.

For you, what would constitute a humanistic design?

It would be a park. It would be a green space, where everybody would be surrounded by nature. A design is not just humanistic, however; it has to be ecological and suitable for the user. I believe very strongly that it has to be based on the local ecology and the local plant palette, and that foreign plants should not be brought in. That means also addressing the sociology of the site. It has to be comfortable to walk through. It has to be giving you vistas so that your eyes can rest and be refreshed. A humanistic design would be for all the people that use the space of a park or green space, with plants that are planted of the local ecology, so that no storm can ever ruin the area.

Longing for the garden of paradise is built into our genes. Throughout history we have been influenced by the gardens of ancient Egypt, Mesopotamia, Greece, Rome, and Asia, and they continue to inspire our contemporary gardens around the world. It is my hope that with the reconceptualization of the site of the Canada Pavilion, I will have made a small contribution to contemporary garden design and to the people of Venice.

Sixty Years of Biennales: Exhibitions in the Canada Pavilion, 1958–2018

Chronology prepared by Cammie McAtee, with assistance from Nicole Burisch and Cyndie Campbell

1958
Biennale Arte XXIX
James Wilson Morrice, Jacques de Tonnancour, Anne Kahane, Jack Nichols
Commissioner: Alan Jarvis
Assistant Commissioner: Donald W. Buchanan
Commissioning institution: National Gallery of Canada

1960
Biennale Arte XXX
Edmund Alleyn, Graham Coughtry, Jean-Paul Lemieux, Frances Loring, Albert Dumouchel
Commissioner: Donald W. Buchanan
Commissioning institution: National Gallery of Canada

1962
Biennale Arte XXXI
Jean Paul Riopelle
Commissioner: Charles Comfort
Assistant Commissioner: J. Russell Harper
Commissioning institution: National Gallery of Canada

1964
Biennale Arte XXXII
Harold Town, Elza Mayhew
Commissioner: W. S. A. Dale
Assistant Commissioner: Robert H. Hubbard
Commissioning institution: National Gallery of Canada

1966
Biennale Arte XXXIII
Alex Colville, Yves Gaucher, Sorel Etrog
Commissioner: Robert H. Hubbard
Assistant Commissioner: Willem A. Blom
Commissioning institution: National Gallery of Canada

1968
Biennale Arte XXXIV
Ulysse Comtois, Guido Molinari
Commissioner: Brydon Smith
Assistant Commissioner: Willem A. Blom
Commissioner for Canada: Joanna Woods-Marsden
Honorary Commissioner: Jean S. Boggs
Commissioning institution: National Gallery of Canada

1970
Biennale Arte XXXV
Michael Snow
Commissioner: Brydon Smith
Commissioner for Canada: Joanna Woods-Marsden
Commissioning institution: National Gallery of Canada

1972
Biennale Arte XXXVI
Gershon Iskowitz, Walter Redinger
Commissioner: Brydon Smith
Commissioner for Canada: Joanna Woods-Marsden
Commissioning institution: National Gallery of Canada

1974
No Biennale held

1976
Biennale Arte XXXVII
Greg Curnoe
Commissioner: Pierre Théberge
Commissioner for Canada: Joanna Woods-Marsden
Commissioning institution: National Gallery of Canada

1978
Biennale Arte XXXVIII
Ron Martin, Henry Saxe
Commissioner: Pierre Théberge
Commissioner for Canada: Joanna Woods-Marsden
Commissioning institution: National Gallery of Canada

1980
Biennale Arte XXXIX
Canada Video: Colin Campbell, Pierre Falardeau/Julien Poulin, General Idea, Tom Sherman, Lisa Steele
Commissioner: Bruce Ferguson
Commissioner for Canada: Joseph Martin
Commissioning institution: National Gallery of Canada

1982
Biennale Arte XL
Paterson Ewen
Commissioner: Jessica Bradley
Commissioner for Canada: Joseph Martin
Commissioning institution: National Gallery of Canada

1984
Biennale Arte XLI
Ian Carr-Harris, Liz Magor
Commissioner: Jessica Bradley
Commissioner for Canada: Joseph Martin
Commissioning institution: National Gallery of Canada

1986
Biennale Arte XLII
Melvin Charney, Krzysztof Wodiczko
Commissioner: Diana Nemiroff
Commissioner for Canada: Joseph Martin
Commissioning institution: National Gallery of Canada

1988
Biennale Arte XLIII
Roland Brener, Michel Goulet
Commissioner: France Gascon
Commissioning institution: Musée d'art
contemporain de Montréal

1990
Biennale Arte XLIV
**Geneviève Cadieux: *La fêlure, au cœur
des corps***
Commissioner: Chantal Pontbriand
Commissioning institution: Parachute in
collaboration with the Montreal Museum
of Fine Arts

1991
Biennale Architettura 5
CCA: *Buildings and Gardens*
Curator: Larry Richards
Commissioners: Brooke Hodge, Larry
Richards
Commissioning institution: Canadian
Centre for Architecture

1993
Biennale Arte XLV
Robin Collyer
Commissioner: Philip Monk
Commissioning institution: Art Gallery
of Ontario

1995
Biennale Arte XLVI
Edward Poitras
Commissioner: Gerald McMaster
Commissioning institution: Canadian
Museum of Civilization

1996
Biennale Architettura 6
Reciprocity: Patkau +16
Curatorial committee: Sandy Hirshen
(Canadian Council of University Schools
of Architecture); Phyllis Lambert (Canadian
Centre for Architecture); Kim Storey (Royal
Architectural Institute of Canada)
Commissioner: Yves Pépin
Commissioning institution: Department
of Foreign Affairs and International Trade
of Canada

1997
Biennale Arte XLVII
Rodney Graham: *Island Thought*
Commissioner: Loretta Yarlow
Commissioning institution: Art Gallery
of York University

1999
Biennale Arte XLVIII
Tom Dean
Commissioner: Jessica Bradley
Commissioning institution: Art Gallery
of Ontario

2000
Biennale Architettura 7
Melvin Charney: *UN DICTIONNAIRE...*
Commissioner: Phyllis Lambert
Commissioning institution: Canadian
Centre for Architecture

2001
Biennale Arte XLIX
**Janet Cardiff & George Bures Miller:
*The Paradise Institute***
Commissioners: Wayne Baerwaldt,
Jon Tupper
Commissioning institution: Plug In ICA;
The Walter Phillips Gallery, The Banff
Centre

2002
Biennale Architettura 8
***Next Memory City—Toronto: Venice—
Michael Awad, Eve Egoyan, David Rokeby***
Curators: Michael Awad, John Knechtel
Commissioner: Kathleen Pirrie Adams
Commissioning institution: InterAccess
Electronic Media Arts Centre,
Alphabet City

2003
Biennale Arte L
Jana Sterbak: *From Here to There*
Commissioner: Gilles Godmer
Commissioning institution: Musée d'art
contemporain de Montréal

2004
Biennale Architettura 9
Saucier + Perrotte: *Found Objects*
Curator: Georges Adamczyk
Commissioner: Brigitte Desrochers
Commissioning institution: Canada
Council for the Arts

2005
Biennale Arte LI
Rebecca Belmore: *Fountain*
Commissioners: Jann L. M. Bailey,
Scott Watson
Commissioning institutions: Kamloops
Art Gallery; Morris and Helen Belkin Art
Gallery, University of British Columbia

2006
Biennale Architettura 10
Pechet and Robb Studio: *SweaterLodge*
Curators: Greg Bellerby, Chris Macdonald
Commissioner: Greg Bellerby
Commissioning institution: Emily Carr
Institute of Art + Design

2007
Biennale Arte LII
David Altmejd: *The Index*
Commissioner: Louise Déry
Commissioning institution: Galerie de
l'Université du Québec à Montréal

2008
Biennale Architettura 11
***41° to 66°: Architecture in Canada—
Region, Culture, Tectonics***
Curators: John McMinn, Marco Polo
Commissioning institution: Cambridge
Galleries

2009
Biennale Arte LIII
Mark Lewis: *Cold Morning*
Commissioner: Barbara Fischer
Commissioning institution: Justina M.
Barnicke Gallery

2010
Biennale Architettura 12
Philip Beesley: *Hylozoic Ground*
Curator: Philip Beesley
Commissioner: Philip Beesley
Architect Inc.

2011
Biennale Arte LIV
Steven Shearer: *Exhume to Consume*
Commissioner: Josée Drouin-Brisebois
Commissioning institution: National
Gallery of Canada

2012
Biennale Architettura 13
**5468796 Architecture Inc.: *Migrating
Landscapes***
Curators: Jae-Sung Chon, Johanna
Hurme, Sasa Radulovic (5468796
Architecture Inc.)
Commissioner: 5468796 Architecture
Inc. with the Royal Architectural Institute
of Canada

2013
Biennale Arte LV
Shary Boyle: *Music for Silence*
Commissioner: Josée Drouin-Brisebois
Commissioning institution: National
Gallery of Canada

2014
Biennale Architettura 14
**Lateral Office: *Arctic Adaptations:
Nunavut at 15***
Curators: Lola Sheppard, Matthew
Spremuli, Mason White (Lateral Office)
Commissioner: Royal Architectural
Institute of Canada

2015
Biennale Arte LVI
BGL: *Canadassimo*
Curator: Marie Fraser
Commissioning institution: National
Gallery of Canada

2016
Biennale Architettura 15
OPSYS: *Extraction*
Curator: Pierre Bélanger (OPSYS)
Commissioner: Catherine Crowston
Commissioning institution: Art Gallery
of Alberta

2017
Biennale Arte LVII
Geoffrey Farmer: *A way out of the mirror*
Curator: Kitty Scott
Project director: Josée Drouin-Brisebois
Commissioning institution: National
Gallery of Canada

2018
Biennale Architettura 16
***Canada Builds/Rebuilds a Pavilion
in Venice***
Curator: Réjean Legault
Commissioning institution: National
Gallery of Canada

In 2019 the NGC inaugurated the first
contemporary art exhibition in the
restored pavilion:

2019
Biennale Arte LVIII
**Isuma: *One Day in the Life of Noah
Piugattuk***
Curators: Asinnajaq, Catherine Crowston,
Barbara Fischer, Candice Hopkins, and
Josée Drouin-Brisebois
Commissioning institution: National
Gallery of Canada

Notes

Introduction
Karen Colby-Stothart

1 Architecture, which was introduced as a component of the Art Biennale in 1968, became autonomous in 1980. The initial exhibitions of the Mostra di Architettura di Venezia were presented in various locations within the city. In 1991 the national pavilions, including the Canada Pavilion, were used as venues for the first time.

2 It should be noted that the Canadian architectural representation has never fallen within the organizational jurisdiction of the National Gallery of Canada. Selected by a peer-review jury at the Canada Council for the Arts, the architect(s) chosen to represent Canada receives partial production funding as well as organizational support from the Canada Council. The National Gallery makes the Canada Pavilion available by joint agreement.

3 The National Gallery of Canada Foundation is a not-for-profit charity with a self-elected Board of Directors, not controlled but significantly influenced by the National Gallery of Canada. The Foundation raises funds in support of National Gallery initiatives with a special focus on those with national impact.

4 The Canadian Artists in Venice Endowment capital target is $10 million (CAN). The goal of this endowment is to establish the primary revenue stream for the Canadian representation program going forward.

5 The Gallery received notification that the Canada Pavilion was of heritage interest by the Soprintendenza Archeologia, Belle Arti e Paesaggio per il Comune di Venezia e Laguna in 2010 (letter from Soprintendente Arch. Renata Codello to Marc Mayer and Karen Colby-Stothart, 5 August 2010). Buildings over fifty years old (in 2017 amended to seventy years old) identified as such are subject to stringent regulations and oversight. While the formalization of this designation would require a more elaborate assessment process that might take several years, the importance of the Canada Pavilion's Italian architects and its location within the historic Giardini were indicators that this designation was inevitable. Close cooperation with the Soprintendenza in all restoration details became an inherent part of the process.

The National Gallery of Canada Commissions an Exhibition Pavilion
Cammie McAtee

For their help with my research for this essay, I thank Julie Roy, Andrew Horrall, Martin Lanthier, Alexandra Clemence, Rebecca Murray, and Jean Matheson at Library and Archives Canada; and Cyndie Campbell of the NGC Library and Archives.

1 A description of the event, which took place three days before the Biennale officially opened, is recorded in a letter from the Canadian ambassador, Pierre Dupuy, to officials in the Department of External Affairs in Ottawa, 16 June 1958, n. letter 460; file 9703-AJ-1-40, vol. 7213, External Affairs, LAC [hereafter Ext Affairs]. A career diplomat, Dupuy was Canadian ambassador to Italy from 1952 to 1958.

2 Dupuy, speech, 11 June 1958, typescript, 2; file 9703-AJ-1-40, Ext Affairs.

3 Charles Fell, speech, 11 June 1958, typescript, 2; file 9703-AJ-1-40, Ext Affairs.

4 Dupuy, letter to External Affairs, 16 June 1958.

5 For this reading, see the pioneering article by Michelangelo Sabatino, the first architectural historian to study the design of and motivations behind the project for the Canada Pavilion: "A Wigwam in Venice: The National Gallery of Canada Builds a Pavilion, 1954–1958," *Journal of the Society for the Study of Architecture in Canada* 32, no. 1 (2007), 3–14. Moving away from issues of national and architectural identity, my study of the commission focuses instead on the visions and contributions of key actors at the National Gallery.

6 In addition to extensive primary research in the papers of various government departments, the NGC Library and Archives, and other sources, Andrew Horrall's excellent biography of Alan Jarvis, the third Director of the NGC, and Douglas Ord's much broader study of the institution have helped shape my understanding of the institutional context of the Canada Pavilion. Andrew Horrall, *Bringing Art to Life: A Biography of Alan Jarvis* (Montreal & Kingston: McGill-Queen's University Press, 2009); Douglas Ord, *The National Gallery of Canada: Ideas, Art, Architecture* (Montreal & Kingston: McGill-Queen's University Press, 2003).

7 The exhibition featured two living artists (Goodridge Roberts and Alfred Pellan) and two deceased ones (Emily Carr and David Milne). In response

to Lawren Harris's question about how the works had been chosen, McCurry explained that "as there was insufficient time to call a meeting of the Board and as the space at the Biennale devoted to Canada was extremely limited, with the help of the senior staff and with consultations with the Chairman, twenty-two pictures had been selected after hanging them experimentally in a similar room in the National Gallery. Mr. Harris proposed that a definite plan to select Canadian pictures for exhibition abroad under the auspices of the National Gallery should be devised. The matter was left for further thought and suggestion." NGC Board of Trustees [hereafter BOT], "Minutes of the 77th Meeting of the Trustees," 15–16 October 1952, typescript, 564; NGC Library and Archives [hereafter NGC Archives]. There is no known photographic documentation of the 1952 exhibition.

8 Sandra Paikowsky, "Constructing an Identity: The 1952 XXVI Biennale di Venezia and 'The Projection of Canada Abroad,'" *Journal of Canadian Art History* 20, no. 1/2 (1999), 134. The present essay is indebted to Paikowsky's thorough analysis of the underlying ambitions below the surface of the exhibition.

9 Donald W. Buchanan, "The Biennale of Venice Welcomes Canada," *Canadian Art* 9, no. 4 (Summer 1952), 146.

10 Buchanan, "The Biennale of Venice Welcomes Canada," 147.

11 NGC BOT, "Minutes of the 78th Meeting," 11–12 March 1953, typescript, 591–92. Harry O. McCurry (1889–1964) was a career civil servant who entered the NGC in 1919 as the assistant to Eric Brown. Succeeding Brown in 1939, McCurry led the institution through some of its most difficult years and laid the ground for its entry into some of the most exciting ones. Jean Sutherland Boggs credited McCurry for the "great years of collecting" (*The National Gallery of Canada* [Toronto: Oxford University Press, 1971], 39–45). A member of the community of tight-knit families that made up the capital's political elite, McCurry never hesitated to put his connections into the service of the Gallery's interests. The Canada Pavilion is just one of the many early post-war projects that constitute his substantial legacy. McCurry's contributions to the NGC's dynamic post-war years have been sidelined in more recent studies, most notably by Douglas Ord, who saw McCurry as merely "keeping the course" set by Brown and the Trustees (*NGC:*

Ideas, Art, Architecture, 96). For views on McCurry's direction by his peers and colleagues, see "H. O. McCurry, Servant of the Arts," *Canadian Art* 12, no. 3 (Spring 1955), 118–22; and Paul Arthur, "Editorial," obituary for Harry O. McCurry, *Canadian Art* 21, no. 4 (July/August 1964), n.p.

12 NGC BOT, "Minutes of the 79th Meeting," 20-21 October 1953, typescript, 614.

13 Notes recorded on a copy of the resolution, 20-21 October 1953; 19-4, vol. 1, 1953, Canadian Pavilion Venice, NGC Archives.

14 On the Massey Commission report, see Paul Litt, *The Muses, the Masses, and the Massey Commission* (Toronto: University of Toronto Press, 1992).

15 Harris, letter to Vincent Massey, 15 June 1951; file 16, box 409, Vincent Massey Personal Records (B1987-0082), University of Toronto Archives [hereafter Massey Records].

16 These recommendations are succinctly outlined in "The Relation of the National Gallery to the Department of Citizenship and Immigration," n.d.; file N-32-2, vol. 18, Hon. J. W. Pickersgill (MG 32, B 34), LAC [hereafter Pickersgill Papers]. The significance of the 1913 Act is briefly discussed in Robert Hubbard's "A Note on the Development of the National Gallery of Canada," published in the first two volumes of *The National Gallery of Canada Catalogue of Paintings and Sculpture, Vol. I: Older Schools* (Toronto: University of Toronto Press, 1957), vii; and *Vol. II: Modern European Schools* (Toronto: University of Toronto Press, 1959), vii; and in Kathleen Fenwick's introduction to A. E. Popham and K. M. Fenwick, eds., *Vol. IV: European Drawings (and Two Asian Drawings) in the Collection of the National Gallery of Canada* (Toronto: University of Toronto Press, 1965), vii. The revision of the National Gallery Act in November and December 1951 is documented in file 16, box 409, Massey Records.

17 For a description of the Victoria Memorial Building, see F. Maud Brown, *Breaking Barriers: Eric Brown and the National Gallery* (Ottawa: Society for Art Publications, 1964), 60–62.

18 On the increase of the number of the trustees, see correspondence in file N-20-1, 1951–52, vol. 125, Louis St. Laurent fonds (MG 26 L), LAC [hereafter St. Laurent fonds].

19 In an exchange of notes with Canada, the Netherlands set aside over two million dollars "for expenditure in the Netherlands by the Canadian Government for general governmental purposes or for expenditure in the Netherlands by Canadians for cultural and educational purposes." Quoted by Pierre Dupuy, Canadian ambassador to the Netherlands, in a letter to the Secretary of State, External Affairs, 17 March 1950; file 10441-AB-40, vol. 8344, Ext Affairs. Canada was not the only nation to use blocked funds in Europe to further its post-war ambitions. One of the most well-known cases of a country using these financial resources for architecture and design is the US State Department's famous "foreign building program," which saw the construction of embassies,

consulates, and other diplomatic facilities across the globe. On this subject, see Jane Loeffler, *The Architecture of Diplomacy* (New York: Princeton Architectural Press, 1998).

20 Royal Commission on National Development in the Arts, Letters and Sciences, "Chapter XVII: The Projection of Canada Abroad," in *Report* (Ottawa: E. Cloutier, Printer to the King, 1951), 262.

21 On the program, see files 10441, vol. 8343, Industry Canada Fonds (RG 20), LAC [hereafter Industry Canada]; articles in *Canadian Art* (Winter 1953), (Summer 1955), and (Autumn 1956); and Paikowsky, "Constructing an Identity," 138, 168 n. 44.

22 Donald Buchanan's summer trip to Europe in 1950 included research on "availability for purchase with blocked francs of certain modern French painting to round out National Gallery's collection." Buchanan, "Proposed Official Duties During European Trip," attached to letter to McCurry, 12 July 1950; "Buchanan, Donald," National Film Board; file 1-B01-51, vol. 1113, 2137, Public Service Personnel Records (RG 32), LAC [hereafter Personnel Records].

23 McCurry's use of blocked guilders in the Netherlands is briefly discussed by Myron Laskin, Jr., "Collecting Old Masters in Ottawa," in Myron Laskin, Jr. and Michael Pantazzi, eds., *Catalogue of the National Gallery of Canada Ottawa: European and American Painting, Sculpture, and Decorative Arts, Volume I / 1300–1800* (Ottawa: NGC, 1987), xiii. Correspondence about the first Van Gogh painting (*Vase with Zinnias and Geraniums*) purchased with blocked guilders is held in file 10441-AB-40, vol. 8344, Ext Affairs. The other Van Gogh painting was *Bowl with Zinnias and Other Flowers*. Reports on acquisitions in the NGC BOT meeting minutes suggest that more works may have been purchased through blocked funds.

24 In a discussion of a third Van Gogh acquisition (*Iris*, 1890), McCurry reported that the "Treasury Board had objected to making any more blocked funds available for the purchase of works of art." NGC BOT, "Minutes of the 81st Meeting," 20–21 October 1954, 650; NGC Archives. According to a letter from McCurry to a Dutch dealer, sent sometime before August 1954, the use of blocked funds for the purchase of artworks ended when the government decided to use the rest of the funds for scholarships. Letter cited by Peter Zimonjic, "Transplanting Van Gogh's Iris," 1 January 2012; https://www.gallery.ca/magazine/exhibitions/transplanting-van-goghs-iris [accessed 28 August 2018].

25 Dispatch from Secretary of State for External Affairs to Pierre Dupuy, Canadian ambassador to the Netherlands, 17 July 1950; file 10441-AB-40, vol. 8344, Ext Affairs. Any suggestion that Canada was participating in a second looting of Europe was anathema to both politicians and members of the art community.

26 The United States and the United Kingdom forgave the Italian government's relief debts. This history is summarized in a document prepared for the Information Division of External Affairs for use in a memo to Cabinet, which was

trying to determine if it was possible to renegotiate to have the funds returned to Canada. Storer to Norman Berlis, "Settlement of Military Relief Fund to Italy," 31 May 1960; file 10441-AJ-40 pt. 3.2, vol. 7281, Ext Affairs.

27 On the Rome embassy, see documents in file 10441-AJ-40 pt. 3.1, vol. 7281, Ext Affairs. The Villa Grandi near the Appian Way was acquired as the Canadian ambassador's official residence. Blocked funds in the Netherlands also helped pay for a new embassy in The Hague.

28 In a 30 March 1950 letter to Canadian ambassador Jean Désy, Count Carlo Sforza, Minister of External Affairs, Rome, described the agreement: "The Italian Government undertakes to conclude with the Canadian Government as soon as possible a cultural agreement providing for the creation of a Foundation destined to promote cultural relations between Italy and Canada and into which the Italian Government will pay in, in the form of Italian Government bonds bearing interest at the rate of 5 p.c. to the equivalent of $500,000 (Canadian) at the rate of exchange prevailing on the date of the transaction. This amount will form part of the assets of the said Foundation and the income derived therefrom will be used for the educational purposes prescribed by the Statutes of the Foundation. Whatever else the Statutes to be agreed on in connection with the Cultural Agreement may provide for, however, it is already understood that the President of the Foundation shall be the Ambassador of Canada in Rome" (file 10441-AJ-40 pt. 3.2, vol. 7281, Ext Affairs). Four years later, the "cultural agreement" was outlined in a memorandum to the Cabinet by Lester B. Pearson, Secretary of State for External Affairs, 8 February 1954 (file 10441-AJ-40 pt. 1.2, vol. 8344, Ext Affairs). A few days later, Pierre Dupuy, Désy's successor, fleshed out the establishment of a Canadian Foundation in Rome, and further means of exchange, including "the organization and presentation in one interested country of artistic exhibitions, concerts, lectures, radio and television programs, films and other cultural activities originating in the other country." Dupuy, letter to Attilio Piccioni, Minister of External Affairs, Italy, 12 February 1954; file 10441-AJ-40 pt. 3.2, vol. 7281, Ext Affairs. Despite good will on both sides, Canada was unable to implement the ambitious project. These debates are documented in External Affairs files 10441-AJ-40 pt. 3.1 and pt. 3.2, vol. 7281, Ext Affairs. For its part, the Italian government opened an Istituto Italiano di Cultura in Montreal in 1962.

29 McCurry became a solid supporter of Buchanan, writing to Vincent Massey, then BOT Chair, on 29 September 1934: "I have had the opportunity of trying out this young man here and, in my opinion, he is in every way the type we badly need in Canadian Museum service" (file 4, box 3, Massey Records). See also correspondence in Buchanan's personnel file, LAC. On Buchanan's education, wartime service, and contributions to film and art history, see Gloria Lesser, "Biography and

Bibliography of the Writings of Donald William Buchanan (1908–1966)," *Journal of Canadian Art History* 5, no. 2 (1981), 129–37. Research produced by Nancy Townshend for an online exhibition on Buchanan at the University of Lethbridge is another valuable source: https://nancytownshend.ca/buchanan.html [accessed 23 October 2018]. An exhibition on Buchanan's photography was recently organized at the NGC. See Andrea Kunard, "Universal Experiences and the Aesthetic Eye: Images by Donald Buchanan," 3 July 2018; https://www.gallery.ca/magazine/your-collection/at-the-ngc/universal-experiences-and-the-aesthetic-eye-images-by-donald [accessed 18 December 2018].

30 Robert Ayre, "Donald Buchanan as a Writer," 1970, unpublished typescript, 18; file 171, box 36, Alan Jarvis Papers (171), Thomas Fisher Rare Books Library, University of Toronto [hereafter Jarvis Papers]. Jarvis commissioned the essay for a book on Buchanan, who died in an accident in 1966. It was not published.

31 Buchanan's account of how his work for the NFB led to the creation of the NIDC and the NGC's Industrial Design Division is related in a letter to McCurry, 13 February 1951. "Buchanan, Donald"; file 1-B01-51; vol. 1113, 2137, Personnel Records.

32 On this important exhibition, see John Collins, "'Design in Industry' Exhibition, National Gallery of Canada, 1946: Turning Bombers into Lounge Chairs," *Material History Bulletin* 27 (Spring 1988), 27–38; and Virginia Wright, *Modern Furniture in Canada, 1920 to 1970* (University of Toronto Press, 1997), esp. 91–101.

33 The reasons behind the founding of the NIDC through an order-in-council are recorded in a report, "National Industrial Design Services," n.d. [1949]; "National Gallery of Canada: National Industrial Design Committee"; file N-20-2-2 1 June 28—1949-50-51, vol. 125, St. Laurent fonds.

34 Letter from Giovanni Ponti, President of the Biennale di Venezia, to Jean Désy, Canadian ambassador to Italy, 9 October 1951; file 9703-AJ-40, vol. 3960, Ext Affairs. Buchanan's initial discussions with Biennale officials took place in July 1950. Buchanan, report to McCurry: "Proposed Official Duties During European Trip," 12 July 1950, Personnel Records. On Buchanan's role in the 1952 exhibition, see Paikowsky, "Constructing an Identity," 138–39.

35 Although the magazine was officially no longer formally associated with the Gallery, it continued to be produced under Buchanan's direction. He shared the masthead with the Montreal-based critic Robert Ayre. Through these years, Buchanan was assisted by Kathleen Fenwick, whose diaries document regular weekend meetings to work on *Canadian Art* (box 4, Kathleen Fenwick fonds, NGC Archives [hereafter Fenwick fonds]).

36 On the Design Centre, see two NIDC publications: *The Story of Canadian Design: In Everything You Use from a Tea-Kettle to a Chair* (Ottawa: NIDC, 1954); and *The Story Behind the Design Centre: Encouraging Better Design of Canadian Products* (Ottawa: NIDC, 1955).

37 These efforts and the rough specifications for the proposed pavilion are outlined in a report by Buchanan sent to Minister Howe and Alex Skelton, Associate Deputy Minister of Trade and Commerce, on 10 May 1949, by J. W. Pickersgill, who was then working in the office of Prime Minister St. Laurent. Buchanan, "Display and Working Quarters for Industrial Design Activities as Recommended by the National Industrial Design Committee," n.d. [1949]; "National Gallery of Canada: National Industrial Design Committee," St. Laurent fonds. *The House in the Museum Garden* was on view at the Museum of Modern Art from 12 April to 30 October 1949.

38 Massey directly referred to the Industrial Design Section's space problem in the report (81). Massey, letter to Alphonse Fournier, Department of Public Works, 12 December 1949; "National Gallery of Canada: National Industrial Design Committee," St. Laurent fonds. Prime Minister St. Laurent personally approved Massey's suggestion, but the continuing work of the Commission delayed the move.

39 At the October 1952 BOT meeting, McCurry reported that "an architect had been employed in connection with the work required to make the Laurentian Building suitable for the work of this [Industrial Design] section." NGC BOT, "Minutes of the 74th Meeting," 2 October 1952, typescript, 2; file 16, box 409, Massey Records. James Watson Balharrie, who did not have any formal architectural training, came to architectural modernism through practise and wartime service for the Navy as a designer. After the war, he went into partnership with William James Abra. In April 1946, Balharrie won second prize in a competition for post-war house design sponsored by *Progressive Architecture*. A shared interest in cinema also connected Buchanan and Balharrie; the latter became the first Chair of the Ottawa Cine Club in 1941.

40 A 1946 description of Balharrie states that he was a member of CIAM: "This Month," *Progressive Architecture* 27, no. 4 (April 1946), 20. On ARGO, see Dustin Valen, "Politicking for Postwar Modernism: The Architectural Research Group of Ottawa and Montreal," *Urban History Review* 45, no. 2 (Spring 2017), 25–44.

41 The 1950 project for the NIDC pavilion was drawn by Guy Desbarats, who worked for Abra, Balharrie & Shore from 1948 until 1952.

42 For a description of the first Design Centre, see Humphrey Carver, "The Design Centre—The First Year," *Canadian Art* 11, no. 3 (Spring 1954), 105–108. Balharrie and his partners Abra and David Shore were the architects of such notable buildings and structures in Ottawa as the Tilden Drive Yourself Quonset Hut (1952); Canadian General Electric Building (1953–54); Commonwealth Building (1954–55); Hog's Back Refreshment Pavilion (1955); Otis Elevator Co. Ltd. Field Office (1959); Lansdowne Park Stadium (1960); and the Sparks Street Mall (1961).

43 For reviews of the inaugural exhibition, see clippings in files for exhibition 659, "Canadian Designs of Merit from 'Trend House,' Toronto, 11 February 1953," NGC Archives. In the summer of 1956, the Design Centre relocated to the Daly Building on MacKenzie Avenue before being reinstalled as part of the new National Gallery in the Lorne Building in 1960. It was then taken over by the Department of Trade and Commerce and moved to an office in a government building, where the country's first gallery devoted to modern design languished until it completely disappeared.

44 For a chronology of exhibitions developed by the NIDC and exhibitions presented at the Design Centre, see Garry Mainprize, "The National Gallery of Canada: A Hundred Years of Exhibitions—List and Index," *RACAR* 11, no. 1/2 (1984), 3–78.

45 See correspondence in vol. 13, Robert H. Hubbard Papers (MG31 E76), LAC [hereafter Hubbard Papers]. Hubbard's papers also document his close friendship with the architect Douglas Rowland, who was a student at the Harvard Graduate School of Design in the 1950s.

46 While the advertised subject was the same as the 1952 conference—"Design: A Function of Management"—Buchanan's report on the conference noted another theme. He singled out the discussion led by Max Bill on "Art, Business, Culture and Design;" presentations by two designers, Dave Chapman and Charles Eames; Pevsner's talk on "Fallacies in Design," which argued that industrial design was still deeply influenced by fine craftsmen; and an address by the conference Chairman, Lionni, distinguishing three types of industrial designers. Donald W. Buchanan, "Third Annual International Design Conference Aspen—Colorado," October 1953, typescript, 2; file 6, box 304, NGC Archives. The records for the 1953 conference are held in file 8, box 1, and file 8, box 117, International Design Conference in Aspen Records, 1949–2006, Getty Research Institute [hereafter GRI]. I am grateful to Isabel Wade for her assistance with these records.

47 According to Peressutti's Princeton employment record, upon the recommendation of MIT professors John Burchard and Pietro Belluschi, he was engaged as a visiting lecturer on 1 February 1953. He continued to teach as visiting professor for one term each year until 31 January 1960. "Peressutti, Enrico," Faculty and Professional Staff files, Subgroup 1: A, Box Primary Run; Princeton University Archives, Department of Rare Books and Special Collections, Princeton University Library.

48 Curated by Greta Daniel, *Thonet Furniture* was presented in the Museum of Modern Art's third floor galleries from 11 August to 4 October 1953. In a letter to Thonet Industries, Philip Johnson, Director of the Architecture and Design Department, wrote: "We were particularly fortunate in securing the help of Mr. Peressutti for a dramatic and impressive presentation of the furniture and other exhibition material." Johnson, 25 March 1953; file 539.3, Department of Architecture and Design Records, Exhibition Records, MoMA Archives.

49 The exhibition, held from 6 November to 2 December 1953, received 2,861 visitors (file II.I.81.1.4, Department of Circulating Exhibitions Records, MoMA Archives). In addition to the MoMA records, see correspondence in file 6, box 304, NGC Archives, and file 1, box 74, Ada Louise Huxtable Papers, GRI. The exhibition then travelled to the University of Manitoba (22 January—12 February 1954).

50 These loans are detailed in an insurance list dated 6 November 1953; file 6, box 304, NGC Archives.

51 "Modern Italian Pattern Shown in Design Centre Exhibition," *Ottawa Citizen* (evening edition), 7 November 1953.

52 "Italian Architecture Topic of Address," *Ottawa Journal*, 27 November 1953, 2.

53 The lecture and party are recorded in Kathleen Fenwick's diary, 26 November 1953, box 4, Fenwick fonds.

54 A translation of a letter sent from the Secretary of the Triennale expressing pleasure about the NIDC's interest in participating in the 1954 exhibition, as communicated by Peressutti, is contained in the project files, vol. 3125, Department of Trade and Commerce (RG 20), LAC [hereafter Trade and Commerce]. Buchanan discussed Peressutti's role in a letter to Paul Malone, Information Division, Department of External Affairs, 12 February 1954; Canadian Cultural & Educational Programs in Italy Financed by Blocked Funds Arising "Triennale di Milano" International Exhibition of Decorative & Industrial Modern Art & Architecture (Brt. Fwd. fr. 9456-LX-40 and 12670-AJ-2-40); file 12670-AJ-2-40, vol. 4434, Ext Affairs. It was not Canada's first invitation: in 1946 the Triennale invited the Royal Architectural Institute of Canada to participate. Citing difficult "present conditions," the offer was turned down. See file 8675-40 pt. 1, vol. 3821, Ext Affairs.

55 See correspondence in file 6, box 304, NGC Archives; and file 12670-AJ-240, vol. 4434, Ext Affairs. The Canadian display is documented in Agnoldomenico Pica, *Storia della Triennale di Milano 1918–1957* (Milan: Edizioni del Milione, 1957), 66.

56 Peressutti was commissioned to install objects drawn from the Museum of Modern Art's "good design" shows in the US Pavilion designed by BBPR.

57 "Coast to Coast in Art: Canada Participates in the X Triennale," *Canadian Art* 12, no. 2 (Winter 1955), 82.

58 Shirley MacDonald, Commercial Counsellor, Canadian Embassy, Rome, "Report on Tenth Triennale di Milano August 28 to November 15, 1954"; file 950-I4-4, vol. 3125, Trade and Commerce. The report also mentions that a selection of Canadian designed objects, including Julien Hébert's aluminum folding chair, was included in two composition displays assembled by the Triennale authorities.

59 Buchanan, postcard to Hubbard, 28 August 1954; file 6, box 304, NGC Archives.

60 The exhibition was shown in Ghent from 3 April to 1 May 1955. See Fredie Floré, *Lessen in goed wonen: woonvoorlichting in België 1945–1958* (Leuven Universitaire Pers, 2010), 192.

61 Toward that goal, Massey commissioned studies from Percy Erskine Nobbs (1931) and Haldenby and Mather (1937). For correspondence about these projects, see NGC files and the Massey Records. A single presentation drawing for Nobbs's project is held in the Percy Erskine Nobbs Fonds, Canadian Architecture Collection, McGill University. It would seem to have been very much a Massey family preoccupation; Massey's son Hart, then an architecture student at the University of Toronto (B.Arch 1951), won the 1951 Pilkington Prize for his design for a national gallery. I thank Tys Klumpenhouwer for information on Hart Massey's education.

62 In addition to records in the NGC Archives, see also correspondence between Massey, other trustees, McCurry, and members of Parliament in file 16, box 409, Massey Records.

63 The first notice of the competition appeared in the April 1952 *RAIC Journal* issue. It sparked much interest in the architectural community including schools. A McGill student project was presented in the autumn 1952 issue of *Canadian Art* (37).

64 NGC BOT, "Minutes of the 74th Meeting," 2 October 1952, typescript, 8; file 16, box 409, Massey Records.

65 *National Gallery of Canada: Competition* (1952), 8; 9.5 N "National Gallery Building"; file 3, box 348, NGC Archives.

66 "I personally do not know of one art gallery lobby that is really efficient and at the same time beautifully designed." Lawren Harris, letter to McCurry, 16 April 1952; 9.5 N "National Gallery Building"; file 1, box 347, NGC Archives.

67 Early in the process Eric Arthur consulted its professional advisor, Joseph Hudnut. In a letter to McCurry on 24 January 1952, Arthur presented this project as one of the reasons he wanted to pursue Saarinen's participation on the jury (file 1, box 347, NGC Archives). He also considered Clarence Stein, Philip Johnson, and Pietro Belluschi.

68 Eero Saarinen, letter to Aline Louchheim, n.d. [1953]; item 6, file 32, box 2, Aline and Eero Saarinen Papers, Archives of American Art, Smithsonian Institution.

69 Arthur repeated this several times in the published report on the competition: "The National Gallery of Canada Competition," *RAIC Journal* 31 (April 1954), 104–17.

70 Arthur, letter to Walter Harris, Minister of Citizenship and Immigration, 8 April 1954; file N-32-2, vol. 18, Pickersgill Papers. Early correspondence suggests that it was Arthur who recommended that the goal of the competition be to select an architect rather than a project. This unusual situation may have been motivated by uncertainty about the site of the future building and a change in the Gallery's direction when McCurry retired. See correspondence between McCurry and Massey in August 1951; file 16, box 409, Massey Records.

71 They offered to go unpaid when a third review was added to the selection process. Saarinen went on to serve on three other Canadian competitions. George Thomas Kapelos, "Shaping Canadian Modernity: Toronto's 1958 New City Hall and Square Competition and its Legacy," in *Competing Modernisms: Toronto's New City Hall and Square* (Halifax: Dalhousie Architectural Press, 2015), 13, 36 n. 29.

72 The Smithsonian competition was undoubtedly considered the last significant one. McCurry, letter to Harris, 27 March 1953; file N-23-3, vol. 18, Pickersgill Papers.

73 Arthur, "Comments of the Jury on the Second Stage of the National Gallery Competition," n.d. [February 1954]; Alfred H. Barr Papers, series I.A.273; microfilm 2180:620-622, MoMA Archives. Copies of this document are also held in file N-23-3, vol. 18, Pickersgill Papers.

74 The delay in the competition was due to a serious accident in July 1953 that left Arthur immobile for many months. The first round of the competition selected six projects from 104 submissions. Arthur, "The NGC Competition," 104.

75 The firm's principals were Cecil Blankstein, Morley Blankstein, Lawrence Green, and Leslie Russell. Morley Blankstein completed two years at IIT (1950–52), graduating with the master's thesis "A Study of a Union Building" (M.Arch, 1952). One year behind his colleague, Isadore Coop began at IIT in 1951, graduating with a thesis on "A Public Library" (M.Arch, 1953).

76 Arthur, "The NGC Competition," 109.

77 Arthur, letter to Minister Harris, 24 February 1954; file N-23-3, vol. 18, Pickersgill Papers.

78 Hubbard, letter to his former teacher, Oskar Hagen, 8 March 1954; file "National Gallery of Canada Correspondence n.d., 1954," vol. 13, Hubbard Papers.

79 Correspondence between George Hulme and John Coolidge, March, May, and June 1957; 9.5 N "National Gallery Building"; file 1, box 347, NGC Archives. Coolidge had known about the project since 1950, when Arthur contacted him for his survey on museum architecture.

80 Buchanan, "The Biennale of Venice Welcomes Canada," 147.

81 McCurry, letter to Rodolfo Pallucchini, 9 December 1953, typescript copy; 19-4, vol. 1, 1953, Canadian Pavilion Venice, NGC Archives.

82 W. G. Constable, letter to McCurry, 21 December 1953; 19-4, vol. 1, 1953, Canadian Pavilion Venice, NGC Archives.

83 "I have no idea about building costs in Italy and any information you can send me will be very gratefully received." McCurry, letter to Peressutti, 20 January 1954, copy; 19-4, vol. 1, 1954, Canadian Pavilion Venice, NGC Archives.

84 Peressutti, letter to McCurry, 27 January 1954; 19-4, vol. 1, 1954, Canadian Pavilion Venice, NGC Archives.

85 Excerpt from a letter from Constable to McCurry, 26 February 1954, quoted in a letter from McCurry to Harris, 15 March 1954; 19-4, vol. 1, 1954, Canadian Pavilion Venice, NGC Archives.

86 Excerpt from a letter from D. H. Watters, Assistant Secretary, Treasury Board, 16 February 1954; 19-4, vol. 1, 1954, Canadian Pavilion Venice, NGC Archives. The idea that the interest on these funds might be used starts to

percolate through government correspondence in early 1954.

87 Dupuy, letter responding to "Proposal for a Canadian Pavilion at Biennale of Venice," to the Under-Secretary of State for External Affairs, 17 March 1954, numbered letter 198; 19-4, vol. 1, 1954, Canadian Pavilion Venice, NGC Archives. Dupuy's report on his first visit to the Biennale (1952) had shown the ambassador to be critical of many trends within modern art. See Dupuy, letter to the Secretary of State for External Affairs, 17 June 1952; file 9703-AJ-40, vol. 3960, Ext Affairs.

88 Dupuy's unwillingness to support the pavilion initiative may also have been influenced by McCurry's very assertive use of blocked funds to buy art in the Netherlands. External Affairs officials often registered surprise with McCurry's direct approach.

89 McCurry, letter to Paul Malone, Information Division, Department of External Affairs, 5 April 1954; dossier 9703-AJ-40, vol. 3960, Ext Affairs. The letter drew on notes made by Hubbard about the impact of the Canadian section in the 1924–25 British Empire Exhibition at Wembley and the 1927 exhibition of Canadian art at the Musée du Jeu de Paume on Canadian artists.

90 Aline B. Saarinen, "For Shows Abroad: Museum of Modern Art Taking Steps to Aid Our Cultural Prestige," *New York Times*, 4 April 1954. The Museum of Modern Art purchased the pavilion from Grand Central Art Galleries in 1954. In 1964 management of the pavilion was handed over to the United States Information Service. In 1986 the pavilion was sold to the Solomon R. Guggenheim Foundation.

91 For example, in his letter to the Information Division of External Affairs, McCurry wrote: "I enclose a clipping from last Sunday's *New York Times*, April 4, 1954, which shows that the United States is taking very definite action to ensure that the American section at the Biennale is adequately presented." McCurry, letter to Malone, 5 April 1954.

92 "Coast to Coast in Art: Canadian Art and Design Abroad," *Canadian Art* 11, no. 3 (Spring 1954), 118.

93 Excerpt from a letter from Hubbard to McCurry, 22 June 1954; 19-4, vol. 1, 1954, Canadian Pavilion Venice, NGC Archives.

94 Buchanan, letter to McCurry (on Grand Hotel Duomo, Milan, paper), 28 August 1954; 19-4, vol. 1, 1954, Canadian Pavilion Venice, NGC Archives. Buchanan also reported on his meeting with the ambassador at the October 1954 BOT meeting (659). Dupuy nevertheless continued to oppose paying for the pavilion with funds earmarked for culture. Dupuy, letter to the Under-Secretary of External Affairs, 6 March 1956; file 9703-AJ-40, vol. 3960, Ext Affairs.

95 Dupuy was knowledgeable about construction and maintenance expenses since he had worked on at least two renovations of Canadian embassy properties in Europe (The Hague and Rome). On The Hague embassy (Antoine Monette and Henri le Grand, architects; 1952–57), see Marie-Josée Therrien, *Au-delà des frontières: L'architecture des ambassades canadiennes 1930–2005* (Québec: Les Presses de l'Université Laval, 2005), 56–60.

96 First rented to the Canadian government after the Second World War for use as the ambassador's residence, the Wassenaar villa, which was commissioned by the famous art collectors Anton and Hélène Kröller-Müller, was purchased from the heirs of the second owner, Daniel Wolf, in 1949. For a brief history of the property, see http://wassenaarsemonumenten.nl/deel-nemers-2018/villa-groot-haesebroek/ [accessed 20 November 2018]. It is worth speculating that Dupuy's experience with modern architecture impacted his later work as the Commissioner General of Expo 67.

97 The article seems to have been based on Hubbard's BOT report on his activities in the summer during his first trip to Europe for the Gallery. Charles Fell was especially impressed, calling it "one of the best expenditures the Board had made for a long time." NGC BOT, "Minutes of the 81st Meeting," 20 and 22 October 1954, typescript, 647.

98 Robert H. Hubbard, "Show Window of the Arts—XXVII Venice Biennale," *Canadian Art* 12, no. 1 (Autumn 1954), 14–20, 35.

99 Ibid., 16.

100 Ibid., 17.

101 Ibid., 35.

102 J. W. Pickersgill, "Donald Buchanan as I Knew Him," 1970, typescript, 8; file 171, box 36, Jarvis Papers.

103 My knowledge of Jarvis's connections to design is based on Horrall's biography.

104 Jarvis's contributions to the organization are documented in the Design Council Archives, University of Brighton. His involvement in the 1946 exhibition is discussed in Patrick Maguire and Jonathan Woodham, eds., *Design and Cultural Politics in Postwar Britain: The "Britain Can Make It" Exhibition of 1946* (London: Leister University Press, 1997).

105 Ness Wood, "Setting Up Home with Bill and Betty, 'Avoid the Tragedy of the Bad First Buy,'" Association of Art Historians annual conference, 2012. I am grateful to Ness Wood for sharing her unpublished research with me.

106 The excitement Jarvis's appointment as NGC Director stirred in Canada is captured in an article in the Canadian edition of *TIME Magazine* that presents him as an agitator for change: "New Fixture," 1 August 1955, 24.

107 Robert McKeown, "Interview with Alan Jarvis Tape 1," transcript, 3; file 19, box 26, Jarvis Papers. Jarvis's papers document many talks to architecture audiences during his 1955–59 tenure as NGC Director. See correspondence in box 3, Jarvis Papers.

108 The Minister of Public Works took exception to remarks that were "critical of public buildings and on the timidity of bureaucracy," and requested that Jarvis bring them directly to the Chief Architect and himself. H. A. Young, Deputy Minister, letter to Jarvis, 7 June 1956; "Correspondence—June 1956," box 3, Jarvis Papers. These comments were included in McKeown's interview with Jarvis, published as "Is Art Necessary?" *Weekend Magazine*, 19 May 1956, 2–5, 36, 39. On the controversy they unleashed in the House of Commons and their impact on Jarvis's directorship,

see Horrall, *Bringing Art to Life*, 254 ff. The Central Mortgage and Housing Corporation considered appointing Jarvis to the National Housing Design Council (file N-22-2, vol. 18, Pickersgill Papers).

109 "The Art Gallery Competition: Awards, Entries and Reports," *Canadian Architect* 2, no. 9 (September 1957), 49–54; and "Postscript to the September 1957 Issue," *Canadian Architect* 2, no. 11 (November 1957), 55. J. Blair Macdonald and Barry Downs were awarded first prize; Geoffrey Massey, E. J. Watkins, R. B. Archambault, and C. D. Rowett won second prize.

110 In his letter, Massey stated that he and his partner Arthur Erickson had long wanted to design such a structure and felt they could "design a pavilion which would be a source of pride and prestige for Canada at the Biennale." Jarvis apologetically responded that the project could only be given to an Italian architect because of the blocked funds that were paying for it. He named Peressutti, adding, "whom I imagine you know." Massey and Jarvis, letters, 10 and 14 May 1956; 19-4, vol. 1, 1956, Canadian Pavilion Venice, NGC Archives.

111 In 1955 Hay, who had left Vancouver for London to become a designer in the 1930s and like Jarvis had worked for the Council of Industrial Design, replaced Buchanan at the Design Centre. On Jarvis and Hay's relationship, see Horrall, *Bringing Art to Life*, 212–25. Hay's experience is briefly noted in the May 1955 NGC BOT meeting minutes. See also references to Hay's experience in Alan Elder, "On the Home Front: Representing Canada at the Triennale di Milano, 1957," M.A. thesis, Department of Fine Arts, University of Victoria, 2000, esp. 60–61.

112 On Paul Arthur's NGC work, see Diane Hiebert, "Typesetting to Settling National Identity: Alan Jarvis, Paul Arthur, and the Influence of the International Typographic Style on Exhibition Catalogues at the National Gallery of Canada from 1956–67," *Render: The Carleton Graduate Journal of Art and Culture* 5 (2016–17), 2–7. Correspondence between Jarvis and Arthur about the position as the Gallery's graphic designer is held in correspondence in box 3, Jarvis Papers.

113 While the font for the Gallery's catalogues was based on a typeface created by Claude Garamond in the sixteenth century, Arthur chose Perpetua, a font designed by the English typeface designer Eric Gill in the late 1920s, for the Gallery's annual reports. Plans for other publications are recorded in box 4, Jarvis Papers.

114 Arthur had immediately begun working with Buchanan on the covers of *Canadian Art* in 1957. In the January 1960 issue, the first one directed by Jarvis, who succeeded Buchanan and Ayre as editor, Arthur is listed as Managing Editor.

115 Plans to publish two books by Eric Arthur—one on the Toronto City Hall competition, the other his book on Toronto architecture, *No Mean City*—were outlined in the June 1959 BOT meeting minutes (964). Jarvis's resignation brought an end to both projects.

116 No reason or source for the new figure, which first appears in the meeting minutes of October 1954, was given.

117 Minister Pickersgill's letter to the Secretary of the Treasury Board summarized the arguments that had been developed to support the project: "Canada is one of the few major countries which does not have a permanent pavilion. For the past two years, Canada has had an exhibition at the Exhibition in loaned space in the Italian pavilion which is entirely inadequate." It also indicates that an agreement had been reached about the use of blocked funds: "It is understood that Canada has assets in Italy in the form of 'blocked funds' which are available for this purpose, and this is to request authority for the construction of an Art Pavilion with 'blocked funds.' This proposal has been discussed by officials of my department with officials of the Department of External Affairs and the latter have expressed agreement in principle." Pickersgill, letter to the Secretary of the Treasury Board, 30 November 1955; file N-23-26, vol. 19, Pickersgill Papers.

118 Buchanan, letter to Peressutti, 8 December 1955; 19-4, vol. 1, 1955, Canadian Pavilion Venice, NGC Archives.

119 Peressutti, letter to Buchanan, 13 December 1955; 19-4, vol. 1, 1955, Canadian Pavilion Venice, NGC Archives.

120 John Steegman, Director of the Montreal Museum of Fine Arts, who attended the inauguration of the Canada Pavilion and met Peressutti, unequivocally stated that the Gallery had given the architect "a free hand in his design." John Steegman, "New Vision at Venice," *Impulse* (London: Mitchell Engineering Ltd., 1958), 38. I thank Audrey Marcoux at the Musée des beaux-arts de Montréal Archives for bringing Steegman's writings on the Canada Pavilion to my attention.

121 Barr knew Peressutti through his design of the US Pavilion at the 1951 Triennale di Milano, which had been commissioned by MoMA, and his subsequent design of the 1953 *Thonet Furniture* exhibition. In a letter that mentioned meeting Peressutti in Milan, Saarinen referred to him as "a wonderful guy." Saarinen, letter to Astrid Sampe, 21 November 1952; Astrid Sampe Collection of Eero Saarinen Correspondence, Cranbrook Archives, Bloomfield Hills, Michigan.

122 The description of the funding within the main estimates of the Ministry of Citizenship and Immigration is as follows: "82. To provide for the construction of a Permanent Canadian Pavilion at the Venice International Biennale of Art from currencies owned by Canada and available only for governmental or other limited purposes in Italy. 25,000 00." *Journals of the House of Commons of Canada*, Third session of the Twenty-Second Parliament of Canada, Session 1956, vol. C, 8 August 1956, 1021. The funds were not used in the 1956–57 allotment and had to be re-voted in 1957. At a meeting of the Treasury Board on 25 January 1957, T.B. 504820-1 approving the contract with the contractor for 14,950,000 lire (estimated as $23,000) and 1,950,000 (estimated as $3,000) for contingencies was signed. T.B. 515666, 12 April 1957, provided an allotment of $24,100 from Vote 128, 1957–58, to cover the construction and unpaid architects'

fees through the use of blocked funds. On 18 July 1959, an additional $10,000 for the "Administration, operation and maintenance—further amount required for the completion of the permanent Canadian pavilion at the Venice international biennale of art" was voted. *House of Commons Debates: Official Report*, Second session, Twenty-Fourth Parliament, vol. 5, 1959, 6398.

123 On 20 March 1957, the Canadian Embassy, Rome, was instructed to "deposit the 16,254,873 blocked lire in your regular embassy current account before closing your March accounts and use as required, but make no payments to contractor until you hear further" (file 9703-AJ01-40, vol. 7213, Ext Affairs).

124 *House of Commons Debate: Official Report*, Third Session, Twenty-Second Parliament, vol. VII, 1956, 8 August 1956, 7256.

125 On the design of the pavilion, see Réjean Legault's essay in this volume.

126 As well as his official duties as an exhibition commissioner, Jarvis's diary records meetings with Peggy Guggenheim on 13 June and Belgiojoso on the 14th. Yearly diary, 1956, box 39, Jarvis Papers. Pierre Dupuy also toured the two sites during the 1956 exhibition, later reporting to officials in Ottawa that the one between the British and German Pavilions "in the less crowded section of the grounds [. . .] had] beautiful trees and the back of the building will be overlooking the water. Canada could not expect better treatment." His vision was captured in his final line: "The problem is now to plan for something that will blend into the glory of Venice." Dupuy, report to External Affairs, 11 December 1956; file 9703-AJ-40, vol. 3960, Ext Affairs.

127 McKeown, "Interview with Alan Jarvis Tape 1," 16–17.

128 On 20 June 1956, Frederick Bell, Deputy Minister, Public Works, signed a budget of $2,750,000. Of that amount, $1,056,670 was earmarked for the pavilion. See correspondence in file T-8-556, vol. 1314, Industry Canada.

129 Donald W. Buchanan, "Impressions of the Fair," *Canadian Art* 15, no. 3 (August 1958), 182–87, 239. His review was reprinted in the *RAIC Journal* in August 1958.

130 NGC BOT, "Minutes of the 87th Meeting," 18–19 September 1957, 834.

131 Documentation for the project is held in vol. 3125, Trade and Commission; and vol. 4434, Ext Affairs. Glenn Bannerman, Head of the Canadian Exhibition Commission, acted as the Commissioner, with Gordon E. Stranks, Norman Hallendy, and Norman Hay credited for arranging the exhibition. For a description of the exhibition, see Agnoldomenico Pica, ed., *Undicesima Triennale* (Milan: Triennale, 1957), 189–91, 305. For a close study of the Canadian display, see Elder, "On the Home Front." True to Buchanan's commitment to promoting Canadian art alongside design, Hay hung a selection of Canadian paintings on the side walls and placed small sculptures on table tops and display shelves. See Elder for a list of these works (54–55).

132 Buchanan, letter to Peressutti, 31 October 1957; 19-4, vol. 1, 1957,

Canadian Pavilion Venice, NGC Archives. This letter followed discussion of Buchanan's proposal at the September 1957 BOT meeting (834). Correspondence with Italian authorities in 1959 about customs charges for "two tables and three chairs imported into Venice as furnishings for the Canadian Pavilion" indicate that the pieces stayed in Italy. J. R. Veit, Business Administrator, NGC, letter to Mary Dench, Information Division, Department of External Affairs, 10 June 1959; file 9703-AJ-40 "Exhibitions of Canadian Art and Paintings in Italy," vol. 3960, Ext Affairs.

133 The pieces were purchased from Bush and donated by Imperial Furniture. See correspondence in 19-4, vol. 1, 1957, NGC Archives. Buchanan's identification of a space as an "information corner" shows its connection to the earlier Design Centre.

134 I thank Andrew Horrall for sharing his belief that Jarvis received a call from Ellen Fairclough, the new Minister of Citizenship and Immigration, to let him know how serious the matter had become. This might explain Jarvis's absence during the President of Italy's visit to the Canada Pavilion the following day. On the circumstances of Jarvis's firing, see Horrall, *Bringing Art to Life*, 281 ff.

135 The idea of making a film on the NGC had been raised two years earlier. In a letter to Jarvis, a friend at the NFB stated: "I do think that the Board would be greatly interested in doing a film on the National Gallery. [. . .] I have no ideas but perhaps you have." S. R., letter to Jarvis, 21 August 1956; "Correspondence—August 1956," box 3, Jarvis Papers. In April 1958, Jarvis told trustees "he had been carrying on discussion with the National Film Board of Canada regarding the possibility of having the opening of the Canadian Pavilion in Venice recorded on film. The NFB reaction is very enthusiastic and they feel they can make the $15,000 available for this under their Canada Carries On program. They ask if the National Gallery could contribute up to $10,000 toward the making of the film." NGC BOT, "Minutes of the 88th Meeting," 16–17 April 1958, 881. The project ended up costing more than the original amount of the pavilion. Although the film was completed in 1959, the NGC only settled their financial commitment to the film in 1960. NGC BOT, "Minutes of the 92nd Meeting," 17–19 February 1960, 988.

136 Kathleen Fenwick's diaries record a meeting with Colin Low in Venice the evening after the opening (12 June 1958, box 4, Fenwick fonds). Documents record that some thirteen technicians were needed for the shooting and that the team stayed in Venice for several weeks. There is also evidence suggesting that some footage was ruined. Aside from launching the project, there is no sign in the files that Jarvis (or Buchanan) had any involvement in the planning. I thank Denis McCready for checking the surviving files on the film in the NFB archives. As part of the 2018 exhibition on the Canada Pavilion, footage from the 1959 film, including

rushes, was assembled for the exhibition in the pavilion.

137 For an interpretation of the film as cultural propaganda, see Elizabeth Diggon, "The Politics of Cultural Power: Canadian Participation at the Venice and São Paulo Biennials, 1951–1958," M.A. thesis, Department of Art History, Queen's University, 2012, 73–77.

138 Donald W. Buchanan, "Canada Builds a Pavilion in Venice," *Canadian Art* 15, no. 1 (January 1958), 29.

139 The source for Mumford's praise is unknown. It is curious that he would have said something so positive about Peressutti given his intense dislike of the Olivetti Showroom, reviewed in his Skyline column in the *New Yorker* ("Charivari and Confetti," 18 December 1954, 114–19). Mumford did, however, position his protégé, the Polish-American architect Matthew Nowicki, between Le Corbusier and Wright in this way.

140 "Picture Buildings: Canadian Pavilion: Biennale, Venice," *Canadian Architect* 3, no. 11 (November 1958), 63. A month prior, Eric Arthur briefly mentioned the pavilion in a report on the international competition for Toronto City Hall. Arthur, who must have known of the project early on, somewhat disingenuously relayed the news in a side note about one of the jurors: "It is perhaps of interest to architects in Canada to know that Dr [Ernesto] Rogers' firm is engaged on the Canadian Pavilion for the 'Biennale d'Arte,' Venice, 1958." Eric Arthur, "Toronto City Hall and Square Competition: The Jury," *RAIC Journal* 35 (October 1958), 360.

The Harmony of Human Proportions: BBPR's Architectural Dialogues
Serena Maffioletti

Dates for BBPR's projects are taken from Ezio Bonfanti and Marco Porta, *Città, Museo e Architettura: Il Gruppo BBPR nella cultura architettonica italiana 1932–1970* (Florence: Vallecchi, 1973).

1 Gian Luigi Banfi, Lodovico B. Belgiojoso, Enrico Peressutti, Ernesto N. Rogers, "Presentazione ai progetti di laurea," in Ernesto N. Rogers, *Esperienza dell'architettura* (Turin: Einaudi, 1958), 55. Translation by Roberta Maracaccio from her article, "The Hero of Doubt," *AA Files* 75 (2017), 60.

2 Ernesto N. Rogers, "Il mestiere dell'architetto," in *Esperienza dell'architettura*, 32. In speaking of "dark years," Rogers certainly alluded to the difficulties of Italian architecture under Fascism and to the role played by some Italian architects, and in particular by BBPR in connecting with European Rationalist architecture culture, especially through contacts with CIAM members.

3 Lodovico B. Belgiojoso, "In memoria di Enrico Peressutti," 10 May 1976, typescript, 5; Fondo Enrico Peressutti, Archivio Progetti, Università Iuav di Venezia [hereafter Fondo Peressutti, Iuav].

4 Edoardo Persico, "Bilancio a Roma," *L'Italia letteraria*, 29 September 1934, in Giulia Veronesi, ed., *Edoardo Persico, Tutte le opere 1923–1935* (Milan: Edizioni di Comunità, 1964), 291.

5 For a list of the main exhibitions BBPR participated in before the Second World War, see Bonfanti and Porta, *Città, Museo e Architettura*.

6 Edoardo Persico, "Alla Mostra dell'Aeronautica," in *Tutte le opere*, 262.

7 Enrico Peressutti, "Visita a due mostre contemporanee," *Rassegna di architettura* (September 1935), 336.

8 See Serena Maffioletti, ed., *Enrico Peressutti: fotografie mediterranee* (Padua: Il Poligrafo, 2010).

9 *Mostra internazionale della fotografia*, V Triennale di Milano, 1933. Photographs by Peressutti were published in *Quadrante*, no. 7 (November 1933), 11; nos. 16–17 (August–September 1934), 11, 61; no. 22 (February 1935), 25; and no. 29 (September 1935), 1. On *Quadrante*, see David Rifkind, *The Battle for Modernism: Quadrante and the Politicization of Architectural Discourse in Fascist Italy* (Vicenza: Centro Internazionale di Studi di Architettura Andrea Palladio / Venice: Marsilio Editori, 2012).

10 Peressutti was sent to the Russian front in August 1941. During the final months of 1942 he fell ill and was repatriated. He returned with many images he had taken during the military campaign, documenting the hardships of the war as well as the life and architecture he had observed in the countries he had seen on his travels. BBPR became members of the anti-Fascist movement Giustizia e Libertà; they were registered in the anti-Fascist liberal-socialist political party Partito d'Azione and they engaged in the resistance. Peressutti joined the military committee within the Comitato di liberazione nazionale, which directed the Italian resistance in the last phase of the war. Rogers, who was Jewish, fled to Switzerland soon after German forces occupied Milan in September 1943. Banfi and Belgiojoso were arrested in March 1944 and deported to the Mauthausen concentration camp, where Banfi died in April 1945.

11 Belgiojoso, "In memoria di Enrico Peressutti," 11.

12 Gillo Dorfles, letter to Marina Peressutti, 25 May 2008, Archivio Marina Peressutti, Milan.

13 Lodovico Belgiojoso credited the work solely to Peressutti. See "In memoria di Enrico Peressutti," 11. The monument was transformed three times between 1946 and 1955 and became internationally acclaimed.

14 Manfredo Tafuri, *History of Italian Architecture, 1944–1985*, trans. Jessica Levine (Cambridge, MA: MIT Press, 1989), 5.

15 Gio Ponti founded *Domus* in 1928 and directed the journal until 1941, when Massimo Bontempelli, Giuseppe Pagano, and Melchiorre Bega took over its direction. In 1942 Guglielmo Ulrich replaced Pagano. In October 1943, Bega took over direction until 1945, when the journal suspended publication. Publication resumed in January 1946 under the direction of Rogers, who continued in that role until the end of 1947. His issues include nos. 205 through 223–225.

16 Ernesto N. Rogers, "Programma: Domus, la casa dell'uomo," *Domus*, no. 205 (January 1946), 3.

17 Ernesto N. Rogers, "Misura e grandezza," conference paper for the first international conference on the subject of proportion in the arts, "De Divina Proportione," IX Triennale di Milano, 27–29 September 1951; reproduced in Serena Maffioletti, ed., *Ernesto N. Rogers. Architettura, misura e grandezza dell'uomo* (Padua: Il Poligrafo, 2010), 439–45.

18 Rogers prepared the exhibition with Vittorio Gregotti and Giotto Stoppino. For a reading of the exhibition from the point of view of the photographs presented in it, see Olivier Lugon, "Architecture, Measure of Man, Milan, 1951," *Aperture*, no. 213 (Winter 2013), 50–51.

19 Introductory panel, *Architettura, misura dell'uomo*, IX Triennale di Milano, March–September 1951. For his explication of the project, see Ernesto N. Rogers, "Architettura, misura dell'uomo," *Domus*, no. 260 (July–August 1951), 1–5. It is worth noting that the American historian and photographer G. E. Kidder Smith included the exhibition in his early survey *Italy Builds / L'Italia Costruisce: Its Modern Architecture and Native Inheritance* (New York: Reinhold Publishing, 1955), 194–95.

20 Curated by Greta Daniel, the exhibition *Thonet Furniture, 1830–1953*, on the centenary of the furniture company (14 August–4 October 1953), confirmed MoMA's interest in the work of BBPR. As well as commissioning the US Pavilion, in 1953 it included BBPR in the travelling exhibition *The Modern Movement in Italy: Architecture and Design*, curated by Ada Louise Huxtable.

21 "The Thonet exhibition at the Museum of Modern Art," *Interiors + Industrial Design* 113, no. 2 (September 1953), 87.

22 Le Corbusier, letter to Enrico Peressutti, 28 February 1955, Fondo Peressutti, Iuav. The letter and the photographs are reproduced in Maffioletti, ed., *Peressutti: fotografie mediterranee*.

23 Olga Gueft, "Olivetti, New York," *Interiors + Industrial Design* 114, no. 4 (November 1954), 124.

24 On the genesis of the pavilion, see Serena Maffioletti, *BBPR* (Bologna: Zanichelli, 1994), 112–15.

25 On BBPR's collaboration with Steinberg, see Joel Smith, *Saul Steinberg: Illuminations* (New Haven: Yale University Press, 2006), 48, 130–31.

26 Rogers directed *Casabella Continuità* from no. 199 (December 1953–January 1954) to nos. 294–295 (December 1964–January 1965).

27 Ernesto N. Rogers, "Continuità," *Casabella Continuità*, no. 199 (December 1953–January 1954), 3.

28 Ernesto N. Rogers, "Our Responsibilities Toward Tradition," *Italian Quarterly* (Los Angeles), nos. 7–8 (Autumn 1958/Winter 1959), 76–77; translation by Stanford Drew of "Le responsabilità verso la tradizione," *Casabella Continuità*, no. 202 (August/September 1954), 2.

29 On the commission, see Carolina Di Biase, "Nel cuore della città: Progetto e cantiere al Castello Sforzesco di Milano (1946–1956), in Chiara Baglione, ed., *Ernesto Nathan Rogers: 1909–1969* (Milan: FrancoAngeli, 2012), 221–34; and Orietta Lanzarini, "'Per restare Civitis ornamentum': Il progetto storico

di Ernesto Nathan Rogers nel Museo d'Arte antica del Castello Sforzesco di Milano (1947–1956)," *Arte Lombadia*, nos. 161/162 (1–2) (2011), 108–15.

30 Giuseppe Samonà, "Un contributo alla museografia," *Casabella Continuità*, no. 211 (1956), 51.

31 Ernesto N. Rogers, "The Heart: Human Problem of Cities," paper given at the CIAM 8 conference, Hoddesdon 1951, in Jaqueline Tyrwhitt, Josep Lluís Sert, and Ernesto N. Rogers, eds., *The Heart of the City: Towards the Humanisation of Urban Life* (London: Lund Humphries, 1952), 71.

32 Ernesto N. Rogers, "Pretesti per una critica non formalistica," *Casabella Continuità*, no. 200 (1954), 1–3.

33 Ernesto N. Rogers, "Le preesistenze ambientali e i temi pratici contemporanei," *Casabella Continuità*, no. 204 (February/March 1955), 5.

34 Giuseppe Samonà, "Il grattacielo più discusso d'Europa: la Torre Velasca a Milano," *L'Architettura. Cronache e storia*, no. 40 (1959), 659.

35 On the choice of Bergamo as the site of CIAM 7 and BBPR's contributions to it, see Eric Mumford, *The CIAM Discourse on Urbanism, 1928–1960* (Cambridge, MA: MIT Press, 2000), 183–200.

36 On BBPR's teaching at the AA, see Maracaccio, "The Hero of Doubt," 68.

37 Having obtained a teaching position in architectural composition in 1955, Peressutti was given tenure after three years of teaching in collaboration with the Director of Iuav, Giuseppe Samonà, a prestigious recognition. See Enrico Peressutti, Cartella libera docenza, Fondo Peressutti, Iuav.

38 Dates for Peressutti's time at Princeton are taken from his employment records. Peressutti was first hired to fill in for Jean Labatut. His status became more permanent in August 1954, when he was given a three-year contract and he was promoted to Visiting Professor. Robert McLaughlin, Director of the School, recommended Peressutti be offered the visiting professorship, writing, "There are many reasons why his residence here for one term, in combination with his practice, would perhaps best give us the relationship with the professional world that the School of Architecture so definitely needs." McLaughlin, letter to Dean J. Douglas Brown, 18 March 1954; Faculty and Professional Staff files, Princeton University Archives, Department of Rare Books and Special Collections, Princeton University Library [hereafter Peressutti Records, Princeton]. Josep Lluís Sert, one of Peressutti's CIAM colleagues, recommended him for the position. On Peressutti's teaching at Princeton, see also Federica Soletta, "Under the Magnifying Glass of History: Enrico Peressutti in Princeton," in Pippo Ciorra and Caterina Padoa Schioppa, eds., *Erasmus Effect: Italian Architects Abroad* (Rome: Quodlibet, 2013), 125–29.

39 Peressutti, comments made at the conference "Architecture and the University," 11–12 December 1953, published in *Architecture and the University: proceedings of a conference held at Princeton University, December eleventh and twelfth, nineteen hundred*

fifty-three (Princeton: Princeton School of Architecture, 1954), 60–61.

40 Peressutti, *Architecture and the University*, 61.

41 Charles Moore, quoted in David Littlejohn, *Architect: The Life and Work of Charles Moore* (New York: Holt, Rinehart and Winston, 1984), 121–22.

42 Peressutti, letter to Douglas Haskell, 26 January 1956; Douglas Haskell Papers, Avery Drawings Collection, Columbia University, New York.

43 The documents relating to the second-year course of the Graduate School taught by Peressutti during the academic year 1957–58 are held in the Louis I. Kahn Collection, Series 11, 55.75, Architectural Archives of the University of Pennsylvania [hereafter Kahn Collection].

44 Peressutti, letter to Louis Kahn, dated 12 December 1957, inviting him to take part in the jury that gathered on 19 December 1957 (Kahn Collection). It is interesting to note that he included the newly designed traffic routes made by his students in the letter. Kahn and Peressutti likely met at the 20 November 1953 Yale symposium "Signs for Streets and Buildings," which was convened in Kahn's recently completed Yale Art Gallery. See "Architects meet Alphabets," *Interiors + Industrial Design* 113, no. 5 (December 1953), 144–46. The following month the two architects both participated in the Princeton conference "Architecture and the University." Furthermore, Kahn taught at Princeton during the winter term of 1956, right after the students returned from their December 1955 trip to the Yucatán with Peressutti.

45 It was only after the CIAM '59 conference in Otterlo that Kahn attended that *Casabella* published its first article on the architect. See "L'Architetto Louis Kahn," and Francesco Tentori, "Ordine e forma nell'opera di Louis Kahn," *Casabella Continuità*, no. 241 (1960), 2–17.

46 Peressutti, letter to Allen D. Black, Associate Editor of the *Daily Princetonian*, 27 November 1961; Archivio BBPR, Milan.

47 Peressutti, letter to President Robert Francis Goheen, Princeton University, 29 November 1959; Peressutti Records, Princeton.

48 Ibid.

49 Peressutti's comments reported in "Princeton Critic Resigns," *Architectural Forum* 112, no. 2 (February 1960), 16. In a later clarification of his position, Peressutti wrote: "I did, in previous years, suggest entrusting the new planning of the campus to architects and engineers of great renown who would certainly have been able to conceive modern buildings, but as characteristic and significant as the old ones of Princeton. Then I suggested the names of Frank Lloyd Wright, Le Corbusier, Louis Kahn and others of great renown." Enrico Peressutti, "Princeton Not a Leader: Peressutti Attacks Structures," *Daily Princetonian*, 12 January 1962.

50 Peressutti, letter to Goheen, 29 November 1959.

51 Ibid.

52 "Le dimissioni di Peressutti dall'Università di Princeton," editorial in *Casabella Continuità*, no. 238 (1959), 50.

53 Kahn, letter to Rogers, 2 March 1960;

folder 030.II.A.64.24 Misc. 1959 thru, Kahn Collection.

54 On the commission, see Cammie McAtee's essay in this volume.

55 Lodovico Belgiojoso, "In memoria di Enrico Peressutti," 7–8.

56 Bruno Zevi, "Arredi scarpiani, spaccato BBPR," *L'Espresso*, 29 June 1958, 16; later reprinted in *Cronache di architettura*, no. 216 (Bari: Universale Laterza, 1971), 118.

57 Bruno Zevi, "Il Padiglione BBPR ai Giardini," *La Biennale di Venezia* 8, no. 30 (January–March 1958), 46.

58 Reyner Banham, "Neoliberty: The Italian Retreat from Modern Architecture," *Architectural Review* 125, no. 747 (April 1959), 230–35.

59 Aldo Rossi, Luciano Semerani, and Silvano Tintori, "Sei risposte alle domande," *Casabella Continuità*, no. 251 (May 1960), 31.

60 Paolo Portoghesi, "Introduzione," in Bonfanti and Porta, *Città Museo e Architettura*, n.p.

61 Ernesto N. Rogers, "Architettura… 'sostanza di cose sperate,'" *Casabella Continuità*, no. 246 (December 1960), 3.

62 Ernesto N. Rogers, "Le responsabilità verso la tradizione," 2.

63 Ernesto N. Rogers, "Conquista della misura umana," *Tempo* (August 1945), 116.

Designing the Canada Pavilion
Réjean Legault

I would like to thank Cammie McAtee, Serena Maffioletti, Carlo Carbone, and Louis Martin for their comments on early drafts of this essay.

1 Kathleen M. Fenwick, "The New Canadian Pavilion at Venice," *Canadian Art* 15, no. 4 (November 1958), 275. A shorter version of this text also appeared under the title "The Canadian Pavilion at Venice," in *The National Gallery of Canada: Annual Report of the Board of Trustees for the Fiscal Year 1958–1959* (Ottawa: NGC, 1959), 33–34.

2 Fenwick, "The New Canadian Pavilion at Venice," 276.

3 John Steegman, "New Vision at Venice," *Impulse* (London: Mitchell Engineering Ltd., 1958), 37–40. In a private letter written after the inauguration, Steegman reported: "The Canadian Pavilion has aroused immense interest. Extremely modern, iron girders and glass, enclosing a large growing tree which projects upwards through an opening in the roof. It is the only 'advanced' building in the whole Biennale complex." Steegman, letter to Bill Bantey, 24 June 1958; Montreal Museum of Fine Arts Archives. These comments were then quoted in "Canadian Show in Venice Hailed as Major Success," *Gazette* (Montreal), 9 July 1958.

4 Among others, the German art critic Juliane Roh of *Die Kunst* wrote that the conservatism of the artworks shown in the new Canada Pavilion could not match "the modernity of the architecture." Cited in "Coast to Coast in Art: Reactions to Canada's Art in Venice," *Canadian Art* 15, no. 4 (November 1958), 300.

5 Fenwick, "The New Canadian Pavilion at Venice," 275–76.

6 Ibid., 276.

7 That a tepee—a North American Indigenous dwelling primarily used in

the Plains region—could be so readily associated with the image of Canada in the 1950s or '60s was redolent of folkloric assumptions, if not to say cultural blindness. While the tepee was no doubt part of the Canadian imagination, its evocation must be read against the plight of the country's Indigenous population. The practice of seizing aboriginal children from their parents and subjecting them to forced assimilation through the residential-school system reached its peak at the end of the 1950s. See John S. Milloy, *A National Crime: The Canadian Government and the Residential School System, 1879 to 1986* (Winnipeg: University of Manitoba Press, 1999). For negative readings of the pavilion as a tepee, see, among others, "Gallery Director Wants a New Pavilion in Venice," *Globe and Mail*, 23 July 1966.

8 In the first scholarly essay on the pavilion, the Canadian architectural historian Michelangelo Sabatino framed his analysis of the design through a discussion of the building's national identity. See Michelangelo Sabatino, "A Wigwam in Venice: The National Gallery Builds a Pavilion, 1954–1958," *Journal of the Society for the Study of Architecture in Canada* 32, no. 1 (2007), 3–14. The pavilion's association with a wigwam was first made by the British critic Lawrence Alloway in his book *The Venice Biennale, 1895–1968: From Salon to Goldfish Bowl* (Greenwich: New York Graphic Society / London: Faber & Faber, 1968).

9 Fenwick, "The New Canadian Pavilion at Venice," 275.

10 For a discussion of the connections between Buchanan and Peressutti, see Cammie McAtee's essay in this volume.

11 The talk was given in conjunction with *The Modern Movement in Italy: Architecture and Design*, an exhibition presented at the NGC's Design Centre from 6 November to 2 December 1953.

12 On this issue, see McAtee's essay in this volume.

13 Donald W. Buchanan, letter to Peressutti, 8 December 1955; Canadian Pavilion Venice, 19-4, vol. 1, 1955, NGC Library and Archives [hereafter NGC Archives].

14 As early as 1955, Peressutti figured in the group of influential voices interviewed by John Peter. John Peter, *Oral History of Modern Architecture: Interviews with the Greatest Architects of the Twentieth Century* (New York: Harry N. Abrams, 1994), 50, 73, 88–91, 96.

15 For a thorough analysis of the work of BBPR, see the pioneering study by Ezio Bonfanti and Marco Porta: *Città, Museo e Architettura. Il Gruppo BBPR nella culture architettonica italiana 1932–1970* (Florence: Vallecchi, 1973).

16 The brief is titled "Venice Pavilion," n.d.; Canadian Pavilion Venice, 19-4, vol. 1, NGC Archives. It gives the following suggested dimensions: 30' × 60' for the building, to comprise a 30' × 50' gallery, 10' × 10' entrance hall, 10' × 10' storeroom, and 10' × 10' office.

17 The Dutch Pavilion by Gerrit Rietveld, about which NGC Chief Curator Robert Hubbard had expressed much appreciation in a 1954 article, was also mentioned as a model for lighting.

18 Buchanan's personal archives have not survived, leaving little material to assess his thinking about the project.

19 Rodolfo Pallucchini, letter to Jarvis, 26 January 1956; Canadian Pavilion Venice, 19-4, vol. 1, 1956, NGC Archives. For a discussion of the complex shared management structure of the Giardini della Biennale, see Franco Panzini's essay in this volume.

20 The meeting was suggested by Buchanan in a letter to Pallucchini, 7 February 1956; Canadian Pavilion Venice, 19-4, vol. 1, 1956, NGC Archives.

21 Peressutti, letter to Buchanan, 23 March 1956; Canadian Pavilion Venice, 19-4, vol. 1, 1956, NGC Archives.

22 Pallucchini included this plan in his 26 January letter to Jarvis.

23 Peressutti, letter to Jarvis, 26 June 1956; Canadian Pavilion Venice, 19-4, vol. 1, 1956, NGC Archives.

24 In a letter to Jarvis, Peressutti wrote: "We already started studying a possible solution on this site [B] but knowing that you were coming for the last decision, we did only some tentative sketches." 6 June 1956; Canadian Pavilion Venice, 19-4, vol. 1, 1956, NGC Archives.

25 The original drawings for the pavilion are preserved in the BBPR Archive, a private collection located in Milan. Reproductions of most of the drawings are held at the Archivio Progetti, Università Iuav di Venezia.

26 A clear indication that this sketch was made early in the design process comes from a letter from Buchanan to Peressutti dated 29 March 1956. In it, Buchanan comments on the shortcomings of the office space located in the alcove. Canadian Pavilion Venice, 19-4, vol. 1, 1956, NGC Archives.

27 For a discussion of the "drafts" in architecture and their arrangement in a chronological sequence, see Pierre Marc de Biasi and Réjean Legault, eds., "Architecture," thematic issue of *Genesis* no. 14 (Paris, 2000).

28 First international conference on the subject of proportion in the arts, "De Divina Proportione," IX Triennale di Milano, was held from 27–29 September 1951. For the papers presented, see Anna Chiara Cimoli and Fulvio Irace, *La Divina Proportione: Triennale 1951* (Milan: Electa, 2007), 36–134. On Rogers's talk, see Serena Maffioletti, ed., *Ernesto N. Rogers. Architettura, misura e grandezza dell'uomo* (Padua: Il Polygrafo, 2010), 439–45.

29 The symposium "De Divina Proportione" was held on 11 March 1952. Chaired by Josep Lluís Sert, the speakers included George Howe, Eero Saarinen, Dr. W. V. Dinsmoor, and Peressutti.

30 While an involute is a geometrical figure similar to a spiralling curve, the pavilion's spiral plan was composed of straight segments.

31 On this issue, see Niklas Maak, *Le Corbusier: The Architect on the Beach* (Munich: Hirmer, 2011).

32 See "BBPR, Il labirinto dei ragazzi," *Casabella Continuità*, no. 203 (November–December 1954), 49–51.

33 Gillo Dorfles, "La sintesi delle 'arti maggiori,'" *Casabella Continuità*, no. 203 (November–December 1954), 48.

34 Peressutti, letter to Buchanan, 28 October 1956; Canadian Pavilion Venice, 19-4, vol. 1, 1956, NGC Archives. The letter was sent from Princeton where Peressutti was teaching during the fall term. The model was received at the Gallery on 21 November 1956. At Peressutti's request, it was returned to BBPR's office in Milan.

35 While we know that Peressutti did not go to Ottawa, correspondence suggests that he and Buchanan may have met in New York City in December 1956.

36 Buchanan, letter to Pallucchini, 3 April 1956; Canadian Pavilion Venice, 19-4, vol. 1, 1956, NGC Archives.

37 Pallucchini, letter to Peressutti, 18 September 1956; Archivio Storico delle Arti Contemporanee [hereafter ASAC].

38 Peressutti, letter to Pallucchini, 22 October 1956; ASAC.

39 Peressutti, letter to Buchanan, 28 October 1956; Canadian Pavilion Venice, 19-4, vol. 1, 1956, NGC Archives.

40 Romolo Barzoni, letter to Pallucchini, 26 September 1956; ASAC. Barzoni, who worked for the Biennale, was reporting on a request from the Comune di Venezia.

41 Peressutti, letter to Pallucchini, 22 October 1956; ASAC.

42 Peressutti, letter to Umbro Apollonio, a Biennale official, 3 September 1956; ASAC. Peressutti wrote: "*A puro titolo di sondaggio, se la costruzione del Padiglione (dato che questo é in gran parte di legno) fosse concessa a titolo 'provvisorio,' questo puo risolvere la difficoltà?*"

43 Despite being made up of prefabricated parts, the Finnish Pavilion ultimately became a "permanent" construction. See Timo Keinänen, ed., *Alvar Aalto: The Finnish Pavilion at the Venice Biennale* (Milan: Electa, 1991).

44 Massimo Alesi, letter to Roberto Tognazzi, 24 November 1956; ASAC.

45 Tognazzi, letter to Dupuy, 26 March 1957; Archives of the Canadian Embassy in Rome. A translation of this letter is held in NGC Archives.

46 Peressutti, letter to Vladimiro Dorigo, Comune di Venezia, 5 February 1957; Archivio Municipio di Venezia.

47 The total area of the project proposed was 230 m², including a patio of 50 m². The project as built has an area of 185 m², including the 40 m² patio.

48 S.I.C.C.E.T. was the acronym for the Società Industriale Commerciale Compensati e Tranciati.

49 See Alfredo Giarratana, *L'Industria Bresciana ed i suoi Uomini negli Ultimi 50 Anni* (Brescia, 1953), 119–20.

50 The furniture produced by the firm was for the displays designed by the architects Pier Luigi Spadolini and Ignazio Gardella. See *Decima Triennale di Milano: Esposizione internazionale delle arti decorative e industriali moderne e dell'architettura moderna* (Milan: SAME, 1954).

51 The firm, whose main office was near that of Studio BBPR in Milan, was also known to the architects through their advertising in *Casabella Continuità*.

52 The plant was located in Concorezzo near Milan. Canadian officials were aware of the firm's expertise. As Fenwick wrote: "The wooden roof was built by a firm of Italian shipbuilders." Fenwick, "The New Canadian Pavilion at Venice," 277.

53 See Antonio Piva, "Gli edifice della cultura: il Castello Sforzesco e Palazzo Reale a Milano," in A. Piva, ed., *BBPR a Milano* (Milan: Electa, 1982), 63 [61–70].
54 Most of the correspondence between March 1957 and April 1958 concerns the logistics behind the payments to the contractor and the architect.
55 Peressutti, letter to Buchanan, 8 July 1957; Canadian Pavilion Venice, 19-4, vol. 1, 1957, NGC Archives.
56 Dinu Bumbaru, "Canadian Pavilion 1958: Remotely Sensing the Place," in Diener & Diener with Gabriele Basilico, eds., *Common Pavilions: The National Pavilions in the Giardini in Essays and Photographs* (Zurich: Verlag Scheidegger & Spiess, 2013), 215–22.
57 See Richard J. Goy, *Venetian Vernacular Architecture: Traditional Housing in the Venetian Lagoon* (Cambridge: Cambridge University Press, 1989).
58 Commonly used in the construction of garden walls, the Flemish bond intersperses the long and short ends of the brick.
59 Adapting the system developed for their Castello Sforzesco museum, BBPR replaced the cruciform inserts with cylindrical ones.
60 *Rosso di Verona* was also used for the round pedestals fabricated for the small outdoor sculpture garden.
61 On BBPR's interaction with craftsmen, see Piva, "Gli edifice della cultura," 64. This propensity was noted at the time by an observant reviewer during the construction of the Olivetti showroom in New York. He/she wrote: "Italians don't have as strict a notion of measured drawings as Americans do. [. . .] And I think Italian architects enjoy ad-libbing more than ours do." "The Talk of the Town: Natural," *The New Yorker*, 5 June 1954, 21–22.
62 According to Luciano Semerami, who worked closely with Rogers, the design of these curls was by Rogers, who proposed to extend the flaps of the I-beams and twist them to imitate the curls that flank the dome of the Venetian Church of Santa Maria della Salute. Luciano Semerami, "Continuità e discontinuità," in *Giornale Iuav*, no. 65 (2009), 3.
63 This statement appears on the back of a set of BBPR's official photos of the pavilion (Archivio Progetti, Iuav). It was taken up by Fenwick, "The New Canadian Pavilion at Venice," 276, and then by Roberto Aloi, *Esposizioni Architetture Allestimenti* (Milan: Ulrico Hoepli, 1960), 115. It appeared in Marco Mulazzani, *I padiglioni della Biennale: Venezia 1887–1988* (Milan: Electa, 1988), 108. For the photographs, see "Il padiglione del Canada alla Biennale di Venezia," *Casabella Continuità*, no. 221 (September–October 1958), 40–45.
64 Bruno Zevi, "Il padiglione BBPR ai Giardini," *La biennale di Venezia* 8, no. 30 (January–March 1958), 46–48. See also Bruno Zevi, "Arredi scarpiani, spaccato BBPR," *L'Espresso*, 29 June 1958, 16. A similar appreciation was made fifteen years later by Paolo Portoghesi in the introduction to the 1973 book by Bonfanti and Porta, *Città, Museo e Architettura*, n.p.
65 Peressutti, letter to Buchanan,

28 October 1956; Canadian Pavilion Venice, 19-4, vol. 1, 1956, NGC Archives.
66 Fenwick, "The New Canadian Pavilion at Venice," 276.
67 Enzo Paci, "Continuità e coerenza dei BBPR," *Zodiac* 4 (1959), 82–115.
68 Steegman, "New Vision at Venice," 38. The same reference was brought up by the Department of Public Works architect in charge of the pavilion's repairs in 1963. Describing the roof structure, W. T. Rutherford noted: "Steel beams laid one on the other in Indian Tee-Pee fashion [. . .]," which would tend to confirm the currency of this equation. Plan of the Canadian Pavilion, Department of Public Works of Canada, 23 February 1963; NGC Archives.
69 Peressutti was undoubtedly aware of Sibyl Moholy-Nagy's articles on anonymous architecture, which culminated in her book *Native Genius in Anonymous Architecture* (New York: Horizon Press, 1957).
70 On these photographs, see Serena Maffioletti, ed., *Enrico Peressutti: Fotografie mediterranee* (Padua: Il Polygrapho, 2010).
71 See Federica Soletta, "Under the Magnifying Glass of History: Enrico Peressutti in Princeton," in Pippo Ciorra and Caterina Padoa Schioppa, eds., *Erasmus Effect: Italian Architects Abroad* (Rome: Quodlibet, 2013), 125–30.
72 A newspaper report recorded that as well as discussing "the exhibit and deal[ing] with modern trends," Peressutti also presented coloured slides of "peasant dwellings built in conical shape." "Italian Architecture Topic of Address," *Ottawa Journal*, 27 November 1953, 2. According to his biography, Peressutti lectured on "spontaneous architecture" at Harvard in 1956 and 1957. Bonfanti and Porta, *Città, Museo e Architettura*, 140.
73 In his 2007 essay titled "A Wigwam in Venice," Michelangelo Sabatino argues that the Canadian cultural context, as well as NGC officials, encouraged the design of a building inspired by Indigenous architecture as an alternative to English or French models. Though acknowledging that he found no statement from the client to support this claim, the author maintains that the form of the building is the result of an institutional intention. In a subsequent article, Sabatino revised his reading, now suggesting that the inspiration was a tepee rather than a wigwam. Since this second essay focuses on a member of BBPR, this version privileges the deciding role of the designer. Newly discovered documents would seem to confirm Sabatino's intuition that the tepee was a significant design source. But our respective interpretations diverge on the conclusions that can be drawn from the import of Indigenous architecture on the design of the pavilion. See Sabatino, "A Tipi in Venice: BBPR's Canadian Pavilion for the Biennale (1954–58)," in Chiara Baglione, ed., *Ernesto Nathan Rogers 1909–1969* (Milan: FrancoAngeli, 2012), 261–70.
74 Ernesto N. Rogers, "Continuità o crisi?," *Casabella Continuità*, no. 215 (April–May 1957), 3–4.
75 Reyner Banham, "Neoliberty: The Italian Retreat from Modern Architecture," *Architectural Review* 125 (April 1959),

230–35. See also Manuel Lopèz Segura, "Neoliberty & Co. *The Architectural Review* against 1950s Italian historicism," *Cuadernos de Proyectos Arquitectonicos*, no. 4 (2013), 136–39.
76 Ernesto N. Rogers, "L'evoluzione dell'architettura. Risposta al custode dei frigidari," *Casabella Continuità*, no. 228 (June 1959), 2–4.
77 This position was well argued in Ernesto N. Rogers's long introduction to G. E. Kidder Smith, *Italy Builds / L'Italia Costruisce: Its Modern Architecture and Native Inheritance* (New York: Reinhold, 1955), 9–14.
78 Peressutti praised Wright's Fallingwater in his 1956 interview with John Peter (*Oral History of Modern Architecture*, 89). He also later expressed great admiration for the Solomon R. Guggenheim Museum. For Zevi, the pavilion's "open-form structure" was proof of BBPR's subtle transition from Rationalism—still present in their 1951 US Pavilion—to a new kind of modern organicism. See Bruno Zevi, "Arredi scarpiani, spaccato BBPR."
79 Peressutti singled out the Farnsworth House in his 1956 interview with John Peter (*Oral History of Modern Architecture*, 89).
80 Completed in 1955, the Ronchamp Chapel was a revolution in the world of modern architecture. In Italy, it was discussed with great fascination and acuteness by none other than Ernesto Rogers, who paid great attention to the design method of Le Corbusier. See Ernesto N. Rogers, "Il metodo di Le Corbusier e la forma della Chapelle de Ronchamp," *Casabella Continuità*, no. 207 (September–October 1955), 2–6.

The Life and Times of the Canada Pavilion
Josée Drouin-Brisebois

1 For a complete list of exhibitions presented in the Canada Pavilion between 1958 and 2018, see the chronology in this volume.
2 For discussion about the art-selection process from 1952 to 1986, see Carol Harrison Reesor, "The Chronicles of the National Gallery of Canada at the Venice Biennale," M.A. thesis, Department of Art History, Concordia University, 1995.
3 In some of the early Biennale catalogues it is even stated which works by Canadian artists were available for sale. In 1952 works by Emily Carr, David Milne, and Alfred Pellan were available; and in 1958 the catalogue entry mentions that additional proofs of Jack Nichols' lithographs were available from the artist. One might argue that this service fit well with the idea that the Biennale could provide international opportunities for Canadian artists.
4 From the late 1950s through the 1970s, many countries presented group exhibitions. The Venice Biennale awarded prizes between 1948 and 1968 in different disciplines (painting and sculpture, graphic arts), which would arguably have influenced the decision to showcase group exhibitions. A comparative analysis between the representation of Canada and other nations remains outside the scope of the current essay.

5 The exhibition included twenty-two paintings by Morrice produced between 1900 and 1922; eleven paintings by de Tonnancour realized between 1944 and 1958; five sculptures by Kahane created between 1954 and 1957; and seven prints by Nichols produced in 1957.
6 In 1947 Donald Buchanan began working for the Gallery in various capacities, among them establishing and directing the Industrial Design Division (part of the Gallery at the time), a role that was formalized in 1951 with the title Chief. He was promoted to Associate Director, 1955–59, 1960; Acting Director (1959–60); and Board Member, 1963–66. Alan Jarvis was the Gallery's Director from 1955 to 1959.
7 Alan Jarvis, *Canada XXIX Biennale di Venezia* (Ottawa : NGC, 1958), n.p.
8 It is interesting to note that in the years leading up to 1958 the Venice Biennale had invited Canada to showcase its artists in the Italian Pavilion. Jarvis and Buchanan were in fact writing a narrative by approaching each new Biennale as an opportunity to continue telling the story of Canadian art, chapter by chapter. For example, Jacques de Tonnancour's work is described in relation to Goodridge Roberts and Alfred Pellan, both of whom had shown in Venice in 1952 alongside Emily Carr and David Milne.
9 The partition screens could increase the running wall space from 31 to 67 metres.
10 NGC Board of Trustees, "Minutes of the 87th Meeting of the Trustees," 18–19 September 1957, typescript, 834; NGC Library and Archives.
11 Three Canadian exhibitions were presented in the Italian Pavilion: in 1952, Emily Carr, David Milne, Goodridge Roberts, and Alfred Pellan were represented by a total of eighteen works; in 1954, thirteen works by Bertram Charles Binning, Paul-Émile Borduas, and Jean Paul Riopelle were on display; and, in 1956, twenty-five works by Louis Archambault, Jack Shadbolt, and Harold Town were featured.
12 Yves Gaucher also showed twelve paintings.
13 Jarvis, *Canada XXIX Biennale di Venezia*; Robert H. Hubbard, "Canada," in *XXX Biennale Internazionale d'arte, Venezia, 18 guigno–16 ottobre 1960* (Venice: La Biennale, 1960), 201–202; and Charles F. Comfort et al., *XXXII Biennale di Venezia, 1964: Harold Town and Elza Mayhew* (Ottawa: NGC, 1964), n.p.
14 Brydon Smith was appointed NGC Curator of Contemporary Art in 1967, a position he held until 1979, when he became Chief Curator and Assistant Director of Collections and Research. From 1994 until 1999 he was Curator of Modern Art.
15 Brydon Smith, *Ulysse Comtois, Guido Molinari, XXXIV International Biennial Exhibition of Art, Venice* (Ottawa: NGC, 1968), 5.
16 Ibid.
17 Brydon Smith, *Michael Snow, XXXV International Biennial Exhibition of Art, Venice* (Ottawa: NGC, 1970), 3.
18 Smith, *Ulysse Comtois, Guido Molinari*, 5. Emphasis added.

19 Smith, *Michael Snow*, 3.
20 Brydon Smith, "Canadian Artists," *Globe and Mail*, 12 September 1970. Reply to Bruce L. Smith of Owen Sound, quoted in Reesor, "The Chronicles of the National Gallery of Canada at the Venice Biennale," 44.
21 The films were shown at the Cinema Olimpia.
22 John Russell, "Venice Resurgent," *Sunday Times* (London), 28 June 1970.
23 Ibid.
24 First appointed Assistant Curator of Canadian Art at the NGC in 1966, Pierre Théberge was Curator/Acting Curator of Contemporary Canadian Art from 1970 to 1979 (it is not clear why Théberge's title changed from Curator to Acting Curator. It may have had something to do with the structure of the curatorial departments, which were changing during this period). He later became NGC Director (1998–2009).
25 In his introduction to the Biennale catalogue, Chairman Giuseppe Galasso wrote: "This edition concerns itself with an unusual, thought-provoking theme: a retrospective view of the art of the seventies." In *La Biennale di Venezia* (Venice: La Biennale di Venezia, 1980), 9.
26 Hsio-Yen Shih, "Preface," in Bruce Ferguson, *Canada Video: Colin Campbell, Pierre Falardeau / Julien Poulin, General Idea, Tom Sherman, Lisa Steele. XXXIX International Biennial Exhibition of Art, Venice, 1980* (Ottawa: NGC, 1980), n.p. Hsio-Yen Shih was Director of the NGC from 1977 to 1981.
27 Bruce Ferguson in conversation with the author, 18 July 2018. Ferguson was Assistant Curator of Contemporary Canadian Art at the NGC from 1978 to 1979. He worked on contract for the 1980 Biennale.
28 Ferguson, *Canada Video*, 9. Ferguson also mentioned that "The National Gallery's collection of video work and the Vancouver Art Gallery's appointment of a video curator are among the few exceptions to the conventional museum system's estimate of the alternative system's importance in contemporary Canadian art."
29 The publication features essays, biographies, selected bibliographies, descriptions of the Canadian video works in the Biennale, a list of video resource centres, as well as more than fifty black-and-white illustrations.
30 Following the 1972 example set by Walter Redinger, who installed some of his sculptures in Piazza San Marco, Krzysztof Wodiczko presented his works—monumental projections on buildings—outside of the Giardini. In this particular exhibition, curator Diana Nemiroff was interested in the debate about the role of public art, and paired Melvin Charney with Wodiczko. Nemiroff's NGC career began in 1984, when she was appointed Assistant Curator of Contemporary Art. In 1990, she was promoted to Curator of Contemporary Art, and from 2000 until 2005 she was Curator of Modern Art.
31 According to Chantal Pontbriand, a first plan was to realize a site-specific project in Piazza San Trovaso near the church situated close to the Accademia and to use the Canada Pavilion as an

information office, but the project had to be abandoned due to lack of production time. Email to the author's research assistant, 28 March 2018.
32 Chantal Pontbriand, *Geneviève Cadieux: Canada XLIV Biennale di Venezia, 1990* (Montreal: Éditions Parachute, 1990), 78.
33 Ibid. Cadieux's exhibition is one of only a few that have featured photography.
34 Sarah Milroy, "Collage: Venice the Menace," *Canadian Art* 5, no. 2 (Summer/June 1988), 23.
35 John Bentley Mays, "Canada's ugly art pavilion ripe for the wrecker's ball," *Globe and Mail,* 1 June 1990, A21. Original emphasis.
36 Ibid.
37 Loretta Yarlow, "Foreword," in Rodney Graham, ed., *Island Thought: Canada XLVII Biennale di Venezia* (North York: Art Gallery of York University, 1997), 3.
38 Ibid.
39 Rodney Graham, "Siting Vexation Island," in *Island Thought*, 17.
40 In 1996 the US Pavilion presented *Building a Dream: The Art of Disney Architecture*.
41 Interestingly, video became the medium of choice for the next twelve years, notable exceptions being the work of sculptors Tom Dean (1999) and David Altmejd (2007).
42 On the 1968 exhibition, see Léa-Catherine Szacka, "The Architectural Public Sphere," *Multi* 2, no. 1 (Winter 2008), 19–34, 25–26.
43 The architecture exhibitions took place in 1980, 1981, 1985, 1986, 1991, 1996, and every two years from 2000 to 2018.
44 This was the second time Melvin Charney represented Canada; the first was at the 1986 Art Biennale.
45 Lateral Office, "Modernity at an Edge," in *Arctic Adaptations: Nunavut at 15* (Toronto: Lateral Office, 2014), 5.
46 Paolo Baratta, https://www.labiennale.org/en/architecture/2016/biennale-architettura-2016-reporting-front [accessed 25 March 2019].
47 Robert Enright, "What's at Stake? The Canadian Presence at the 2016 International Architecture Exhibition, An Interview with Pierre Bélanger," *Border Crossings Magazine* 35, no. 2 (June 2016), https://bordercrossingsmag.com/article/whats-at-stake-the-canadian-presence-at-the-2016-international-architecture [accessed 25 March 2019]. Bélanger worked in association with his OPSYS Landscape Infrastructure Lab, the architectural firm RVTR, Nina-Marie Lister (Ecological Design Lab, Ryerson University), and Kelsey Blackwell (Studio Blackwell).
48 Louise Déry, *David Altmejd: The Index, La Biennale di Venezia, 52nd International Art Exhibition* (Montreal: Galerie de l'UQAM, 2007), 23.
49 Louise Déry, quoted in Peter Goddard, "So This Is What $1.1 Million Buys Us," *Toronto Star,* 9 June 2007.
50 This section is an abridged version of my essay from the exhibition catalogue *Steven Shearer: Exhume to Consume, La Biennale di Venezia, 2011* (Ottawa: NGC, 2011), 71–80.
51 Josée Drouin-Brisebois, "Exhume to Consume: An Interview with Steven Shearer," in *Exhume to Consume*, 143–44.

The description was mentioned earlier in the discussion of Rodney Graham, who had referred to the pavilion as an outbuilding for the surrounding pavilions (this comparison has been made by art critics as well).

52 Ibid., 144.

53 Ibid.

54 Kitty Scott, *Geoffrey Farmer: A Way Out of the Mirror, Biennale di Venezia, 2017* (Ottawa: NGC / Milan: Mousse Publishing, 2017), 227.

55 Unpublished statement by Geoffrey Farmer sent to the author, September 2016.

56 The funds actually came from blocked funds for repayment of civilian relief given by Canada. On this subject, see Cammie McAtee's essay in this volume.

57 Unpublished statement by Farmer.

58 For an analysis of the landscaping project, see Franco Panzini's essay in this volume.

59 For an analysis of the restoration project, see Susanna Caccia Gherardini's essay in this volume.

60 Paolo Baratta, President, La Biennale di Venezia, interview by Réjean Legault for the NGC, 1 March 2018.

"A careful, museum-quality restoration": Rethinking and Rebuilding the Canada Pavilion
Susanna Caccia Gherardini

1 Ignasi de Solà-Morales Rubio, *Mies van der Rohe: Barcelona Pavilion* (New York: Watson Guptil Publications, 1993).

2 On the topic of temporary architecture and "building the unbuilt," see Neil Levine, "Building the Unbuilt: Authenticity and the Archive," *Journal of the Society of Architectural Historians* 67, no. 1 (March 2008), 14–17.

3 Audrey Rieber, *Art, histoire et signification: Un essai d'épistémologie d'histoire de l'art autour de l'iconologie d'Erwin Panofsky* (Paris: L'Harmattan, 2012), 234–46.

4 On this, see Antoine Lilti, *Autour de figures publiques: L'invention de la célébrité 1750–1850* (Paris: Fayard, 2014).

5 Roberto Tognazzi, Mayor of Venice, letter to Pierre Dupuy, Canadian ambassador to Italy, 26 March 1957; Archives of the Canadian Embassy in Rome. The proposal to move the entire building did not displease the designers themselves, to judge from Lodovico Belgiojoso's comments: "In view of our pavilion's structural features, it might at some stage need to be moved and its small size means that it would not be detrimental to the landscape at all in the position suggested." Belgiojoso, letter to Rodolfo Pallucchini, 15 December 1956; Archivio Storico delle Arti Contemporanee, Porto Marghera. On the circumstances behind the project's approval, see essays by Réjean Legault and Franco Panzini in this volume.

6 Linda Aimone and Carlo Olmo, *Les Expositions Universelles, 1851–1900*, trans. Philippe Olivier (Paris: Belin, 2002 [1993]), 53–56.

7 On the indiscriminate use in architectural literature of the term restoration of the modern rather than restoration of the contemporary, see Susanna Caccia, "Contemporaneo," in Chiara Dezzi Bardeschi, ed., *Abbeceddario Minimo:*

'Ananke: Cento voci per il restauro (Florence: Altralinea Edizioni, 2017), 43–46.

8 Maurizio Ferraris, *Documentality: Why It Is Necessary to Leave Traces*, trans. Richard Davies (New York: Fordham University Press, 2013 [2009]).

9 Gérard Genette, *Palimpsests: Literature in the Second Degree*, trans. Channa Newman and Claude Doubinsky (Lincoln: University of Nebraska Press, 1997 [1982]).

10 Perhaps the most complete example dates from 2012: *Créations d'atelier: L'éditeur et la fabrique de l'œuvre à la Renaissance*, Colloquium organized by Anne Réach-Ngô (Atelier XVIe siècle de Paris-Sorbonne), 1–2 June 2012, Paris.

11 On *jeux d'échanges*, see Fernand Braudel, *Civilization and Capitalism, 15th–18th century. Vol. 2: The Wheels of Commerce*, trans. Sian Reynolds (Berkeley: University of California Press, 1992 [1979]).

12 Étienne Anheim and Olivier Poncet, "Fabrique des archives, fabrique de l'histoire," *Revue de Synthèse* 125, no. 1 (October 2004), 1–14.

13 On the use and abuse of photographs in the restoration of modern architecture, see Susanna Caccia Gherardini, "La posizione delle immagini: Restauration fidèle fotografia cinema nell'opera architettonica di Le Corbusier / About images position: Restauration fidèle photography cinema in Le Corbusier works," in Annunziata Berrino and Alfredo Buccaro, eds., *Delli Aspetti de Paesi: Vecchi e nuovi media per l'immagine del paesaggio / Old and New Media for the Image of the Landscape* (Naples: CIRICE, 2016), 839–50.

14 Anna Crespi, "Intervista a Alberico Barbiano di Belgiojoso," 3 February 2014; http://blog.amicidellascala.it/intervista-alberico-belgiojoso/ [accessed 19 June 2019].

15 Giuliano Gresleri, "L'enigma della ricostruzione vent'anni dopo," in Luisella Gelsomino, ed., *Il Padiglione dell'Esprit Nouveau e il suo doppio: Cronaca di una ricostruzione* (Florence: Alinea, 2000), 49–78.

16 On this unrealized project, see Sven Sterken, "New Media and the Obsolescence of Architecture: Exhibition Pavilions by Le Corbusier, Xenakis, Stockhausen, and E.A.T.," *Interior Design, Architecture, Culture* 3 (2012), 127–42.

17 Susanna Caccia Gherardini, *Le Corbusier dopo Le Corbusier: Retoriche e pratiche nel restauro dell'opera architettonica* (Milan: FrancoAngeli, 2014), 99–209.

18 Carlo Olmo and Susanna Caccia Gherardini, "Le Corbusier e il fantasma patrimoniale. Firminy-Vert: tra messa in scena dell'origine e il restauro del non finito," *Quaderni Storici* 50, no. 150 (2015), 689–722. See also Levine, "Building the Unbuilt."

19 Marco Dezzi Bardeschi, "Conservare non Riprodurre il Moderno," *Domus* 649 (April 1984), 10–14.

20 On the phenomenon of "collecting" Prouvé's Maisons Tropicales, see among others, Christoph Rausch, "Maisons Tropicales/Maisons Coloniales: Contesting Technologies of Authenticity and Value in Niamey, Brazzaville, Paris, New York and Venice," *International Journal of Heritage Studies* 24, no. 1 (2018), 83–100.

21 As recently theorized by Luc Boltanski and Arnaud Esquerre in their study *Enrichissement: Une critique de la marchandise* (Paris: Gallimard, 2017), especially 265–72.

22 Nathalie Heinich, *La fabrique du patrimoine: De la cathédrale à la petite cuillère* (Paris: Ed. de la Maison de Sciences de l'Homme, 2009).

23 Carlo Ginzburg, *Rapports de force: histoire, rhétorique, preuve*, trans. Jean-Pierre Bardos (Paris: Gallimard Le Seuil, 2003 [2001]).

24 On Canadian national identity in the context of international art exhibitions and the Venice Biennale, see Francine Couture, "L'exposition de la modernité artistique, lieu de construction de l'identité nationale," *RACAR: Canadian Art Review* 21, no. 1/2 (1994), 32–42; Sandra Paikowsky, "Constructing an Identity: The 1952 XXVI Biennale di Venezia and 'The Projection of Canada Abroad,'" *Journal of Canadian Art History* 20, no. 1/2 (1999), 130–81; and Michelangelo Sabatino, "A Wigwam in Venice: The National Gallery of Canada Builds a Pavilion, 1954–1958," *Journal of the Society for the Study of Architecture in Canada* 32, no. 1 (2007), 3–14.

25 "Meetings with Soprintendenza and Biennale, 5th and 6th May 2015," in Canada Pavilion—Biennale Venezia. Preliminary Design, June 2015, 33; Studio Belgiojoso.

26 Renata Codello, letter to Marc Mayer, 5 August 2010, reproduced in Canada Pavilion—Biennale Venezia, March 2014; Studio Belgiojoso.

27 See Bruno Zevi's discussion of "Organic Space of Our Time," in *Architecture as Space: How To Look at Architecture*, trans. Milton Gendel (New York: Horizon Press, 1957 [1948]), 140–59.

28 On the four horizons on the site of the Ronchamp Chapel, see Danièle Pauly, *Le Corbusier: La Chapelle de Ronchamp/ The Chapel at Ronchamp* (Basel: Birkhäuser, 1997).

29 Elisa Brilli, "L'essor des images et l'éclipse du littéraire: Notes sur l'histoire et sur les pratiques de l'histoire des représentations,'" *L'Atelier du Centre de recherches historiques* 6 (2010), https://journals.openedition.org/acrh/2028 [accessed 22 May 2019].

30 On this theory see Ferraris, *Documentality*.

31 Pierre Nora, "Pour une histoire au second degré," *Le Débat* 122 (2002), 24–31. See also Felipe Brandi, "L'avènement d'une 'histoire au second degré,'" in *L'Atelier du Centre de recherches historiques*, 7 (2011), https://journals.openedition.org/acrh/3749 [accessed 22 May 2019].

32 Copyright is linked to Napoleonic legislation regarding property rights, but it is above all a social construct, as Paolo Grossi argues in *L'invenzione del diritto* (Bari: Laterza, 2017).

33 "Introduction," in Canada Pavilion—Biennale Venezia, March 2014; Studio Belgiojoso.

34 "For Soprintendenza it's very important the continuity of the same architect firm of the original pavilion in the design of the extension." "Soprintendenza. Meeting of March 24th, 2014," in Canada Pavilion—Biennale Venezia, March 2014; Studio Belgiojoso.

35 See the introductory chapter, "Architecture—The Unknown," in Zevi, *Architecture as Space*, 15–21. On Peressutti as designer of the Canada Pavilion, see essays by Serena Maffioletti and Réjean Legault in this volume.

36 See Susanna Caccia and Carlo Olmo, *La Villa Savoye: Icona, rovina, restauro (1948–1968)* (Roma: Donzelli, 2016).

37 Sébastien Dubois, "Mesurer la réputation," *Histoire & Mesure* 2 (2008), 103–43.

38 Final approval was given on 8 June 2017, as notified by the Soprintendenza. Belgiojoso received technical assistance from Studio M+B of Venice, founded in 1999 by Daniela Iride Murgia and Troels Bruun, and from Francesco Toaldo with regard to matters pertaining to the building site.

39 The solutions considered and developed are documented in the project dossier Canada Pavilion—Biennale Venezia, March 2014; Studio Belgiojoso.

40 For the three proposals, see especially dossiers for February, March, September, and December 2014 (Studio Belgiojoso). The Soprintendenza outlined a series of alternatives: "An opportunity could be that in our external space, a temporary construction would be allowed, for just the time of the exhibition, and then disassembled in the interval between one exhibition and the other [...]. It could be [...] considered by the Biennale a 'special site,' due to the view from the Biennale space to the outside and to the Laguna; being the only point were this is possible, the Biennale could decide (and they told us this is already under consideration) to put there a facility like a bar or a kind of kiosk; in this case it could be arranged with Canada for a collaboration; and in exchange allow for the possibility of using part of that space, at least temporarily." "Soprintendenza and Biennale. Meeting of February 25th, 2014," in Canada Pavilion—Biennale Venezia, March 2014; Studio Belgiojoso.

41 "Soprintendenza. Meeting of March 24th, 2014," in Canada Pavilion—Biennale Venezia, March 2014; Studio Belgiojoso.

42 Carlo Ginzburg, *Threads and Traces: True, False, Fictive*, trans. Anne C. Tedeschi and John Tedeschi (Berkeley: University of California Press, 2012 [2006]).

43 The report detailed: "Refurbishing of existing building is based on: on the roof: new waterproofing with thermal insulation and elastoplastomeric bitumen polymer membrane and replacement of flashing; new zinc-titanium roofing system; existing windows refurbishing and painting; existing wood false ceiling and mullions refurbishing; on the external walls: replacement of bricks on the façade where necessary, and replacement and restoration of original wood/steel/glass walls; remaking of glass frame on the courtyard and interior trees exactly in the same shape to improve airtightness; wall painting; repair of terrazzo floor; conservation and repair of paving of the courtyard; upgrade of electrical equipment; of cooling system (adding a new chiller), cleaning and maintenance of the existing." Analysis of the original project and restoration of existing building in Canada Pavilion—

Biennale Venezia. Preliminary Design, June 2015; Studio Belgiojoso.

44 Reference to the outstanding position, with "view onto the lagoon" recurs several times in the dossiers.

45 On this issue, see François-Ronan Dubois, "La Princesse de Clèves: Le problème de l'originalité dans la construction de l'identité," *Philological Studies and Research: Romance Languages Series* 4, no. 10 (2011), 54–69.

46 "Canada is prepared to invest in a careful, museum-quality restoration of its original structure, but insists that it concurrently adds essential display space." "Meetings with Soprintendenza and Biennale 5th and 6th May 2015," in Canada Pavilion—Biennale Venezia. Preliminary Design, June 2015; Studio Belgiojoso.

47 Canada Pavilion—Biennale Venezia—Restoration of the Existing Pavilion, October 2016; Studio Belgiojoso.

48 The report submitted for approval dates from October 2016 and was followed by a further program in early 2017.

49 "The Restoration Program," in Canada Pavilion—Biennale Venezia—Restoration of the Existing Pavilion, October 2016; Studio Belgiojoso.

50 The architect Troels Bruun has been involved in the restoration and maintenance of several other national pavilions in the Giardini, among them those of Austria, Denmark, and Greece, since 1995.

51 Notes and remarks on sheet "Pianta e Detagli" dated January 1957, Studio BBPR, Venezia padiglione del Canada alla Biennale; Archivio Progetti, Università Iuav di Venezia.

52 The restoration of the building's brick surfaces was performed by the Unione Stuccatori Veneziani (Uni.S.Ve.).

53 The "naked" frame of the roof, with the reinforced concrete pillar and the seven beams with different sections and lengths was clearly visible at the 2017 Biennale when the pavilion housed Geoffrey Farmer's installation.

54 The 7/10-mm-thick zinc-copper-titanium (zintek®) membrane is fixed with anchoring clips. Waterproofing is provided by a wicker-type partition layer and a waterproof cloth set under the roof cladding. The company Zintek has operated a plant in the Venetian region since 1936.

55 In addition, an internal false ceiling made of a metal framework and double sheets of Gyproc Saint Gobain fibreglass-reinforced gypsum for a total thickness of 100 mm was inserted between the roof and the visible wooden ceiling. A 4-mm layer of skim coating was applied over the entire surface using plaster reinforced with a fibreglass mesh.

56 With regard to the "respect" due to the two existing trees, Zevi had this to say: "The BBPR architects have understood that although they were eliminating a piece of the landscape, they should at least avoid closing off the area defined by the French, English and German pavilions and respect the trees. With their usual intelligence, they created a low building, placed askew and in a different style with respect to the other pavilions." Bruno Zevi, "Arredi scarpiani, spaccato BBPR," *L'Espresso*, 29 June 1958, 16.

57 More precisely, the terrazzo floor was mechanically smoothed and pointed and given a final polish by mechanical means using a special powder. Cracks over 2 cm wide were filled with small stones of the same colour and size as the existing ones.

58 On the relationship between word and thing, see Carlo Olmo, *Città e democrazia: Per una critica delle parole e delle cose* (Roma: Donzelli, 2018).

59 Some of Dewey's thoughts on an artwork's material reality and on the technical and material means the artist uses to express his emotions apply today more than ever in the debate on the restoration of the modern. See John Dewey, *Art as Experience* (New York: Minton, Balch, 1934).

60 Georges Didi-Huberman, *The Eye of History: When Images Take Positions*, trans. Shane B. Lillis (Cambridge, Mass.: MIT Press, 2018 [2009]).

61 See Franz Graf, *Histoire matérielle du bâti et projet de sauvegarde: Devenir de l'architecture moderne et contemporaine* (Lausanne: Presses Polytechniques et Universitaires Romandes, 2014).

62 In a certain sense, what lies at the heart of the question of semantic shift is the "legitimacy of the action"; on this, see Hans Blumenberg, *The Legitimacy of the Modern Age*, trans. Robert M. Wallace (Cambridge, Mass.: MIT Press, 1983 [1966]).

63 Susanna Caccia Gherardini, "Les 'mots-matière': Alcune riflessioni tra glossario e linguaggio scientifico per il restauro," in Milagros Palma Crespo et al., *ReUSO, Granada 2017. Sobre una arquitectura hecha de tiempo, Vol. 1* (Granada: Universidad de Granada, 2017), 115–22.

"The Venetians are jealous of every tree": The Canada Pavilion and the Giardini della Biennale
Franco Panzini

I wish to thank the agronomist and landscape architect Marco Tosato for his generosity in providing me with information about the overall state of the vegetation in the Giardini della Biennale and about the restoration work carried out in the area surrounding the Canada Pavilion.

1 Edward Osborne Wilson, *Biophilia* (Cambridge: Harvard University Press, 1984).

2 From the introduction to the first project outline by Cornelia Hahn Oberlander and Enns Gauthier Landscape Architects, "Creating a Setting for the Canada Pavilion at the Venice Biennale," Canada Pavilion, Venice: Design Explorations (July 2016), n.p.

3 On Giannantonio Selva's design, see Giandomenico Romanelli, "Progetti di Giannantonio Selva per il giardino pubblico a Castello," in Lionello Puppi and Giandomenico Romanelli, eds., *Le Venezie possibili: Da Palladio a Le Corbusier* (Milan: Electa, 1985), 158–60; Vincenzo Fontana, "Giardini pubblici di Castello, Venezia," in Margherita Azzi Visentini, ed., *Il giardino veneto. Dal tardo Medioevo al Novecento* (Milan: Electa, 1988), 175–79; Mariapia Cunico, "Alcuni pensieri sui giardini di Giannantonio Selva a Venezia," in *Parchi e Giardini Storici, Parchi Letterari: Atti del II*

Convegno Nazionale (Monza: Ministero per i Beni Culturali e Ambientali, 1992), 227–33; and Franco Panzini, *Per i piaceri del popolo. L'evoluzione del giardino pubblico in Europa dalle origini al XX secolo* (Bologna: Zanichelli, 1993), 127–29.

4 Giannantonio Selva, quoted in Cunico, "Alcuni pensieri sui giardini di Giannantonio Selva a Venezia," 228.

5 In 1867 Karl Baedeker published the first guide to the region, *Northern Italy, as far as Leghorn, Florence, and Ancona, and the Island of Corsica* (Coblenz: K. Baedeker / London: Williams & Norgate).

6 On the origins of Venice's legendary status, see David Barnes, *The Venice Myth: Culture, Literature, Politics, 1800 to the Present* (London: Pickering & Chatto, 2014).

7 On the transformation of the Giardini della Biennale over the years, see Tiziana Favaro and Francesco Trovò, eds., *I Giardini napoleonici di Castello a Venezia. Evoluzione storica e indirizzi* (Venice: Libreria Cluva Editrice, 2011); and Federica Martini and Vittoria Martini, "The Giardini: Topography of an Exhibition Space," in *Alfredo Jaar: Venezia Venezia* (New York and Barcelona: Actar, 2013), 24–33.

8 On the architecture of the pavilions, see Marco Mulazzani, *I padiglioni della Biennale: Venezia 1887–1988* (Milan: Electa, 1988) translated as *Guide to the Pavilions of the Venice Biennale since 1887* (Milan: Electa, 2014).

9 Ernesto Rogers's design appears as anonymous; the racial laws prevented Rogers practising as an architect owing to his Jewish background. See Serena Maffioletti, *BBPR* (Bologna: Zanichelli, 1994), 84–85.

10 In "Il paesaggio ideale per la casa dell'arch. Enrico Peressutti," *Domus* no. 176 (August 1942), 313.

11 Ibid., 314.

12 See Franco Panzini, "Working with Architects: Collaborations, 1937–60," in Marc Treib and Luigi Latini, eds., *Pietro Porcinai and the Landscape of Modern Italy* (Farnham: Ashgate Publishing, 2015), 144–79.

13 On the circumstances of the commission, see Cammie McAtee's essay in this volume.

14 Rodolfo Pallucchini, letter to Alan Jarvis, 26 January 1956; 19-4, vol. 1, 1956, Canadian Pavilion Venice, NGC Library and Archives [hereafter NGC Archives].

15 Enrico Peressutti, letter to Donald W. Buchanan, 23 March 1956; 19-4, vol. 1, 1956, Canadian Pavilion Venice, NGC Archives.

16 Ibid.

17 Peressutti, letter to Buchanan, 28 October 1956; 19-4, vol. 1, 1956, Canadian Pavilion Venice, NGC Archives.

18 Pierre Dupuy, letter to Roberto Tognazzi, 9 February 1957; Archives of the Canadian Embassy in Rome.

19 Tognazzi, letter to Dupuy, 26 March 1957; Archives of the Canadian Embassy in Rome.

20 See, among others, Michelangelo Sabatino, "A Wigwam in Venice: The National Gallery of Canada Builds a Pavilion, 1954–1958," *Journal of the Society for the Study of Architecture in Canada* 32, no. 1 (2007), 3–14; and Joel Robinson, "Folkloric Modernism: Venice's Giardini della Biennale and the

Geopolitics of Architecture," *Open Arts Journal*, no. 2 (Winter 2013–14), 1–24. For a discussion of this interpretation, see Réjean Legault's essay in this volume.

21 The lush and invasive vegetation that grew over the site was mainly made up of privet and laurel, both evergreen shrubs that had been used in the past to form hedges within the gardens.

22 Oberlander and Enns Gauthier Landscape Architects, "Creating a Setting for the Canada Pavilion at the Venice Biennale," n.p.

23 The project was spearheaded by Joanna Woods-Marsden, NGC Coordinator of International Exhibitions, NGC Archives.

24 The project for a new walkway behind the pavilions of Russia, Korea, Germany, Canada, Great Britain, and France was realized between 2016 and 2018. The project team of the Biennale's Servizi Tecnico-Logistici department included team leader, Cristiano Frizzele, Director of Servizi Tecnico-Logistici; architectural and landscape project, Cristiano Frizzele, Marco Tosato, Cinzia Bernardi, Elisa Roncaccia; project engineer, Enzo Magris; site managers for lot n.1, Andrea Ferialdi, Marco Tosato; site manager for lot n.2, Marco Tosato.

25 Oberlander and Enns Gauthier Landscape Architects, "Foreword," Canada Pavilion, Venice: Final Phase 2 Design Guidelines (5 January 2018), 5.

26 The Giardini della Biennale are subject to multiple levels of regulations. In 1985 the whole area was placed under legal protection by the new environmentally protective prescriptions imposed on the historic centre of Venice and the islands of the lagoon (Decreto Ministeriale 1.08.1985). In 1998 the national pavilions of the Biennale with over fifty years from the date of construction were designated as cultural monuments by a decree of the Ministry of Culture (Decreto Ministeriale 19.09.1998). In 2004 the so-called "Codice dei beni Culturali e del Paesaggio" (Code of Cultural Heritage and Landscape) further increased the protection of areas of historical interest owned by a public body (Decreto Legislativo 22.01.2004). On the impact of these regulations on the restoration of the Canada Pavilion, see Susanna Caccia Gherardini's essay in this volume.

27 The Soprintendenza is the regional authority of the Ministero dei Beni e delle Attività Culturali e del Turismo based in Rome.

28 ICOMOS-IFLA, Florence Charter on Historic Gardens, article 12, 1981 (adopted December 1982); https://www.icomos.org/charters/gardens_e.pdf [accessed 1 April 2019]. On the Florence Charter, see Patricia M. O'Donnell, "Florence Charter on Historic Gardens (1982)," in Claire Smith, ed., *Encyclopedia of Global Archaeology*, (New York: Springer, 2014), 2812–17.

29 Robert Z. Melnick, "Climate Change and Landscape Preservation: A Twenty-First-Century Conundrum," *APT Bulletin: The Journal of Preservation Technology* 40, no. 3–4 (2009), 40.

30 Ron Williams, *Landscape Architecture in Canada* (Montreal: McGill-Queen's University Press, 2014), 396.

31 Susan Herrington, "Restoring a Modern Landscape in the Anthropocene:

Cornelia Hahn Oberlander," *APT Bulletin: The Journal of Preservation Technology* 47, nos. 2–3 (2016), 27.

32 Nancy Baele, "Northern Terrain: National Gallery of Canada, Ottawa," *Landscape Architecture Magazine* 78, no. 8 (December 1988), 38–40. Also quoted in Susan Herrington, *Cornelia Hahn Oberlander: Making the Modern Landscape* (Charlottesville and London: University of Virginia Press, 2013), 165–66.

Interview with Cornelia Hahn Oberlander

1 World Commission on Environment and Development, *Our Common Future* (Oxford: Oxford University Press, 1987).

2 From *Rewilding Europe*, working definition published 24 June 2015; https://rewildingeurope.com/ [accessed 10 February 2019].

3 The new Fred & Elizabeth Fountain Garden Court.

4 Edward Osborne Wilson, *Biophilia* (Cambridge: Harvard University Press, 1984).

Bibliography

Prepared by Cammie McAtee with the assistance of Nicole Burisch

This chronological bibliography focuses on published sources, theses, and dissertations that offer commentary on the history, reception, and interpretation of the Canada Pavilion. It does not include all the catalogues for or reviews of Canadian exhibitions at the Venice Biennale.

Buchanan, Donald W. "The Biennale of Venice Welcomes Canada." *Canadian Art* 9, no. 4 (Summer 1952), 144–47.

Hubbard, Robert H. "Show Window of the Arts – XXVII Venice Biennale." *Canadian Art* 12, no. 1 (Autumn 1954), 14–20, 35.

"Coast to Coast in Art: A Pavilion for Canadian Art in Venice." *Canadian Art* 13, no. 3 (Spring 1956), 303–04.

Hubbard, Robert H. "Days at the Fair – A Review of the Venice Biennale 1956." *Canadian Art* 14, no. 1 (Autumn 1956), 21–27.

Buchanan, Donald W. "Canada Builds a Pavilion in Venice." *Canadian Art* 15, no. 1 (January 1958), 29–31.

"Le Canada aura son pavillon, cet été, à la Biennale de Venise." *La Presse*, 28 February 1958.

Zevi, Bruno. "Il Padiglione BBPR ai Giardini." *La Biennale di Venezia* 8, no. 30 (January–March 1958), 46–48.

Jarvis, Alan. *Canada XXIX Biennale di Venezia*. Ottawa: National Gallery of Canada, [June] 1958.

Russell, John. "Who's In, Who's Out in Venice." *Sunday Times* (London), 15 June 1958.

Sprigge, Sylvia. "Variety of the World's Art in Venice." *Manchester Guardian Weekly*, 19 June 1958; reprinted in *Gazette* (Montreal), 28 June 1958.

Zevi, Bruno. "Arredi scarpiani, spaccato BBPR." *L'Espresso*, 29 June 1958, 16; reprinted in *Cronache di architettura*, no. 216. Bari: Universale Laterza, 1971, 117–19.

"Canadian Show in Venice Hailed as Major Success." *Gazette* (Montreal), 9 July 1958.

Vorres, Ian. "Art and Reflections." *Hamilton Spectator*, 12 July 1958.

"Morrice Retrospective at Canada Pavilion in Venice." *Ottawa Citizen*, 12 July 1958.

"Our Own Pavilion at the Biennale." *Montreal Star*, 19 July 1958.

Blouin, Nicole. "Nouveau pavillon canadien à 'La Biennale' de Venise." *L'Action catholique*, 28 July 1958.

"Our New Pavilion Impresses Venice." *Weekend Magazine (Montreal Standard)* 8, no. 33 (23 August 1958), 40–42.

Buchanan, Donald W. "Un pavillon du Canada à la biennale de Venise." *Vie des arts*, no. 12 (Autumn 1958), 4–8.

"Il padiglione del Canada alla Biennale di Venezia." *Casabella Continuità*, no. 221 (September–October 1958), 40–45.

"Picture Buildings: Canadian Pavilion: Biennale, Venice." *Canadian Architect* 3, no. 11 (November 1958), 62–64.

Fenwick, Kathleen M. "The New Canadian Pavilion at Venice." *Canadian Art* 15, no. 4 (November 1958), 274–77.

"Coast to Coast in Art: Reactions to Canada's Art in Venice." *Canadian Art* 15, no. 4 (November 1958), 300.

Steegman, John. "New Vision at Venice." In *Impulse*. London: Mitchell Engineering Ltd., 1958, 37–40.

"The Canadian Pavilion at Venice." In *The National Gallery of Canada: Annual Report of the Board of Trustees for the Fiscal Year 1958–1959*. Ottawa: National Gallery of Canada, 1959, 30–34.

Paci, Enzo. "Continuità e coerenza dei BBPR." *Zodiac* 4 (1959), 82–115.

Aloi, Roberto. *Esposizioni Architetture Allestimenti*. Milan: Ulrico Hoepli, 1960.

Hale, Barrie. "It's Canadian and it's terrible." *Toronto Telegram*, 4 July 1966.

Kritzwiser, Kay. "Gallery director wants a new pavilion in Venice." *Globe and Mail*, 23 July 1966.

Malcolmson, Harry. "We triumphed in Venice, despite riots." *Toronto Star*, 20 July 1968.

Alloway, Lawrence. *The Venice Biennale 1895–1968: From Salon to Goldfish Bowl*. Greenwich: New York Graphic Society / London: Faber & Faber, 1968.

Kritzwiser, Kay. "Venice 'best ever' for Snow." *Globe and Mail*, 18 August 1970.

Boggs, Jean Sutherland. *The National Gallery of Canada*. Toronto: Oxford University Press, 1971.

Bonfanti, Ezio and Marco Porta. *Città, Museo e Architettura: Il Gruppo BBPR nella cultura architettonica italiana 1932–1970*. Florence: Vallecchi, 1973.

Balfour Bowen, Lisa. "The 40th Venice Biennale." *Artmagazine* 14, no. 60 (September/October 1982), 29–33.

Pastor, Barbara and Sandro Polci. "Parliamo un po' di esposizioni: Le esperienze di Franco Albini, del gruppo BBPR e di Carlo Scarpa." *Quaderni di documentazione dell'U.I.A.* 1 (1985), 41–52.

Day, Peter. "Canada rates also-ran status at Biennale." *Globe and Mail*, 23 July 1986.

Charney, Melvin. "A Venice Construction: a Banquet." *Parachute* 43 (June/July/August 1986), 14–15.

184

Townsend-Gault, Charlotte. "Reviews: XLII Biennale d'arte di Venezia." *Canadian Art* 3, no. 3 (Fall 1986), 100–102.

Lepage, Jocelyne. "De la Biennale de Venise à la galerie Blouin." *La Presse*, 31 January 1987.

"A Venezia, la città per l'arte / A city for art within the city of Venice." *Abitare*, no. 270 (December 1988), 164–73.

Mays, John Bentley. "Engaging dialogues on art." *Globe and Mail*, 24 June 1988.

Mays, John Bentley. "Caught between industry and art." *Globe and Mail*, 28 June 1988.

Duncan, Ann. "Canada's star rises at Venice Biennale." *Gazette* (Montreal), 13 August 1988.

Laurence, Jocelyn. "Flashback: Venice Absurd: the 43rd Biennale." *Canadian Art* 5, no. 3 (Fall 1988), 136.

Gascon, France. *Roland Brener, Michel Goulet: Canada XLIII Biennale di Venezia 1988*. Montreal: Musée d'art contemporain, 1988.

Mulazzani, Marco. *I padiglioni della Biennale: Venezia 1887–1988*. Milan: Electa, 1988.

Duncan, Ann. "Montreal artist's powerful images bound to conjure range of reactions." *Gazette* (Montreal), 21 April 1990.

Mays, John Bentley. "Venetian Visions." *Globe and Mail*, 26 May 1990.

Mays, John Bentley. "Canada's ugly art pavilion ripe for the wrecker's ball." *Globe and Mail*, 1 June 1990.

Lepage, Jocelyne. "La Biennale de Venise: le plus vieux et le plus gros show d'art actual." *La Presse*, 20 June 1990.

Lepage, Jocelyne. "Venise, Jour II: Quand l'art vous sort par les oreilles." *La Presse*, 25 June 1990.

Lepage, Jocelyne. "Geneviève Cadieux: doux souvenirs de Venise." *La Presse*, 7 July 1990.

Semerani, Luciano. "Ernesto N. Rogers: Un modo di intendere l'architettura." *Phalaris* 2, no. 10 (October–November 1990), 1–3.

Richards, Larry. "29 Days of Architecture: Report from Venice." *Canadian Architect* 36, no. 11 (November 1991), 31–33.

Ferguson, Bruce. "Biennale is tough venue." *Gazette* (Montreal), 26 June 1993.

Mays, John Bentley. "The art will find a way." *Globe and Mail*, 6 July 1993.

Maffioletti, Serena. *BBPR*. Bologna: Zanichelli, 1994.

Reesor, Carol Harrison. "The Chronicles of the National Gallery at the Venice Biennale." M.A. thesis, Department of Art History, Concordia University, 1995.

Graham, Rodney, ed. *Island Thought: Canada XLVII Biennale di Venezia*. Toronto: York University Art Gallery, 1997.

Paikowsky, Sandra. "Constructing an Identity: The 1952 XXVI Biennale di Venezia and 'The Projection of Canada Abroad.'" *Journal of Canadian Art History* 20, no. 1/2 (1999), 130–77.

Lehmann, Henry. "Video dog does Venice." *Gazette* (Montreal), 22 June 2003.

Godmer, Gilles with John W. Locke. *Jana Sterbak: From Here To There: Canada L Biennale di Venezia*. Montreal: Musée d'art contemporain, 2003.

Sabatino, Michelangelo. "A Wigwam in Venice: The National Gallery of Canada Builds a Pavilion, 1954–1958." *Journal of the Society for the Study of Architecture in Canada* 32, no. 1 (2007), 3–14.

Bélisle, Jean-François. "Canadian Voices at the Venice Biennale: The Production of a Canadian Image through the Venice Biennale between 1988 and 2005." M.A. thesis, Department of Art History, Concordia University, 2007.

Lam, Elsa. "Wilderness National: The Myth of Nature in Canadian Architecture." *Journal of the Society for the Study of Architecture in Canada* 33, no. 2 (2008), 11–20.

Mark Lewis: Cold Morning: Canada 2009, 53rd International Art Exhibition, la Biennale di Venezia. Toronto: Justina M. Barnicke Gallery / Vancouver: Vancouver Art Gallery, 2009.

Garneau, Sarah. "Représentation du Canada à la Biennale de Venise, 1952–2007." *Actes du 8e Colloque Étudiant du Département d'Histoire de l'Université Laval*. Quebec: Université Laval, 2009, 223–36.

Moreno, Valentine. "Venice Biennale and the Canada Pavilion: Politics of Representation in the Gardens of Art." *University of Toronto Faculty of Information Quarterly* 3, no. 1 (2010/11), 6–17.

Fung, Jason. "Architecture and Canada: The Character of Context." M.A. thesis, Department of Architectural Science, Ryerson University, 2011.

Drouin-Brisebois, Josée. *Steven Shearer: Exhume to Consume, La Biennale di Venezia, 2011*. Ottawa: National Gallery of Canada, 2011.

Diggon, Elizabeth. "The Politics of Cultural Power: Canadian Participation at the Venice and São Paulo Biennials, 1951–1958." M.A. thesis, Department of Art History, Queen's University, 2012.

Sabatino, Michelangelo. "A Tipi in Venice: BBPR's Canadian Pavilion for the Biennale (1954–58)." In Chiara Baglione, ed. *Ernesto Nathan Rogers: 1909–1969*. Milan: FrancoAngeli, 2012, 261–67.

Bumbaru, Dinu. "Canadian Pavilion 1958: Remotely Sensing the Place." In Diener & Diener with Gabriele Basilico, eds. *Common Pavilions: The National Pavilions in the Giardini in Essays and Photographs*. Zurich: Verlag Scheidegger & Spiess, 2013, 212–18.

Basilico, Gabriele. *Pavilions and Gardens of Venice Biennale: Photographs by Gabriele Basilico / Padiglioni e Giardini della Biennale di Venezia: Fotografie di Gabriele Basilico*. Rome: Contrasto, 2013

Robinson, Joel. "Folkloric Modernism: Venice's Giardini della Biennale and the Geopolitics of Architecture." *Open Arts Journal*, no. 2 (Winter 2013–14), 1–24.

Mulazzani, Marco. *Guide to the Pavilions of the Venice Biennale since 1887*. Milan: Electa, 2014.

Fraser, Marie et al. *BGL: Canadassimo*. Ottawa: National Gallery of Canada, 2015.

Windsor-Liscombe, Rhodri and Michelangelo Sabatino. *Canada: Modern Architectures in History*. London: Reaktion Books, 2016.

Michon, David. "Our Pavilion." *Canadian Art* 34, no. 1 (Spring 2017), 13, 68–69.

Weder, Adele. "Venice Redux." *Canadian Architect* 63, no. 2 (February 2018), 4.

Sharpe, Emily. "Canada's 1950s Venice Pavilion Gets a Facelift." *Art Newspaper* (International edition) 27, no. 301 (May 2018), 41.

Soulez, Juliette. "Biennale d'architecture de Venise: Le Canada pend la crémaillère." *Le Quotidien de l'Art*, no. 1501 (23 May 2018), 6–7.

185

Contributors

Susanna Caccia Gherardini is professor of restoration at the Università degli Studi di Firenze. She carries out research and teaching activities in the cultural heritage sector, pursuing her interests in the field of restoration studies through collaborations with the scientific community in Europe and beyond. She is Co-director of the journal *Archaeological Restoration*, and has published extensively on cultural heritage. Her recent books include *Le Corbusier dopo Le Corbusier* (FrancoAngeli, 2014); and, with Carlo Olmo, *Le Corbusier e l'Accademia invisibile della modernità. La villa Savoye. Icona, rovina, restauro 1948–1968* (Donzelli Editore, 2016).

Karen Colby-Stothart has spent more than thirty years in the visual arts sector, holding key positions at major Canadian museums, including the Art Gallery of Ontario, the Montreal Museum of Fine Arts, and the National Gallery of Canada, where she was Deputy Director, Exhibitions and Outreach. In 2013 she was appointed Chief Executive Officer of the National Gallery of Canada Foundation, an independent charity dedicated to achieving sustained private funding for the Gallery and key national initiatives. She led the Canada Pavilion program renewal from 2009 to 2019 on behalf of the Gallery and Foundation.

Josée Drouin-Brisebois is Senior Curator of Contemporary Art at the National Gallery of Canada, responsible for Canadian and international contemporary art collections. She has been highly involved in Canada's participation at the Venice Art Biennale since 2011. She has curated numerous exhibitions, including monographs of major Canadian artists and thematic exhibitions at the National Gallery of Canada, the Art Gallery of Alberta, the Museum of Contemporary Art Toronto, and The Rooms. Her writing on contemporary art has appeared in a variety of publications and periodicals in Canada and abroad.

Réjean Legault is professor at the École de design of the Université du Québec à Montréal, where he has taught since 2001. His research focuses on the history of post-war architecture in North America and Europe. His extensive publications include the co-edited volume *Anxious Modernisms: Experimentation in Postwar Architectural Culture* (MIT Press, 2000). He was the guest curator of the National Gallery of Canada's exhibition *Canada Builds/Rebuilds a Pavilion in Venice*, presented in the Canada Pavilion during the 2018 Venice Architecture Biennale, and is collaborating with the National Film Board of Canada on a documentary about the pavilion.

Serena Maffioletti is an architect and professor of architecture and urban design at Università Iuav di Venezia, where she has taught since 1992. She is also the Director of the Iuav's Archivio Progetti, an archive and documentation centre of modern and contemporary architecture and design. Her research focuses on twentieth-century Italian and international architecture. She has organized several exhibitions and published extensively on the work of the members of Studio BBPR, including *BBPR* (Zanichelli, 1994), *Ernesto N. Rogers: Architettura, misura e grandezza dell'uomo* (Il Poligrafo, 2010), and *Enrico Peressutti. Fotografie mediterrannee* (Il Poligrafo, 2010).

Cammie McAtee is a Montreal-based historian, curator, and editor. She has curated many exhibitions and published widely in the field of post-war architecture and design. Her recent publications include the co-edited volume *The Politics of Furniture: Identity, Diplomacy and Persuasion in Post-War Interiors* (Routledge, 2017) and *Montreal's Geodesic Dreams: Jeffrey Lindsay and the Fuller Research Foundation Canadian Division* (Dalhousie Architectural Press, 2017). She was the lead researcher for the National Gallery of Canada's exhibition on the Canada Pavilion in Venice and provided key research and editorial expertise for the accompanying publication.

Franco Panzini is an architect, landscape historian, and guest lecturer at Università Iuav di Venezia and in the Dipartimento di Architettura, Università Roma Tre. He is a member of many institutions, including the Italian Associazione Italiana di Architettura del Paesaggio and the Board of the Fondazione Pietro Porcinai. His numerous publications on the history of gardens and urban green spaces include *Per i piaceri del popolo: L'evoluzione del giardino pubblico in Europa dalle origini al XX secolo* (Zanichelli, 1993); *Progettare la natura* (Zanichelli, 2005); and *Prati urbani / City Meadows* (Fondazione Benetton, 2018).

Andrea Pertoldeo is a photographer and adjunct professor of photography at Università Iuav di Venezia, where he worked for many years as Guido Guidi's teaching assistant. He has carried out several photography research projects and participated in many exhibitions. His work has been presented in such international journals as *Aperture*, *Genda*, *Domus*, *Casabella*, *AIT*, *Goya*, and *Territorio*. In 2017 *Blue Dust*—his photography monograph on the transformation of the desert landscape of Bahrain—was published. In 2018 the National Gallery of Canada commissioned him to document the restoration of the Canada Pavilion.

Reale fotografia Giacomelli was established in Venice in 1907. The photography studio rose to prominence between the two world wars under the direction of Pietro Giacomelli, succeeded by his daughter Vera in 1939. Through photography commissions of major infrastructure projects, the industrial area of the Porto Marghera, and the development of tourism on the Lido, Studio Giacomelli documented the urban and territorial transformation of Venice and the mainland. As its 1958 photographs of the Canada Pavilion attest, the studio also received contracts from architects and building firms.

Acknowledgements

The National Gallery of Canada acknowledges the visual artists and architects who have exhibited at the Canada Pavilion since its inauguration in June 1958 as well as the curators, commissioners, and commissioning institutions who have worked alongside them to bring their artistic visions to fruition.

Patrons

The Gallery and its Foundation are deeply grateful to Reesa Greenberg, Distinguished Patron and Director of the National Gallery of Canada Foundation and Founding Secretary of the Society for the Study of Architecture in Canada, for her visionary support of the renovation of the Canada Pavilion, resulting in a greatly enhanced exhibition space for our country's artists.

Canada's participation at the Venice Biennale would not have been possible without the exceptional gifts to the Canadian Artists in Venice Endowment by Michael and Sonja Koerner; Michelle Koerner and Kevin Doyle; Elizabeth and Donald R. Sobey and Family; and The Jack Weinbaum Family Foundation.

We also extend our gratitude to the countless private and corporate donors who have supported Canada at the International Art Exhibition—La Biennale di Venezia since its first participation as a nation in 1952.

Contributors to the pavilion restoration and landscape renewal

Alberico Barbiano di Belgiojoso
Troels Bruun
Joseph D'Agostino
Carlo Dalla Vedova
Gordon Filewych
Bryce Gauthier
Cornelia Hahn Oberlander

La Biennale di Venezia
Paolo Baratta
Andrea Del Mercato
Cristiano Frizzele
Manuela Lucà-Dazio
Micol Saleri
Marco Tosato

Soprintendenza Archeologia, Belle Arti e Paesaggio per il Comune di Venezia e Laguna
Emanuela Carpani (Soprintendente, 2015–)
Renata Codello (Soprintendente, 2006–14)
Anna Chiarelli
Chiara Ferro

Embassy of Canada to Italy
Ambassador Alexandra Bugailiskis (2017–)
Ambassador Peter McGovern (2013–17)
Louis Saint-Arnaud
Enrica Abbate
Mylène Kahalé

Embassy of Italy in Canada
Ambassador H.E. Claudio Taffuri (2017–)
Ambassador H.E. Gian Lorenzo Cornado (2013–16)

Special recognition is due to all the expert contractors, workers, gardeners, and arborists who have contributed to the restoration and maintenance of the pavilion as well as to the renewal of its landscape.

Institutional partners

Archivio Progetti, Università Iuav di Venezia
Serena Maffioletti
Riccardo Domenichini

Canada Council for the Arts
Simon Brault
Sylvain Cornuau
Kelly Langgard
Pao-Quang Yeh
Carolyn Warren

National Film Board
Claude Joli-Coeur
Katerine Giguère
Annie Leclair
Denis McCready
André Picard

Royal Architectural Institute of Canada
Mike Brennan
Ian Chodikoff
Maria Cook
Barry Johns
Allan Teramura

The editor warmly thanks the following individuals for their assistance with the preparation of the exhibition *Canada Builds/Rebuilds a Pavilion in Venice* and this publication: Tamara Andruszkiewicz, Serge Belet, Ricciarda Belgiojoso, Nicole Burisch, Cyndie Campbell, Sabina Carboni, Douglas Cardinal, Maristella Casciato, Karen Colby-Stothart, Brigitte Desrochers, Josée Drouin-Brisebois, Anne Eschapasse, Martina Frank, Sasha Hastings, Margherita Lancellotti, Louis-Charles Lasnier, Jolin Masson, Marie-Claude Mongeon, Marina Peressutti, Andrea Pertoldeo, Julie Roy, Howard Shubert, Alexis Sornin and Kevin Zak. Anne Trépanier provided invaluable assistance by finding key documents in the archives of the Embassy of Canada in Rome.

Index

Canada Pavilion Fact Sheet

Design and Construction

Commissioner:
National Gallery of Canada
Commission: 8 December 1955

1st project: September 1956
2nd project: October 1956
Building permit: 26 March 1957
Inauguration: 11 June 1958

Architect:
Enrico Peressutti / Studio BBPR (Milan)
Assistant: Giorgio Bay

Structural engineer: Aldo Favini (Milan)

General contractor: Siccet—Arch. E.
Monti—Cantieri Milanesi (Milan)

Roofing: Zintek s.r.l. (Porto Marghera)

Furniture:
Robin Bush Associates (Toronto),
Jan Kuypers (Imperial Furniture Mfg.
Co. Ltd., Stratford)

Interior floor area: 145 m^2
Courtyard floor area: 40 m^2
Total area: 185 m^2

Architectural Restoration

Commissioner:
National Gallery of Canada
Commission: 2013 / 2016

Start of construction: December 2017
Inauguration: 24 May 2018

Architect: Alberico Belgiojoso
(Studio Belgiojoso, Milan)
Assistants: Margherita Lancellotti,
Stefania Santopolo

On-site Architect:
Troels Bruun (M+B Studio, Venice)
Assistants: Francesco Toaldo,
Lorenzo Truant (lighting),
Luca Ugolini, Lucia Montan

Design Consultant: Gordon Filewych
(onebadant, Ottawa)

General Contractor: M+B Studio (Venice)
Director of Works: Troels Bruun /
Francesco Toaldo

Engineering: Zero4uno, Ingegneria s.r.l.
Engineering Systems:
Studio Associato Vio

Construction: Busolin Valter

Roofing: Zintek s.r.l.

Brickwork restoration: Lares Restauri

Woodwork: Spazio Legno

Ironwork: Bertoldini & Torre

Terrazzo restoration: Asin Erminio

Lighting: Zumtobel, Penta Architectural

Air conditioning: AerNova, Tecnoresine
s.r.l., Cappello Climatermica

Landscape Renewal

Commissioner:
National Gallery of Canada
Commission: 2016

Construction:
1st phase: Winter-Spring 2017
2nd phase: Winter-Spring 2018

Inauguration: 24 May 2018

Landscape Architects:
Cornelia Hahn Oberlander (Vancouver),
in association with Bryce Gauthier
(Enns Gauthier Landscape Architects,
Vancouver)
Assistants: Jazmín Cedeño,
Beatriz Mendes

Contractor: Servizi Tecnico-Logistici,
La Biennale di Venezia

Consultant: Marco Tosato, Agronomist
and Landscape Architect

Landscaping: Nonsoloverde

Platform area: 70 m^2

National Gallery of Canada
Chief, Publications and Copyright:
Ivan Parisien
Editor: Caroline Wetherilt
Copyright Manager: Véronique Malouin
Picture Editor: Andrea Fajrajsl

5 Continents Editions
Production Manager: Annarita De Sanctis
Editorial Coordination: Laura Maggioni
Editor: Charles Gute
Colour Separation: Maurizio Brivio, Milan
Printed in Italy on Gardamatt Art 150 g
by Tecnostampa—Pigini Group Printing
Division, Loreto—Trevi

Polygraphe
Project Manager and Coordination:
Jean Doyon
Creation and Graphic Designer:
René Clément
Graphic Designer: Lucie Chagnon
Designed and typeset in Maison Neue

Editorial Consultant: Cammie McAtee
Translators: Julian Comoy, Antonia Reiner,
Réjean Legault, and Cammie McAtee
(from the Italian language)

Published by 5 Continents Editions,
Milan, in association with the National
Gallery of Canada, Ottawa.

Texts © National Gallery of Canada, 2019
National Gallery of Canada
P.O. Box 427, Station A
380 Sussex Drive, Ottawa, Ontario
K1N 9N4, Canada
www.gallery.ca

Present edition © 2019—5 Continents
Editions, Milan
5 Continents Editions
Piazza Caiazzo 1
20124 Milan, Italy
www.fivecontinentseditions.com

Cataloguing data available from Library
and Archives Canada.

ISBN: 978-88-7439-884-3

Distributed by ACC Art Books throughout
the world, excluding Italy.
Distributed in Italy and Switzerland by
Messaggerie Libri S.p.A.